THE DRAGONFLIGHT CODEX

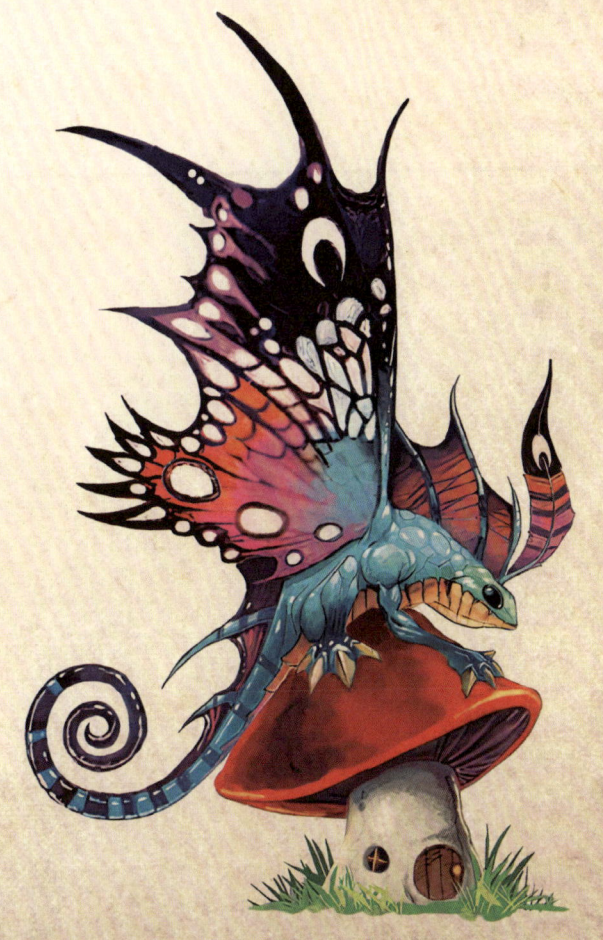

THE DRAGONFLIGHT CODEX

A Definitive Guide to the Dragons of Azeroth

Written by
Khadgar, Archmage of the Kirin Tor

Transcribed by
Sandra Rosner and Doug Walsh

Titan
Books

London

An Insight Editions Book

CONTENTS

Introduction 08

UNENDING SANDS OF TIME 10
 Creation of the Primals 12
 Rise of Galakrond 14
 Gifts of the Titans 16
 War of the Scaleborn 18
 War of the Ancients 22
 War of the Shifting Sands 26
 Second War 28
 Battle of Grim Batol 30
 Nexus War 34
 Fall of Deathwing 38

RED DRAGONFLIGHT 42
 Alexstrasza 46
 Korialstrasz 48
 Tyranastrasz 49
 Caelestrasz 50
 Vaelastrasz 50
 Dragonblight 52
 Wyrmrest Temple 52
 Vermillion Redoubt/
 Twilight Highlands 53
 Waking Shores 53

BRONZE DRAGONFLIGHT 54
 Nozdormu 56
 Soridormi 60
 Chronormu 60
 Anachronos the Ancient 62
 Grakkarond 63
 Zephyr & Zidormi 65
 Erozion 65
 Caverns of Time 66
 Ahn'Qiraj 66
 Andorhal 67
 Thaldraszus 67

BLUE DRAGONFLIGHT 68
 Malygos 70
 Kalecgos 72
 Sindragosa 74
 Balacgos 76
 Azuregos 76
 Arygos 78
 Arcanagos/Nightbane 80
 Tyrygosa 81
 Dalaran/Kirin Tor 82
 Nexus 82
 Azshara 83
 Azure Span 83

GREEN DRAGONFLIGHT 84
 Ysera 86
 Eranikus 88
 Merithra 90
 Ysondre 92
 Emeriss 92
 Taerar 94
 Lethon 95
 Temple of Atal'Hakkar 96
 Mount Hyjal 96
 Emerald Dream 97
 Ohn'ahran Plains 97

BLACK DRAGONFLIGHT 98
 Neltharion 100
 Sinestra 104
 Nefarian 106
 Onyxia 108
 Sabellian 110
 Wrathion 112
 Ebyssian 114
 Sartharion 115
 Dustwallow Marsh 116
 Blackrock Mountain 116
 Deepholm 117

DRAGONKIN 118
 Life Cycle of Dragons 120

HUMANOID 122
 Dracthyr 124
 Drakonid 125
 Ascendant 126
 Tarasek 127

MORE DRAGONKIN 128
 Wyrmkin 128
 Flametongues 129
 Scalebanes 129

CREATURES 130
 Primal Dragons 130
 Cloud Serpents 132
 Elemental Dragons 134
 Thorignir 135
 Veilwings 135
 Faerie Dragons 136
 Dragonhawks 137

PRIMALISTS 138
 Iridikron the Stonescaled 140
 Fyrakk the Blazing One 141
 Vryanoth the Frozenheart 142
 Raszageth the Storm-Eater 143

INFINITE DRAGONFLIGHT 144
 Murozond 146
 Occulus 146
 Epoch Hunter 148
 Aenous, Deja & Temporus 149
 Eternus 151
 Chrono-Lord Deios 151
 End Time 152
 Tarren Mill 152
 Stratholme 153

TWILIGHT DRAGONFLIGHT 154
 Halion 156
 Goriona 158
 Abyssion 159
 Theralion & Valiona 160
 Ruby Sanctum 161
 Bastion of Twilight 161

NIGHTMARE DRAGONFLIGHT 162
 Dragons of Nightmare 164
 Nythendra 166
 Twilight Grove of Duskwood 168
 Val'sharah/Shala'nir 169

FROSTBROOD 170
 Sapphiron 172
 Sindragosa 174
 Sarathstra 175
 Icecrown Citadel 175

NETHERWING FLIGHT 176
 Neltharaku & Karynaku 178
 Zzeraku 179
 Netherstorm 180
 Shadowmoon Valley 181

PLAGUED DRAGONFLIGHT 182
 Scholomance 182

CHROMATIC DRAGONFLIGHT 184
 Chromatus 186

Future of Dragons 188

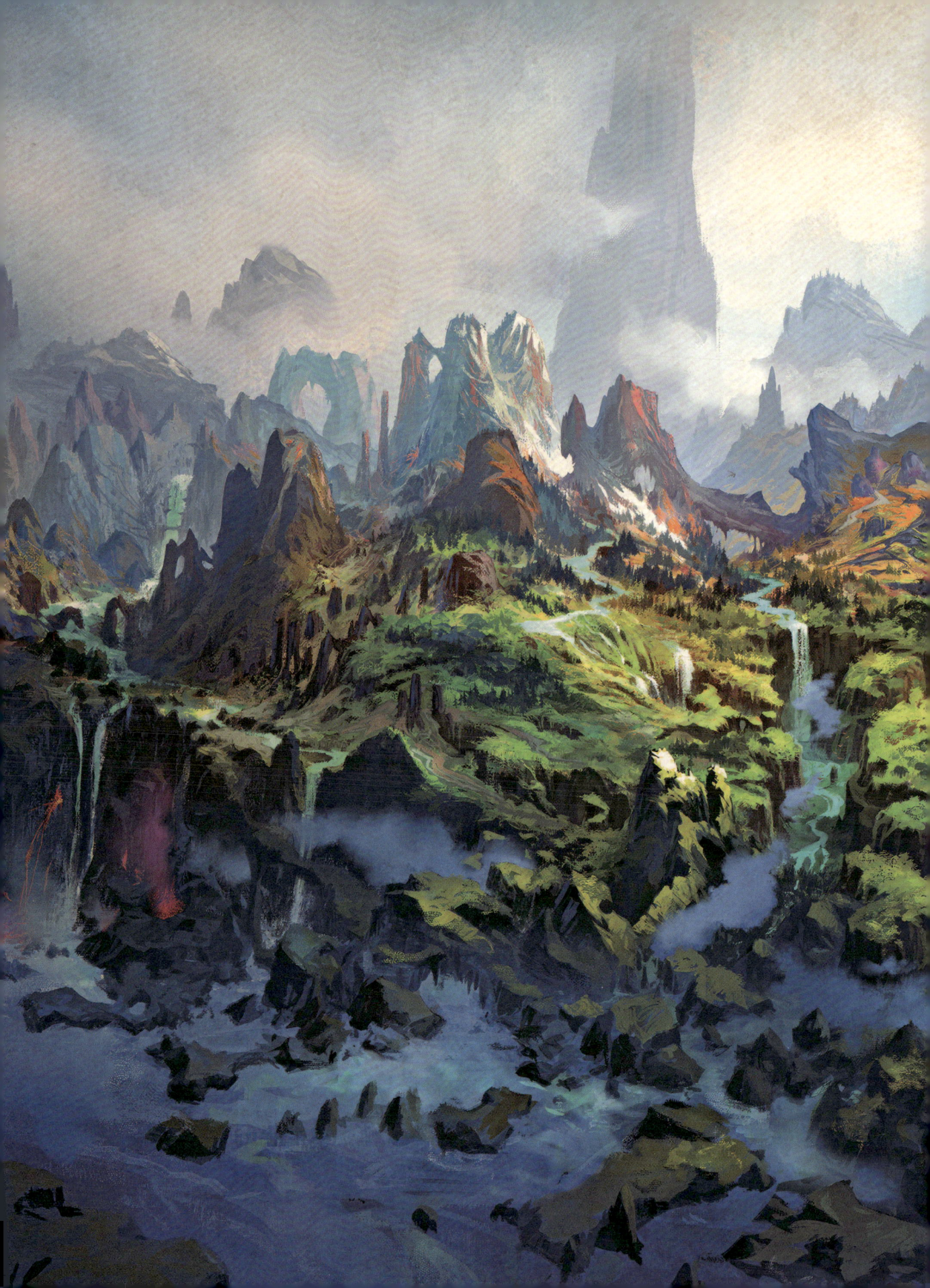

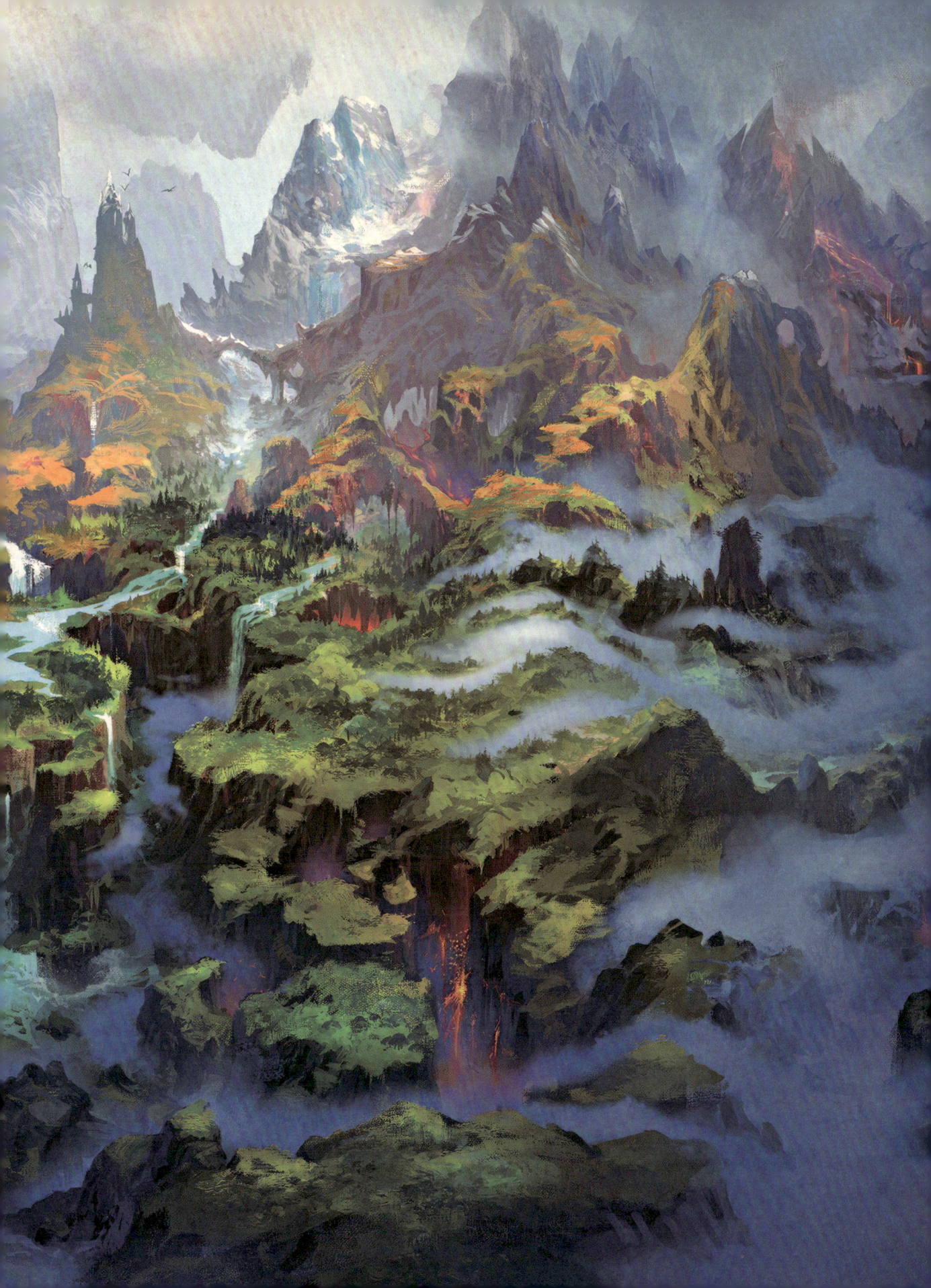

INTRODUCTION
BY KHADGAR, ARCHMAGE OF THE KIRIN TOR

Hello, Dear Friend . . .

During my time spent among the dragonflights of Azeroth, I have come to realize that it is as difficult to comprehend the timelessness of dragons as it is for dragonkind to fathom the brief spark of a mortal existence.

The impulsivity so often associated with the younger races seems the very antithesis of the measured Dragon Aspects who have served as the guardians of Azeroth for eons. Yet for all our seeming differences, it is the blue dragon, Kalecgos, who assures me that we value the very same cornerstones of life—those of love, peace, loyalty, and purpose.

Of all the qualities said to define the mortal experience, it is our <u>perseverance</u> that most endears us to the draconic. Within our brief, timebound existence, dragons are reminded of the sacred joys of life. Such is the reason they chose to open their ancient home to us.

My intent in creating this compendium is not only to write a history of the dragonflights, but also to explore the more intricate threads woven through many of our world's most pivotal moments. Having such privileged access to the great libraries of Dalaran, Karazhan, and now the Dragon Isles has allowed for a gathering of knowledge unrivaled at any other time.

While our modern era is said to begin with the opening of the Dark Portal and the great upheaval it wrought, it also introduced new allies who enriched our world, along with dangerous foes bent on its destruction. Some cities rose and others crumbled as ancient forces sought to define our destiny. Yet in our darkest hour, the champions of hope stood united to save a world shaped by the very titans themselves. And throughout it all, there were dragons. Herein lies their stories.

—Khadgar
Archmage of the Kirin Tor

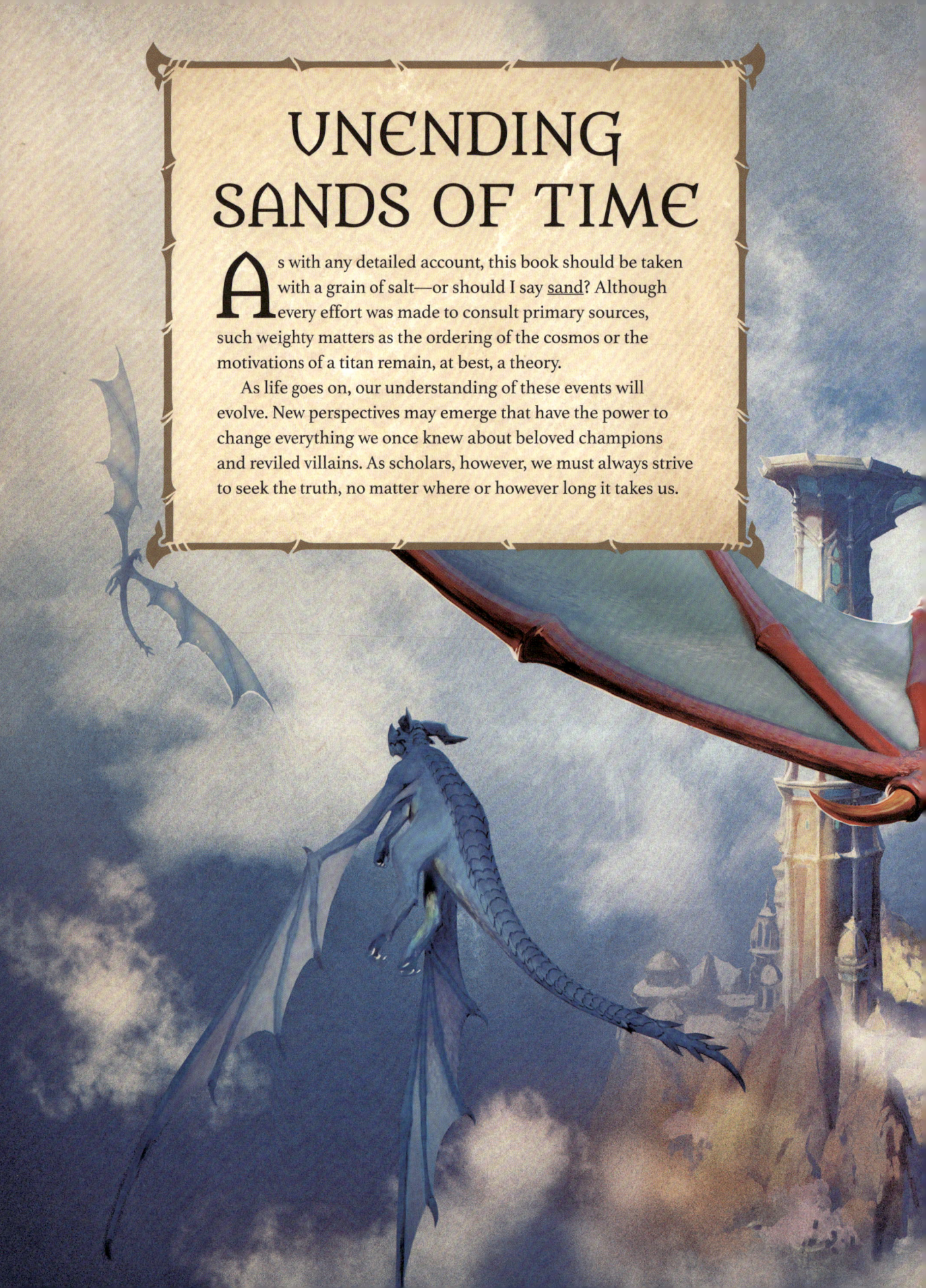

UNENDING SANDS OF TIME

As with any detailed account, this book should be taken with a grain of salt—or should I say <u>sand</u>? Although every effort was made to consult primary sources, such weighty matters as the ordering of the cosmos or the motivations of a titan remain, at best, a theory.

As life goes on, our understanding of these events will evolve. New perspectives may emerge that have the power to change everything we once knew about beloved champions and reviled villains. As scholars, however, we must always strive to seek the truth, no matter where or however long it takes us.

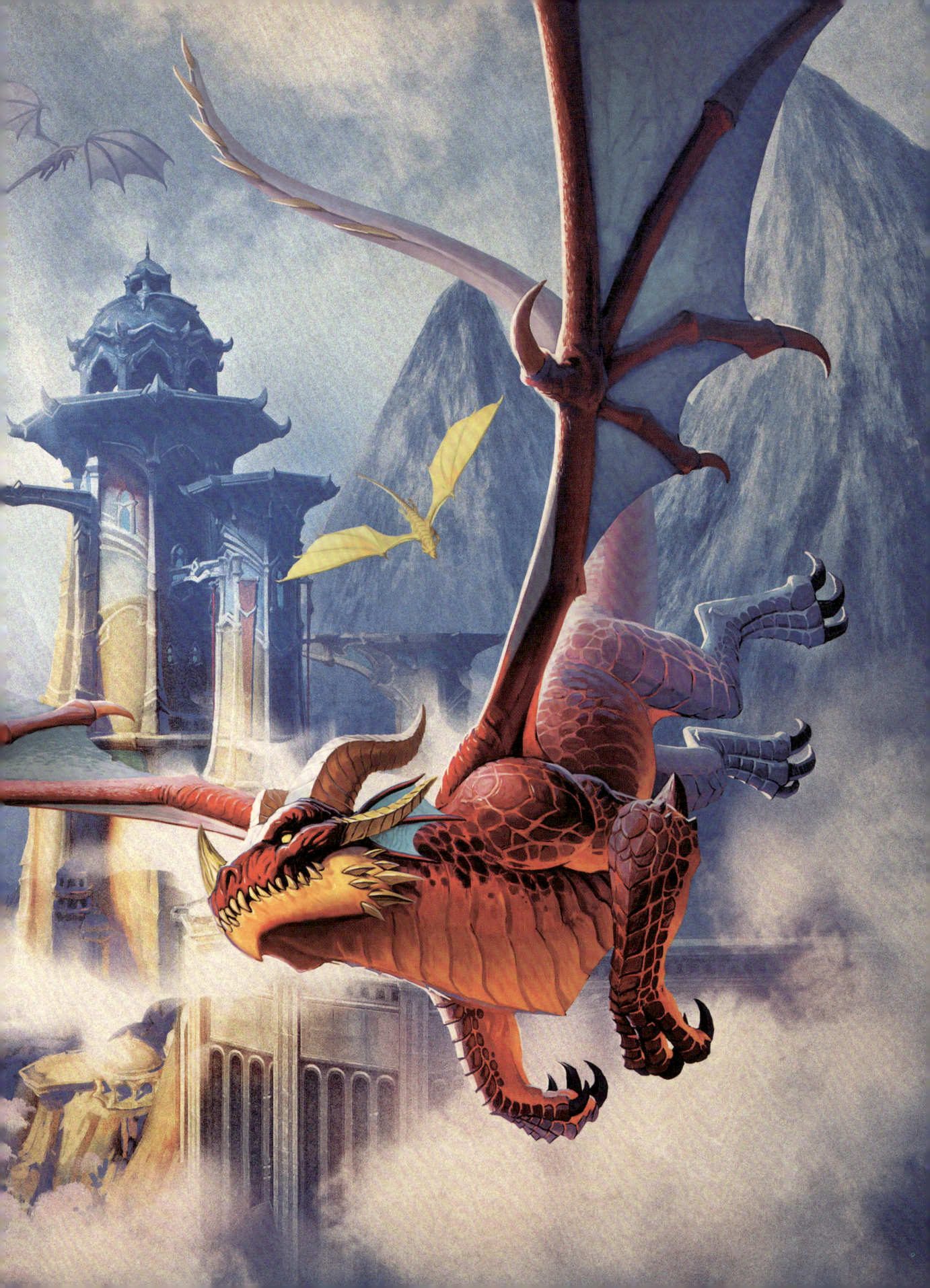

Creation of the Primals

While I could spend endless hours discussing the origins of our world, let us begin with this: Of the many cosmic forces known to exist throughout the Great Dark Beyond, the physical realm of Azeroth consists of five primary elements: earth, fire, air, water, and spirit.

It is believed that a great imbalance of spirit allowed the other elements to rampage unchecked, eventually giving rise to the elemental lords. While each denizen wielded incredible power, their division and warlike natures made them easy to conquer by invading creatures known as the Old Gods. For now, know that as agents of the Void Lords, these parasitic beings traveled the cosmos in hopes of corrupting a nascent world-soul into that of a Dark Titan.

It was in this utterly malignant state that the titans first discovered Azeroth and waged war upon the Black Empire to end its age of malevolence. With the elemental lords banished and the Old Gods imprisoned, balance was achieved for the first time on Azeroth, allowing abundant new lifeforms to emerge.

Though it is said that most of our world's diversity was shaped by Keeper Freya within her enclaves of Un'Goro, Sholizar Basin, and the Vale of Eternal Blossoms, other lifeforms appear to have evolved from the wild elementals who escaped containment within the Elemental Planes. Over time, such rebellious spirits transitioned into sentient creatures born of flesh and blood that each retained a core of primordial power. As these new winged reptilian predators took to the great skies of Azeroth, they called themselves the dragons.

The world was changing evermore . . .

Had the titans not triumphed, mortal life as we know it wouldn't exist.

Rise of Galakrond

Then came the rise of Galakrond, a primal dragon who grew to such monstrous size and strength that it is said the beating of his wings could fell an entire forest!

While there have been many wild theories over time, it is now believed that his accelerated growth and uncontrolled evolution were the result of ingesting the energies of a wellspring located on the Dragon Isles. Blessed also with the cunning of a master hunter, the leviathan quickly claimed all the best hunting grounds within the lush forests and vast grasslands of northern Kalimdor, gorging himself until even those once fertile territories could no longer sate him. Without sufficient game, the monster turned his hunger upon his own kind, making no distinction between the living and the dead. It is this grotesque act that many believe led to the necrotic infliction.

As Galakrond continued to feast on the dragon population, clutch-sisters Alexstrasza and Ysera conspired with Malygos, Neltharion, and Nozdormu to fight back against the threat, only to discover that they faced not only the behemoth, but also his undead brood. While the five dragons stood little chance of defeating Galakrond and his not-living dragons on their own, their unique willingness to work together soon drew the attention of a mighty titan-forged warrior known as Keeper Tyr.

In recognizing the threat Galakrond posed to the natural order of Azeroth, Tyr attempted to rally the other keepers to action. Though his efforts were in vain, Tyr remained undeterred and sought out an alliance with the dragons.

According to my rough calculations, Galakrond had grown to more than three times the size of Dalaran!

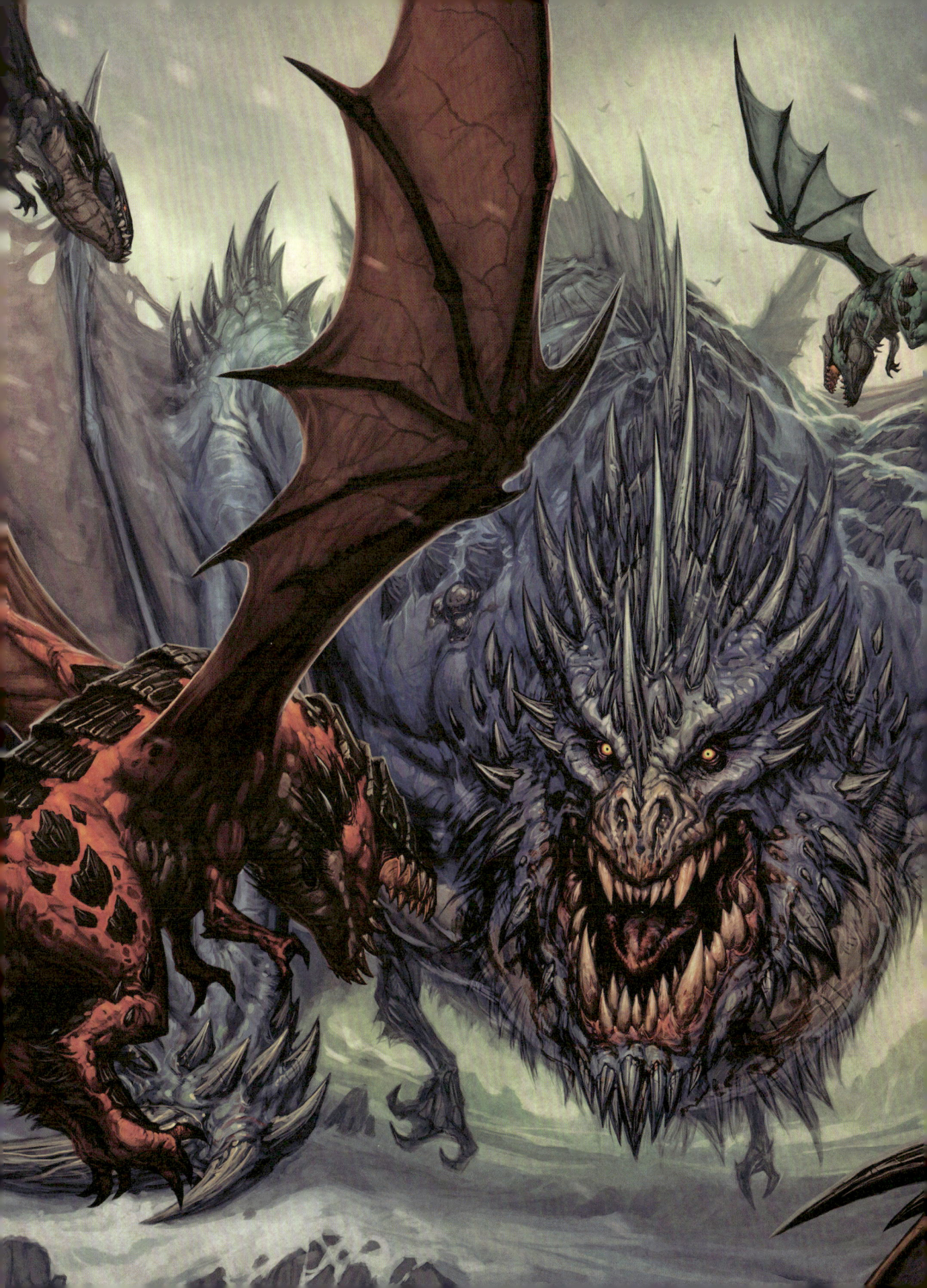

Gifts of the Titans

After plans to ambush their slumbering enemy failed and resulted in the loss of Tyr's hand, the five dragons devised a new strategy: Together, they would lure Galakrond over the snowy mountains of northern Kalimdor and fight with their combined strengths.

And so it was that Alexstrasza, Ysera, Malygos, Nozdormu, and Neltharion launched their legendary attack that brought about Galakrond's end.

Heartened by the bravery of his allies, Tyr gathered the other keepers to offer a proposal: These five heroic dragons would be ascended into guardians to serve as defenders of Azeroth. Despite the vehement refusal of their leader, Odyn, the remaining keepers offered their full support.

Gathering on the icy tundra near where Galakrond fell, keepers Freya, Loken, Ra, and Archaedas acted as conduits and channeled the Pantheon's power to transform Alexstrasza, Ysera,

Malygos, Nozdormu, and Neltharion into the Aspects of the red, green, blue, bronze, and black dragonflights, respectively.

In their new roles, each vowed to safeguard one of the primary forces of Azeroth: life, nature, magic, time, and earth. To further aid in their monumental tasks, the keepers imbued hundreds of primal dragons with the same grace and power of the Aspects, thus creating the five dragonflights of Azeroth.

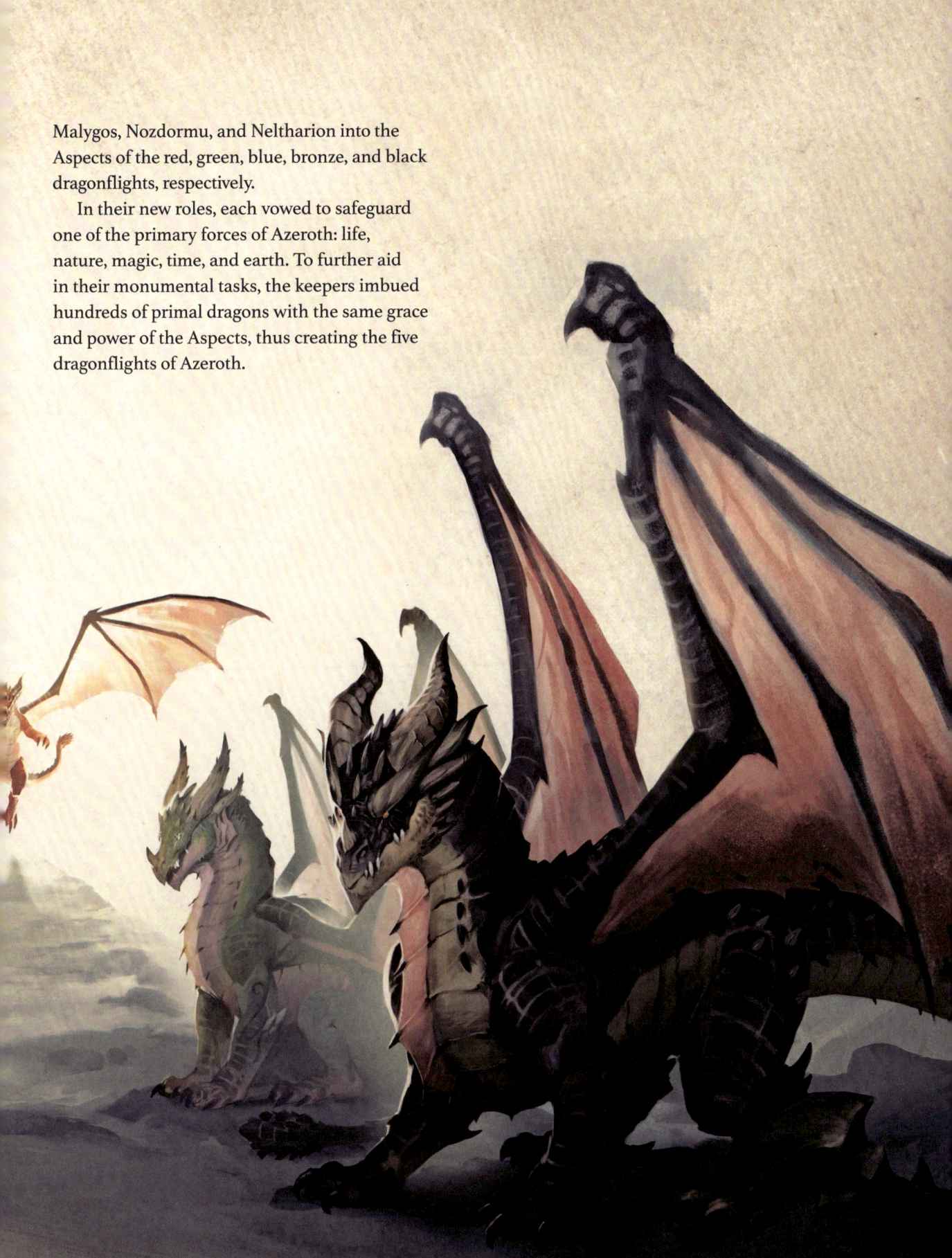

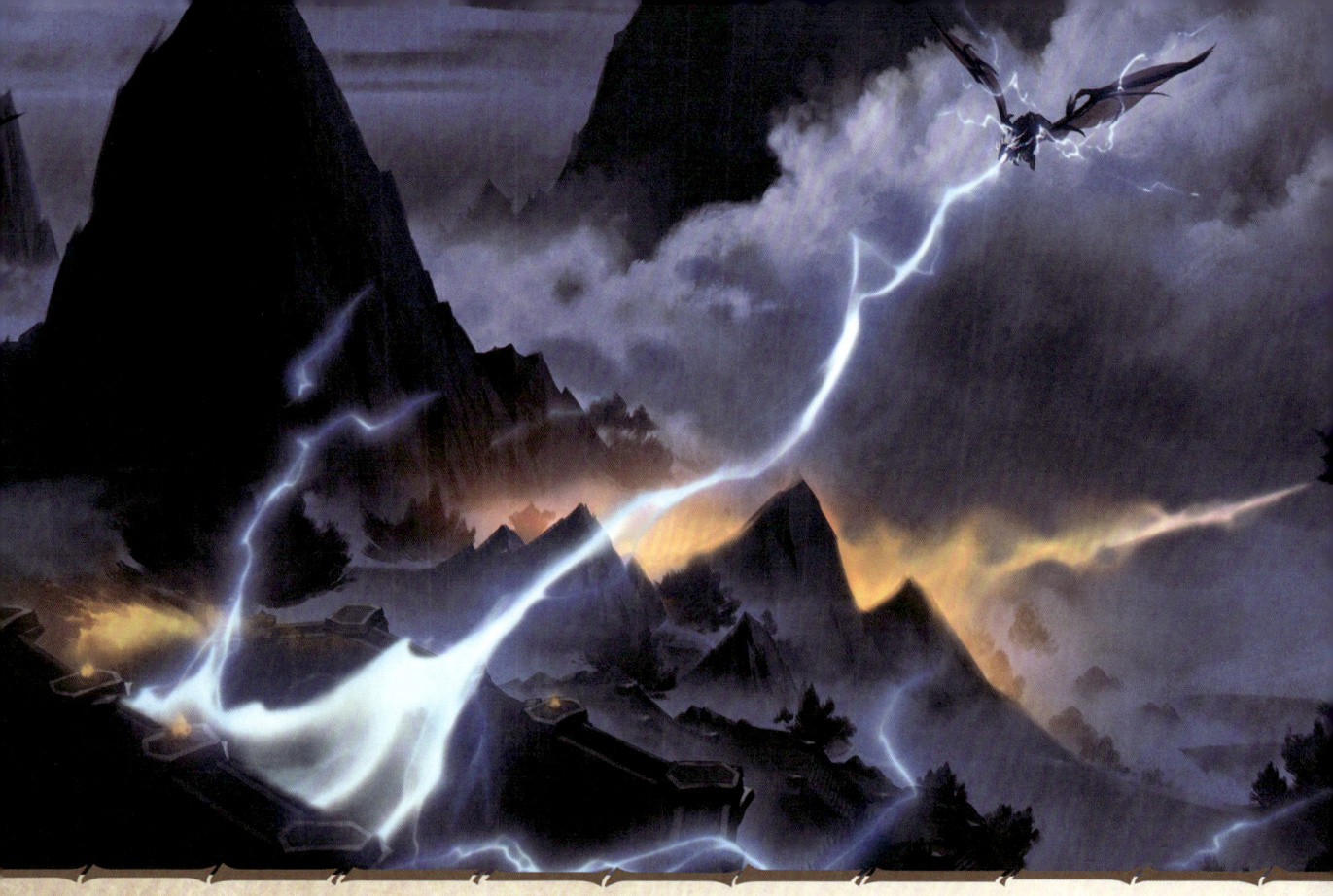

War of the Scaleborn

Though many primal dragons gladly accepted Keeper Tyr's gift of ascension following the fall of Galakrond, others looked upon the newly ordered dragons as traitors to their elemental origin. It is said that the loudest of these dissenters was Alexstrasza's cousin, Fyrakk, whose fierce words drew the support of Iridikron and others who joined together to forge the Primalist movement.

As kin, both sides sought to mediate their disagreements in good faith, until negotiations between the Dragon Queen Alexstrasza and the Primalists met with a swift end. Alexstrasza had allowed a number of primal eggs to be taken by the keepers and infused with Order magic. Infuriated by such a betrayal, Vyranoth joined Fyrakk, Iridikron, and Raszageth, and was infused with elemental power like them to become the fourth Incarnate.

Although they were powerful, the Primalist leaders knew they could not defeat the dragonflights alone. They set out recruiting and training the fringes of mortal society to wield the elements for their cause. The Incarnates were wise to raise their army beyond the borders of the Broodlands, but their actions did not escape the notice of Neltharion, the black Aspect.

Convinced now that war was inevitable, Neltharion set out to create an empowered force of his own that could overcome many of the existing weaknesses seen in the current dragonkin. The resulting soldiers were named dracthyr. Neltharion was amazed by their ability to wield the innate power of the five dragonflights, but he also saw a need to control these capable and intelligent new dragonkin. Using a titan device known as the Oathbinder, Neltharion tied the dracthyr forces to his will.

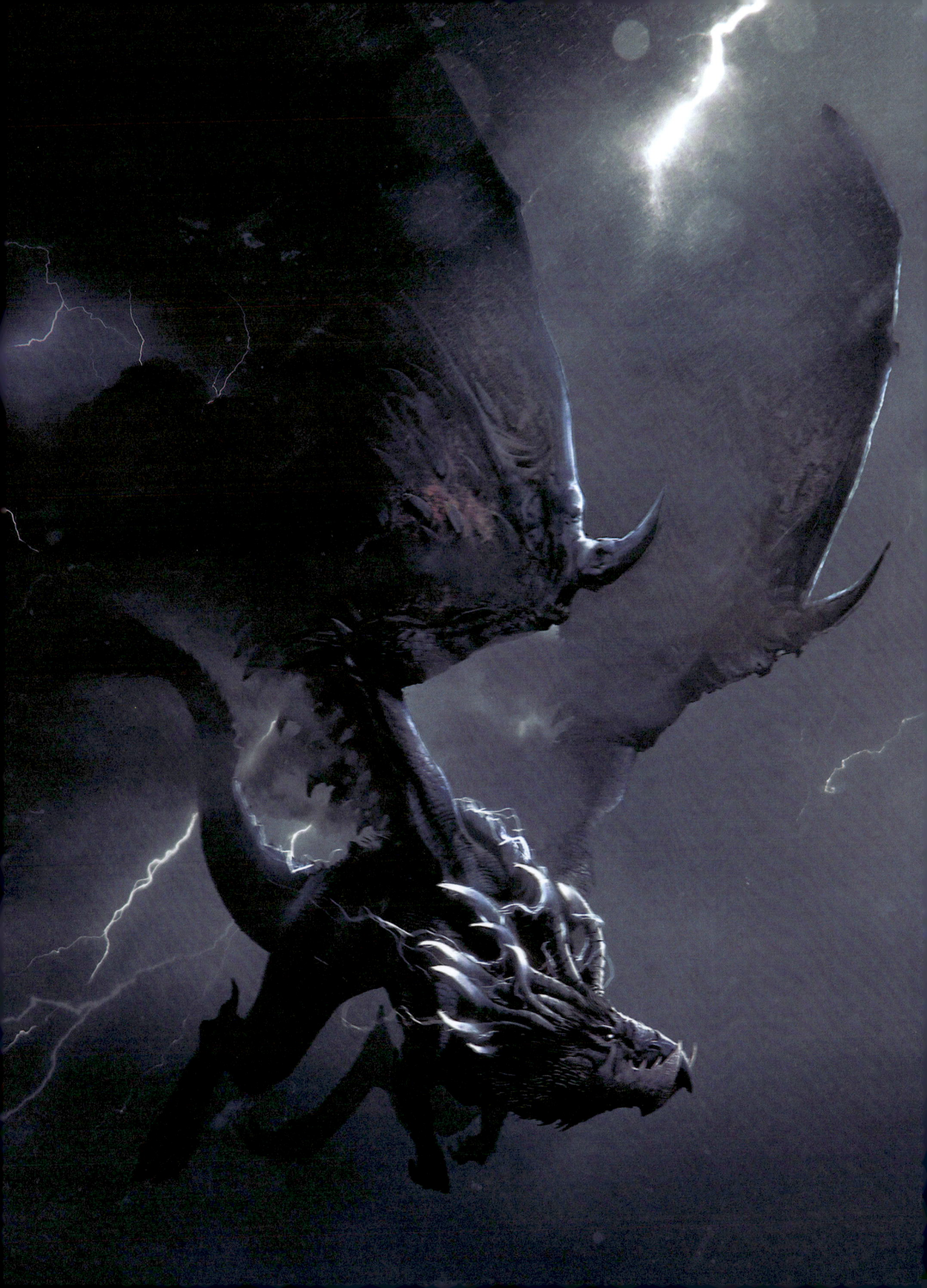

Set against the lone Aspect and his untested dracthyr, it seemed that Raszageth the Storm-Eater and the Incarnate's Primalist forces held the clear advantage. That is, until Neltharion surrendered to the whispers of the Old Gods and called upon the power of the Void. According to what accounts remain, a brutal blast of dark energy forced Raszageth into a vault, where Neltharion sought to contain her for all time.

Though Neltharion had seemingly won the battle, it came at the cost of the Oathbinder artifact, which led the black Aspect to place his dracthyr army into stasis until a new method of control could be devised. To achieve this and ensure the continued imprisonment of Raszageth, Neltharion sought out Malygos for aid. The blue Aspect assisted Neltharion by placing wards about the prison and offering members of his loyal flight to watch over the dracthyr's creche.

With peace no longer possible between the Primalists and the dragonflights, Neltharion informed Alexstrasza of the attack and asserted the need to eliminate both the remaining Incarnates and the Primalist opposition. While saddened by the turn of events, Alexstrasza agreed with Neltharion's assessment but insisted on imprisonment over death. Therefore, a suitable prison was created in Thaldraszus to contain them.

Though the war carried on for many years at great loss to both sides, the remaining Incarnates were eventually captured following the battles of Flamesfall, Icebound Eye, and Harrowsdeep, thus bringing an end to the War of the Scaleborn.

To ensure lasting peace on the Dragon Isles, Neltharion raised a mountain of earth around the Incarnates' titan-forged prison so that it could never again be opened. Or so the story goes . . .

Many areas of Azeroth bear the unfortunate scars of war, including the Dragon Isles.

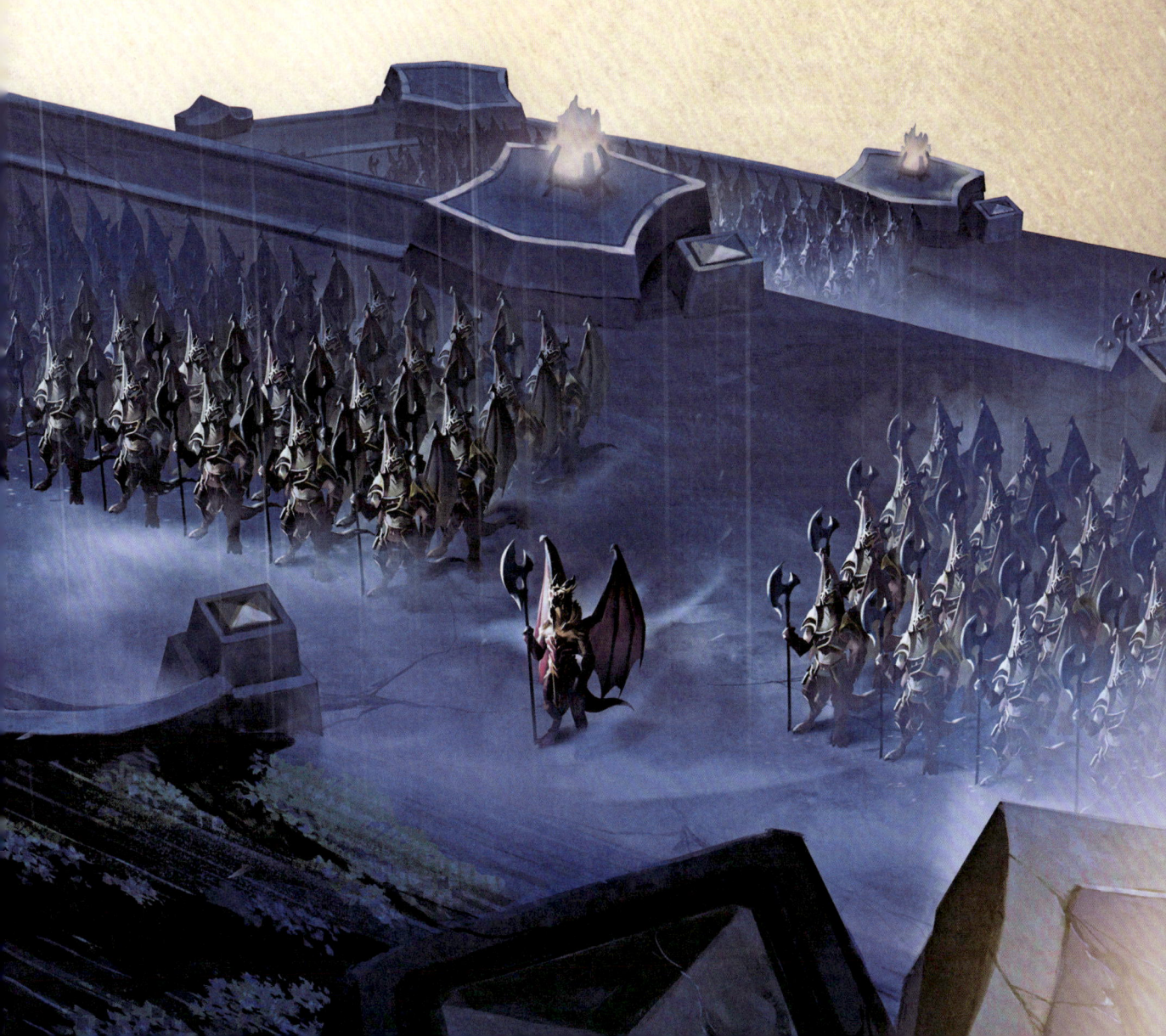

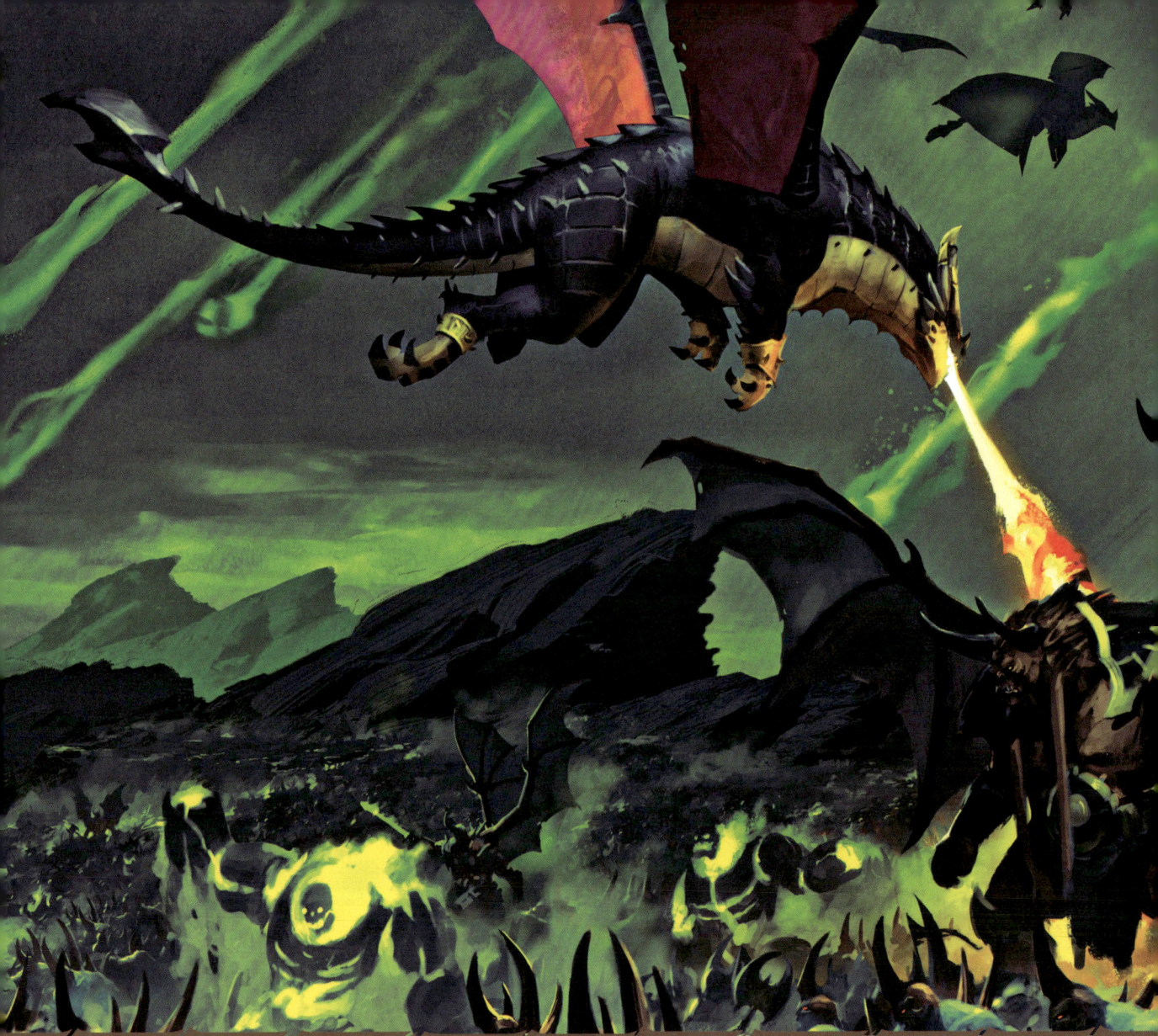

War of the Ancients

While the keepers and their new Aspects carried out their charges on Azeroth, a troubling new threat was rising within the cosmos. After failing to convince his fellow titans of the threat the Void Lords posed to the continuance of reality, Sargeras decided that he alone would save the universe by waging a Burning Crusade across all of existence. He reasoned that if life managed to form once, it could do so again in the absence of the Void. Such is often the solution of the powerful.

To achieve his nihilistic plans, Sargeras tore the prison of Mardum asunder to create a demonic army that he mercilessly unleashed upon each new world he encountered. Though the titan pantheon stood united against Sargeras' Burning Crusade, the titans soon discovered that his power had grown too great for even their combined might. During this battle, Sargeras learned about the existence of Azeroth and began his quest to find and destroy the world-soul before it could be corrupted by the Void.

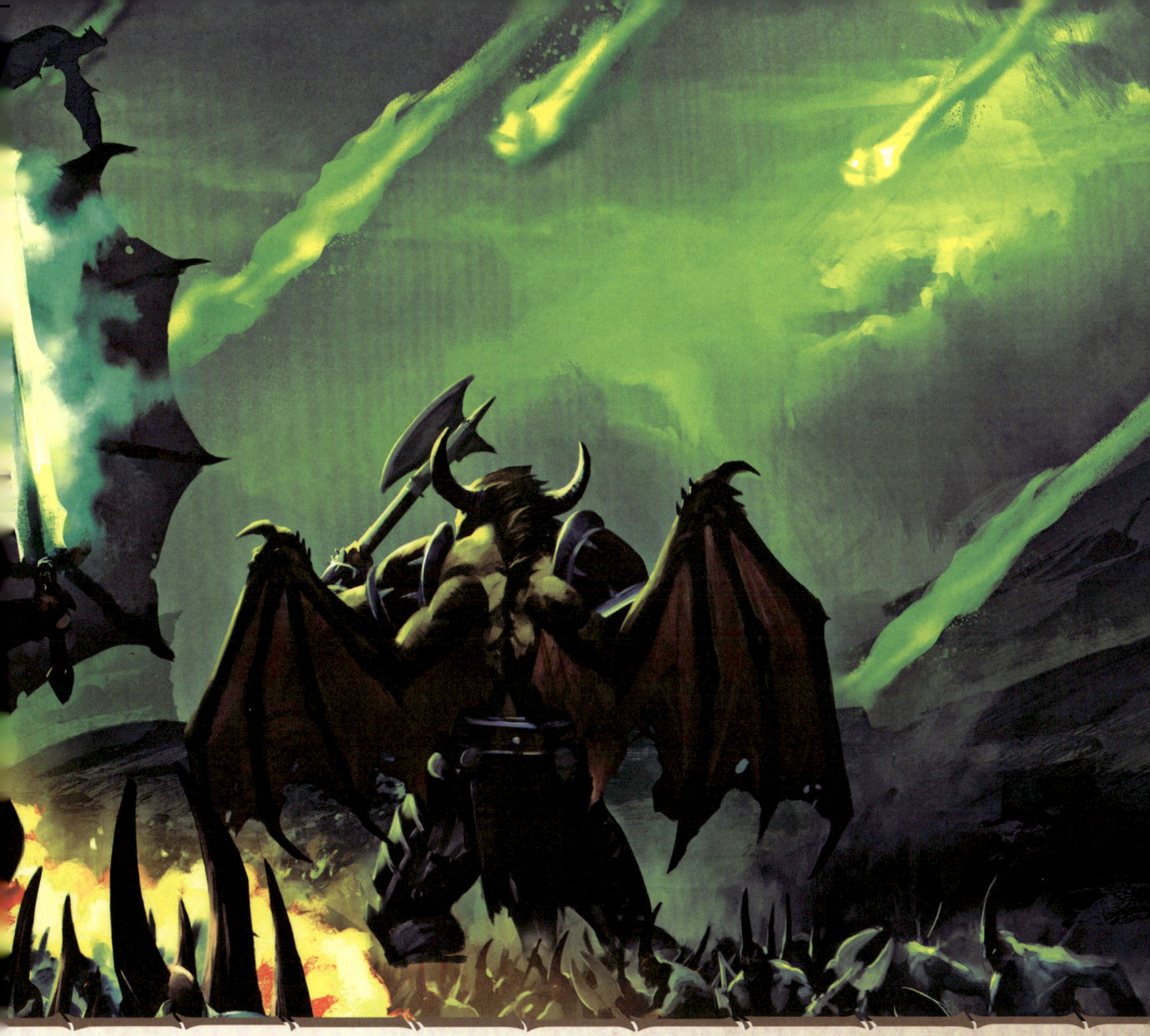

Meanwhile, back on Azeroth, legend tells us that a fateful group of dark trolls followed the path of a winged creature with an affinity for magic, known as a fairy dragon, to a font of immense power that they claimed for their own. Generations spent living near the enchanted well eventually transformed them into lithe and graceful beings of superior intellect who turned their rustic encampments into marvelous cities focused on the wonders of both nature and the arcane. Those dedicated to preserving the raw power and splendor of the wilds came to be known as druids, while elves with an aptitude for magic adopted the name Highborne. And so for generations these elves lived in harmony until the Highborne Queen Azshara, in her vast hubris, sought to trade away the peace and glory of her empire for the mere promise of power.

Unwaveringly supported by her adoring people, Azshara expanded her empire until it eclipsed even that of the mogu Emperor Lei Shen. Then she inexplicably turned her focus inward and recklessly began to experiment with the Well of Eternity (a very dangerous proposition in and of itself!). In the process, several torrents of power were released into the cosmos, drawing the attention of the Dark Titan.

Seeking to bend the sorceress queen's arrogance to his needs, Sargeras promised Azshara unimaginable power; in exchange, he required only that the Dark Titan's agents be allowed into her world. With their deal struck, Azshara ordered her Highborne to summon the denizens of the Legion; they immediately set to slaughtering any kaldorei who opposed their queen's decree.

For many months, the night elf resistance led by the elven archdruid Malfurion Stormrage; his sorcerer twin, Illidan; Lord Kur'talos Ravencrest; and the priestess of Elune, Tyrande Whisperwind managed to stave off the Legion's main onslaught. Yet with losses mounting and the demon horde seemingly endless, they needed to enlist new allies. While the druid patron Cenarius promised the aid of his fellow great spirits, known as the Wild Gods, Malfurion sought the wisdom and fury of the Dragon Aspects.

Tyrande was named High Priestess after her predecessor, Dejahna, was slain in battle.

As the five dragonflights amassed, Neltharion offered a plan to imbue a magical artifact of his own making with a portion of each Aspect's power that could then be turned against the Legion. Seeing no other way to stop Sargeras, the dragons entrusted a portion of their titan gifts to Neltharion, unaware that the Earth-Warder's ties to the deep places of Azeroth had allowed him to be driven mad by the Old Gods. (Be warned that what follows is a tale of great loss and sorrow.)

A nefarious artifact was created by Neltharion that would later be the key to his undoing.

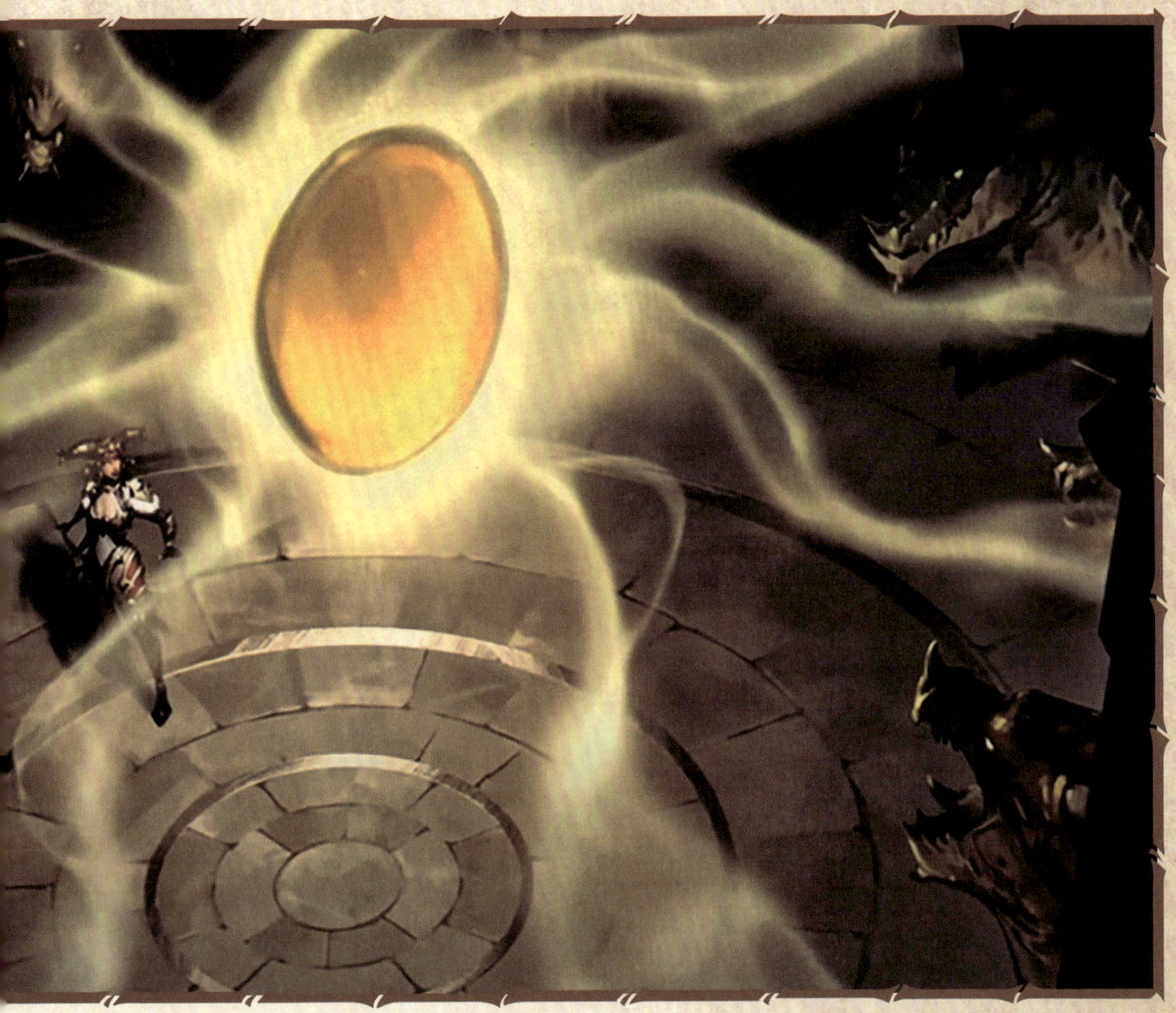

As the dragonflights carried out their final assault, Neltharion fired the empowered artifact, which he named the Dragon Soul, upon the Legion. A wave of hope rippled through the defenders as they watched demons fall by the hundreds. Then, unthinkably, Neltharion turned the weapon against his own allies! In the span of a breath, nearly the entire blue dragonflight ceased to exist, creating a cascade of grief so immense that Malygos would never truly recover. In the wake of such tragedy, who could?

Had it not been for the artifact's immense drain upon Neltharion's body, the losses could have been even more catastrophic for the dragonflights, the resistance, and all of Azeroth. For his betrayal, Neltharion was forever after known as Deathwing.

In the absence of their Aspect, the black dragonflight faced the burden of his crime: They were hunted into near extinction.

From the Well of Eternity to the rise of Ny'althoa, few have shaped the fate of Azeroth like Queen Azshara.

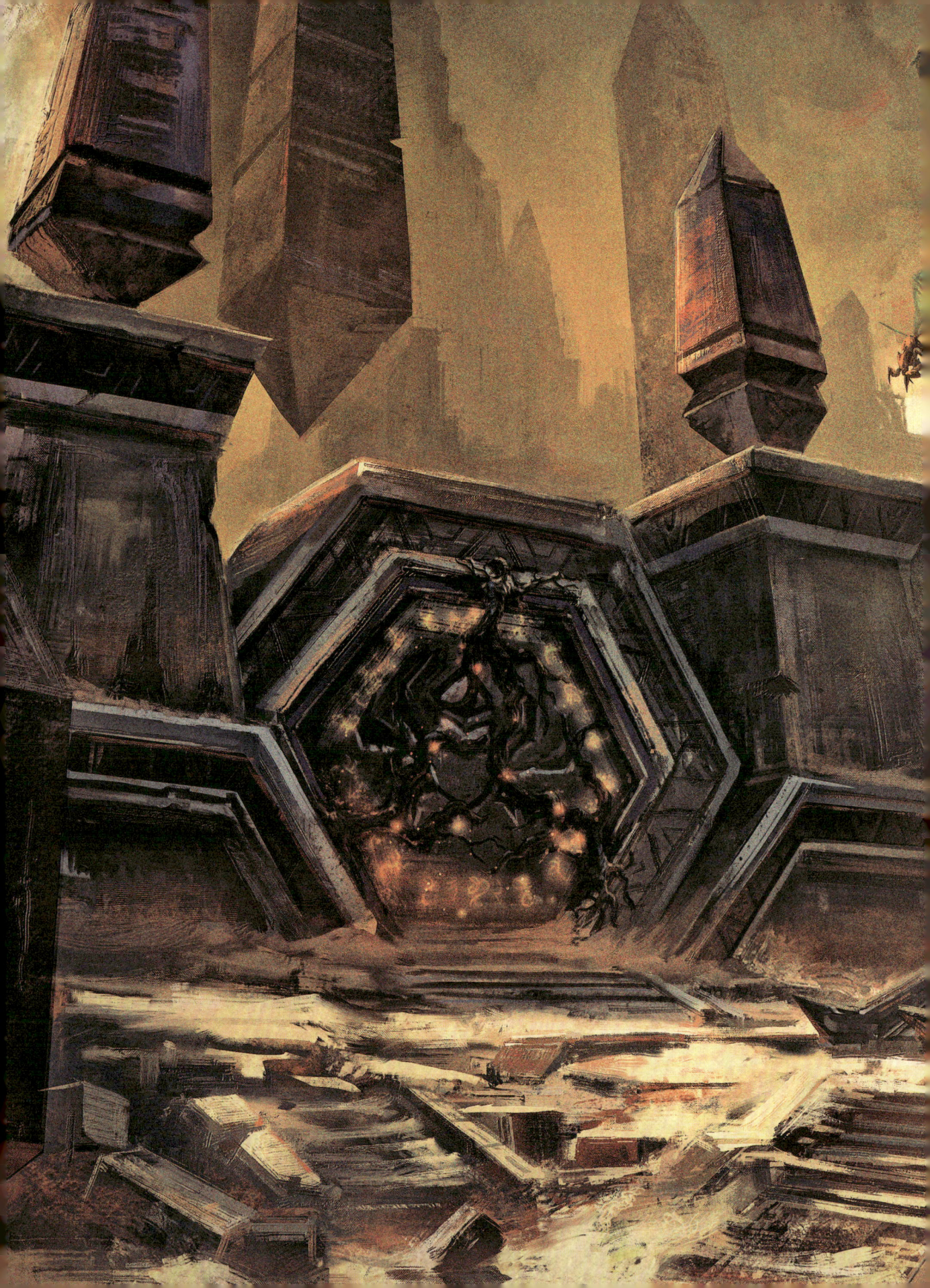

WAR OF THE SHIFTING SANDS

It is said that, a thousand years before the First War, an ancient evil began to stir within the scorching desert of Silithus.

Isolated for millennia within their underground kingdom of Ahn'Qiraj, an insectile offshoot of the Black Empire aqir steadily grew their numbers. They were the qiraji, servants of the great eldritch beings who once dominated Azeroth before their imprisonment by the titans. Driven underground to avoid the same fate as their masters, the qiraji eventually encountered a titan research station near Uldum. There they discovered an ancient and malevolent secret: the weakening prison of the writhing tentacle manifestation known by all as the Old God C'Thun.

C'Thun ordered his loyal qiraji to surge forth from their desert kingdom and consume the neighboring lands of the night elves. For many months, the forces commanded by archdruid Fandral Staghelm and the kaldorei priestess Shiromar fought valiantly against the swarms of bloodthirsty silithid, only to find their enemy's numbers endless. Facing inevitable defeat, the druids turned to the elusive bronze dragonflight for help. Though Nozdormu initially refused to intercede, his brood was drawn into the war once the qiraji crossed into the Tanaris Desert and threatened the bronze lair: the Caverns of Time.

Incredibly, the bronze found even their own vast power insufficient to turn the tide of the battle. The bronze heir, Anachronos, was forced to reach out to his allies within the other dragonflights. Together they assembled a force that managed to push back the qiraji to the gates of Ahn'Qiraj, where the druids and Anachronos awaited to create a magical barrier to seal off the city. Upon realizing that any lessening of their offensive would allow the aqir to escape, Merithra of the green, Caelestrasz of the red, and Arygos of the blue valiantly maintained their positions within the barrier and ordered it raised.

For nearly a thousand years, most assumed the trio to be dead, for the alternative was beyond imagining. Yet survive they did, until an ogre mage of the Twilight's Hammer clan, known as Cho'gall, shattered the wards of the prison containing the Old God C'Thun, thus necessitating the opening of the Scarab Gates of Ahn'Qiraj.

If the study of magical barriers is of keen interest (and how could it not be?), similar techniques were used in Dalaran, Suramar, and Silvermoon, as well as by Queen Azshara in Zin-Azshari during the Sundering.

Second War

Though the destruction of the Well of Eternity proved a setback to the Dark Titan's plans, it didn't stop Sargeras from seeking another path toward Azeroth's destruction—not when the very fabric of existence was at stake! What he needed was a new source of power, one capable of opening a gateway for his vast Legion to traverse the cosmos and finally bring an end to the threat of the Void Lords' corruption. He found that in a brilliant human mage named Medivh and a bitter orcish outcast named Gul'dan.

After years of careful manipulation to ensure the Dark Portal's creation, a pathway was finally opened between Azeroth and Draenor, allowing the orcish Horde to descend upon the human kingdom of Stormwind. Those who escaped the onslaught, like myself, sailed northward in search of refuge and allies. This act eventually led to the Alliance of Lordaeron, which unified the seven human kingdoms, the dwarves of Khaz Modan and the Hinterlands, the gnomes of Gnomeregan, and the high elves of Quel'Thalas. Yet as battle plans were being drawn to repel the invaders, an orc warlock named Nekros Skullcrusher trekked into the Redridge Mountains to recover a devastating weapon: the Dragon Soul.

After sacking Stormwind, the invaders continued their northern march until scouts returned with reports of a dangerous chokepoint lying between the Arathi Highlands and the Wetlands, known as the Thandol Span. Recognizing that the bridge could lead to massive casualties for his troops, the orc Warchief Orgrim Doomhammer brokered an alliance with the goblins of the Steamwheedle Cartel to construct ships that could ferry his forces across the Great Sea and into the verdant fields of Hillsbrad that lay south of the capital.

As construction of the Horde's fleet neared completion, it is said that Nekros succeeded in unlocking the secrets of the Dragon Soul and used it to capture the Dragon Queen. Under threat of their Aspect's torture and death, the red dragonflight had no choice but to serve the Horde as mounts of war.

Despite the goblins' aid, the crudely built Horde ships proved no match for an intercepting fleet under the command of Admiral Daelin Proudmoore. Yet what should have been a rout by the Kul Tirans turned into a sea of fire as the Dragonmaw clan strafed their decks atop several subjugated red dragons, engulfing the enemy ships in an inferno of hellfire. As the admiral's forces scattered, Orgrim ordered the remainder of his vessels to make landfall at Southshore.

With the Horde's movements no longer a secret, Orgrim sought the shortest path to the capital. To this end, he recalled his vow to a local troll tribe known as the Amani and led a small band of warriors to free their imprisoned warlord, Zul'jin. As fate would have it, one of Zul'jin's conditions for allying with the Horde was to march upon the trolls' ancient enemy, the elves of Quel'Thalas. That decision ultimately changed everything.

Though the high elven rangers made a valiant stand against the orc and troll invaders, dozens of red dragons soon filled the skies over their homeland. Deeply pained by the abhorrent loss of innocent life they caused, the captive dragons nonetheless incinerated numerous villages and tracts of pristine woodlands by order of their riders. Despite their rapid advances, Orgrim soon grew impatient with the resilience of Silvermoon's magical barrier. He left Gul'dan to the task of dismantling the city's arcane defenses while he turned the bulk of his forces back toward Lordaeron. For the refugees of Stormwind, it seemed that their worst nightmare was about to repeat itself.

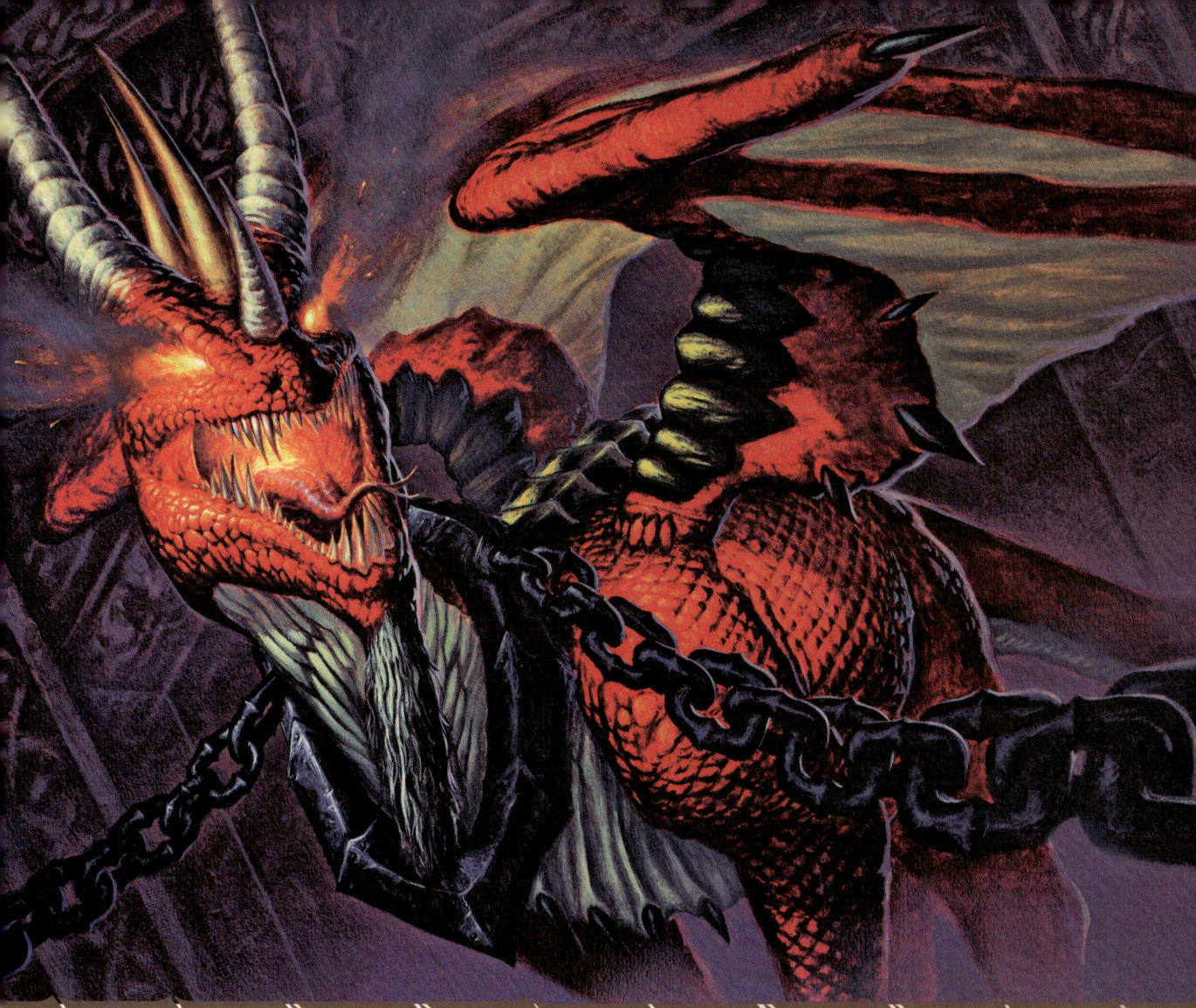

Yet with victory nearly in his grasp, Orgrim learned from the Dragonmaw that Gul'dan, along with the Twilight's Hammer and Stormreaver clans, had abandoned the Horde assault and stolen the ships docked in Southshore. With the regrouped Alliance forces threatening to close in around them, Orgrim ordered his dragon riders to cover the orcs' retreat southward.

The Horde's eventual defeat at Blackrock Mountain by the Alliance might mark the historic end of the Second War, but their story continues ever onward. With the Dark Portal closed and their forces scattered, many orcs were captured and held in areas throughout Lordaeron. Others managed to evade the Alliance hunters and scratch out an existence either in solitude or with what remained of their clans. Yet even as many rejoiced at the end of the war, Nekros Skullcrusher and the Dragonmaw retained their hold over Grim Batol and the captive Dragon Queen Alexstrasza.

Having both ridden a dragon in battle and seen firsthand the destructive potential of a red dragon's flame breath, I can say with little doubt that the Dragonmaw's captured dragons could have obliterated the entire Kul Tiran fleet if they were so inclined.

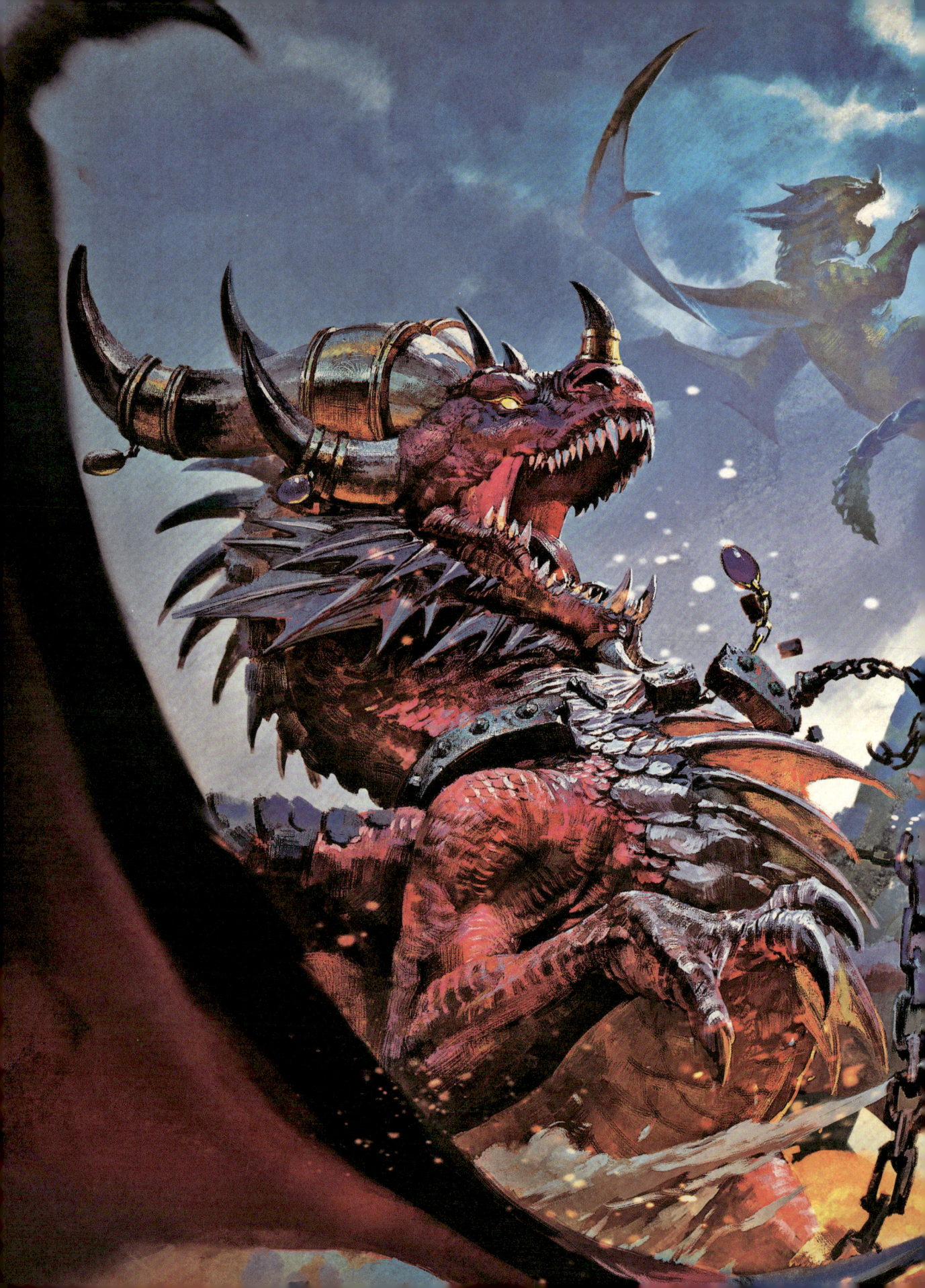

BATTLE OF GRIM BATOL

As with so many tales, I must first take you backward before we can travel forward. Granted, two centuries before the opening of the Dark Portal is quite the leap, but trust me, it shall all make sense by the end. The fate of Grim Batol began with a great schism that occurred within the halls of Ironforge following the death of dwarven High King Modimus Anvilmar. Despite a clear line of succession, the three mightiest dwarven clans each laid claim to the throne of their mountain kingdom in a conflict that came to be known as the War of the Three Hammers. Each clan wielded a particular strength, but it was the Bronzebeards who triumphed and subsequently exiled both the Wildhammer and Dark Iron clans from their ancestral home.

As leader of the Wildhammer dwarves, Thane Khardros accepted his defeat and took his clan north to settle on the mountainous border of the Wetlands, where they built the great city of Grim Batol. Yet as the Wildhammers looked to foster a prosperous future, the Dark Irons, under Thane Thaurissan and his wife, Modgud, thought only of vengeance.

In a coordinated strike, King and Queen Thaurissan called upon their dark magics to each strike one of the rival clans. For her part, Modgud twisted the very shadows of Grim Batol, transforming the Wildhammer capital into a place of horror. The attack managed to bring the Bronzebeard and Wildhammer clans back together to defeat the Dark Iron assault, but the once glorious halls of Grim Batol would forever be cursed, leading to its abandonment.

For years, the fortress stood as a desolate sentinel over the murloc-infested marshland—that is, until the northward march of the Horde warchief Orgrim Doomhammer. In seeking a vast and defensible location to hold the captive Dragon Queen Alexstrasza and warp her children into war mounts known as Nelghor, the Dragonmaw claimed the dwarven city as their own, all the while unaware of the site's dark legacy.

Nekros Skullcrusher's efforts to raise and train red dragons offered a pivotal weapon for the Horde, one that could have brought an end to the human kingdoms had it not been for the betrayal of the orc warlock Gul'dan. Yet after the Horde's defeat at Blackrock, the Dragonmaw simply hid away in their mountain stronghold to continue their dragon-rearing efforts unhindered. And so it happened that, for five long years, the red Aspect and her consort, Tyranastrasz, languished under the cruel yoke of Nekros Skullcrusher, who wielded the Dragon Soul as a tool of domination and cruelty.

Despair not, however, for their salvation came from a most unlikely source: the dragonflights' most dire enemy, Deathwing. After plans to raise his brood on Draenor failed due to the planet's destruction, Deathwing turned his sights on claiming Alexstrasza's clutch. To do so, he needed to draw out the orcs who held her from their impenetrable base. But how? Deathwing sent Nekros a series of terrifying dreams, forewarning of an Alliance raid on their stronghold and prophesying that their only hope was to move Alexstrasza and her eggs to Blackrock Mountain. To complete the ruse, Deathwing arranged for a small Alliance party led by the Kirin Tor mage Rhonin and Korialstrasz of the red dragonflight to investigate Grim Batol.

Known as Draig'cyfaill, or Dragonheart among the dwarves, the late Archmage Rhonin was often speculated to himself be a dragon.

At the very moment the Dragonmaw emerged from the fortress with their precious cargo, Deathwing attacked with the intent of killing both orc and dragon alike before stealing the eggs. Though deathly weakened from his long captivity, Tyranastrasz rallied his final energy and fought to protect his mate. Her consort's sacrifice allowed Alexstrasza to break free and devour Nekros Skullcrusher before he could use the Dragon Soul (now known as the Demon Soul) to regain control over her. Seeing at last their own chance to assist the Dragon Queen, the other Aspects joined the battle against Deathwing and the Dragonmaw clan.

Despite the appearance of the other Aspects, Deathwing believed that he could triumph—until Rhonin destroyed the Demon Soul and released the powers trapped within it. Now facing the combined might of all four renewed Aspects, Deathwing fled to plot his next attack from the unreachable Elemental Plane of Deepholm.

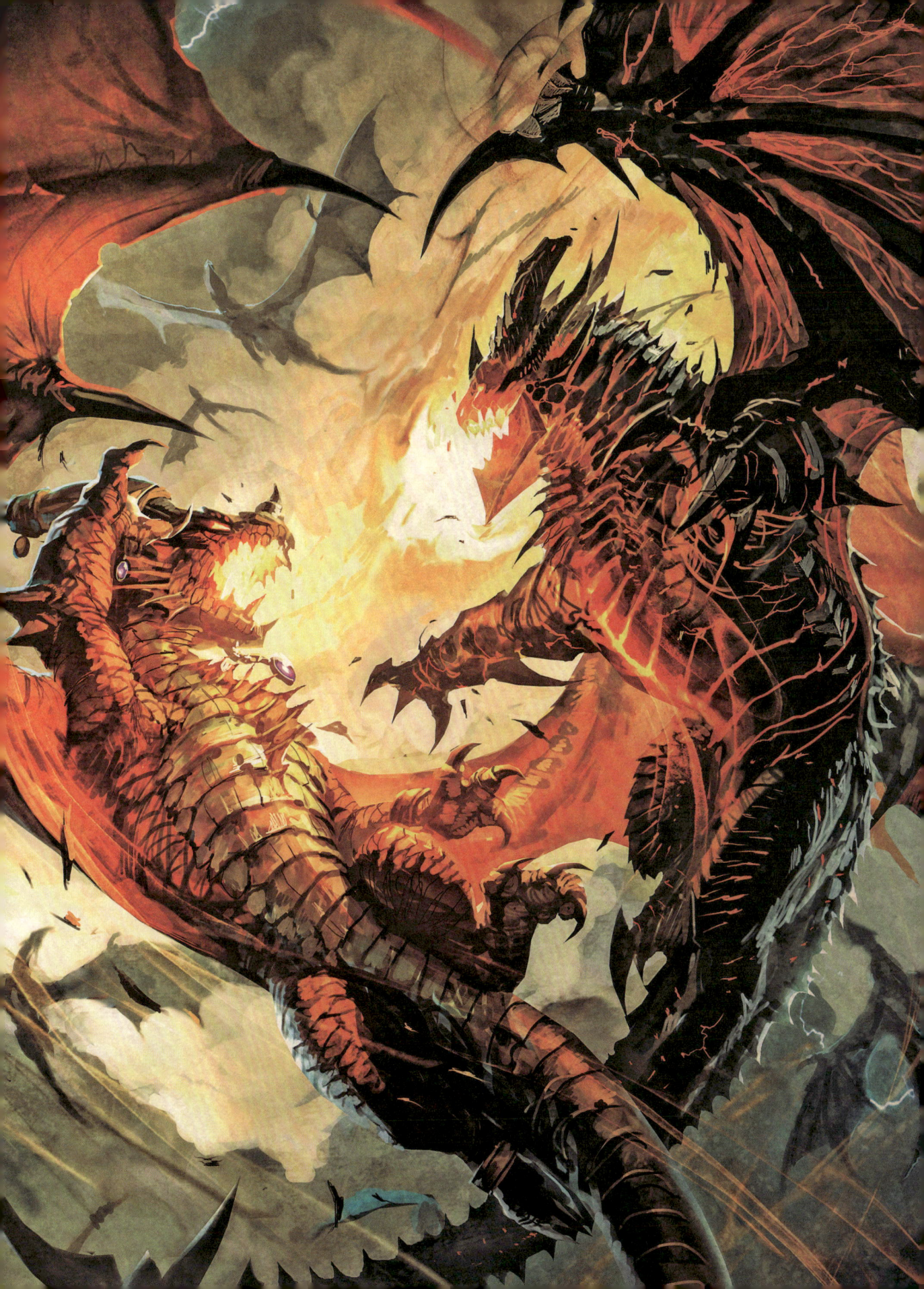

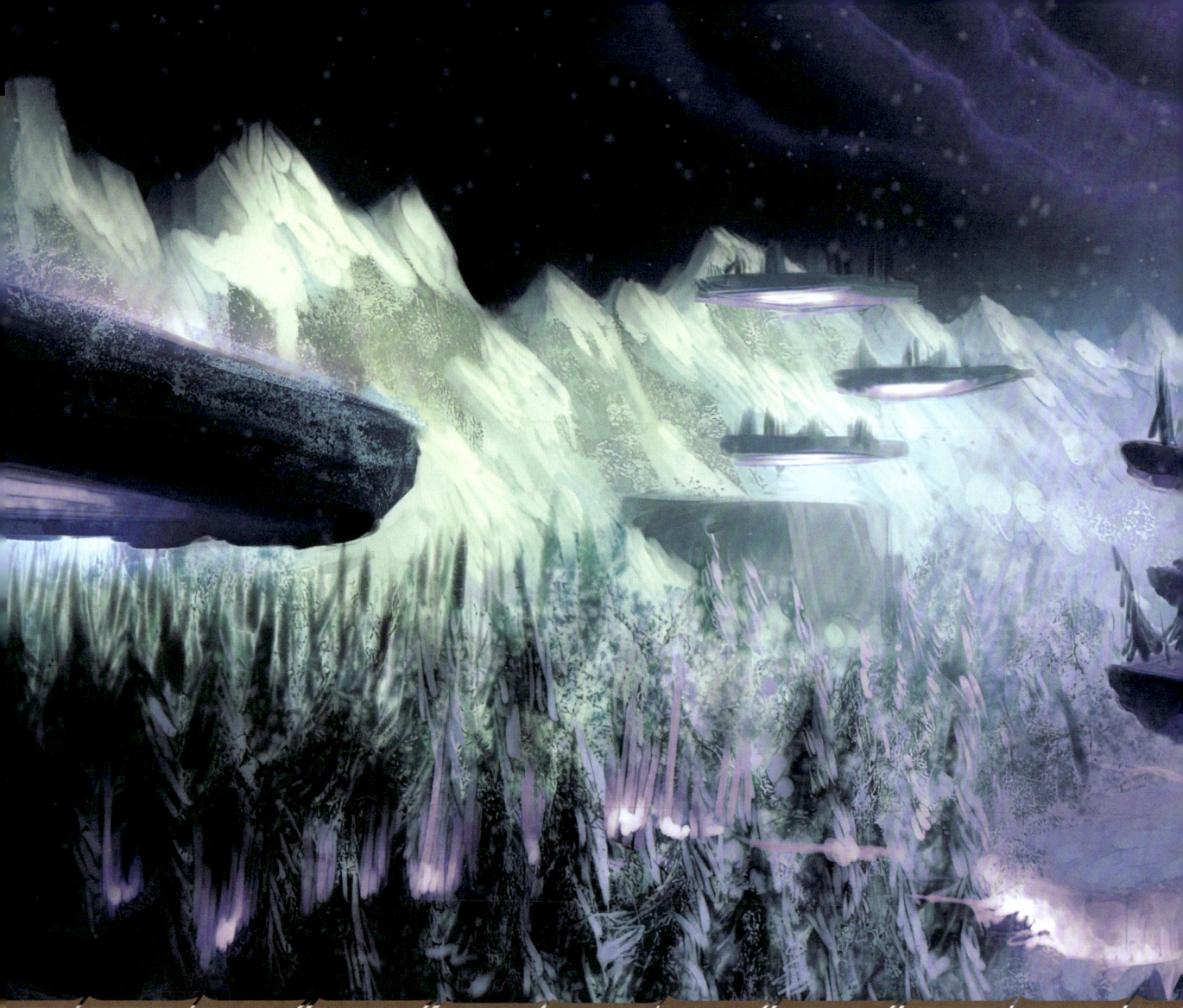

Nexus War

When Deathwing turned the empowered Dragon Soul upon his allies at the Well of Eternity, the blue dragonflight suffered the gravest losses. In a blinding flash of the mighty artifact's power, nearly all of Malygos's flight was destroyed, driving the blue Aspect to a depth of madness and despair from which he never truly recovered. Though he knew Neltharion was responsible for the deaths of his brood, Malygos believed Neltharion to be dead, and thus his thoughts turned inward. Malygos felt a deep shame for the role he played in convincing the Aspects to empower the Demon Soul.

Though it is said that the blue Aspect spent much of his time in isolation, Malygos ordered what remained of his flight out to safeguard the arcane wonders of Azeroth during his brief periods of lucidity. One such dragon, named Tyrygosa, was sent to Lordaeron before her travels brought her to Outland to investigate a strange arcane disturbance. She discovered a flight of incorporeal nether dragons that was created after the wild arcane energies of Draenor's destruction warped Deathwing's final clutch of black dragon eggs.

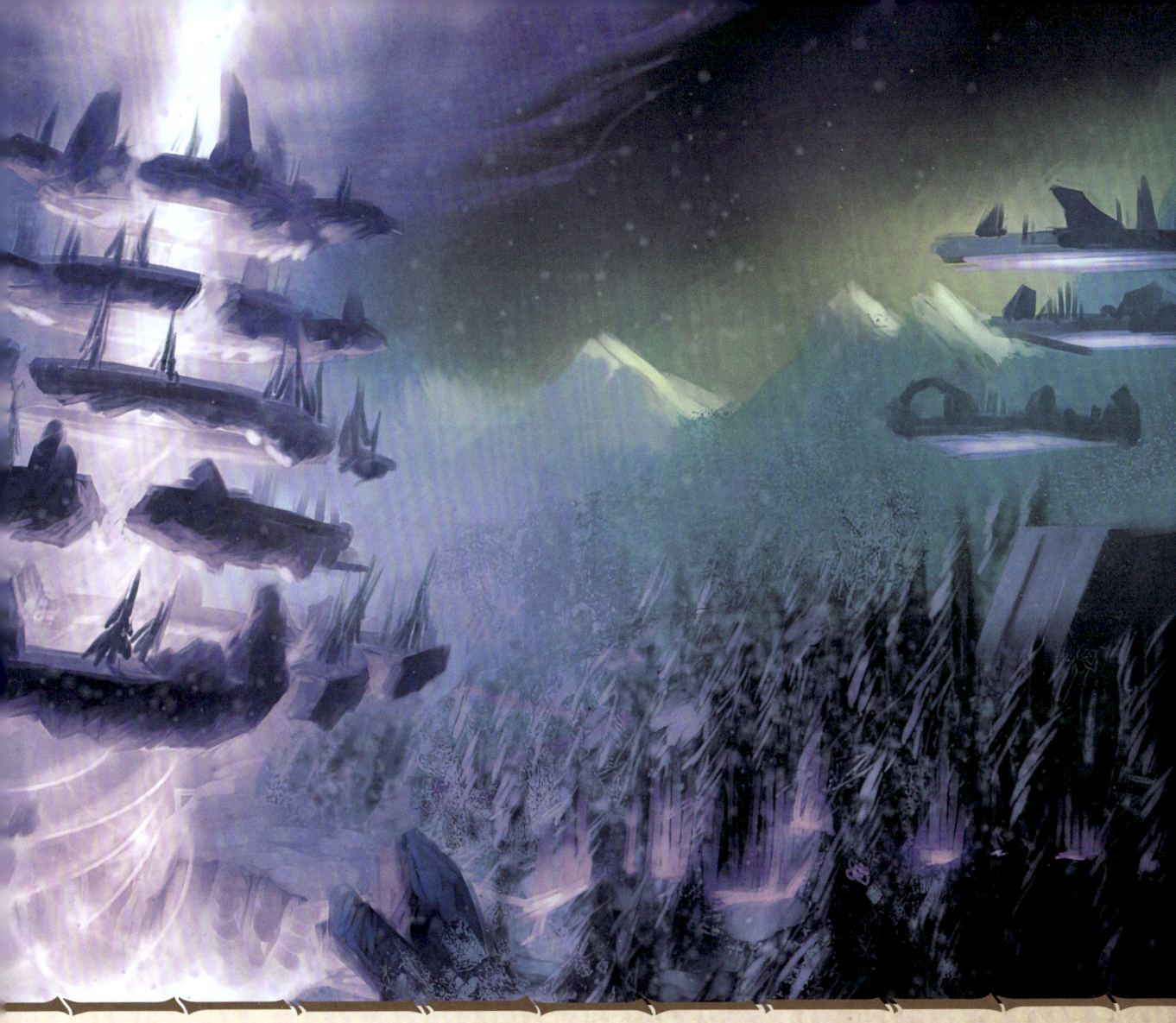

Tyrygosa took pity upon the nether dragons, described as almost childlike in their intelligence yet fierce fighters, and freed them from the brutal captivity of Ragnok Bloodreaver, a renegade death knight intent on conquering Outland. Seeking to earn the nether dragons' trust, Tyrygosa invited Zzeraku and his flight to the Nexus to restore their faded energy.

With their strength renewed, the nether dragons made the brash decision to claim the blue lair for themselves and launched an attack upon the Nexus that stirred Malygos from his apathy. Enraged by such a brazen assault, the blue Aspect lashed out at the invaders and consumed the essence of nearly every dragon. This sudden influx of nether power unexpectedly cleared the fog that had so long clouded Malygos's mind, yet with such clarity came the awareness of the world's chaotic state in his absence. To prevent further damage and the risk of the Legion's return, the blue Aspect took the incompressible step of severing all mortal access to the planet's arcane resources.

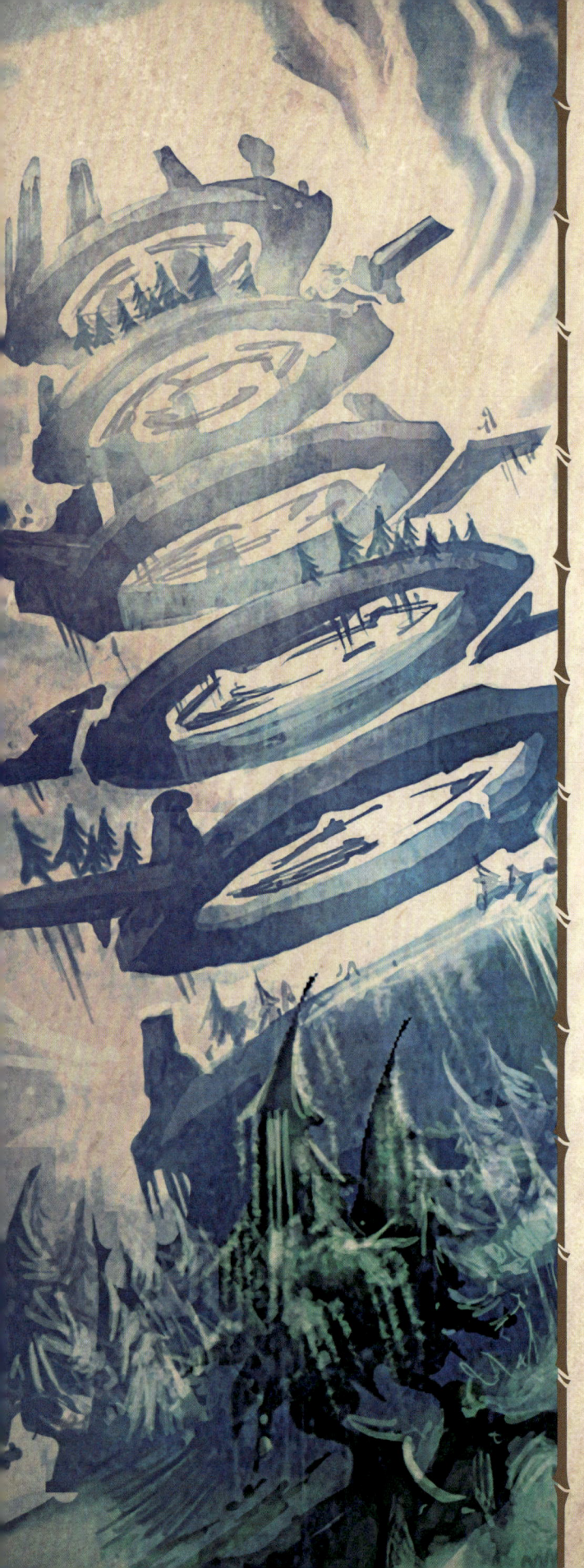

To achieve this, Malygos ordered his flight to locate Azeroth's many magical conduits, known as leylines, and worked to divert their energy into the Nexus so he could channel it harmlessly into the Twisting Nether. Such a disappearance of the arcane paths soon interfered with the spell work of the Kirin Tor, leading the ruling council of Dalaran to send a delegation to the Nexus. Upon their arrival, however, they were given a terrible choice: either join the blue Aspect as mage hunters or be destroyed.

Shocked by the disappearance of their emissaries, the mages of the Kirin Tor joined their powers to teleport Dalaran to Northrend (which is no easy feat, mind you!) in order to find allies against the mad Aspect. After the dragonflights' own delegation was met with a similar hostility, Alextrasza called for a meeting that led to the formation of the Wyrmrest Accord and the joining of efforts with the mortal races of the Horde and Alliance. Though devastated by her inability to help the blue Aspect see reason, the Dragon Queen agreed that countless lives would be lost if Malygos were not stopped: She ordered the assault.

As a united force, the defenders of Azeroth stormed the Nexus and struck down the Aspect of Magic, thus ending Malygos's maligned campaign. With the blue flight weakened by losses and many still enmeshed with their fallen Aspect's vision, it fell to the Kirin Tor to reverse the damage done to the leylines and see the planet's full arcane power restored.

While only Malygos knew how the Eye of Eternity was created, most speculate that it was a pocket dimension. For more on this subject, please refer to my "Essays on Dimensional Convergence."

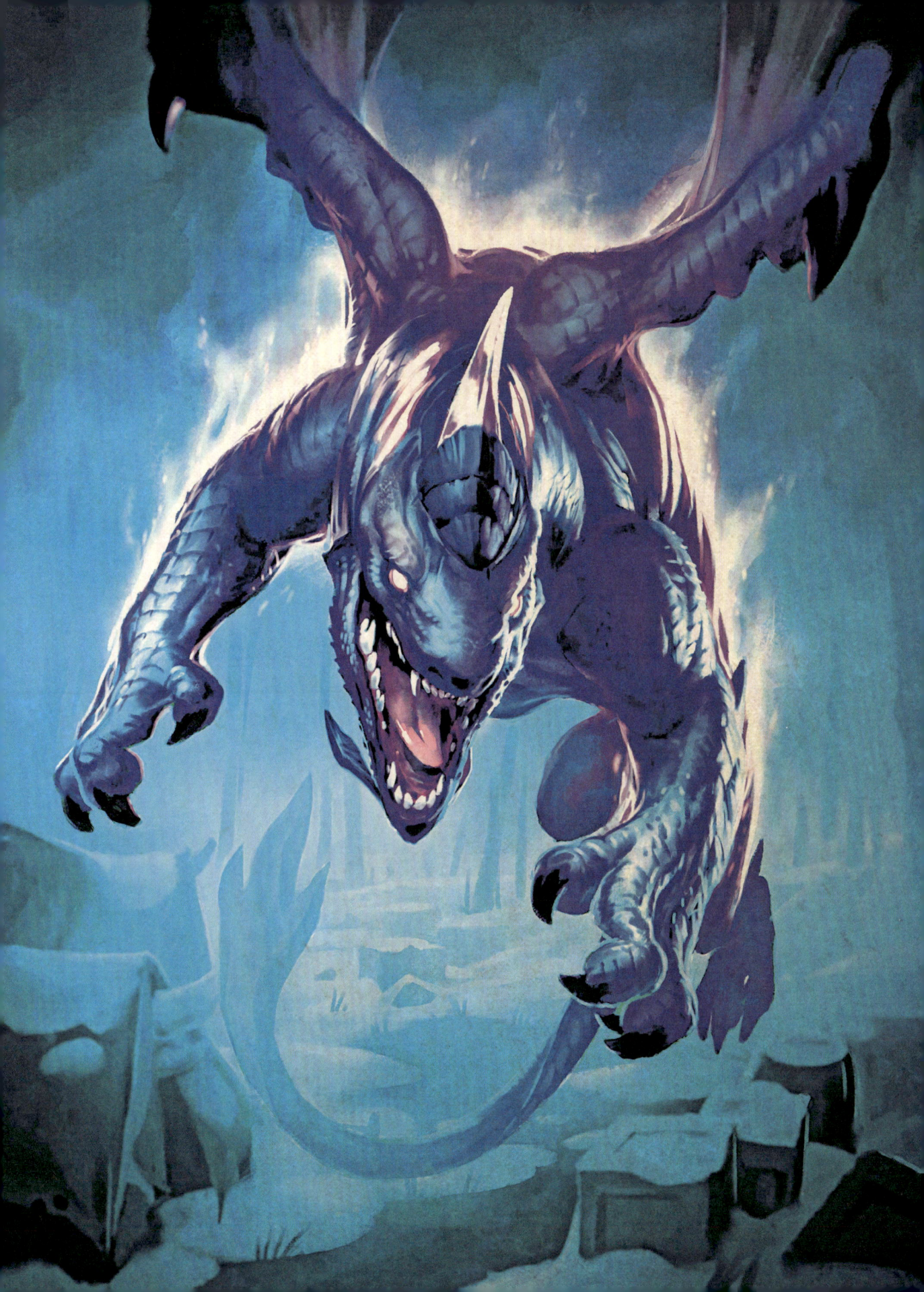

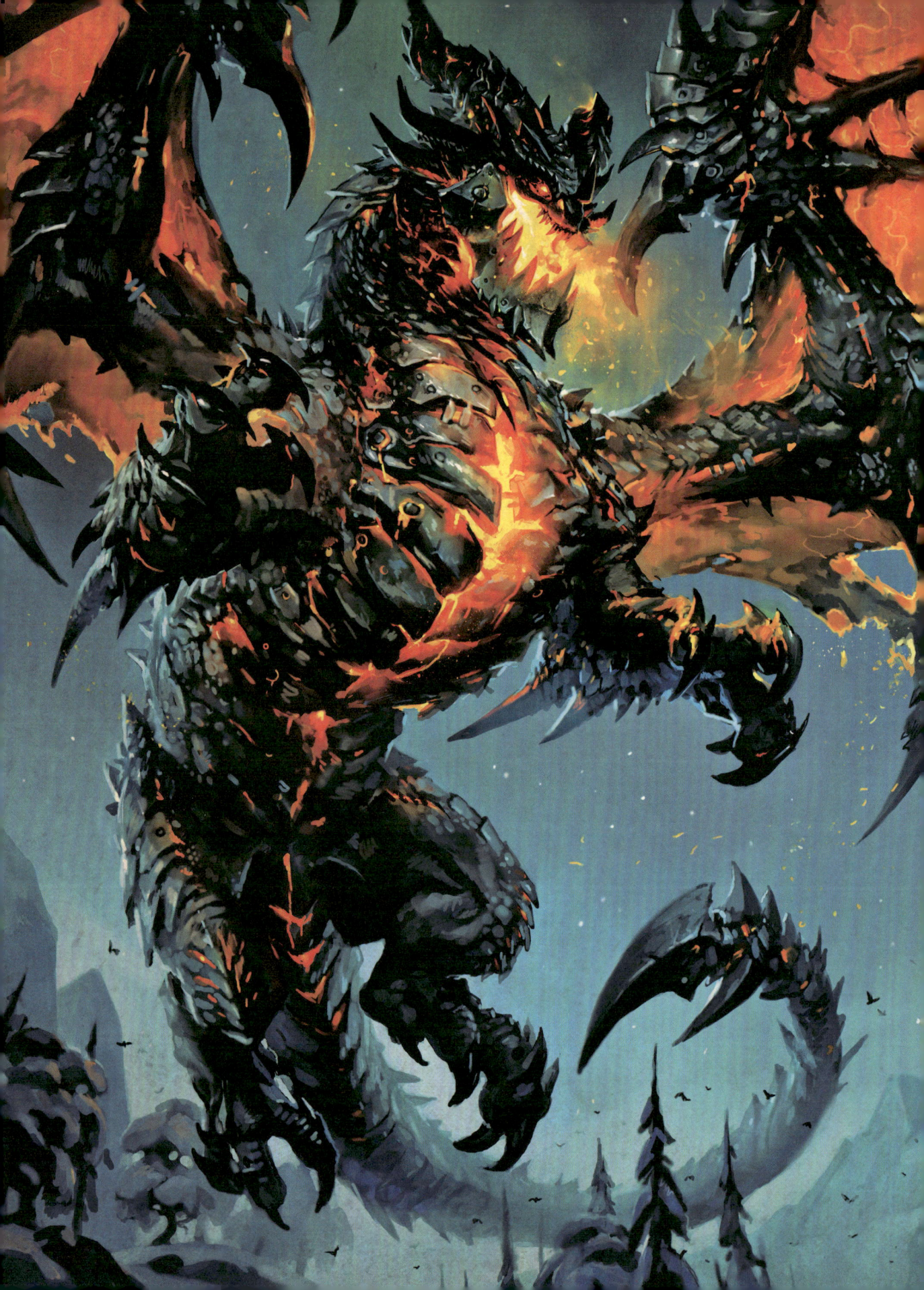

Fall of Deathwing

While the defenders of Azeroth feared a return of the Legion, another darker, more sinister threat was gaining strength. It was a prophecy heralding the end of all existence, known as the Hour of Twilight. Few can imagine a desire to step into one's own oblivion, but that was exactly the goal of the ogre mage Cho'gall as he worked to free the Old Gods of their titan prisons.

Meanwhile, in the impenetrable depths of Deepholm, Deathwing struggled to heal the wounds he had suffered during the Battle of Grim Batol. He had gravely underestimated both the tenacity of the mortals he'd manipulated and the willingness of the other dragonflights to face him in battle. That mistake had nearly cost him his life.

As Deathwing continued to absorb the latent earth energies of the Elemental Plane, the corruption of the Old God N'Zoth feasted upon the Aspect's heart until he was convinced to fully embrace the Void. With the sudden influx of power, his shattered form stabilized as magma coursed through his body. To further strengthen the Aspect, N'Zoth sent the Twilight's Hammer to bolt new elementium plates over the dragon's agonizing wounds and to serve the Aspect until the Hour of Twilight was upon them. Yet no gift of the Void is without its costs . . .

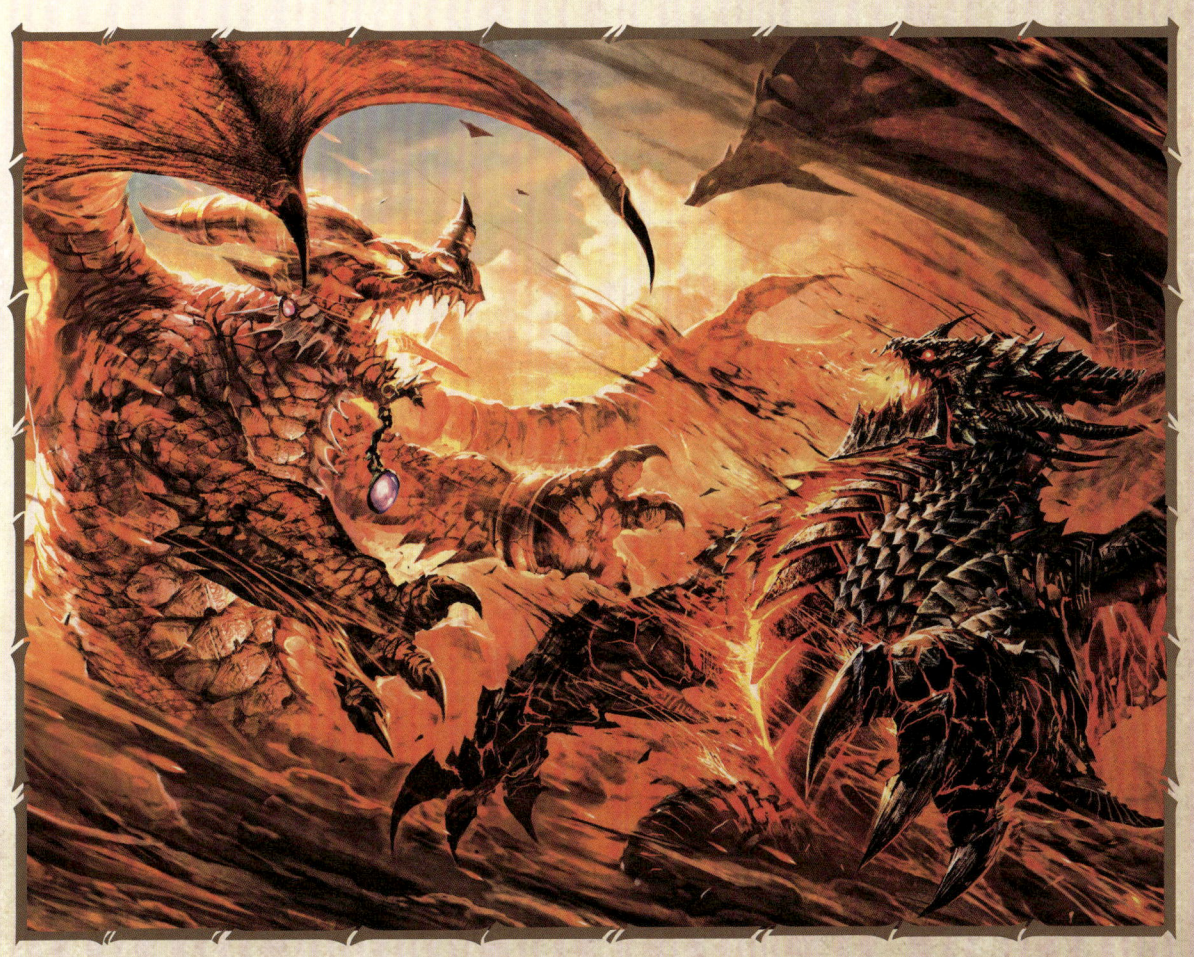

Stoking the searing fire in Deathwing's veins as he erupted from the Elemental Plane, N'Zoth urged the Aspect of Death to surge across Azeroth, shattering mountains and sending towering walls of water crashing upon the coastline in his furious wake. After laying waste to huge stretches of land, the Earth-Warder then turned his wrath against Alexstrasza and her fellow Aspects.

As the dragonflights and their mortal allies answered the Dragon Queen's call to meet at Wyrmrest Temple, twilight dragons descended from the sky to lay siege to their Accord. Though the defenders fought valiantly, they did not realize that the attack was merely a diversion by the Twilight's Hammer to infiltrate the dragon sanctums and corrupt the eggs of each flight with Void energy. By the time Alexstrasza's consort discovered the wicked act, it was far too late to save the clutch. Korialstrasz drew upon his own power to destroy both the eggs and the cultists within.

Though the Accord was nearly shattered by the fall of the sanctums, Kalecgos proposed a bold solution to defeating Deathwing. By traveling back in time to retrieve the Dragon Soul before its destruction, they could place the last of their power into the artifact and allow the powerful orc shaman Thrall to wield the weapon against the Aspect of Death. The bronze Aspect was understandably

reluctant to tamper with the timelines, but he ultimately agreed to help recover the Dragon Soul from the War of the Ancients. Upon their triumphant return, however, they found the joint forces of N'Zoth and the twilight dragonflight laying siege to Wyrmrest Temple.

With great losses mounting on either side, Thrall unleashed the power of the Dragon Soul upon Deathwing, to devastating effect. Reeling from both the shock and agony of such a powerful attack, the Aspect of Death fled toward the Maelstrom and the safety of Deepholm. In sensing the unraveling of his plans, however, the Old God infused Deathwing with an immense surge of Void energy, causing his body to erupt into molten tentacles. In a final effort to destroy the monstrosity, the Aspects infused the Dragon Soul with the last of their power, thus allowing Thrall to annihilate Deathwing's twisted form and prevent the Hour of Twilight.

With the titan-granted power of the Aspects exhausted by their sacrifice at the Maelstrom, the sacred duty of defending Azeroth falls now to us, its mortal champions.

As with most beings who draw too deeply of the Void, Deathwing's body began to take on the appearance of the Old God he served.

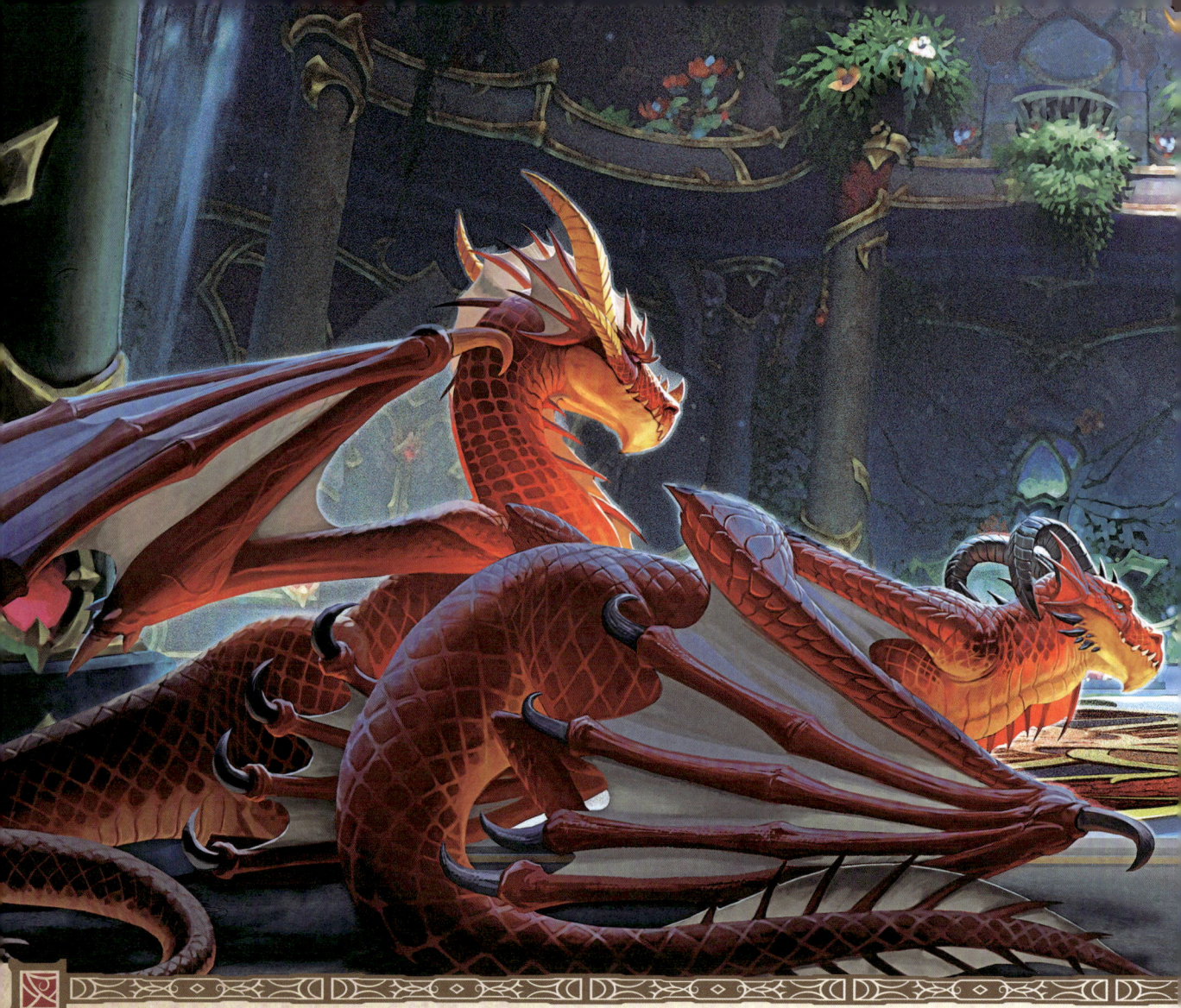

RED DRAGONFLIGHT

Enter any tavern across Azeroth, and you'll find someone with a rusted blade boasting of an encounter with a dragon. Sharp fangs and devastating claws mark the cornerstone of every tale, and always, it must be one of Deathwing's brood the boaster faced. Yet if you buy an ale for the stranger near the hearth fire paying no mind to the storyteller, you may just hear a true story of the red dragonflight.

Chosen by Keeper Freya to serve as the protectors of all life on Azeroth, red dragons are most commonly encountered in their mortal forms, known as visages, which they adopt while among the younger races. To mistake their benevolent charge for weakness is unwise, considering that these fearsome fighters wield a breath attack capable of incinerating entire forests! As members of Alexstrasza's brood, red dragons have a capacity for destruction that is tempered only by the spring of abundant life that emerges in the wake of their cleansing flames. They are considered the most noble and trusting of the five flights, but it is also true that such virtues have led these dragons to suffer

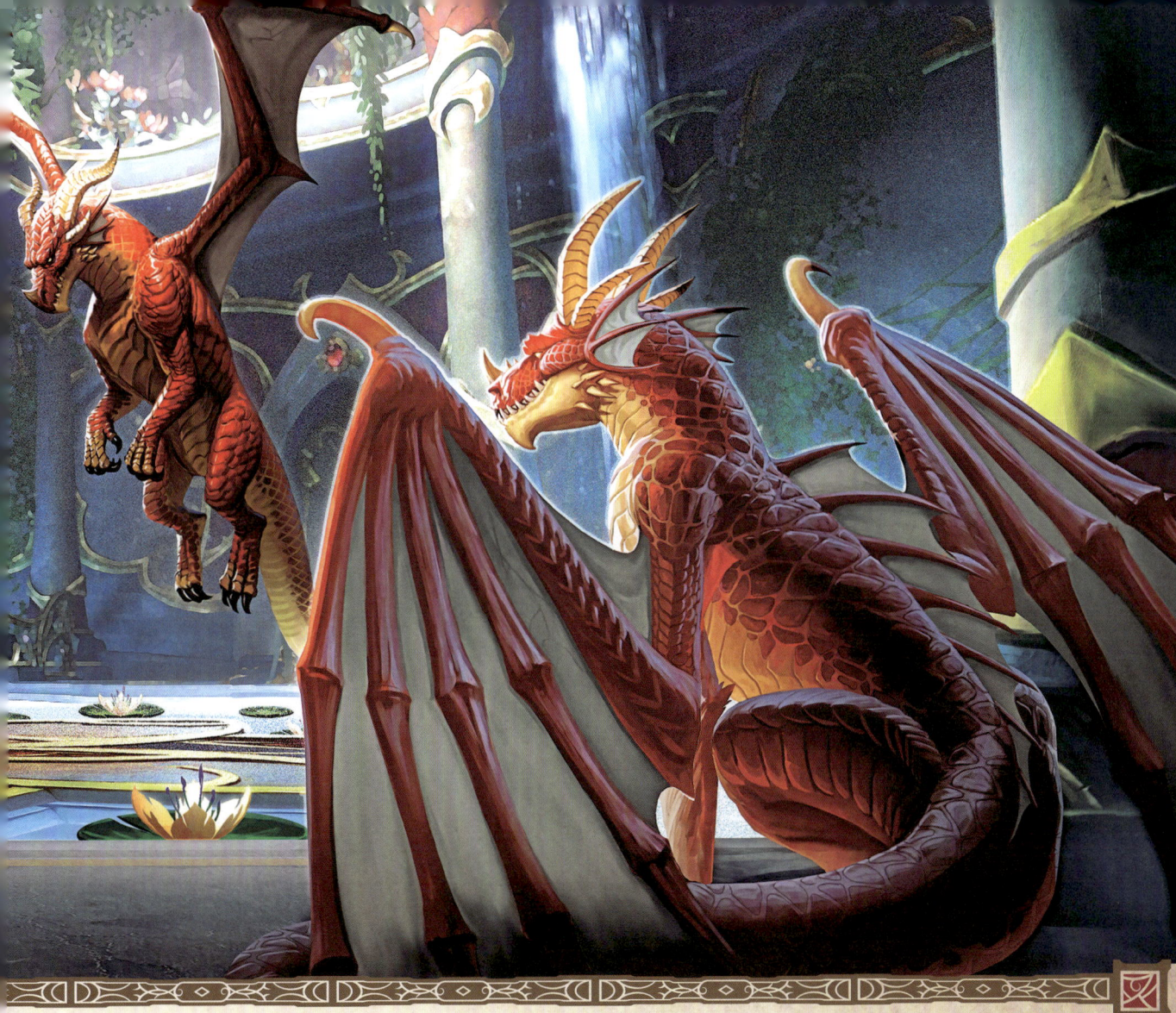

some of the deepest losses among their kind.

In seeking to end the Burning Legion's first invasion of Azeroth, the Dragon Queen Alexstrasza joined her fellow Aspects as they entrusted a portion of their power into the Dragon Soul, the weapon that Neltharion created and later turned against his allies. Though still weakened after the Legion's defeat, Alexstrasza ensured the protection of the new Well of Eternity by imbuing the World Tree Nordrassil with her power and extending its many blessings to the night elves who pledged to defend it.

Centuries passed before Neltharion dared to resurface. His first act struck at the very heart of the red dragonflight: He entrusted the Dragon Soul to the Dragonmaw clan, who used it to capture the Dragon Queen. Held captive and forced to hatch new dragons as war mounts for the orcish dragon riders, Alexstrasza gained her freedom only years later through the efforts of her consort and his mortal allies.

Despite long years of suffering and the loss of many children, Alexstrasza never wavered in her guardianship over the mortal races.

Following the release of the Forsaken Blight during the battle for Angrathar the Wrathgate, the Dragon Queen and her brood prevented the contagion's certain spread with their eradicating flames. Not all members of the red dragonflight have managed to forgive their Aspect's mistreatment, but most welcomed the aid of the Horde, the Alliance, and Kirin Tor in the fight to defeat Malygos and end the Nexus War.

After so many trials, perhaps the single greatest sacrifice of the red dragonflight was the intentional destruction of the dragon sanctums by Alexstrasza's consort, Korialstrasz, upon learning of their clutch's corruption by the Twilight's Hammer. Knowing then that only Deathwing's annihilation would end his maddened vision, Alexstrasza joined the other Aspects in imbuing the reclaimed Dragon Soul

with the remainder of her power. Together with Thrall and the mortal champions of Azeroth, the dragonflights brought an end to the Aspect of Death, even though their victory came at the grave cost of both their titan-given powers and their ability to produce future offspring.

Despite their innumerable losses, the red dragonflight continues to stand as the embodiment of all life on Azeroth, in both its sacrifice and its eternal hope for renewal.

While dragons can control all aspects of their visage forms, it is rare for them not to carry the color of their scales into their mortal form.

ALEXSTRASZA

The Life-Binder • Aspect of the Red Dragonflight • Dragon Queen

As the designate of Keeper Freya to wield the titan powers of Eonar, the Dragon Queen Alexstrasza has served as the Aspect of Life since the defeat of Galakrond. Fierce yet compassionate, the red Aspect watched the rise of all races on Azeroth with a genuine fondness and has offered her aid to each in their time of greatest need. Though preferring the guise of a high elf as her visage form, the red Aspect claims to hold all mortals in equal regard, even the orcs who caused her and her flight such suffering during the Second War.

As the guardian of life and the leader of the five dragonflights, Alexstrasza has brought the full might of the Aspects against the enemies of Azeroth and helped to heal the deep wounds wrought by those many terrible battles. Despite her moments of deepest loss, the Dragon Queen has always chosen to uphold her noble charge, even when doing so required her to stand against allies who had become irrevocably lost to the depths of their own corruption.

Bereft of her titan-gifted powers following the black Aspect's defeat at the Maelstrom, Alexstrasza is left to navigate an uncertain future for herself and her dragonflight. Without the ability to produce eggs, the age of dragons and their guardianship over Azeroth may eventually end. Yet despite this grim reality, the Dragon Queen once again proved the strength of her enduring pledge by lending her strength at the Chamber of Heart to aid in the world-soul's healing. Though the losses of her consort, Korialstrasz, and her clutch-sister, Ysera, have driven the red Aspect to seek what refuge and solace she may within the distant heights of the Vermillion Redoubt, I am told that the rediscovery of the Dragon Isles has given the Dragon Queen a renewed sense of hope for the continued survival of dragonkind.

The Dragon Queen's command over the cycle of life is most dramatically seen in the wake of her devastating flames.

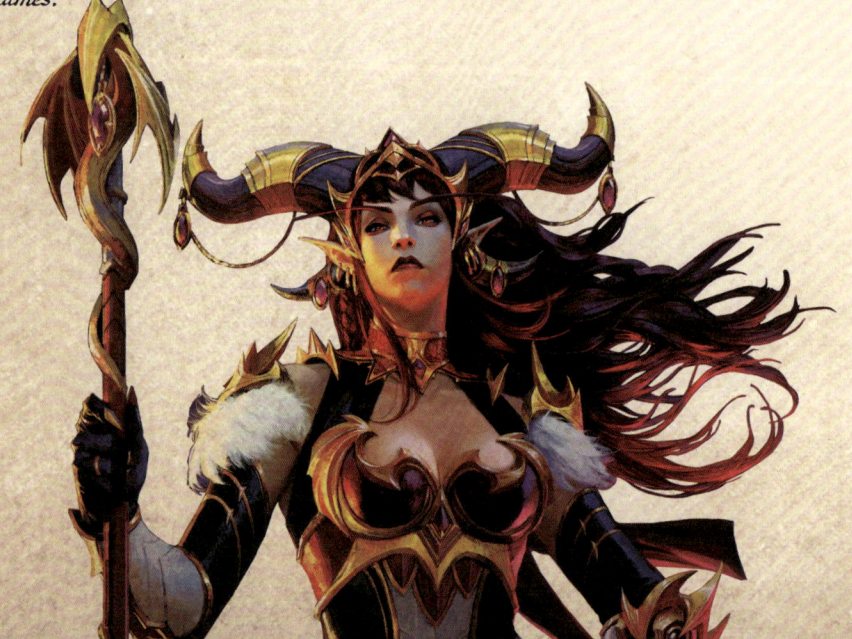

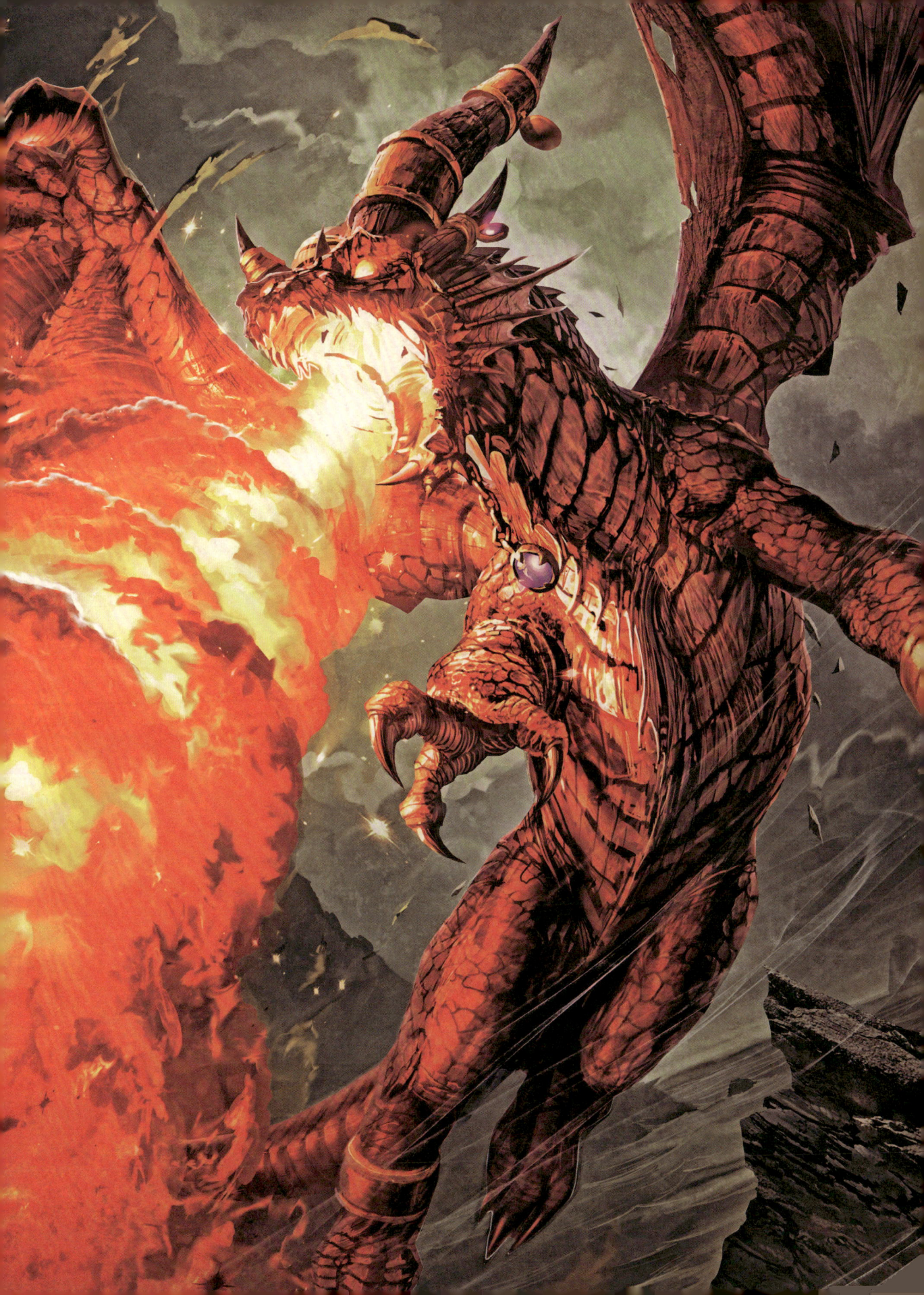

KORIALSTRASZ

Prime Consort of the Aspect Alexstrasza • Krasus • Member of the Council of Six

If Alexstrasza is the guardian of all life, then her consort, Korialstrasz, was the embodiment of his Aspect's love of the younger races. Korialstrasz is known more commonly by his high elven visage name, Krasus. Few of his kind have spent as much time within mortal society or meddled as much within their affairs.

Though his esteemed tenure as a member of Dalaran's ruling Council of Six offered Krasus many advancements for the Kirin Tor, I am most reminded of his wise council: It proved instrumental in uncovering Guardian Medivh's corruption and his opening of the Dark Portal. When the Dragonmaw orcs under the guidance of Deathwing managed to capture the Dragon Queen, it was Korialstrasz who served both as the voice of temperance against his flight's desire for vengeance against the mortals and as his Aspect's savior by eliciting the help of the human mage Rhonin and his allies who aided in Alexstrazsa's rescue. After the devastation of Quel'Thalas by Prince Arthas Menethil of Lordaeron, Korialstrasz and the blue dragon Kalecgos managed to safeguard the font of magical energy known as the Sunwell against the Burning Legion and enable its eventual restoration to the sin'dorei.

Apart from the Aspects themselves, no dragon's influence is so strongly seen throughout the entirety of Azeroth's existence, nor his loss so keenly felt. As his last act of service, Korialstrasz sacrificed himself to prevent the spread of the Twilight Hammer's chromatic corruption and to spare his beloved Alexstrasza the agony of destroying the dragonflights' final clutch of eggs.

The towers of Dalaran and Wyrmrest are dimmer in your absence, old friend.

TYRANASTRASZ

First Consort and Majordomo to the Aspect Alexstrasza

Though I never had the honor of meeting the prime consort, it is said that ancient Tyranastrasz was a true leviathan among the red dragonflight and the first among Alexstrasza's mates. Though he was known to follow his queen into every major battle since the War of the Ancients, Tyranastrasz is most honored for giving his life to save Alexstrasza after their capture by the Dragonmaw clan.

For five long years, the pair lay chained within the depths of Grim Batol, held captive by the orcish warlock Nekros Skullcrusher. Under such depraved conditions, the mighty Tyranastrasz slowly succumbed to a wasting illness, but not before using the last of his power to valiantly defend his Aspect from Deathwing's attack. In granting Korialstrasz and his allies time in which to free Alexstrasza, the ancient red ensured the future of his dragonflight and his beloved queen.

Though Tyranastrasz's sacrifice continues to be honored among his kind, the story of his heroic final battle is also remarkably well known to the mortal races. Unable to make his return to the final resting place of all dragons, known as the Dragonblight, the elder consort drew his last breath in the Wetlands north of Loch Modan, where the dwarven Explorers' League later discovered his remains. Despite my numerous requests to have his skull transported and laid to rest within Northrend, it continues to be on display within the Hall of Explorers in Ironforge with a plaque that reads:

"The remains of the gargantuan red dragon were found in the Wetlands shortly after the Battle of Grim Batol. Tyranastrasz was rumored to have been the elder consort of the Dragon Queen Alexstrasza."

CAELESTRASZ

Calen • Veteran of the War of the Shifting Sands • Heir to the Red Dragonflight

While dragons rarely use their m[agic] to alter mortal allies, they can d[o so] in dire situations.

Legend states that, as swarms of qiraji surged forth from the boundaries of Silithus to threaten the Caverns of Time, it was Caelestrasz, son of Alexstrasza, who convinced the red dragonflight to enter the war in answer to the bronze's call for aid. Together with the heirs of the green and blue dragonflights, Caelestrasz made the ultimate sacrifice to hold back the endless wave of aqir so that a magical barrier could be erected around the entire city of Ahn'Qiraj.

It was believed that Caelestrasz and his allies had perished within the accursed city until the great Scepter of the Shifting Sands was reforged a thousand years later and struck against the Scarab Gong to bring down the Gates of Ahn'Qiraj. As the combined forces of Azeroth breached the city's defenses to defeat the Old God C'Thun, they discovered the unfathomable truth that Caelestrasz and his allies were alive and had been held as prisoners since the war.

Despite the many horrors he'd endured, Caelestrasz proved his unending valor when he faced off against Deathwing to allow his mother's escape into the mountains around Grim Batol during the Cataclysm. He later infiltrated the nearby Bastion of Twilight and discovered the efforts of Deathwing's consort, Sinestra, to hatch a brood of twilight dragons. As his final heroic act, Caelestrasz expended the last of his strength to empower his mortal allies so they could defeat Sinestra and destroy her corrupted brood.

VAELASTRASZ

Vaelastrasz the Corrupt • Vaelan • Ward of the Red Dragonflight

After the archdruid Fandral Staghelm shattered the Scepter of the Shifting Sands in grief over his son's death, the shards of the relic were entrusted to a member of each ally dragonflight, in case the artifact ever needed to be reforged. Serving as the red dragonflight's ward, Vaelastrasz safeguarded the shard until his final battle against Nefarian nearly a thousand years later.

Sworn to end the black dragonflight's evil machinations, Vaelastrasz reportedly aided powerful mortals in forging the Seal of Ascension, an artifact that played an essential role in the defeat of Rend Blackhand, the orc Warchief of the Dark Horde. After locating his true quarry, however, Vaelastrasz tragically fell when Nefarian compelled the red dragon to fight against his mortal allies. Before the corruption could completely consume him, Vaelastrasz imparted a portion of his power to his champions. Through his sacrifice, the group managed to end Vaelastrasz's suffering and continue their pursuit of Nefarian within Blackwing Lair.

If it's worth stealing, it's worth learning the spell work to secure it. To learn more about artifacts like the Seal of Ascension, review the timeless tome Of Trapes and Lockes.

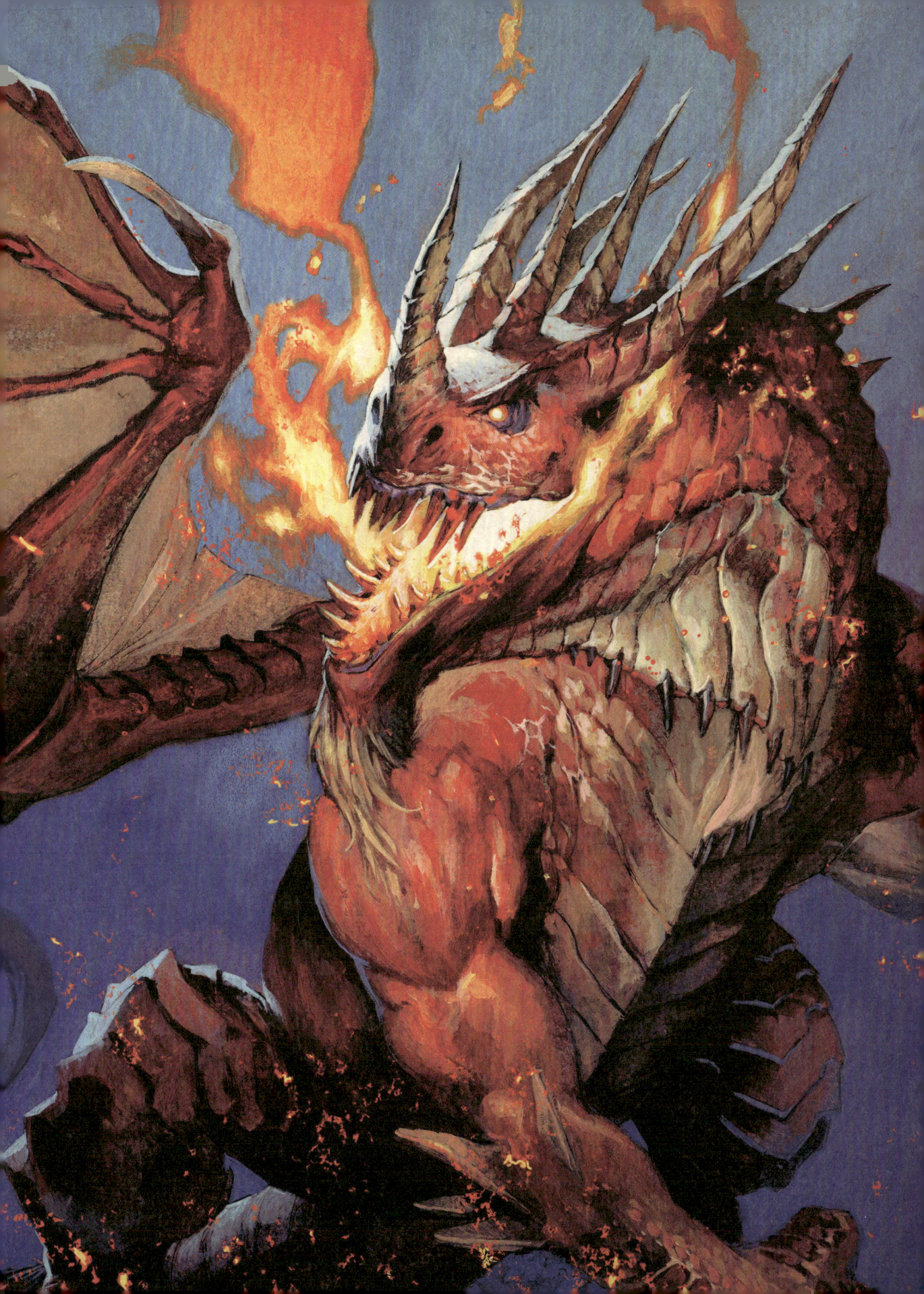

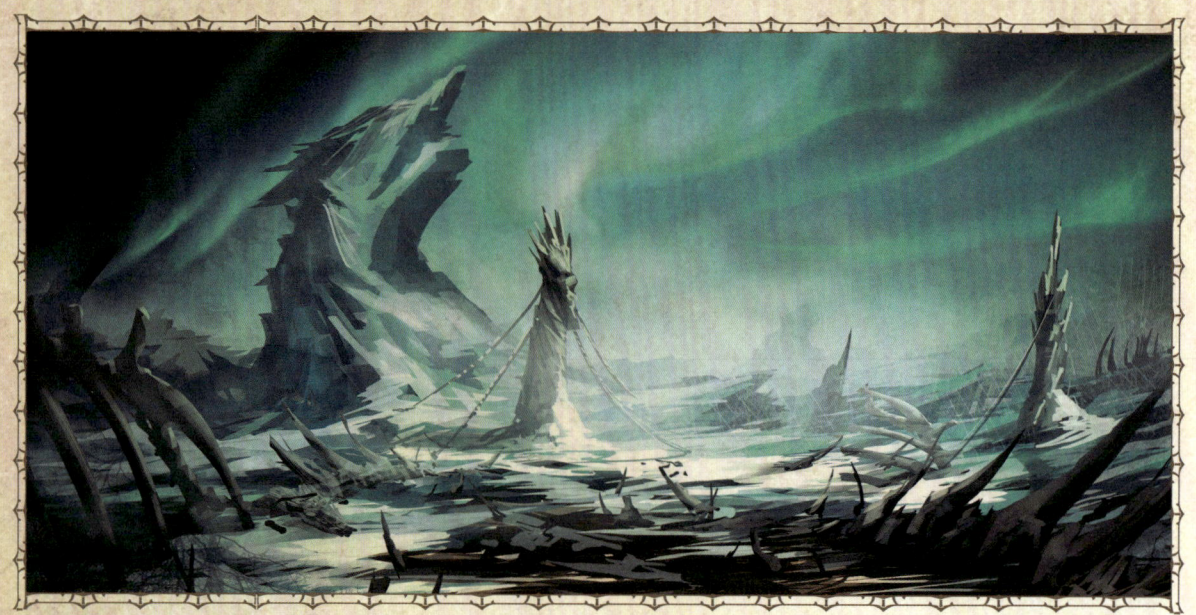

DRAGONBLIGHT

Bitter winds cascade down from the distant Storm Peaks to scour the barren landscape, its kulning howl calling the dragonflights home to their final rest. The bones of the flight's great heroes lie scattered like constellations, some as ancient as the land itself. Scars of the twilight siege still dot the wastes where bursts of dragon fire strafed the crater of the Old God's horrific n'raqi.

Seen from above, the Dragonblight appears a solemn place devoid of life—until one catches a hint of woodsmoke on the breeze and the deep and hearty laughter of a tuskarr hunting with his young. Even in such desolation, the power of the Life-Binder thrives.

WYRMREST TEMPLE

Through the blinding snow, a tower rises from the desolate plains, a beacon of light where only ice and the shifting aurora seem willing to hold dominion. It is Wyrmrest Temple, seat of the dragonflights and monument to the Aspects' unity in defeating the mighty Galakrond.

Sitting on the edge of Northrend's sundered coast, the tower stands as an ageless reminder of a keeper's faith and the worthy guardians he created.

VERMILLION REDOUBT/ TWILIGHT HIGHLANDS

A glade of perpetual crimson stands sentinel high above the accursed fortress of Grim Batol, where the scale-shaped leaves of mighty oaks tremble and drift in a brisk highland breeze. What was once a peaceful respite for the red dragonflight must now bear the mournful remembrance of its Dragon Queen's binding at the hands of the Dragonmaw clan.

In the distance, a tower of twisting void rises, its twilight energy seeping into the once pristine landscape to mutate all it touches. Even years after the defeat of the Twilight's Hammer, the land appears no closer to healing, so the red dragons maintain their constant vigil for any stirrings of the Void.

WAKING SHORES

Budding green foliage blankets the gentle rises of lowland hills, offering a serene landing for those arriving on the Dragon Isles by wing or by wave. Named the Waking Shores in honor of the sun-kissed coastline, this timeless land has shaped every sanctuary of the red dragonflight for thousands of years.

Broken by the magic of life and the might of time, much of the strand's titan architecture has turned to ruins amid the untamed chaos of nature. Here the elements reign, powerful yet unharried, with a willingness to show the true shape of their primal forms. Animals, too, have evolved to take advantage of the wild energies, diverging and adapting until they are eventually freed from the constraints of their titan design.

The balance between chaos and order has shifted greatly in the dragonflights' absence, causing many ancient inhabitants to look upon the Aspect's return with concern and even scorn. Though the Dragon Queen is sworn to protect all life on Azeroth, sometimes harmony can be achieved only through sacrifice.

BRONZE DRAGONFLIGHT

Hidden among the shifting sands of the great Tanaris desert lies an unassuming outcrop of basalt, its craggy features nearly as old as time itself. No grand gates speak to its importance; no carved monuments speak to its purpose beyond a haphazard collection of towers and hovels seemingly plucked from the farthest reaches of Azeroth. Yet wander too close, and you will be met by Chronalis and Tick, the site's timeless draconic guardians. Whether you are granted entrance to the Caverns of Time or sent to a windswept grave is not their decision, but rather, a consequence of fate.

If this seems cruel, it is because few mortals can truly grasp the bronze dragonflight's ability to exist outside of time itself. For us, the path is linear and predictable, with the present offering our only opportunity for change. For the bronze, however, the past, present, and future are infinitely accessible and infinitely corruptible. For this reason, Keeper Ra charged the flight with protecting the pathways from any who would seek to meddle with the keystone moments of Azeroth's history.

Given the enormity of their charge, the bronze spend most of their lives navigating time itself

When conversing with a member of the bronze, always ensure that you're speaking of the same time.

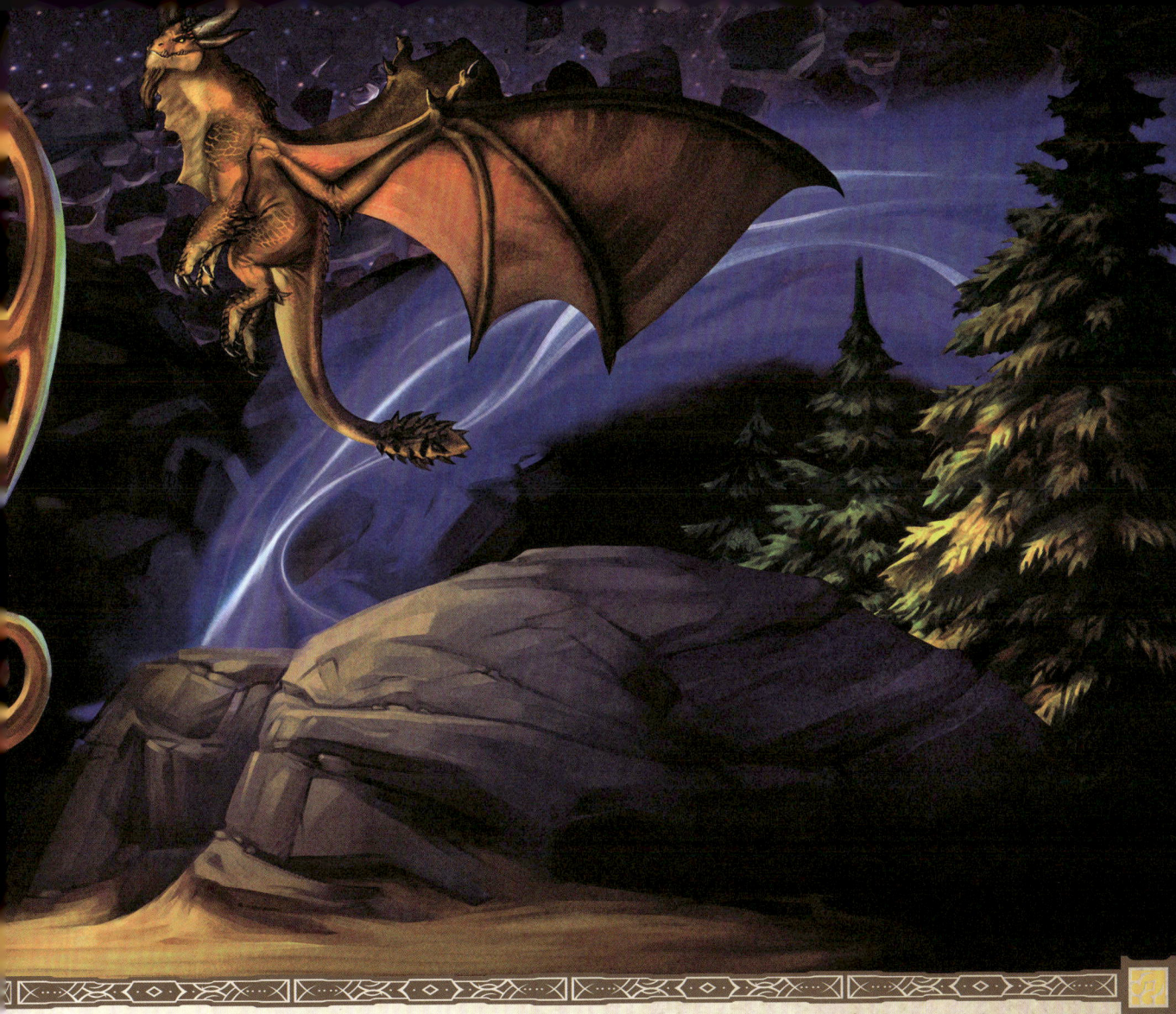

rather than meddling in our present mortal affairs. This makes them the most elusive flight to encounter, but their fascination with Azeroth's history makes them staunch defenders of her ongoing future.

The dragonflights' efforts to defeat the Legion during the War of the Ancients is well documented, but the record of the bronze contribution is often incomplete. It is known that Nozdormu channeled his power into the Dragon Soul, but mortal accounts fail to capture, or perhaps make sense of, the many strange temporal anomalies that later occurred. What these ancient historians could not know was that the bronze Aspect would send champions back in time to preserve Azeroth's future from the tampering of both the Old Gods and the infinite dragonflight.

Despite the dire prophetic knowledge that points to their seemingly inevitable corruption, Nozdormu and his bronze dragonflight continue to uphold their temporal duty to Azeroth while fighting the infinite dragonflight's efforts to bend the past, present, and future to its will.

NOZDORMU

The Timeless One • Aspect of the Bronze Dragonflight • Murozond of the Infinite Dragonflight

Chosen by Highkeeper Ra to wield the power of the titan Aman'Thul, Nozdormu was one of the five dragons empowered after the defeat of Galakrond. Granted dominion over time itself, the bronze Aspect is said to spend much of his existence navigating the intricacies of the one true timeline and all its branching possibilities. Though I am told that his flight prefers to experience the heroics of old over meddling with mortal politics, Nozdormu and his brood have never failed to answer the call to aid in Azeroth's defense.

The first such crisis occurred in Northrend after the weakening of Yogg-Saron's prison led to the corruption of Keeper Loken and his accidental killing of Sif. Though none know for sure, it is believed that the mad whispers of the Old God eventually convinced him to betray his fellow keepers and claim control over the titan facility of Ulduar. With unfettered access to the Forge of Wills, Loken created an army of titan-forged, who had been afflicted with the curse of flesh without his knowledge. These titan-forged would eventually become the giants, earthen, and vrykul with whom we are familiar. A particularly warlike group of these vrykul known as the Winterskorn would fall under the sway of Ignis and Volkhan, two of Loken's most powerful creations. They would wage a war against the earthen, who, in seeking the aid of Keeper Tyr, also secured the assistance of his dragon allies. Working together as they had to defeat Galakrond, the Aspects succeeded in containing the vrykul forces and sending them into a dreamless slumber that lasted for nearly a thousand years.

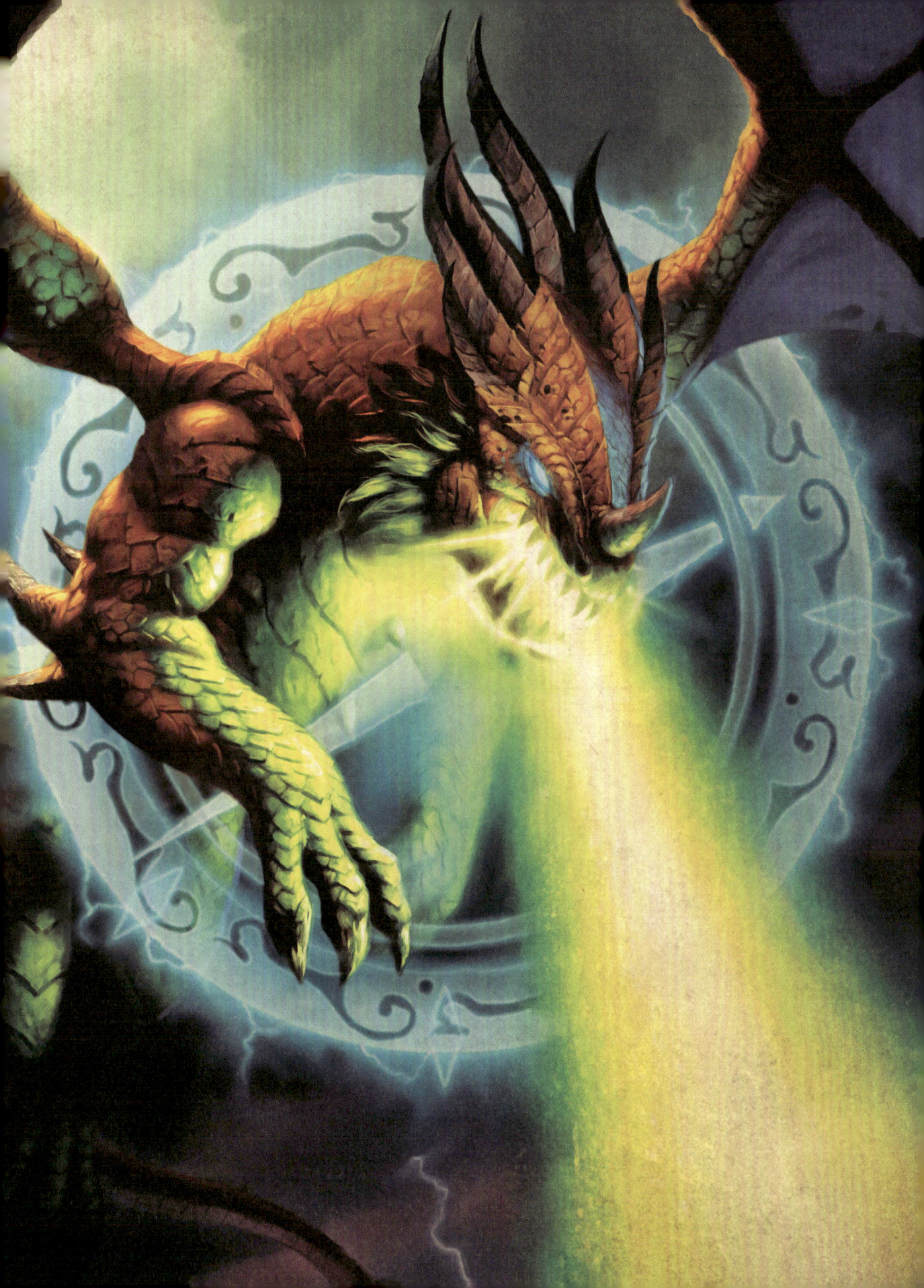

Many within the dragonflights believe Nozdormu's fate to be inevitable, but only time will tell.

After the Winterskorn War and the death of Keeper Tyr, the enduring bond of the dragonflights he had helped forge what was shattered due to Neltharion's deceit at the Well of Eternity. While this led many dragons, the black and blue in particular, to immediately withdraw into seclusion, Nozdormu was present alongside Ysera and Alexstrazsa at the blessing of the World Tree Nordrassil. Shortly after bestowing his gift of immortality to the night elves, he withdrew into the timeways.

By all accounts, the bronze Aspect was not seen again until after the Second War, when the Dragon Queen Alexstrasza was taken prisoner by the Dragonmaw clan. Answering the call of the red consort, Korialstrasz, Nozdormu joined in the Battle of Grim Batol that led to the red Aspect's rescue and the destruction of the Dragon Soul. With his powers renewed, Nozdormu turned to his charge with a renewed vigor. During his explorations, he found a series of temporal anomalies and began to investigate them. Nozdormu ultimately discovered a group of bronze dragon defectors known as the infinite dragonflight.

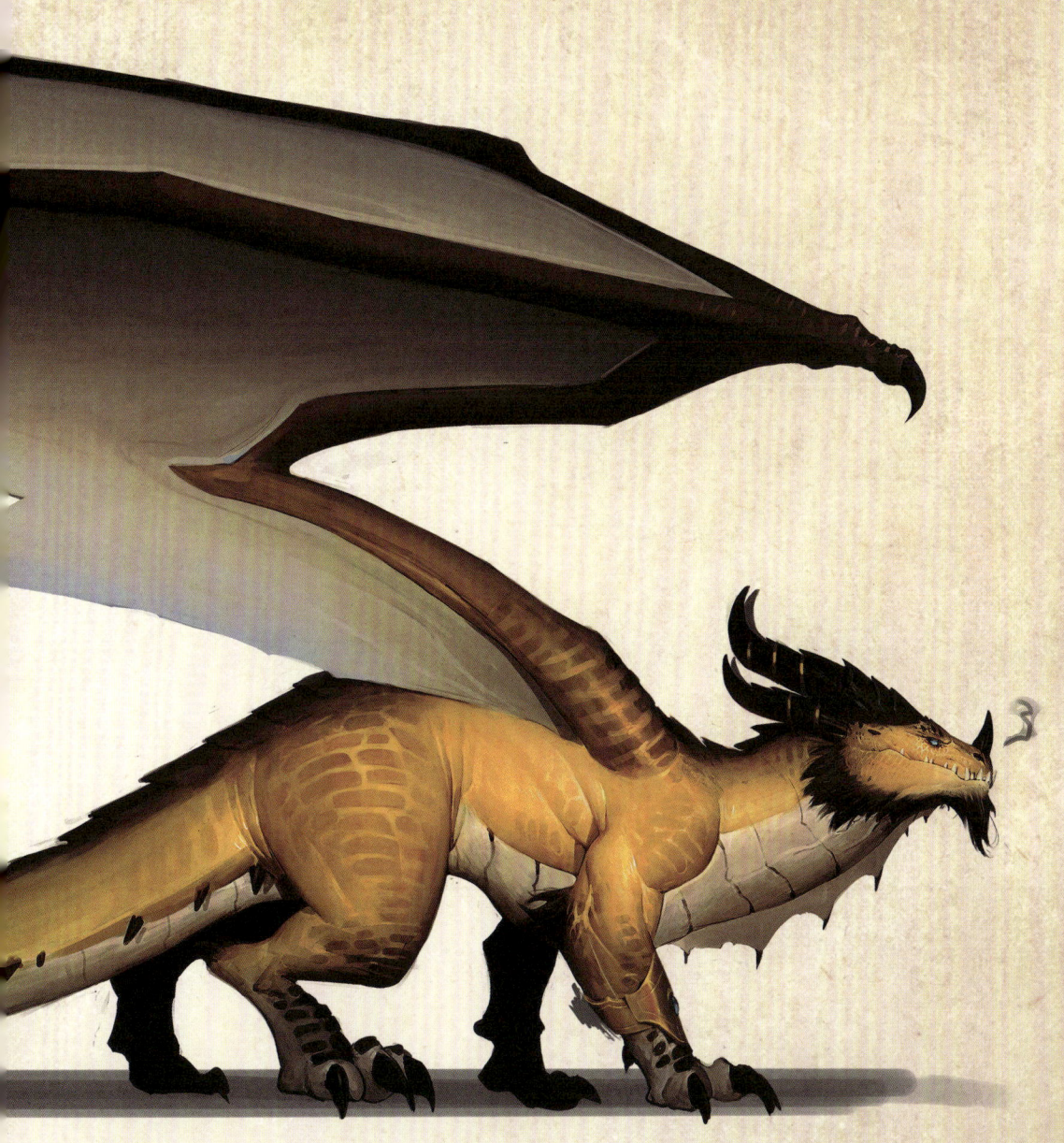

He soon discovered that the leader of this group was none other than a future version of himself. Seeking to understand how this could have come to pass, Nozdormu dove deeper into the timeways and soon found himself lost and trapped in all moments in time (a state, I am told, that is quite uncomfortable). After being freed by the orc shaman Thrall, Nozdormu lent his aid to a group of champions sent to confront a series of twisted futures that the bronze Aspect was destined to bring about as the infinite leader Murozond.

With the timelines cleansed, the dragonflights turned their attention to retrieving the Dragon Soul from the past so that it could be used as a weapon against Deathwing. After infusing the golden disk with the totality of the Aspects' power and Thrall's command of the elements, Nozdormu and his allies ended the threat of both Deathwing and the Hour of Twilight.

SORIDORMI

Prime Consort of Nozdormu the Timeless One • Leader of the Scale of the Sands

As prime consort of the bronze Aspect, Soridormi serves as the bronze dragonflight's second-in-command and ensures that the directives of her mate are carried out by the rest of the flight. Believed to be nearly as perceptive to the flow of time as Nozdormu, Soridormi was reportedly first to recognize the minute ripples of corruption occurring within the pathways from the infinite dragonflight's interference.

Frequent references within the annals of mortal history depict Soridormi as a high elf seeking the help of champions to maintain the proper chronology of events. These concurrent existences most often confuse scholars, especially during the War of the Ancients and the Battle of Mount Hyjal; I've discovered, however, that one can tease out the true timeline by seeking out her dragon form, such as when she helped to empower the Dragon Soul for use against the Legion.

Though unconfirmed, it is believed that Soridormi is the guardian of the last two Vials of Eternity, which contain samples drawn from the Well of Eternity before its destruction. Prior to the bronze's acquisition, the vials were known to be in the possession of Illidan Stormrage's fallen lieutenants: the naga, Lady Vashj, and the blood elven prince of Quel'Thalas, Kael'thas Sunstrider.

Only the bronze know the future consequences of Illidan creating the Vials of Eternity.

CHRONORMU

Chromie • Ambassador of the Bronze Dragonflight • Time Keeper of the Timewalkers

Arguably the most charismatic of all dragons, Chronormu is more commonly known among the mortal races by her visage name, Chromie. In eschewing the typical appearances of either human or elf, Chromie stands out as one of the few dragons to enjoy a gnomish form. As an essential member of the Timewalkers and ambassador of the bronze, Chronormu seems to truly relish her interactions with the mortal races and has taken great efforts to ensure our continued survival.

While the bronze's exploits span much of known history, she is most recognized for her extraordinary efforts to repair the timeline corruption caused by the infinite dragonflight. In this role, much of her efforts focused on maintaining the sanctity of the timeline surrounding the Third War, such as the fall of the human capital of Lordaeron and Prince Arthas's infamous culling of Stratholme.

As Time Keeper of the Timewalkers, Chromie aided Tyrande Whisperwind in presenting

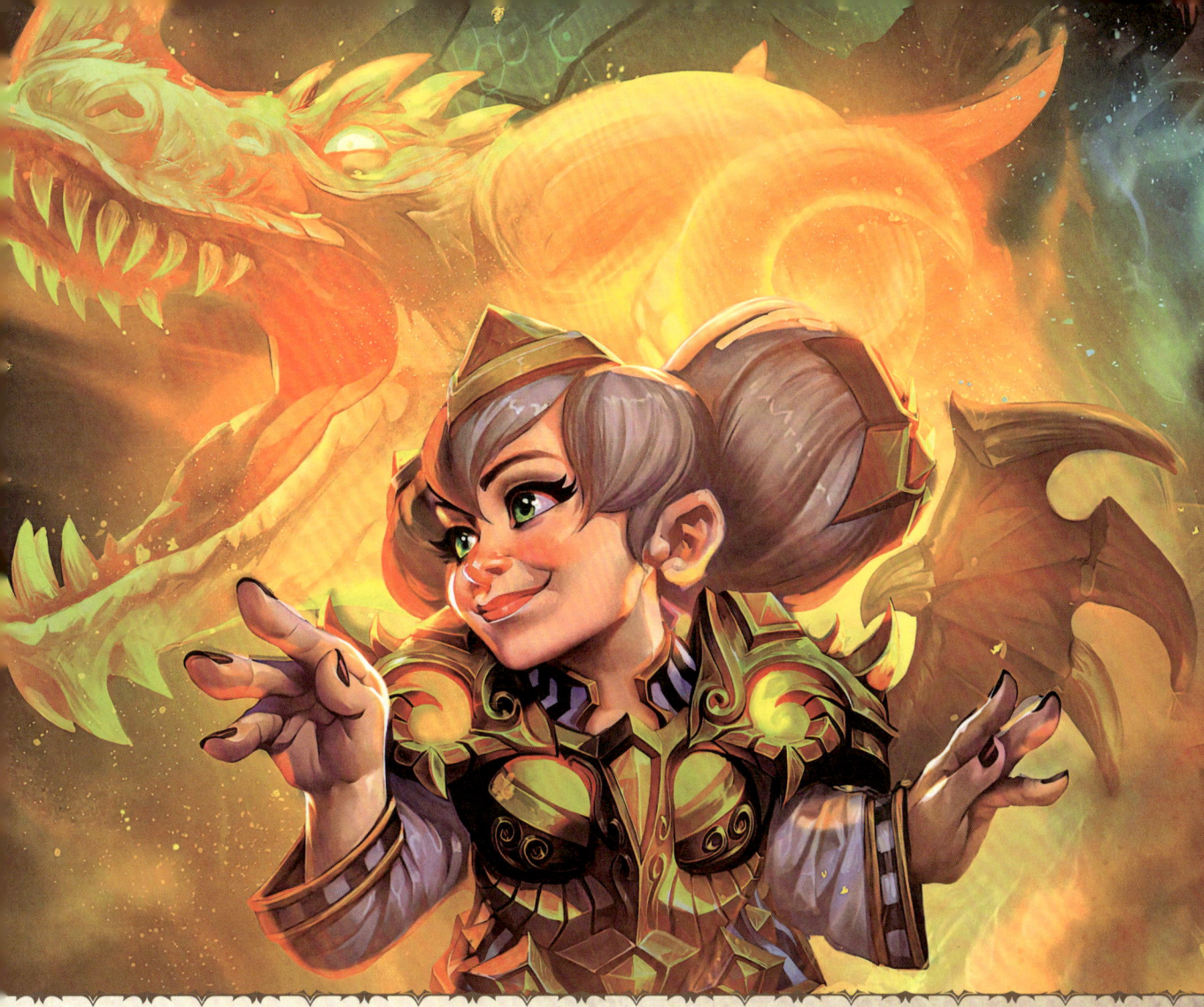

the case against the former Horde warchief Garrosh Hellscream during his trial. Her counterpart, Kairozdormu, offered to deliver the accused's defense but instead assisted in Hellscream's escape to an alternate timeline. In their pursuit, Chromie and her allies discovered the unexpected involvement of the infinite dragonflight along with Kairozdormu's true goal: With the infinite power to change history, he could find a way to defeat the Legion upon their inevitable return to Azeroth.

Though Kairozdormu was ultimately betrayed by Garrosh and his plans were subverted, Chromie continued to fight against the infinite dragonflight, which has since come to see her as a direct threat to its unknown motives. With the help of mortal champions, Chromie managed to repair several tampered timelines intended to lead to her "incorrect" death; the identity of those plotting against her remains a mystery at the time of this telling.

Despite the ongoing threat to her life, Chronormu's dedication to the bronze dragonflight and Azeroth remains steadfast, as was most recently demonstrated when she provided her essence to empower the artifact known as the Heart of Azeroth, used to defeat the Old God N'Zoth.

As Chromie considered her visage form, Nozdormu advised that it should reflect both how she wished to experience the mortal world and how she wanted to be seen by them.

ANACHRONOS THE ANCIENT

Heir to the Bronze Dragonflight

Due to the extraordinary lifespan of dragons, I am told that it is unusual for the dragonflights to declare an heir in advance of an Aspect's demise. The exception, of course, are the bronze, who know the exact moment of their own deaths, a fact that leads many scholars to speculate on Nozdormu's future. Whether the Timeless One is destined to be lost in battle or to corruption by the Old Gods, it is the Aspect's son, Anachronos, who will one day take up leadership of the bronze dragonflight. Until that fated moment, the bronze heir acts in much the same capacity as his mother, the prime consort Soridormi, in performing the most vital missions of their flight.

Anachronos's greatest feat lies in his heroic efforts to rally the dragonflights against the Old

God C'Thun during the War of the Shifting Sands. Though initially successful in holding back the mighty waves of aqir that surged forth from the temple of Ahn'Qiraj, the night elf forces commanded by Fandral Staghelm and Shiromar began to falter after the death of the archdruid's son, Valstann. The loss shattered Fandral's will to fight, leaving the defensive line broken by the murderous aqir, who then set their sights upon the Caverns of Time. With the bronze drawn into the battle, Anachronos called upon the unity of the dragonflights to help push the remnants of the Black Empire back into the temple and seal them away.

After the sacrifice of Arygos, Merithra, and Caelestrasz secured the aqir within the walls of Ahn'Qiraj, Anachronos joined his power with that of the druids to erect an impenetrable magical barrier around the accursed city. Named the Scarab Wall, it held for nearly a thousand years until the further weakening of the Old God's prison necessitated its removal to allow heroic champions to battle C'Thun.

GRAKKAROND
Commander of the Bronze Dragonflight

Remembered as a massive bronze capable of rending devastating damage against the enemies of his dragonflight, Grakkarond heeded Anachronos's call to fight the remnants of the Black Empire within the city of Ahn'Qiraj. It is said that the mighty behemoth was felled only due to a cunning ambush by the anubisath Ossirian, a titan-forged guardian corrupted by the Old God C'Thun. Though wounded by the giant's sword, Grakkarond managed to maul Ossirian to near death before hordes of qiraji swarmed over the noble bronze and ended his life.

Laying for a thousand years beneath the grueling Silithus sun, the monstrous bones of Grakkarond went on to serve a sacred role to the anubisaths until its recent destruction by the sword of Sargeras. To them, the skeletal remains commemorated the defeat of their most powerful enemy and stood as a testament to their strength. For the Farraki trolls of southern Kalimdor, the half-buried bones form a fertile source of legend.

The anubisath are obsidian giants created by Highkeeper Ra to defend Uldum and Ahn'Qiraj.

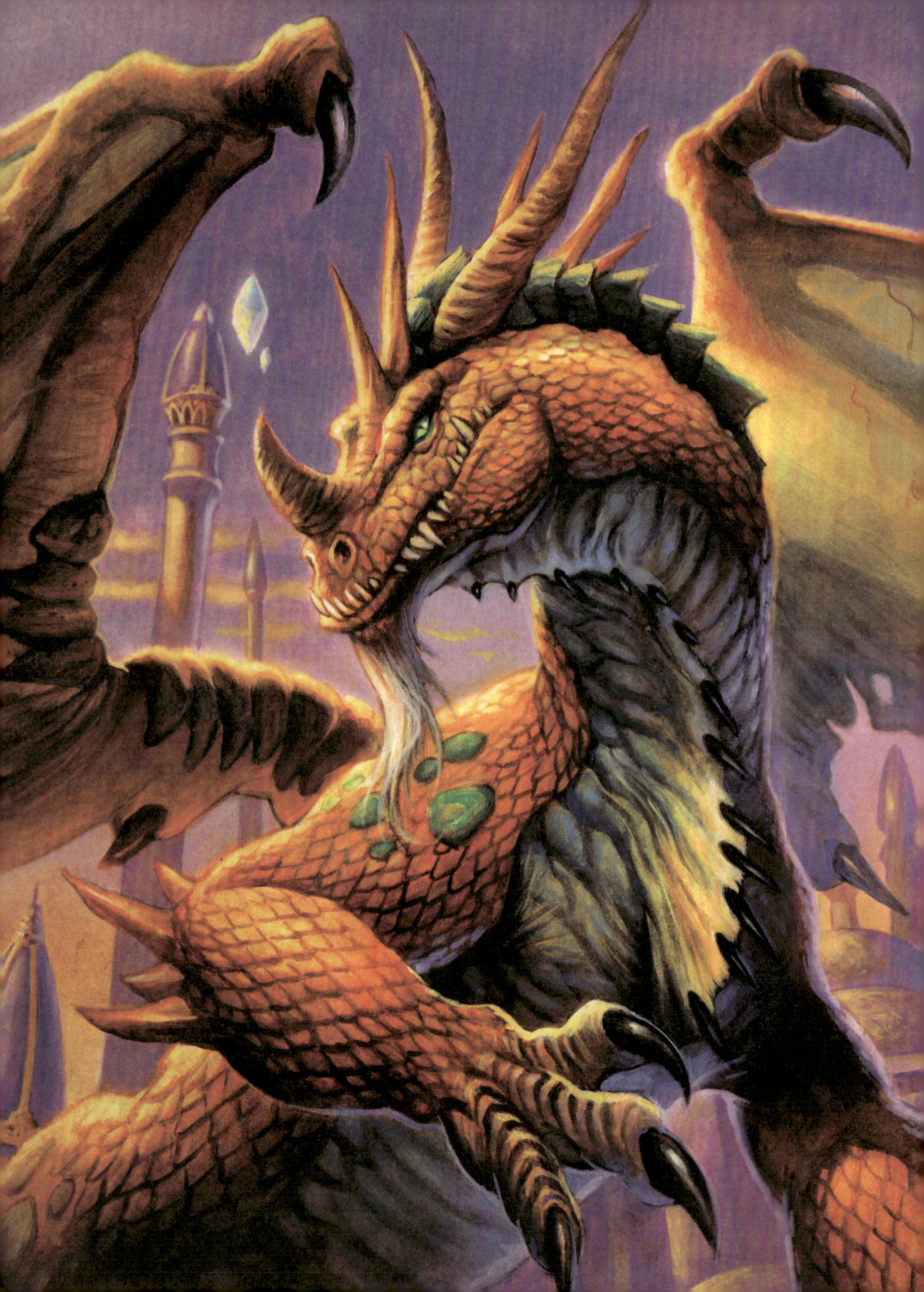

ZEPHYR & ZIDORMI

Representatives of the Keepers of Time • Watchers of the Timewalkers

Most often encountered in their visage forms as a high elf and a human, respectively, Zephyr and Zidormi were said to be claw-picked by Nozdormu himself to serve in the Keepers of Time. As caretakers of the timeways, they are responsible for the more ordinary yet frequent disturbances found throughout the history of Azeroth. Following the loss of the Aspects' powers after the defeat of Deathwing, it was decided that the Keepers of Time would reform into the Timewalkers, who would seek to recruit mortals willing to help protect the pathways of time.

Many experienced travelers report their first encounter with a dragon to be within the city of Shattrath, located on the shattered remains of Draenor. Despite the relative security of Outland after the defeat of the Betrayer, Illidan Stormrage, Zephyr is most often found in the World's End Tavern when not otherwise engaged in her crucial work of maintaining the pathway events leading to the Second War.

While it has been my experience that most bronze dragons tend to stay aloof, Zidormi seems to relish her work as the keepers' liaison charged with granting mortals essential glimpses of the past. In this capacity, she offers thoughtful insight into events such as the tragic destruction of Theramore by the former Horde warchief Garrosh Hellscream, the Legion's invasion of the Blasted Lands via the Dark Portal, the Horde's burning of the elven capital of Teldrassil, and its reprisal, and the Alliance siege of the Forsaken capital within the ruins of Lordaeron.

Though we can never turn back time, we can take an occasional peek.

EROZION

Representative of the Keepers of Time

Though I'm told the bronze dragonflight had grown increasingly aware of anomalies affecting the sanctity of the pathways, direct contact with the infinite dragonflight occurred only after Erozion sent a group of adventurers back in time to protect the essential history of warchief Thrall's escape from Durnholde Keep.

Seeing Thrall as a key factor in the Legion's failed invasion of Mount Hyjal, the infinite dragonflight attempted to end the shaman's existence before he established the Horde.

To achieve this goal, they sent an assassin known as Epoch Hunter to end the orc's life precisely when his legacy first began to present a threat. Yet by guiding a group of champions through the events of Thrall's liberation, Erozion managed to protect the history of one of Azeroth's most crucial heroes.

Though this was not the only attempt by the infinite dragonflight to alter the past and enact its maddened future, the threat to Thrall's fate was successfully averted.

CAVERNS OF TIME

In southern Kalimdor, at the heart of the scorching Tanaris desert, is the Caverns of Time. Home to the bronze dragonflight and the Timewalkers, this system of caves harbors a wonder of twisting realities and infinite pathways, all intersecting and branching from the one true timeline.

Yet even in this domain of timeless potential, malevolent forces seek to destabilize the very fabric of reality. Sacred pathways weaving the very annals of Azeroth's history slowly succumb to dangerous anomalies. Without the specific path Thrall followed, could the Hour of Twilight have been averted? If the Dark Portal had never been opened, might the Legion have conquered Azeroth?

Those who tamper with the pathways know these answers—a seeming impossibility until one dares to gaze into the future of the bronze.

AHN'QIRAJ

Scattered about the shifting dunes of Silithus sat the weathered remnants of Staghelm's outpost, its shelter the only shade a traveler might have found in such an unforgiving land. Even from there, one could hear it: the droning, disquieting buzz of thousands upon thousands of insects working in unison by the command of an unseen force. Those brazen enough to wander the scouring wastes did so for one purpose: to gaze upon the great walls of Ahn'Qiraj.

It is a titan outpost that hides a foreboding secret: a malevolent god entangled so deep in Azeroth's core that its rending could destroy the world-soul itself. Yet even from the impenetrable depths of its eternal prison, the Void manages to call out, drawing the swarms of its Black Empire home.

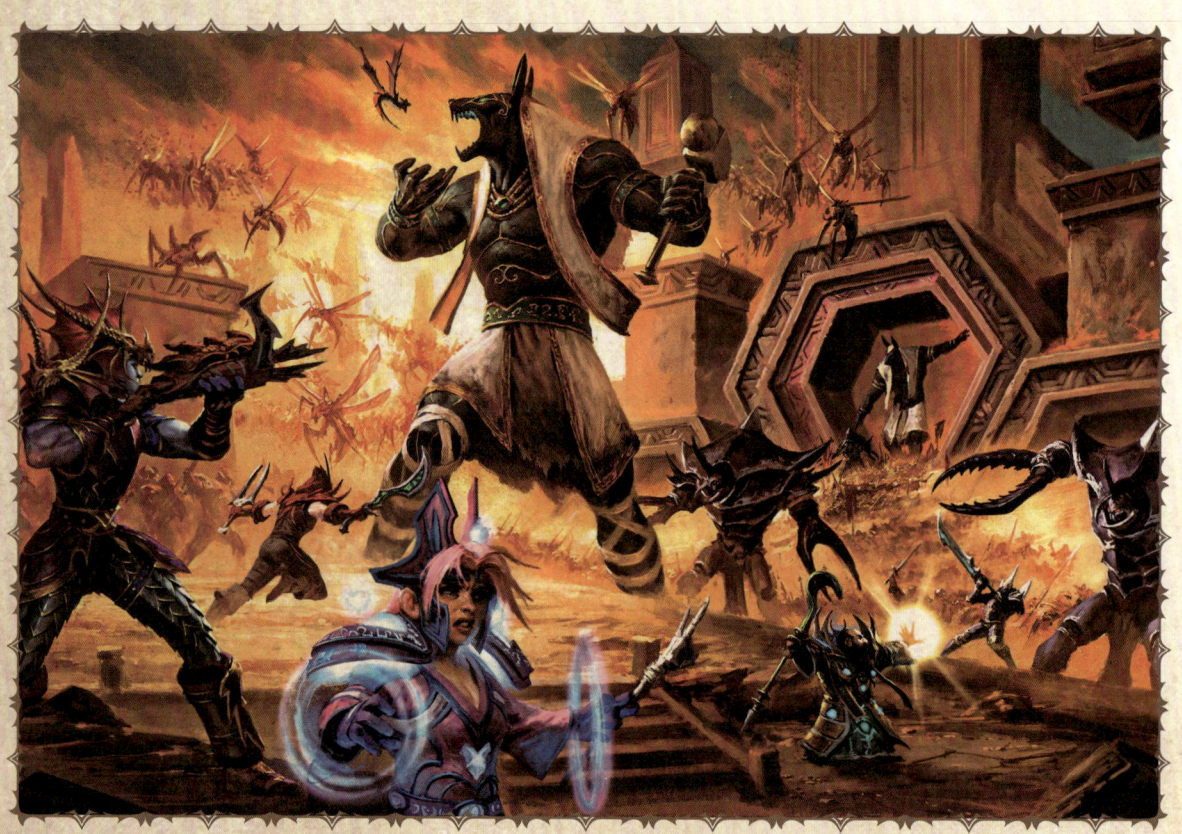

ANDORHAL

Clouds of choking gas hang in the stagnant air as the tortured howls of demonic darkhounds chill the blood of anyone daring enough to tread this accursed place. Once the agricultural hub of Lordaeron and the Eastweald, Andorhal has little left of its once verdant heartland. This is where the plague began, an inhuman affliction created by the vile necromancer Kel'Thuzad, who served at the Lich King's command. It is also where Arthas Menethil's fate was sealed, drawn into a vengeance that ultimately consumed his soul.

Amid the creak of idyllic windmills, a valiant paladin made his final stand against a beloved student lost to darkness, a Light sworn's soul cleaved in two by the power of the Maw. It is a tragedy that can seem senseless and without justice to any lacking a bronze's vision of this hero's ascended future.

THALDRASZUS

Nestled in the vast, mountainous heart of the Dragon Isles stands Thaldraszus, the gathering place of the five ancient flights and location of the revered site of Tyrhold. It is within this sacred monument that the Halls of Infusion reside, a set of complex titan machinery that draws its immense power from the wellspring of Eternity. In the time before the Great Sundering shattered the continent of Kalimdor, this grand device allowed the Aspects and their flights to ascend from mere primal dragons into the guardians of Azeroth they are today.

Though much of the surrounding territory is shaped by titan-forged architecture, the draconic culture left behind its own distinct mark. Among the most splendid of their creations is the glorious city of Valdrakken, from which the Aspects guided the vast lands of Azeroth.

Wander the lush hillsides long enough, though, and you'll uncover distinct echoes of the bronze dragonflight woven throughout. One such example is the Sacred Hourglass, which visitors to the Caverns of Time will recognize as a perfect replica of the one first created here. Keen observers might even notice that a portion of sand from this sacred vessel was carried upon Nozdormu's shoulder until its use in defeating Deathwing. In similar reflection, the temple structures at the Temporal Conflux lend many unique features to the bronze's anomalous lair in southern Kalimdor.

From within the Sanctum of Chronology, Nozdormu is able to directly access the timeways, allowing him to revisit any point in time, including the very moment of his own demise. Though many mortals judge the visions of the titan Aman'Thul as a curse, the bronze see such knowledge as a mere consequence of serving the one true timeline.

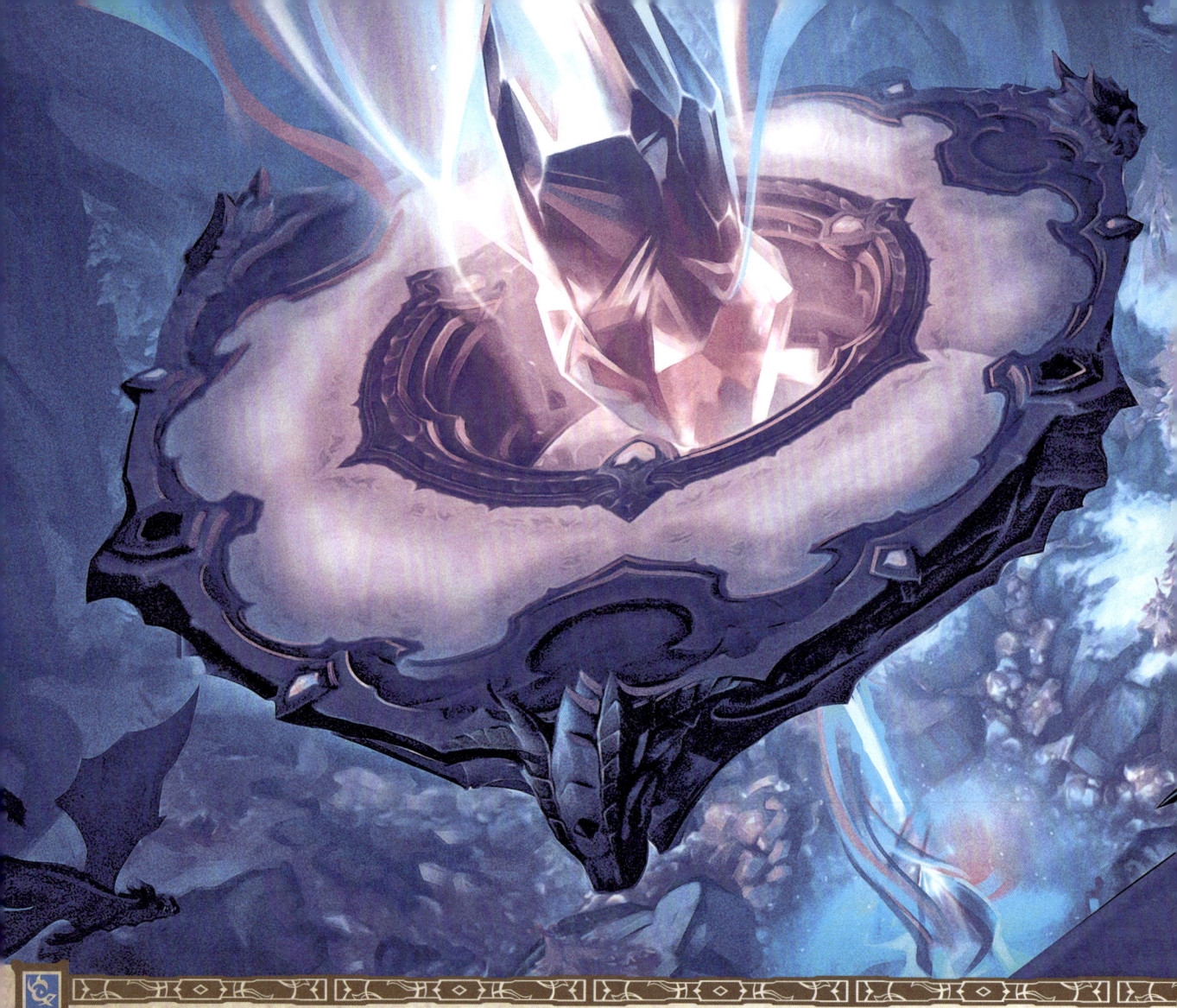

BLUE DRAGONFLIGHT

The story of the blue dragonflight is one of great valor, bitter betrayal, and grief. Though each flight suffered grave losses during the War of the Ancients, none had paid such a staggering price, nor harbored such an enduring hatred for those seen as responsible. With one blast of the Dragon Soul, nearly all of Malygos's flight was wiped out, including his prime consort, Sindragosa. The pain of those losses drove the Aspect of Magic deep into the Nexus.

Following Queen Azshara's actions at the Well of Eternity, the blue dragonflight had largely come to view all mortals as reckless creatures unworthy of wielding magic, including the nearby Shandaral Highborne of Northrend. Stranded after the Sundering from the kaldorei empire and the World Tree Nordrassil, these elven survivors coveted the blue dragons' ability to crystalize living matter into coalesced energy as a replacement for the Well of Eternity that provided their immortality and arcane power.

Rather than offer aid, the blue dragonflight met the elves' entreaties with open hostility for fear that the Highborne would repeat the

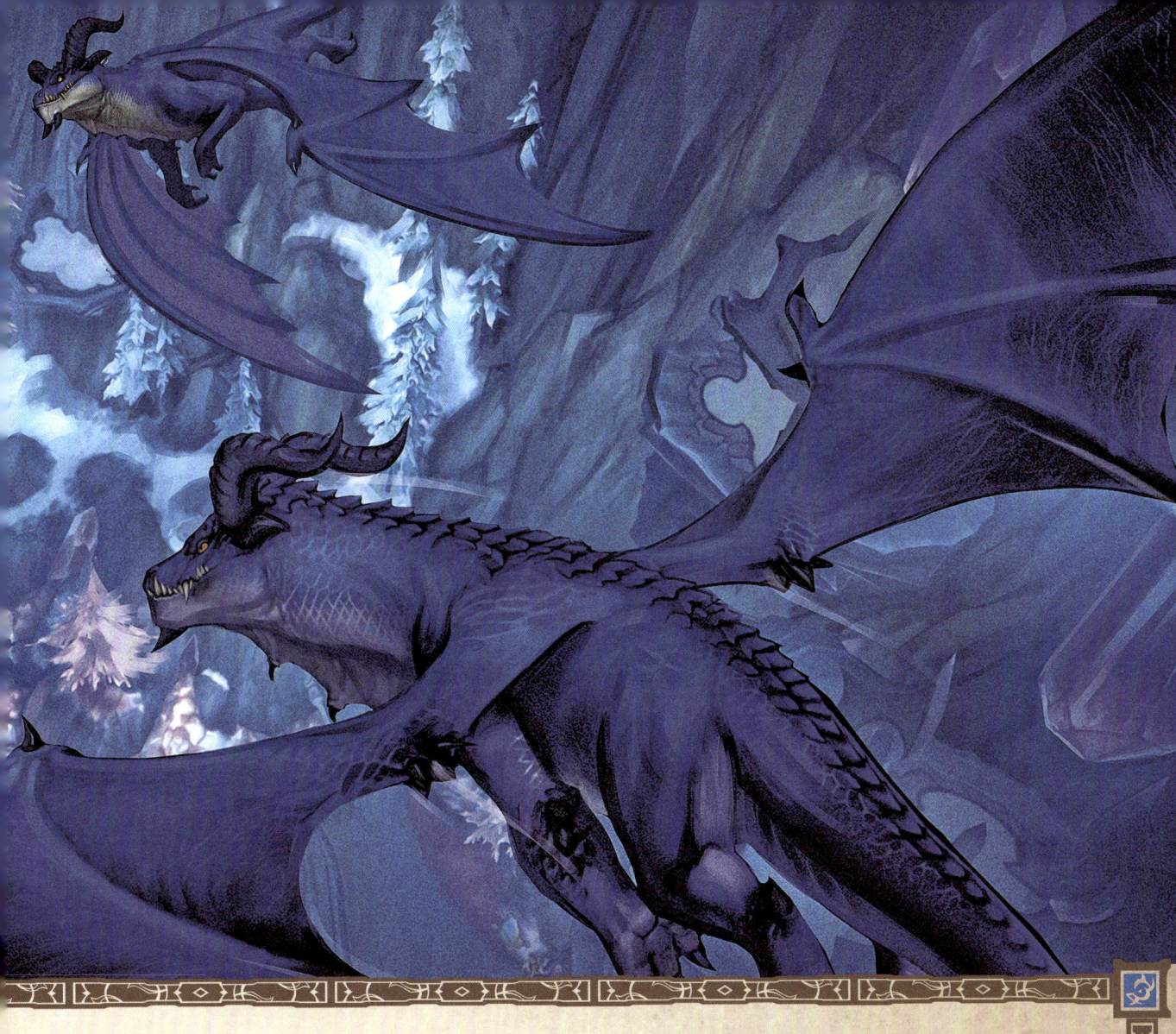

mistakes of the past. Anger and desperation then drove the elves to breach the Nexus and steal the dragonflight's arcane techniques and artifacts; a brazen act that led to the blues' counteroffensive to eradicate the Highborne outpost of Moonsong. In facing certain destruction, the elven mages unleashed the power they had stolen against the wrathful blues, which set off an explosion that crystallized the forest. Twisted by the wild arcane energies, the spirits of the doomed Shandaral wander the shattered boughs of Crystalsong Forest to this very day.

In time, the flight's ancient biases were tempered by the influence of the other dragonflights who had stepped in to care for Malygos's clutch in his absence. Unlike the elder blues, this new generation of dragons accepted both the titan mantle of arcane guardianship and the dragonflights' sacred duty to protect Azeroth. Though they initially hid their true identities behind mortal visages, younger blues sought membership within the Kirin Tor to offer their support, and to ensure that the elite mages of Azeroth did not misuse magic again.

MALYGOS

The Spell-Weaver • Aspect of the Blue Dragonflight • Guardian of Magic

As one of the five primal dragons to face the might of Galakrond, Malygos was entrusted by Keeper Loken with command over the arcane and celestial powers of the titan Norgannon. Remembered by his fellow Aspects as a stalwart defender until the near destruction of his flight at the Well of Eternity, Malygos retreated to the Nexus, where he became utterly lost to his grief. Though the sparse remnants of his flight continued their titan charge in his absence, the Aspect of Magic was not seen again until the aftermath of the Second War.

Stirred by the discovery of Deathwing's return and a chance to free Alexstrasza from the Dragonmaw clan, Malygos answered the call to join his fellow Aspects in the Battle of Grim Batol. Though unsuccessful in sating his ancient rage against Neltharion, the destruction of the Dragon Soul and the release of the Aspect's trapped power restored a sliver of Malygos's sanity, allowing him to roam the Nexus with his flight once more. It was in this state that he encountered the attacking nether dragons brought from Outland by Tyrygosa. For reasons I have yet to discern, the consumption of their energy led to the Aspect's full awakening and the recollection of his sacred duties. Yet upon assessing the state of magic on Azeroth, Malygos immediately turned his fury against the mortals, whom he believed posed a grave threat of drawing the Legion's attention.

To prevent that outcome, the Aspect of Magic ordered his dragonflight to divert Azeroth's leylines to the Nexus so that their energy could be harmlessly channeled out into the Twisting Nether. In seeking the cause of the failing arcane pathways, the Kirin Tor sent an envoy to the blue dragonflight's home in Coldarra; and the dragonflight was ultimately given an impossible choice: join Malygos's mad plans and become mage hunters, or perish in the frozen north. With the mad Aspect's intentions now clear, the decision was made to teleport Dalaran to Northrend, to then wage a united offensive against the Nexus.

For a deeper understanding of the Nexus, Eye of Eternity, and the Focusing Iris, please review: <u>Delving Deeper</u> by Arcanist Perclanea, <u>Notable Antiquities of Ancient Azeroth</u>, and <u>Powerful Magical Foci and Those Who Wielded Them</u> by Archmage Karlain.

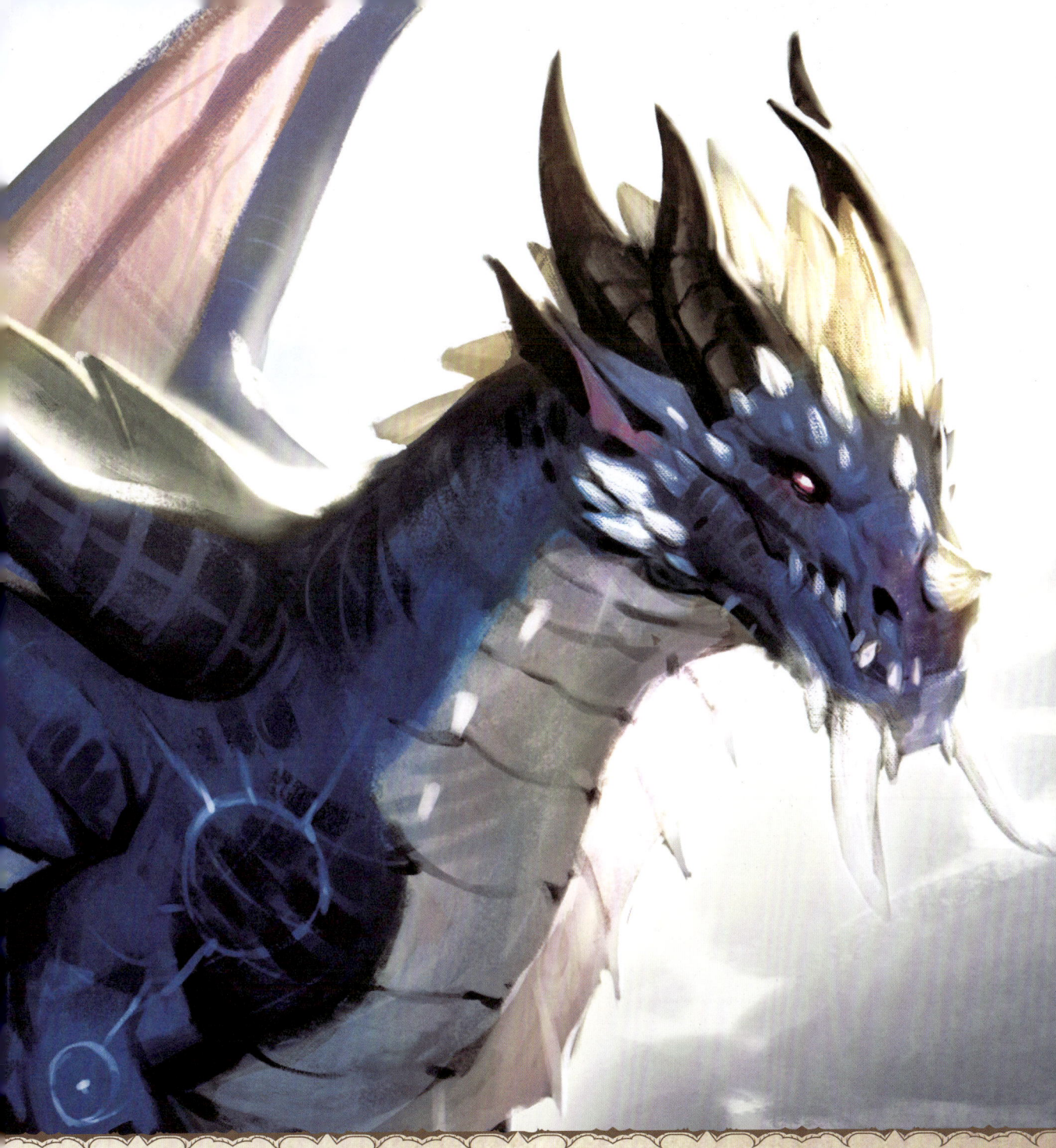

With the signing of the Wyrmrest Accord, the remaining dragonflights joined the champions of the Kirin Tor, Horde, and Alliance to storm Malygos's celestial domain, known as the Eye of Eternity. Though supported by the oldest and most loyal of his flight, the Aspect of Magic fell before the brave heroes of the Accord, and his efforts to drain Azeroth of arcane power were subverted. At the time, we could not know that the quakes caused by Malygos's meddling would be but a shadow of what was to come during the Cataclysm.

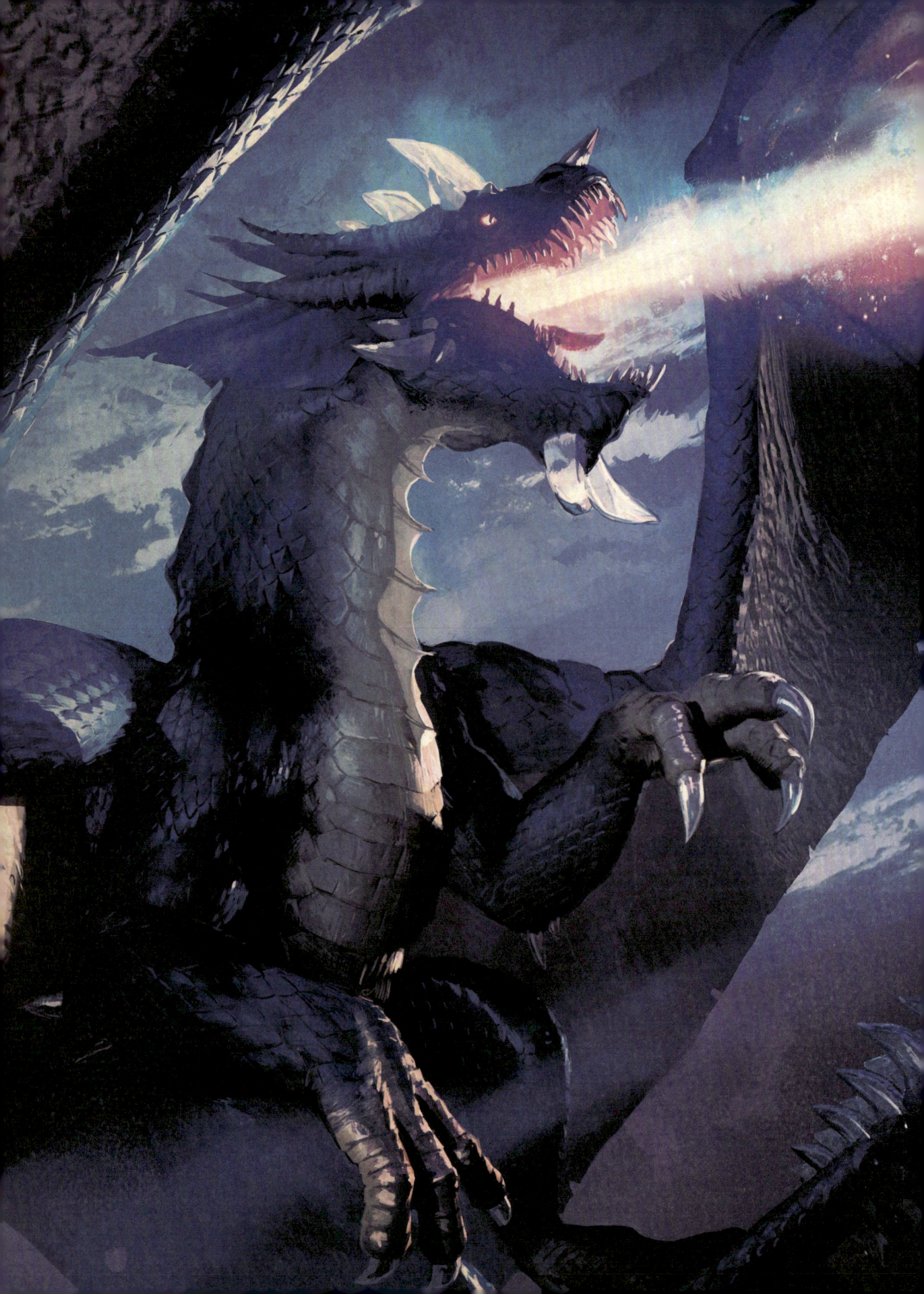

KALECGOS

Aspect of the Blue Dragonflight • Kalec • Archmage of the Kirin Tor
Member of the Tirisgarde • Member of the Council of Six

Known among scholars and mortals alike as one of the most kind and brilliant mages of the present era, Kalecgos contributed more to the defense of Azeroth than any other dragon. Though he no longer considers himself an Aspect, due to the loss of his titan-gifted powers following the fall of Deathwing, Kalecgos remains the leader of the blue dragonflight.

Encountered most often in a half-human, half-elven visage by the name of Kalec, the gifted blue was instrumental in restoring the Sunwell through his protection of the human avatar Anveena Teague. Together with the Dragon Queen's consort, Korialstrasz, the two dragons battled the sin'dorei traitor Dar'Khan Drathir, who sought to siphon the power of the Sunwell for himself. After their enemy's defeat, Kalec steadfastly remained in Quel'Thalas to protect Anveena until her heroic sacrifice to weaken the Eredar lord Kil'jaeden and close the demonic gateway he had opened between Argus and Azeroth.

Fate would see Kalecgos and Korialstrasz cross paths again within the cursed halls of Grim Batol as they uncovered a plot by Sinestra of the black dragonflight to extract the essence of the escaped nether dragon Zzeraku and use it to create the twilight dragon Dargonax. Though Kalecgos and Korialstrasz were successful in defeating the black consort's creation, the destruction of Dargonax came at the grave cost of their draenei ally, the priestess Iridi, and Zzeraku himself.

Though largely absent from the events of the Nexus War, Kalecgos later played a pivotal role in altering the properties of the recovered Dragon Soul so that it could harm Deathwing, by use of Thrall's shamanistic powers. After helping to avert the Hour of Twilight by giving his power to destroy the Earth-Warder, Kalecgos turned his attention to pressing matters within Dalaran and the Kirin Tor. From his position as a member of the Council of Six, Kalec lent his aid to the red dragonflight during the attack by the twilight dragonflight led by Vexiona. Most recently, Kalecgos joined with the other leaders of the dragonflights to empower the Heart of Azeroth, an artifact used to draw upon the titan-created Forge of Origination in Uldum to defeat the Old God N'Zoth.

Creating a simple avatar is no easy feat of conjuration, let alone creating one that can assume a life of its own and steal the heart of a noble blue dragon.

SINDRAGOSA

Prime Consort of Malygos • Veteran of the War of the Ancients

I have seen promises of power and vengeance lead many great leaders down the path of corruption, yet no story offers so stark a warning as that of the kaldorei queen, Azshara. Swayed by the promises of Sargeras after the arcane experiments of her Highborne drew the Dark Titan's notice, Azshara sought to create a portal that would allow the Burning Legion to descend upon Azeroth and purify the world of all she deemed as unworthy. To those wicked ends, the queen urged the Legion's demonic soldiers to flood the cities of Suramar and Zin-Azshari and slaughter any who dared to challenge her command.

In knowing that Sargaras's true intent was to destroy Azeroth, the dragonflights joined ranks with the elven resistance led by Tyrande Whisperwind and Malfurion Stormrage to stand against the Legion. Yet powerful as the Aspects and druids were, they knew they could not defeat a Dark Titan alone. It was then that the black Aspect, Neltharion, offered a solution in the form of an unassuming golden disk: the Dragon Soul.

With the defenders standing united against the Legion's onslaught, the Earth-Warder fired the weapon upon their enemies before inexplicably turning it against his own allies in a stunning betrayal. As prime consort of Malygos, Sindragosa fought at the very core of the blue dragonflight in a position that placed her along the direct path of the energy torrent. Those not killed instantly were instead hurled into the farthest reaches of Northrend.

Legend says that Sindragosa, blinded and near death on a jagged mountainside in Icecrown, struggled desperately to reach the Dragonblight, the final resting place of all dragons. Though claw marks show her desperate descent down the icy slope, it soon became clear that the journey was beyond her failing ability. With the last of her energy, Sindragosa cried out to Malygos for help, only to hear the bitter winds of Northrend in response. Delirious and with a heart full of hatred, the blue consort is said to have cursed all who had led to her death: Neltharion for his betrayal, the Legion for its senseless crusade, and even her once beloved consort, Malygos, who had ignored her desperate pleas.

Yet Sindragosa's rage is said to burn hottest for the mortals whose reckless hubris brought the doom of the Legion upon Azeroth, an undying venom that later turned her into one of the Lich King's most destructive weapons in undeath.

Though the prime consort was lost during the War of the Ancients, much of her wisdom was miraculously preserved by way of a simulacrum discovered in the Azure Span.

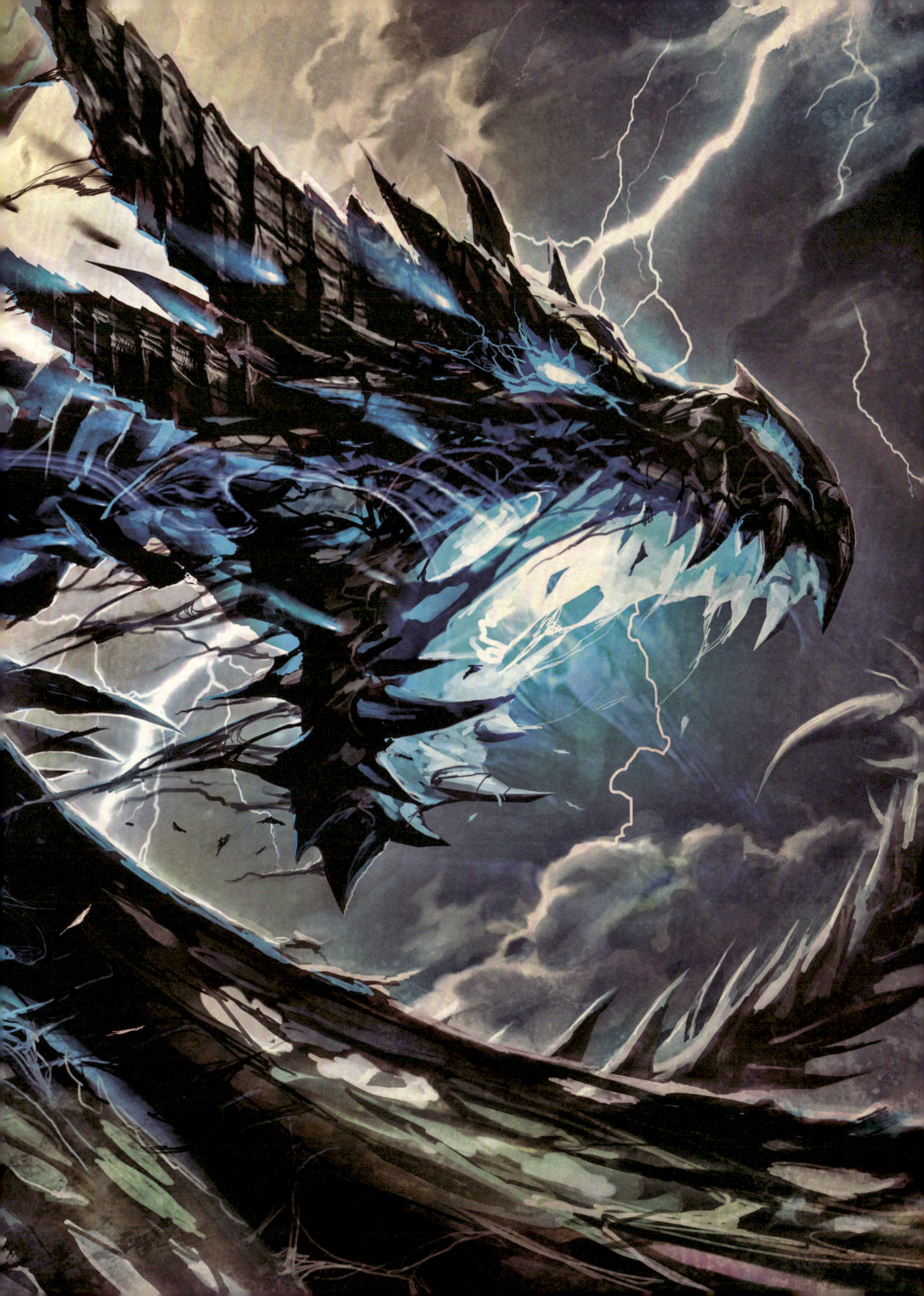

BALACGOS
Caretaker of Magic

As an elder offspring of the blue Aspect Malygos, Balacgos was said to be especially gifted even among dragons who wielded the powers of the arcane with natural ease. Yet as any wise archmage will tell you, rarely does such raw skill and pride make space for sufficient caution.

In an eerie echo of his father's mad plan that led to the Nexus War, Balacgos sought to create an artifact that could harness the latent magic energies of Azeroth and lock them away from the recklessness of mortal practitioners. For this purpose, he designed a cube capable of absorbing and reserving energy that could be used later by the blue dragonflight. Though reviews of his theory proved it was sound, the blue must have made a regrettably fatal calculation.

Upon activation of his flawed device, Balacgos's entire essence was drawn into the artifact, leaving behind only a lifeless husk. For this reason, the cube came to be known as Balacgos's Bane.

Lost for millennia after Malygos gave the device to Neltharion for safekeeping, the cube reappeared in the claws of Deathwing's prime consort, Sinestra, as she sought to produce her flight of twilight dragons. According to Kalecgos, this device allowed her to draw the energy of the nether dragon Zzeraku and redirect it into her new creation, the twilight behemoth Dargonax.

All mages are taught the story of Balacgos, as a reminder to always double-check measurements and calculations.

AZUREGOS
Safekeeper of the Nexus • Spirit of Azurego • Mate of Anara

While dragons are often depicted as stoic and austere beings, it has been my experience that they tend to exhibit many of the same emotions as mortals. Traits such as humor, sarcasm, and passion not only offer them the ability to blend into other cultures while in their visages, but they also serve as a bridge to better understand the mortals they've sworn to protect. Yet of all the dragon emissaries I've encountered, none seems to have such a complete command of satire and subtlety as the blue dragon Azuregos.

Entrusted by Malygos to find and safeguard the flight's most powerful arcane artifacts, Azuregos frequented the elven ruins of Eldarath in southeastern Azshara. Curiosity over the blue dragon's repeated and prolonged visits led many mages to speculate about what treasures may lay hidden among the ancient Highborne temples; some even brazenly suggest that the missing Vials of Eternity were located there. The truth of what the blue dragon safeguarded turned out to be of equally grave importance.

For more than five hundred years after Fandral Staghelm shattered the Scepter of the Shifting Sands, Azuregos acted as one of the three guardians of the scepter shards. Though he carried out his sacred duty without fail, the blue believed that, as long as rumors of a powerful relic existed, it could one day become a beacon to would-be heroes seeking glory and treasure. In the end, his prediction proved correct.

After guiding a group of worthy champions to the shard so they could battle the Old God C'Thun, Azuregos was attacked by a roving band of miscreant fighters. Unwilling to return to the physical world, Azuregos instead hid away in the spirit realm, where he formed a relationship with the spirit healer Anara. Though the demands of his flight eventually required his return to the Nexus, it was with a heavy heart that the dragon departed her realm to serve as the Safekeeper of the Nexus.

Even after my extensive studies in the Shadowlands, I have yet to puzzle out how Azuregos hid so long in the spirit realm—and he refuses to say.

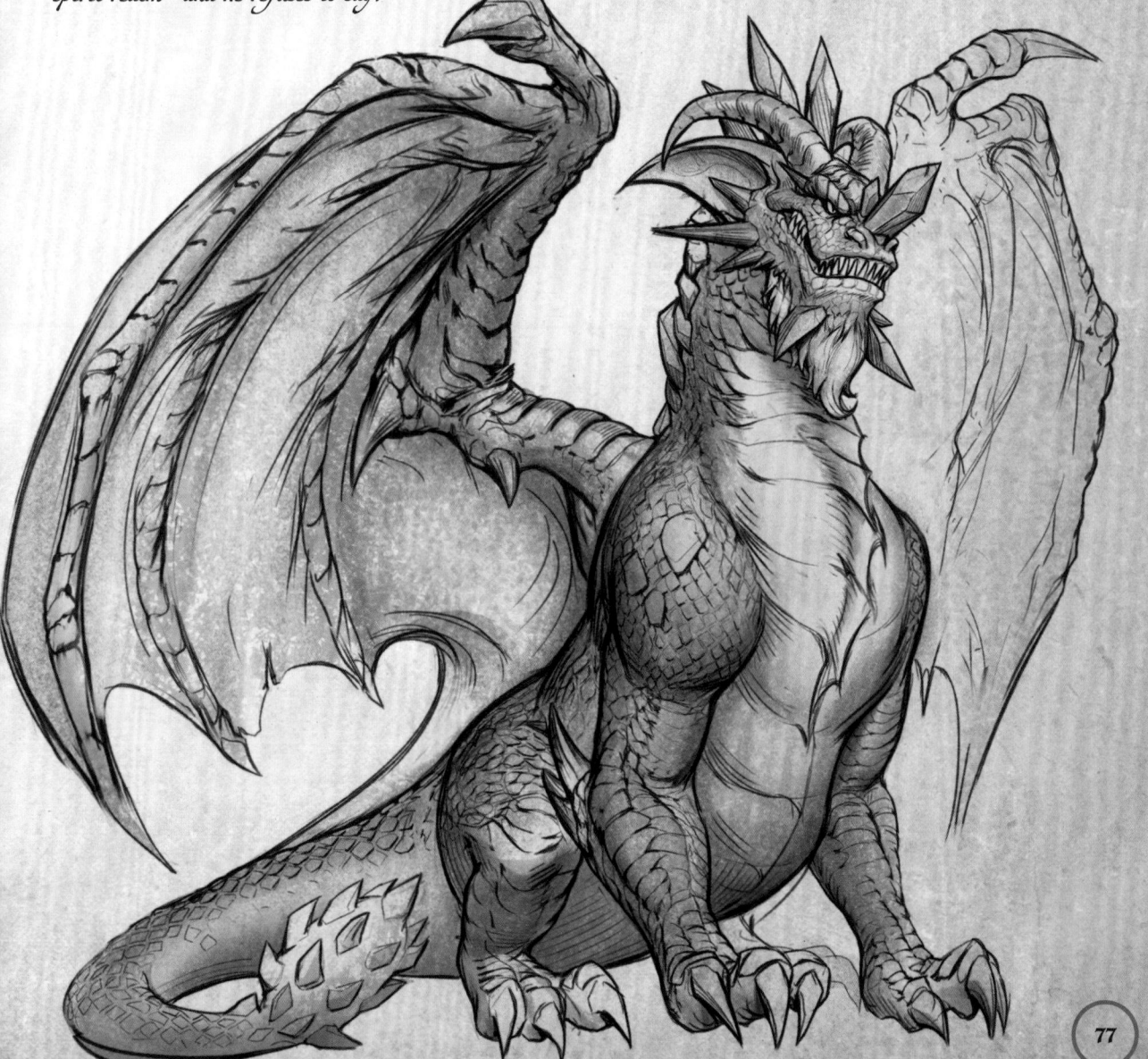

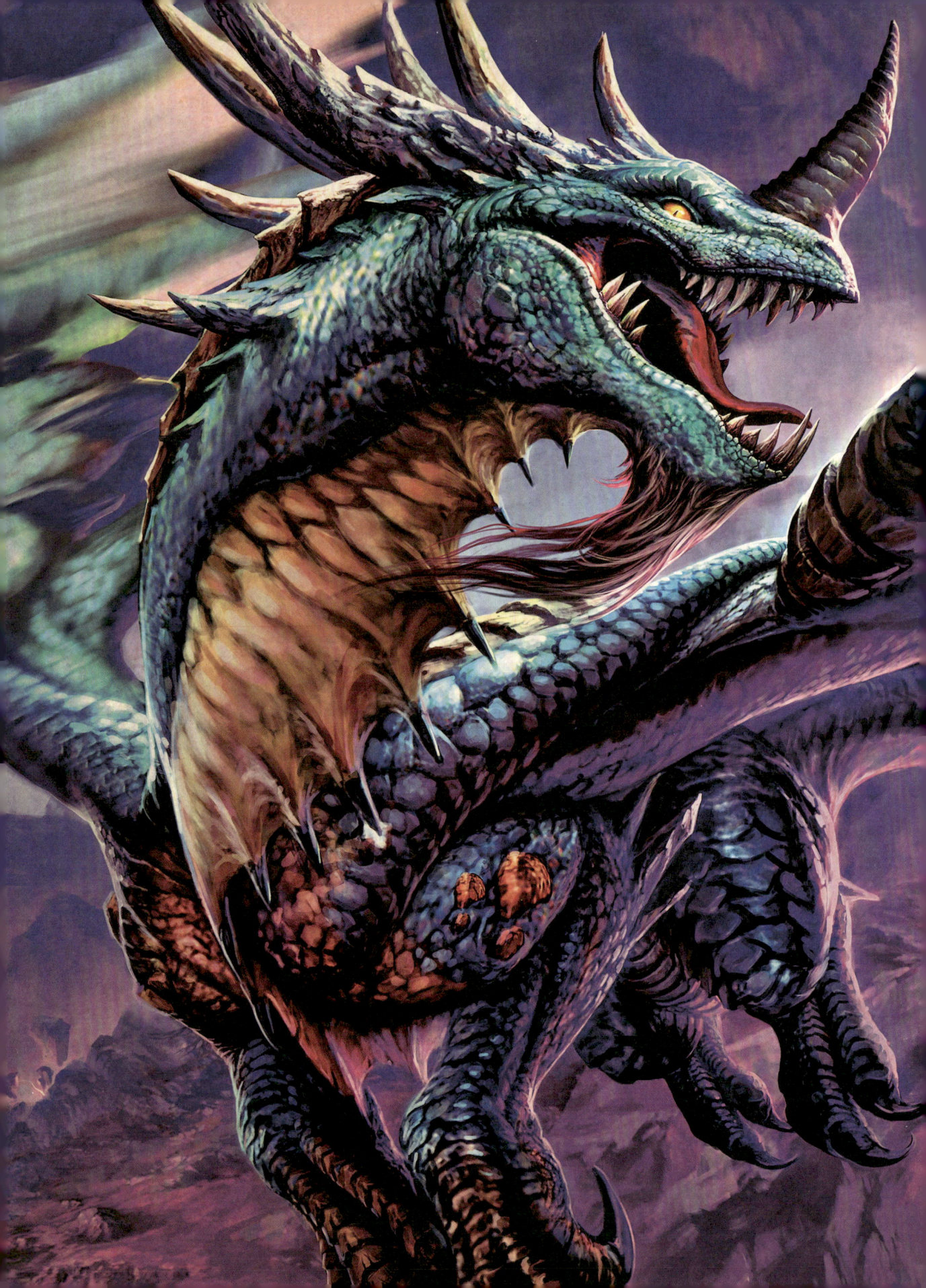

ARYGOS

Son of Malygos • Veteran of the War of the Shifting Sands • Ally of the Twilight and the Infinite

The legacy of Arygos is one of selfless valor, pure arrogance, and an inability to abandon old hatreds. As one of the dragons to heed the bronze call for aid against the aqir of Ahn'Qiraj, Arygos sacrificed himself during the final battle of the War of the Shifting Sands to ensure victory. Fighting alongside the green dragon Merithra and the red dragon Caelestrasz, Arygos and his allies managed to force the enemy swarms back into the city long enough for the Scarab Wall to be raised. Believed dead by all who fought that day, the unimaginable truth was that all three dragons had survived only to be subjected to the inhumane horror of captivity by the Old God C'Thun.

Though the trio never spoke willingly of that dark time, it is known that they fought the madness of the Void for a thousand years until the Scarab Gong was rung and the wall was brought down. Freed from their torment at last, the three dragon heroes refused to abandon the assault. Instead, they rallied alongside the champions who had amassed, hoping to end the Old God's growing influence for good.

Ignoring the fact that his rescue from the accursed city was made possible only by the presence of mortals, Arygos resurfaced many years after the end of the Ahn'Qiraj War as a staunch supporter of Malygos's mad plan to cut off all sources of magic from the younger races of Azeroth. Even in the wake of the Nexus War, Arygos was unable to see the error of his father's actions and the necessity of the Aspect's death at the hands of the Wyrmrest Accord. Seeking to continue his father's work, Arygos asserted his claim as heir and demanded the position and powers of the blue Aspect. Despite the damage Malygos had wrought, the flight remained divided between Arygos's old hatreds and Kalecgos's desire to work alongside the mortal races. In the end, Thrall's impassioned speech convinced the blue dragonflight to choose with their hearts and move beyond the intolerance fostered by Malygos and his son Arygos, leading to Kalecgos' ascension during a sacred celestial event known as the Embrace.

Embittered by his flight's rejection and Thrall's meddling, Arygos called upon the Twilight Father to help enact his revenge. Seeing instead an opportunity to aid the infinite dragonflight, the Twilight Father enacted a bold plan to bring an alternate version of Aedelas Blackmoore, the master of Durnholde Keep who had raised Thrall, into their timeline to carry out the shaman's death. Just as he believed his vengeance was nearly at hand, Arygos was instead betrayed by Aedelas, who plunged his sword into the blue's skull. Using the dragon's blood to activate a powerful artifact known as the Focusing Iris, the enemy forces managed to animate the only true chromatic dragon in existence: Chromatus.

It was a bitter ending to the story of a once beloved hero of the blue.

ARCANAGOS/NIGHTBANE

Ally to the Guardian of Tirisfal

While the corrupted Guardian Medivh managed to conceal most of his meetings with Gul'dan, their opening of the Dark Portal linking Draenor and Azeroth was a far less subtle affair. Though most with an affinity for magic felt the shockwave of energy, none could pinpoint the exact source of the disturbance except for the former Guardian of Tirisfal. After enlisting the aid of her dragon ally Arcanagos, Aegwynn set off to investigate the area of swampland south of Stormwind City known as the Black Morass. There, she was stunned to behold the madness her son had created: a magical doorway connecting Azeroth to a world controlled by the Burning Legion.

Flying immediately to the nearby tower of Karazhan, Aegwynn sought to confront Medivh, who was busy entertaining many of Stormwind's nobles. After a heated argument, she came to the startling realization that her son was possessed by the Dark Titan, Sargeras, who sought to use Medivh's immense power to open a gateway for a new invasion of Azeroth.

The ensuing battle between mother and son shook the mighty towers to their foundations until Aegwynn was struck down, leading to Arcanagos's swift intervention. In response to the loyal blue's interference, the Dark Titan forced Medivh to burn Arcanagos from the inside out, cursing the dragon's skeletal remains with a fiery form of undeath. Fearing that Aegwynn could gain the upper hand, Sargeras drew upon the life energies of the fleeing guests in a desperate bid to end the former Guardian of Tirisfal. Yet in that most dire moment, Medivh managed to claw back control from Sargeras in order to teleport Aegwynn away to safety.

Though few have seen the dreadful skeletal dragon known as Nightbane in recent years, I can assure you that reports still surface on occasion from both travelers and members of the Violet Eye who are tasked with keeping watch over the grounds on behalf of the Kirin Tor. For this reason, it would be quite unwise for anyone to trespass on the terrace of Karazhan, which long served as the fallen blue's primary domain.

TYRYGOSA

Tyri · Member of the Wyrmrest Accord

While accompanying Kalecgos during his investigation of the Scourge in Lordaeron, Tyrygosa became part of the group that found and protected the mysterious Anveena Teague. Together with the red dragon Korialstrasz, the three defeated the elven traitor Dar'Khan, who sought to claim the energy of the Sunwell contained within Anveena for himself. Though betrothed to Kalecgos at the time of their mission, the two parted ways soon afterward due to Kalec's professed love for Anveena, whom he had sworn to protect. Instead, Tyrygosa soon found herself in Outland, where she become involved with the plight of the nether dragons.

Upon realizing that Zzeraku and his nether brood were the twisted remnants of Deathwing's lost clutch, Tyrygosa worked to free them from the renegade death knight Ragnok Bloodreaver, who wished to use the childlike creatures in his efforts to conquer Outland. Seeking to heal the dragons who had experienced such cruelty during their captivity, Tyrygosa brought the nether dragons to the Nexus so that they could be rejuvenated by the structure's arcane energies. Though Zzeraku and his brood quickly regained their strength after feasting on the abundant power, they feared the true motives behind Tyrygosa's kindness. Believing that their only chance to avoid subjugation again was to claim the Nexus's unlimited power for themselves, Zzeraku led his brood in an assault against the blue dragonflight that ultimately led to the awakening of Malygos and the Nexus War.

Tyrygosa returned to Northrend briefly to fight alongside the dragonflights during the siege of Wyrmrest Temple and the Hour of Twilight, but she has sworn herself to the noble task of safeguarding what remains of the nether brood after the tragic events at the Nexus. While she has answered the call for the blue dragonflight to reunite, at the time of this telling, Tyragosa's efforts appear focused on a thriving brood located in an energy-rich area of Outland known as Netherstorm.

With its high concentration of arcane energy, Netherstorm proved the perfect hunting ground for the nether dragons of Outland.

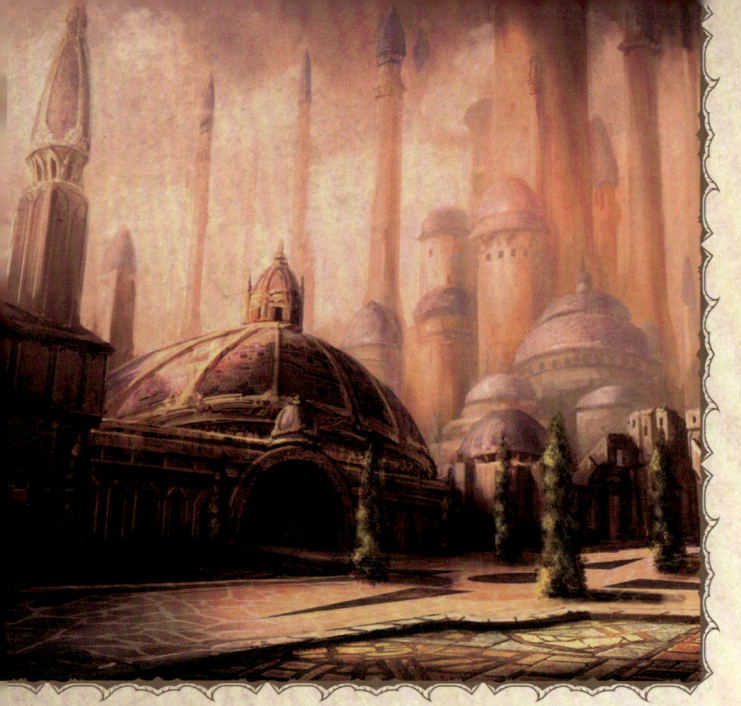

DALARAN/KIRIN TOR

This city of esoteric wonder is known more for its purpose than its many shifting localities. Built upon ancient lines of arcane power, its gleaming white towers, endless libraries, and locked vaults hold an endless array of forbidden secrets. Originally built by the mages of Arathor after their historic pact with the high elves of Quel'Thalas, the floating fortress has offered refuge to mortals and dragons alike for generations.

Since Dalaran's departure from the shores of Lordamere Lake, reagents for slow fall spells have become quite dear to any residents lacking wings and scales.

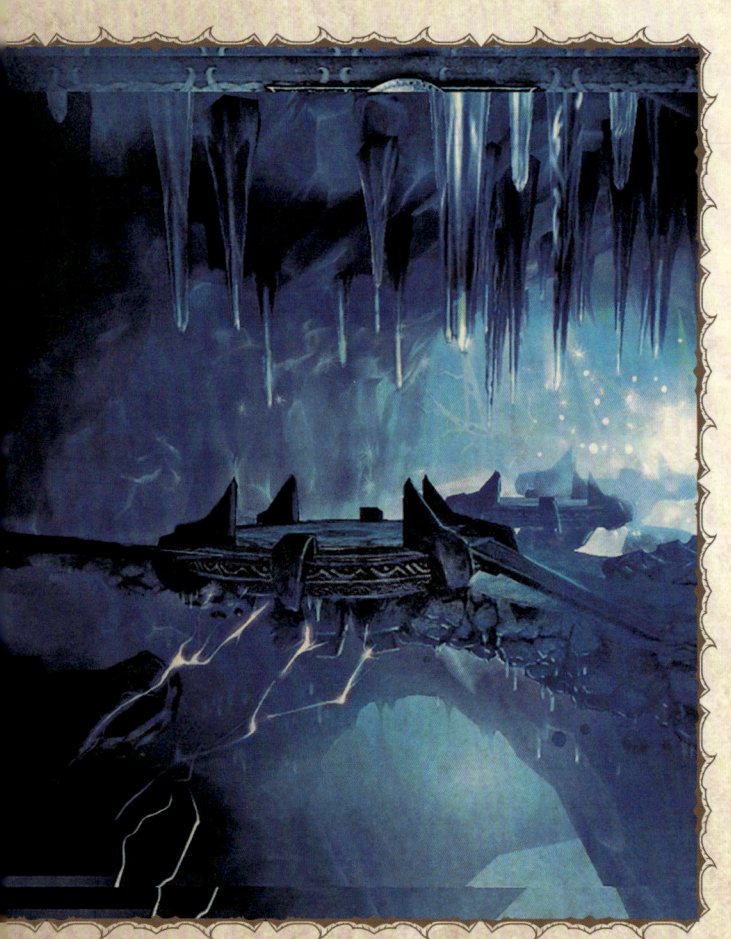

NEXUS

Along the west expanse of Northrend sits the frozen island of Coldarra, an isolated crater rimmed by jagged peaks that is inaccessible without flight. Legend claims that a human once sought an audience with the Aspect of Magic and that Malygos welcomed this daring scholar into his domain. Over the course of many months, mortal and dragon formed a rare friendship, leading to the creation of a foot bridge across the Westrift whose shattered ruins can still be seen today.

Few of the blue dragonflight will suffer the existence of trespassers these days, due to the valuable and dangerous artifacts guarded within. Though most will never set eyes on the blue's arcane lair, one can still behold from the safety of Borean Tundra the brilliant shimmer of lights emanating from the very heart of the Nexus. On especially cold and crystalline nights, one may even see its floating rings hovering above. Mortals are forbidden from entering the rime-coated vault, but it is rumored that even a fraction of the knowledge contained within could turn any mage into the greatest arcanist of their time.

AZSHARA

Perpetual autumn colors blanket a coastal land harboring the echoes of a once great civilization. Sitting at the outer edge of the Sundering's vast devastation, gaudy monuments raised to avarice cast their shadow upon timeworn statues carved to hubris. Here, ancient ruins grant occasional glimpses to the beauty and majesty of the ancient Eldarath Highborne, whose runes and tablets are still hidden amid the toppled pillars and crumbling spires.

Such arcane wonders draw not only mortal mages, but also the blue dragons, whose eternal duty it is to safeguard such relics of power.

Though it was once a common sight to see young azure whelplings near Lake Mennar in Azshara, they have since migrated to the colder climates of Winterspring in the wake of Azuregos's departure.

AZURE SPAN

A timelessness pervades the lowest reaches of the Azure Span, where ancient redwoods stand caressed by lowland fog and icy snowmelt follows ancient contours to reach the open sea. Above, an autumnal tundra quickly gives way to snowy peaks, yet despite the hostility of the mountain's bitter climates, a surprising diversity of life manages to flourish throughout its changing elevations. Ancient groups of tuskarr, gnolls, and furbolgs all seek to carve out their own existence within a realm forged long ago by Malygos and his prime consort, Sindragosa.

Journey deeper into the frozen heart of the blue's ancestral territory, and you will come upon a frozen tower known as Vakthros. Though seemingly benign at first glance, the structure hides defensive capabilities that have kept the Dragon Isles safe since the time of the War of the Scaleborn. Any who require proof of its devastating ability need only look upon the immense spikes of ice surrounding the tower's base.

Ancient draconic rivalries are not the only dangers faced by the returning dragonflights: Enemies old and new seek their own agendas. Most worrying is the Brackenhide shaman whose forbidden use of decay magic poses a threat to the entire island.

Standing in counterbalance to the land's chaos is the ordered wisdom of the Azure Archives, a glorious arcane library designed by Sindragosa. Overseen to this day by the prime consort's simulacrum, it is here that the blue's well-founded suspicions awaited Malygos, for fear she would not return from the War of the Ancients. To hear such prophetic concerns voiced thousands of years too late makes the truth of Neltharion's betrayal all the more tragic.

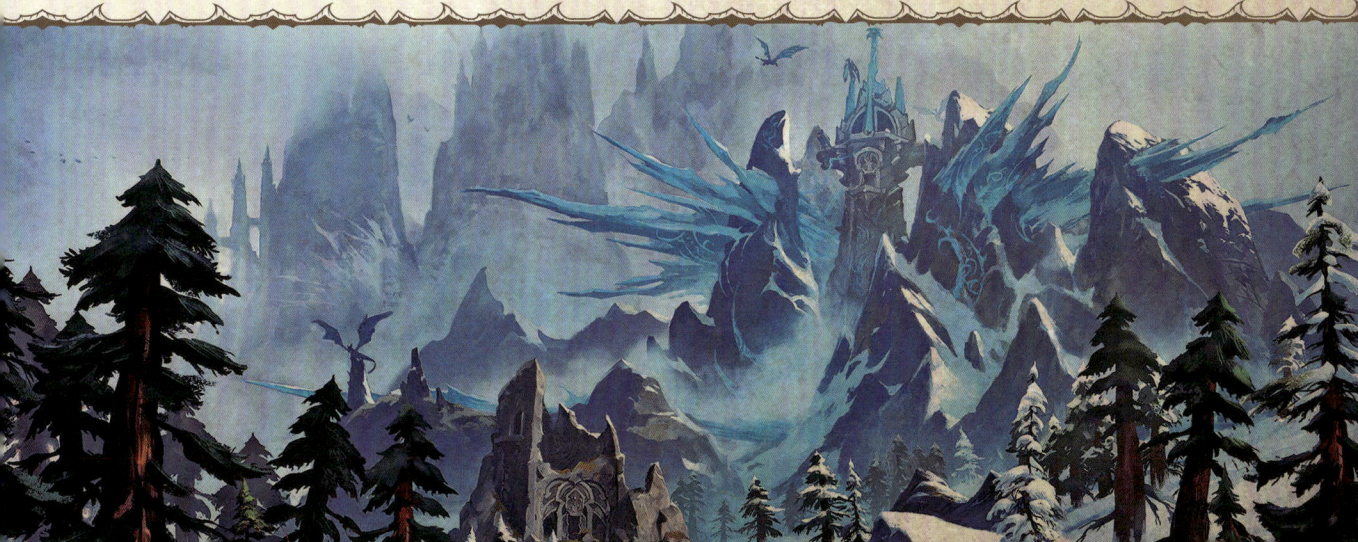

GREEN DRAGONFLIGHT

Though elemental life existed on Azeroth long before the coming of the titans, it was not until Keeper Freya created the verdant sites of Sholazar Basin, Un'Goro Crater, and the Vale of Eternal Blossoms that nature as we know it began to flourish. Believed to have formed where the Well of Eternity's power coalesced, these cradles of life gave rise to a wide diversity of flora and fauna first envisioned within the Emerald Dream.

The Dream exists as an ever-shifting plane of spiritual energy intrinsically tied to the world's unaltered past. It is a vision of Azeroth in a natural state, unaltered by the mortal races and where time as we know it holds no dominion.

As caretakers of the Dream, the green dragonflight seldom exist within Azeroth's waking realm, except in times of dire need. Instead, they've come to rely on the druids who were granted unhindered access to the Dream.

In her role as the guardian of nature, Ysera reportedly forged deep relationships with the primordial creatures who emerged from the early, unchecked abundance of Freya's enclaves, known

as Wild Gods. These mighty denizens who once wandered the vast forestlands of Azeroth at the keeper's side were instrumental during the Cataclysm when they answered the green Apsect's call and helped push back the elemental forces of the Firelord Ragnaros.

Yet despite the green dragonflight's staunch safeguarding of the Emerald Dream, a sinister rot slowly began to creep into the sanctity of their realm. In an attempt to stop the spread of a Void-tainted mineral known as saronite, Archdruid Fandral Staghelm planted several branches of the World Tree throughout Azeroth. While the trees thrived, the roots of the World Tree Andrassil eventually reached so deep that they made contact with the ancient prison of an Old God. Fearing its corruption, the druids destroyed Andrassil, but their intervention came too late. The taint of the Old God Yogg Saron had already found its way into the Dream, where the rot unleashed the Nightmare upon the unsuspecting Dreamers and slowly began to corrupt the Dream.

YSERA

Aspect of the Green Dragonflight · The Dreamer · Aspect of Nature
The Awakened · The Emerald Queen

Ysera is known as the Dreamer for the perpetual trancelike state the Aspect exhibited. It is said that only a few beings in history had ever seen Ysera's eyes open, with such occurrences always heralding dire events. From within the Emerald Dream, Ysera could concurrently observe the workings of both the ever-shifting spirit realm and the physical world of Azeroth.

Charged by Keeper Freya with maintaining the balance of nature and its connection to the Dream, the green dragonflight has a sacred duty to ensure that the cycle of life continues unhindered on Azeroth. To aid in this monumental task, the Aspect of Nature forged an alliance with the elven druids after witnessing their valiant efforts during the War of the Ancients. Through Ysera's blessing, the druids gained direct access to the Dream without the need for intense meditation. Likewise, it is presumed that Ysera's deep connection to the moon goddess was forged through her relationship with the elves, who worshiped Elune as a deity of life.

Though Ysera was rarely known to leave the Dream, she never failed to answer her red sister's call to defend their world against threats from the Legion, from the Void, or from within their own dragonflights. During the Winterskorn War, as Keeper Loken's titan-forged army of warrior vrykul wreaked havoc upon the north, legend has it that Ysera joined her fellow Aspects in halting their conquest by sending the fierce fighters into a deep and dreamless slumber that contained them for many thousands of years.

Ysera also aided in Alexstrasza's escape during the Battle of Grim Batol and stood united with the other Aspects against Deathwing. Yet after the destruction of the Demon Soul and the return of her long-withheld power, Ysera suddenly felt the sinister and brooding darkness slithering deep within the Dream. It was a corruption that would come to be known as the Emerald Nightmare; once exposed, it wasted no time in claiming its first victims.

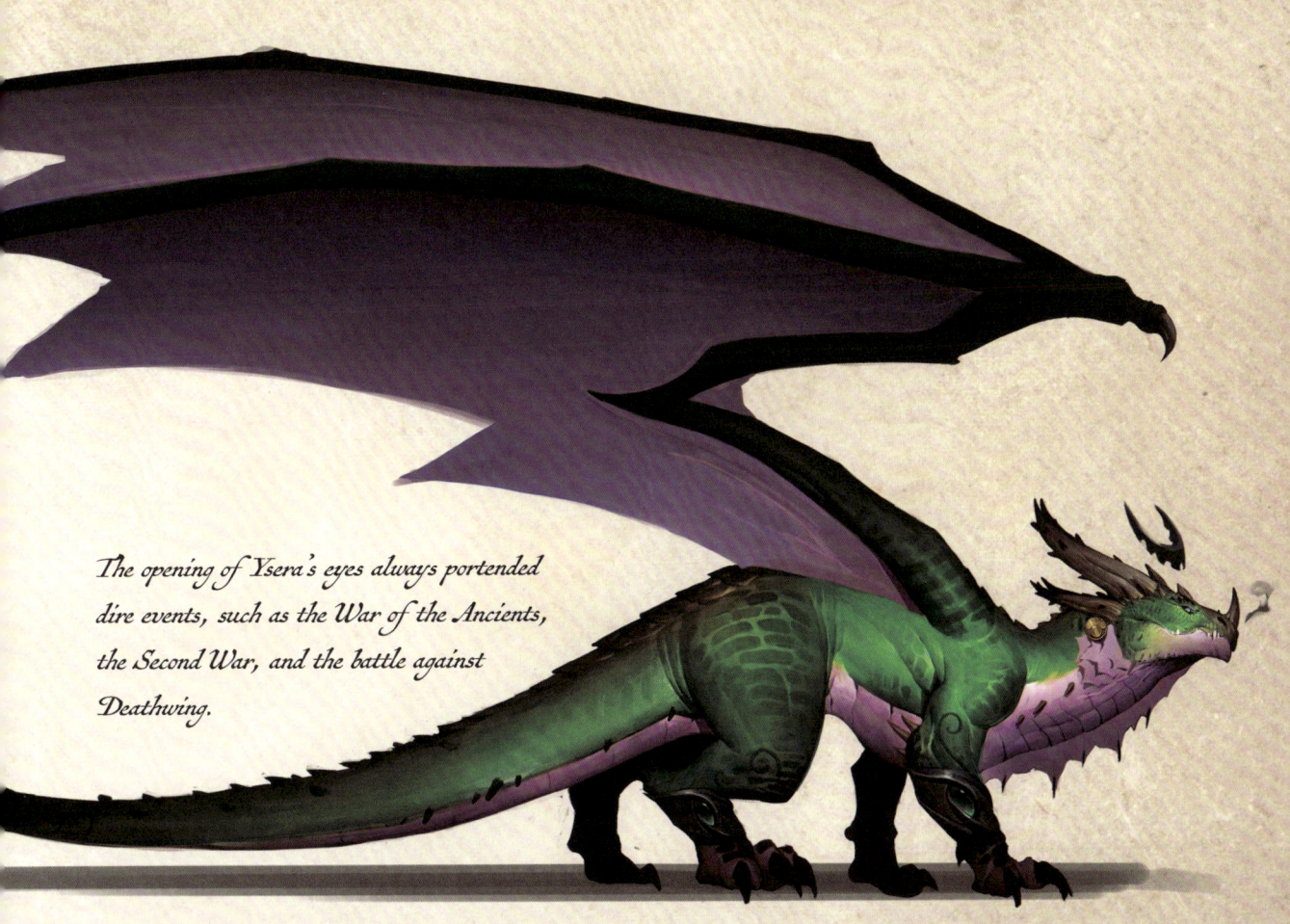

The opening of Ysera's eyes always portended dire events, such as the War of the Ancients, the Second War, and the battle against Deathwing.

Reports soon came in from Kalimdor and the Eastern Kingdoms of twisted green dragons seen emerging from the dream portals located at each of the remaining World Trees planted by Fandral Staghelm. Most shocking, however, was that all four were ancient and trusted lieutenants of Ysera. They became known as the Dragons of Nightmare, terrorizing the local populations. It was decided that the only way to redeem the corrupted was to kill them and hope that their cleansed spirits would return to the Dream. In time, others fell, turning not just dragons into maddened servants of the Void, but any creature with a connection to the Dream itself.

Though the green Aspect managed to resist the Nightmare for many years, she, too, eventually succumbed due to the treachery of the satyr known as the Nightmare Lord Xavius. In recognizing that Ysera's freedom could come only through death, the heartrending task of killing the majestic Aspect fell to one of her closest allies, Tyrande Whisperwind. After Ysera was felled at the Temple of Elune in Val'sharah, the high priestess says that Ysera's spirit was cleansed by the moon goddess and crossed over into the Shadowlands realm of Ardenweald. There, the Aspect of Nature offered her support to the champions of Azeroth until Archdruid Malfurion took Ysera's place within the Winter Queen's domain so that she could return to Azeroth.

ERANIKUS

Prime Consort of Ysera · Guardian of the Dream · Tyrant of the Dream · The Redeemed

Legend says that as terror and famine spread throughout the declining troll empire, the ancient Gurubashi turned in desperation to a fiendish loa known as Hakkar who promised them salvation, but at a dire cost. To secure the Soul Flayer's favor and save their people, the trolls were required to offer up the very blood of their tribe. Though initially satisfied with sacrifices made of the Gurubashi's captives and enemies, Hakkar soon demanded increasingly more tribute until they had no choice but to banish the loa and his fanatical supporters, the Atal'ai.

Exiled from their homeland in the jungles of Stranglethorn Vale, the Atal'ai priests moved northward to take refuge within the Swamp of Sorrows, where they resumed their efforts to manifest Hakkar into the physical realm. Aware of the immense power commanded by the loa, whose strength is said to be akin to the Wild Gods, Ysera feared the actions of the fanatical trolls and shattered the temple they had raised. Though most of the structure sunk beneath the murky waters, enough of its inner sanctum survived to allow the Atal'ai to resume their rituals in secret.

For a thorough study of the Gurubashi, their loa, and their blood rituals, read Legends of the Gurubashi, *Volumes I, II*, and IV. *Please note that the recipes contained in Volume II are for research purposes only.*

Suspecting that the fanatical trolls would not be deterred so easily, Ysera sent members of her flight to watch over the site. As prime consort and shard guardian for the Scepter of the Shifting Sands, Eranikus was considered the strongest dragon of the green flight after only the Aspect herself; he was entrusted with this essential mission along with his friend Itharius and the four young drakes: Dreamscythe, Weaver, Hazzas, and Morphaz.

Despite Eranikus's immense power and enduring will, he and his allies stood no chance of resisting the seeping corruption that was slowly infusing every corner of the Dream. Though they were initially successful in their mission to keep the Atal'ai in check, the Emerald Nightmare soon began to eat at their minds, allowing for the green dragons' eventual capture by their troll enemies.

The truth of the group's regrettable fate was uncovered years later as the need to reassemble the Scepter of the Shifting Sands led Archdruid Malfurion Stormrage and High Priestess Tyrande Whisperwind to seek Eranikus, whom they found trapped within the Nightmare. Though they managed to rescue him from the corruption's absolute control, Eranikus continued to hear the Nightmare calling out to him and knew that Ysera had become similarly trapped within the Dream. While seeking to free the green Aspect, Eranikus and his elven allies came under attack by several corrupted members of their flight. It was during this battle that Eranikus valiantly sacrificed himself to ensure Ysera's escape.

To this day, the shade created by Eranikus remains within the sunken Temple of Atal'Hakkar and is best avoided by those unprepared to face the might of a green dragon.

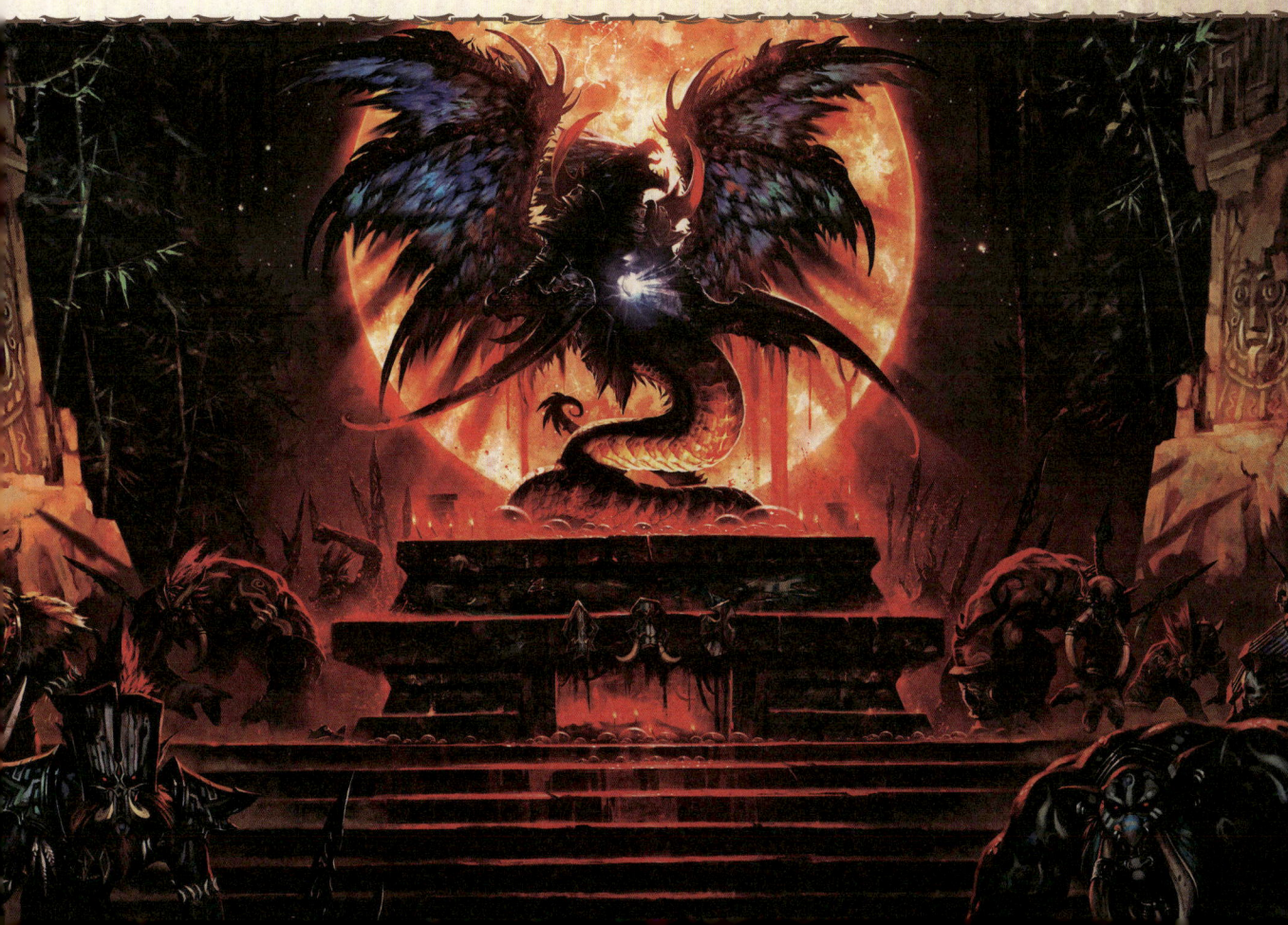

MERITHRA

Leader of the Green Dragonflight • The Dreamer • Of the Dream

Within most mortal societies, the passage of leadership is determined either through birthright or by vicious displays of strength that, as often as not, lead to devastating wars. Such upheaval among the draconic could be catastrophic for our world, so I am told that a new Aspect is selected by vote of the entire flight during a sacred ceremony known as the Embrace. Following the defeat of Deathwing and the loss of the Aspects' power, however, the transfer of leadership has become a less stately affair, as seen most recently with Ysera's daughter, Merithra. An ancient green with a long history of heroic action, Merithra has risen as the clear leader of her beleaguered flight, despite her unfounded concerns over being unworthy of her beloved mother's legacy (a trait, I've come to realize, that seems to be shared by all great leaders).

While examples of her heroic actions are many, the defining example of Merithra's valor was her decision to sacrifice herself to end the War of the Shifting Sands by giving Anachronos and his druid allies a chance to erect the Scarab Wall around Ahn'Qiraj. Together with the red dragon Caelestrasz and Arygos of the blue flight, Merithra spent a thousand years trapped within the aqir-infested walls as a captive of the Old God C'Thun. Though none would have begrudged her decision to flee the vile city upon her release, Merithra instead turned her suffering into action by crafting weapons for the forces who brought down the wall and ended the threat of C'Thun.

Years later, Merithra proved instrumental in empowering the Heart of Azeroth, a conduit capable of drawing upon the powers of the Forge of Origination and the Engine of Nalak'sha, to defeat the Old God N'Zoth. In her mother's absence, the Emerald Dream had come under attack by the Nightmare once again. Together, with a group of unnamed heroes, Merithra fought back the corruption and recaptured lost portions of the green dragonflight's power.

In gathering those portions of power from the Dream and forging them into a dragon scale, Merithra was able to join the remaining Aspects at the Chamber of Heart and infuse the artifact with their combined essence. Ultimately, it was this power that allowed the champions of Azeroth to enter the Old God's manifestation of Ny'alotha and end the malevolent ambitions of the Black Empire, thus saving our world.

Known as Daughter of the Dream among the Ohn'ahran centaur clans, Merithra renewed the ancient pact between the plains and the grove at the Oathstone.

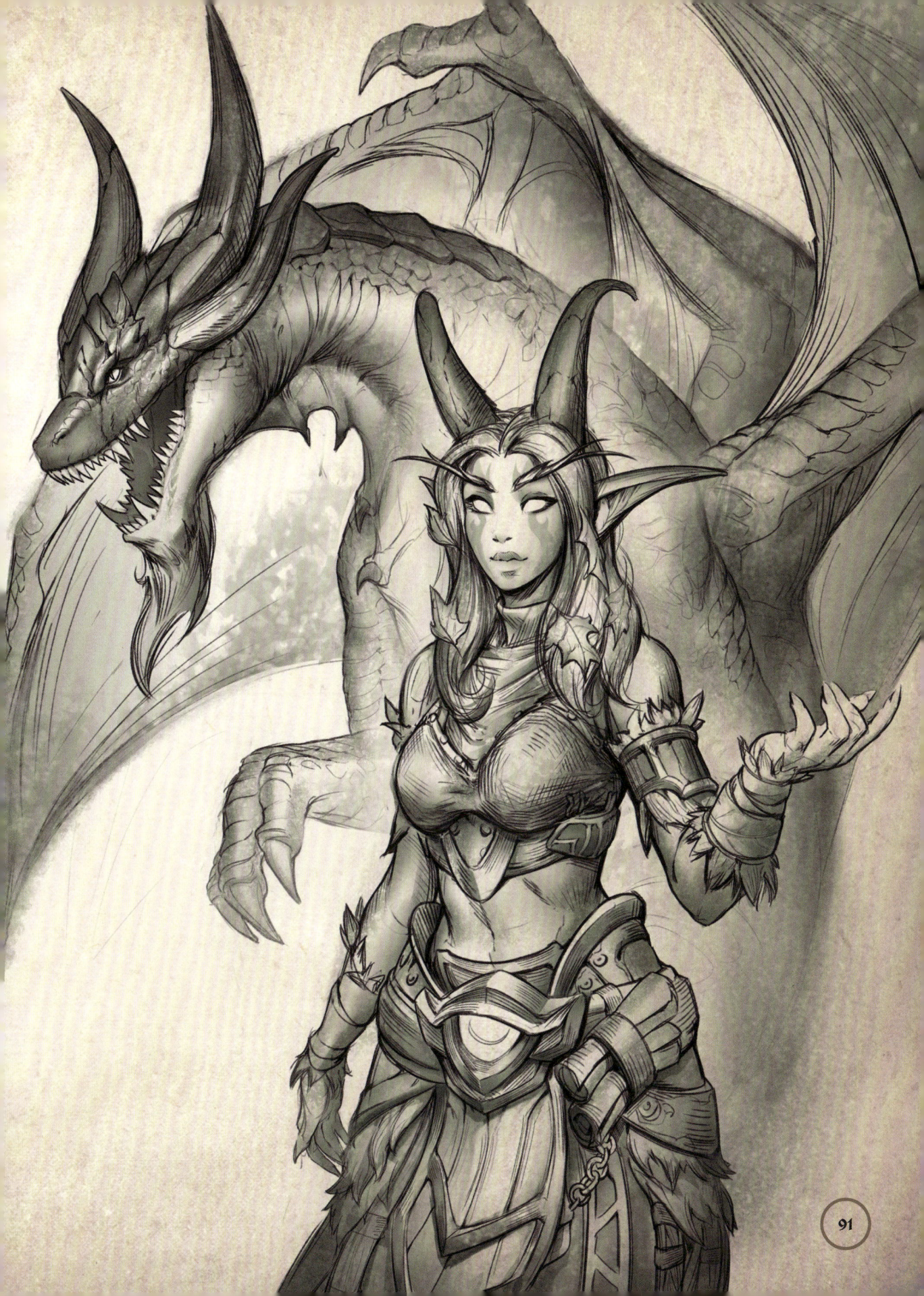

YSONDRE

Guardian of the Dream · The Corrupted · Of the Nightmare

Once considered Ysera's most trusted lieutenant, Ysondre fell like so many others of her flight to the malevolence of the Emerald Nightmare. As one of the first dragons to succumb to the unseen corruption, Ysondre emerged from the World Tree portal of Seradane to terrorize the local population of the Hinterlands.

Those who dared face her terrible might gave account of her once beneficial healing energies being twisted to summon the spirits of mad druids seemingly trapped within the Dream. They also spoke of an especially lethal form of lightning that proved the bane of many skilled fighters. Tragically, many believe that Ysondre struggled against the Nightmare's hold even as she unleashed her vengeance upon the mortal races. Rather than roar the same declarations of death and terror as her counterparts, her battle cry warned: "The strands of *life* have been severed!"

This theory might hold some merit, as Ysondre eventually managed to free herself of the Nightmare, but at the cost of her connection to the Emerald Dream. After seeing to the death of her corrupted ally Taerar, Ysondre assumed her visage and sought a simple life among the elven races, only to be drawn back into the fight against the Nightmare. In seeking to stop the seeping corruption of the World Tree Shaladrassil in Val'sharah, Ysondre was captured by the satyr Xavius and forced to join the other Dragons of Nightmare in a fight against the heroes of Azeroth. Though she was slain during that encounter, I am told that her cleansed spirit has since returned to the Dream.

EMERISS

Guardian of the Dream · The Corrupted · Of the Nightmare

Of the four Dragons of Nightmare, it is said that Emeriss may have suffered the most from the corruption of the Emerald Dream. Upon her sudden appearance within the Bough of Shadow in Ashenvale, eyewitnesses reported that her once shimmering emerald hide had rotted away, turning the benevolent and majestic green into a diseased abomination.

Though the dragon's putrid appearance was enough to drive many hardened fighters from the field of battle, her decaying attacks stood unrivaled until the horrors of Naxxramas and Icecrown Citadel. According to veterans of the battle, those felled by the rot of her infection or the fury of her claws were viciously turned against their allies by becoming hosts for volatile, poisonous mushrooms. Unlike Ysondre, whom many believe actively fought the corruption, Emeriss displayed the true depth of her madness with the spiteful taunt of "Disease."

As an agent of the Nightmare, Emeriss sought for years to corrupt others of her flight, including

Ysondre's tragic fall to the Nightmare was not a weakness of loyalty, but rather the dire consequences of an archdruid's hubris.

the prime consort Eranikus after he was redeemed by Tyrande Whisperwind. During a later encounter, the High Priestess of Elune made a similar attempt to cleanse Emeriss, only to find the dragon too far gone to her corruption. Relief did not come in death, however, for Emeriss's tainted essence was still tied to the Nightmare and its master, the Nightmare Lord Xavius, who forced her to fight a group of champions seeking to cleanse Val'sharah during the Burning Legion's invasion of Azeroth. Upon Xavius's defeat, Emeriss's cleansed soul was able to return to the restored sanctity of the Emerald Dream.

Emeriss's plagued manifestation shared many similarities to the later corruption of Nythendra, Guardian of the World Tree Shaladrassil.

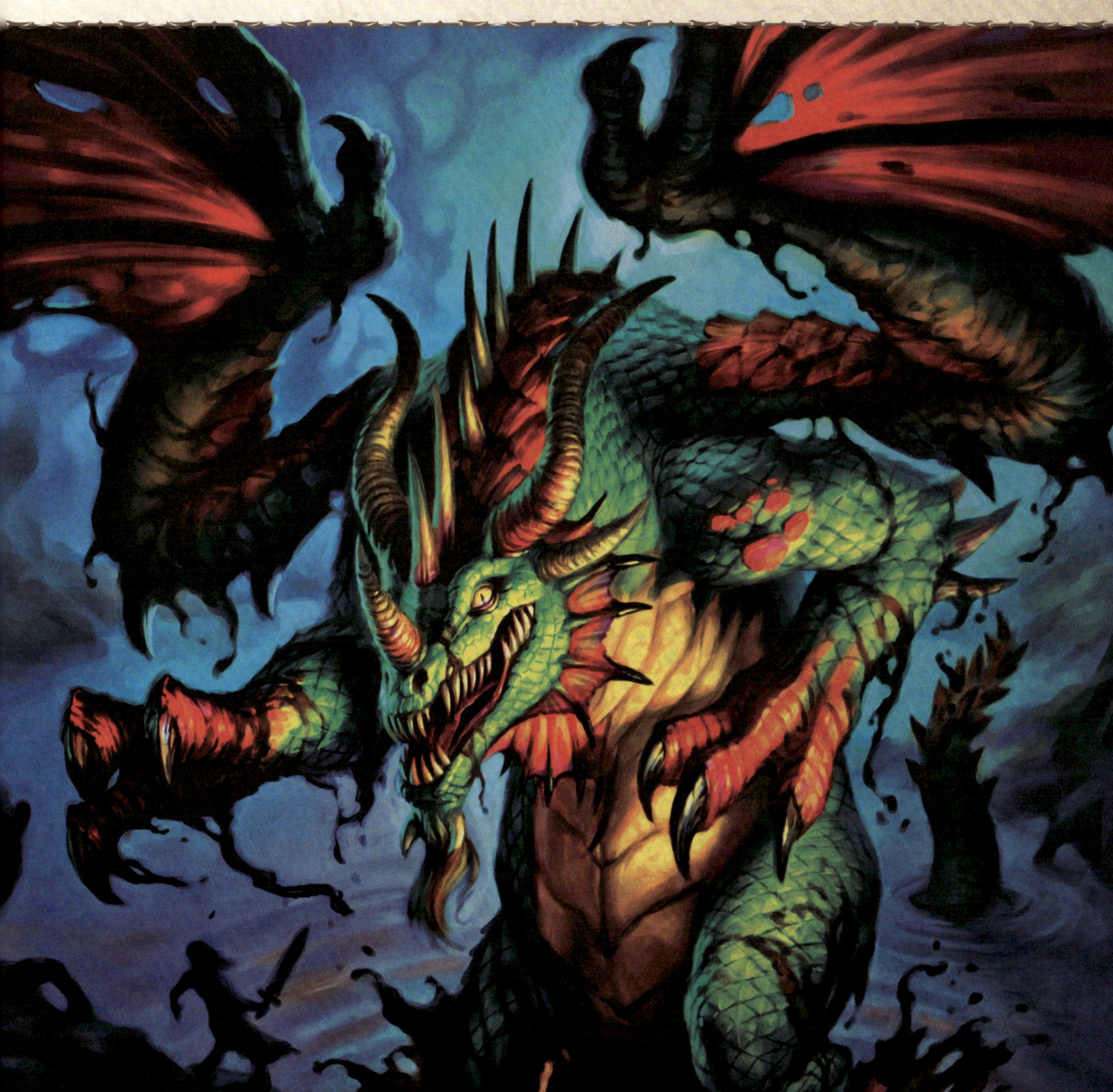

TAERAR

Guardian of the Dream • The Corrupted • Of the Nightmare

Taerar was tainted by the same malevolent rot as the other Dragons of Nightmare. However, the manifestation of his corruption was distinct among his brethren. The dark forces at work within the Emerald Dream shattered not only his sanity, but also his corporeal form. No longer restrained to a single physical appearance, Taerar had become capable of splitting himself into multiple copies, each with a volatile new form of magic that he viciously unleashed upon his enemies.

After emerging from the Dream Bough in Feralas, Taerar quickly earned a reputation for his uniquely cunning tactics. Those who faced

Those who failed to follow their commander's strict orders found themselves easy prey to the corrupted green dragon's shades.

him often spoke of his proclivity to prey upon healers unwary to the presence of his numerous shades. Taerar's war upon the mortal races was eventually halted, but his forced service to the Nightmare continued for many years.

The task of ending Taerar's life fell to Ysondre after she managed to break free of the Nightmare's hold. Upon learning of her former ally's continued attempts to spread the Nightmare's rot, Ysondre journeyed to Feralas to stop him. Though she feared that she could once again fall to the same corruption, the ancient green and her mortal allies succeeded in closing the Dream Bough portal.

Taerar suffered the same fate as his fellow Dragons of Nightmare after being summoned by the Nightmare Lord Xavius to prevent the cleansing of the Emerald Dream. Upon the satyr's defeat, Taerar's essence was freed of the Nightmare's grasp and now resides within the Emerald Dream.

LETHON
Guardian of the Dream · The Corrupted · Of the Nightmare

Though Emeriss exhibited the worst physical manifestations of the four Dragons of Nightmare, many speculate that Lethon's corruption ran far deeper due to his ability to wield the Void. He emerged from the Dream portal in the Twilight Grove of Duskwood, loudly proclaiming his mastery of such forbidden energy, and few were prepared for the raw power they faced. Bands of glory-hungry fighters made the journey from Stormwind, only to charge recklessly into battle and be cut down in a lethal volley of shadow bolts. Even veterans of the Second War who faced the unbridled fury of the Dragonmaw orcs' captive red dragons found themselves fleeing from such an unthinkable merger of green dragon and shadow energies.

Heroes of both the Horde and the Alliance speak of the same impossible talent that allowed Lethon to summon malevolent shades capable of healing each rendering slash and scorching blast leveled against him. Though opinions and accounts differ based on the experience of the group's commander, the unusually high number of casualties incurred to bring down Lethon gave him the dubious reputation of being the most powerful of Ysera's former lieutenants.

Lethon's campaign of death was finally ended by the redeemed green dragon Eranikus, who gave his life in defense of his mate and Aspect, Ysera. Seeing no way to defeat the Void-infused dragon in equal combat, Eranikus drew Lethon into the unstable boundary between the waking world and the Dream, where their physical forms were torn apart.

As with the other Dragons of Nightmare, Lethon's tainted essence was summoned to prevent the heroes of Azeroth from ending the corruption at Shaladrassil. The champions' brave victory over the Nightmare freed Lethon from his corruption and allowed him to return to the splendor of the Dream.

As Lethon's taunts reverberated through the cursed woods of Darkshire, bands of fighters rushed from nearby Stormwind to face him. Sadly, few possessed the skill to match such unfounded bravery.

TEMPLE OF ATAL'HAKKAR

Hidden among the brackish remnants of the Black Morass, shattered ruins of a once grand temple pierce the murky depths of the swamp. These mossy, carved steps speak of a once mighty troll empire, yet the temple's existence so far from the heart of the Gurubashi tells of its builders' exile. Though its foundation lies shattered from the might of an Aspect, the temple's interior writhes with the Atal'ai priests whose rituals seek to draw the Soulflayer into our world.

But be warned: Those who trespass the altars of Hakkar risk more than mere death. Madness stalks the shadowed halls, threatening to entrap the souls of unbelievers while their vessels are given as sacrifice to the Loa of Blood. Whether dragon, dwarf, or orc, the essence of the fallen fuel the winged serpent's return, heralding the end of all life on Azeroth.

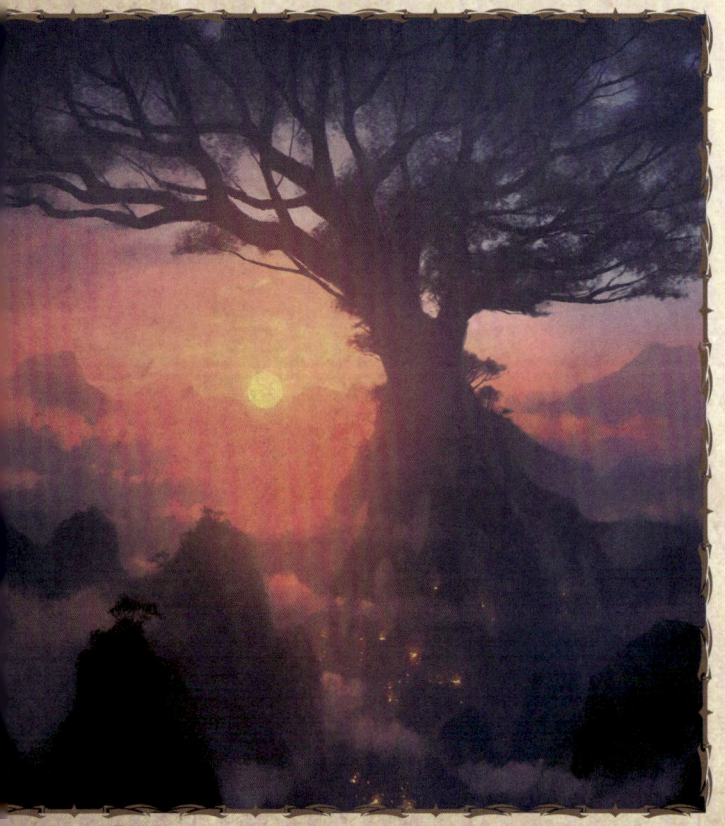

MOUNT HYJAL

Towering high above the northern expanse of Kalimdor, the blessed peak of Mount Hyjal serves as a sacred site to elves, dragons, and all denizens of the forest. As the most cherished grove of Keeper Freya, it is here where she bound her beloved Wild Gods and appointed the Aspect Ysera and her green dragonflight as its eternal guardians.

Yet beneath the protecting roots of the World Tree Nordrassil hides a secret, a source of such immense power that it once drew the might of a Dark Titan and led to the sundering of a vast continent. Recklessly created by the night elf sorcerer Illidan Stormrage from the remnants of the first Well of Eternity, this font of unfathomable energy forever serves as a weakness to the defenses of Azeroth. For such a crime, the Betrayer languished within the mountain's Barrow Deeps prison for ten thousand years.

EMERALD DREAM

Known by many names and traversed by many beings, the Emerald Dream acts as the sacred domain of the green dragonflight, the Wild Gods, and the druids of Azeroth. A spiritual plane of ever-shifting energies, the Dream offers glimpses of an Azeroth untouched by the titans and a verdant vision of what it could yet become.

Walkers of the Dream entrust the care of their physical forms to barrow watchers for years, centuries, and even millennia at a time. And though it is a realm of seemingly endless Life, it is also restrained by the necessity of balance. As spring and summer must give way to fall and winter, so does the Dream connect to Ardenweald in an endless cycle of life, death, and rebirth.

OHN'AHRAN PLAINS

As the winds ripple through a shifting grass sea, they whisper a name: Ohn'ahra. It is a song that carries the ancient tales of the wild plainlands as they stretch ever onward. Here, earth meets sky along primordial vistas eroded over eons of persistent force, yet through the turn of countless seasons, they remain.

Under a high noon sun, rivers and streams of crystalline water weave throughout the land like veins of silver, nourishing everything from the sacred dragon groves of the Emerald Gardens to the boundless hunting grounds of the Maruuk centaur. All who dwell here under the guardianship and blessing of the Wild God Ohn'ahra stand united in their deep love and respect of the land.

BLACK DRAGONFLIGHT

Chosen to wield the power of Khaz'goroth by Keeper Archaedas, Neltharion's brood had an innate connection to the deep places of Azeroth that left them vulnerable to the many malicious creatures imprisoned within its depths. While none who survived the horrors of the Cataclysm or fought to prevent the Hour of Twilight can ever truly forgive the dragons who orchestrated such indiscriminate suffering, I believe it is essential that we study the lessons of their descent: If a once stalwart Aspect could falter, then none of us is truly safe from the treachery of the Void.

Though it is said that Neltharion's mind was twisted by the mad whisperings of the Old Gods, one above all others guided the Earth-Warder's transformation into Deathwing: N'Zoth, Lord of Ny'alotha. After suffering the burden of Azeroth's weight pressing in upon his body, Neltharion finally gave in to the imprisoned god's promise of relief and ultimately turned against his allies.

What the Old Gods didn't expect was that the Burning Legion would find and invade Azeroth in an event that threatened both their own destruction and that of the slumbering world-

Seas rose and mountains crumbled, reforging the face of Azeroth on a scale not seen since the Sundering of ancient Kalimdor.

soul they sought to corrupt. In fact, many learned scholars have argued that Deathwing's use of the Dragon Soul seemed to run counter to the Old Gods' survival; this same view is supported by witnesses who believe that the Aspect's madness may have been so complete that he turned the weapon on both demon and defender indiscriminately. Though we will never know the true motivations behind the black Aspect's attack, history records the outcome as such: Neltharion's dragonflight was made to suffer the consequences of his act as they were hunted to near extinction.

Despite the tragic results of their Aspect's betrayal, Deathwing's flight never wavered in their loyalty to his cause. Opting for infiltration over direct conflict, dragons like Onyxia and Nefarian cunningly integrated themselves into the kingdoms of man. By stoking hatreds old and new, the black dragonflight managed to sew distrust among the kingdoms. It was in this way that Stormwind fell to the orcs without the aid of Lordaeron, how Alterac became a haunted ruin, and how a once beloved king returned home a fractured and vengeful soul.

Yet for all their darkness, a new generation of black dragons seeks to overcome the shadows of their past.

NELTHARION

The Earth-Warder • Aspect of the Black Dragonflight • Deathwing
The Betrayer • The Black Scourge • Lord Daval Prestor • The Destroyer
The Cataclysm • Xaxas • Shuul'wah • Aspect of Death

The story of the black Aspect is one seemingly cleaved by the defining moment of his betrayal at the Well of Eternity. Yet in the years prior to that fated moment, Neltharion was remembered as a wise and staunch protector of the lands under his care. What no one saw was the depth of suffering that his service demanded, a burden he seemed to believe was his to bear alone.

While no one knows when Neltharion first heard the whispers of the Old Gods, it is now believed that he accepted their offer during his desperate battle with the Primal Incarnate Raszageth. No one, not even his fellow Aspects, suspected his secret until it was far too late.

Allies recall the Earth-Warder's presentation of the Dragon Soul as a hopeful moment that they believed could turn the tide of the war against the Legion. Only the blue consort, Sindragosa, seemed to suspect that anything was amiss with Neltharion. Yet she failed to voice her concerns, so the Aspects willingly imparted a portion of their power into the artifact. As the blast tore through the enemy ranks with terrifying force, all rejoiced as hordes of demons disintegrated in a brilliant flash. In that moment of hope, none of the defenders could have imagined that the object of their salvation could become the source of their own demise. But then it happened: a second discharge that caused elf and dragon alike to vanish in an instant. Unthinkable as the losses were, had it not been for the catastrophic damage done to Deathwing's body by the artifact, even more lives could have been lost that day.

Suffering the immense agony of wounds that would forever burn, Neltharion retreated to his lair in Highmountain. Here, his goblin artificers crafted adamantium plates that were then bolted on to stabilize his tortured form by the drogbar under his control. During this period of agonizing recovery, Archdruid Malfurion Stormrage used the Dream to steal the accursed weapon from Deathwing, only to lose it to his brother Illidan, who supported the Dark Titan Sargeras and his plans to bring the Legion to Azeroth. Though Deathwing nearly succeeded in recovering the Dragon Soul, he was ultimately forced to retreat to his lair, where a drogbar uprising awaited him, led by a tauren of the local tribes known as Huln Highmountain.

For all their immense power, the keepers could have learned a thing or two about responsible artifact storage! Fortunately, the Hammer of Khaz'goroth eventually wound up in the hands of Huln Highmountain.

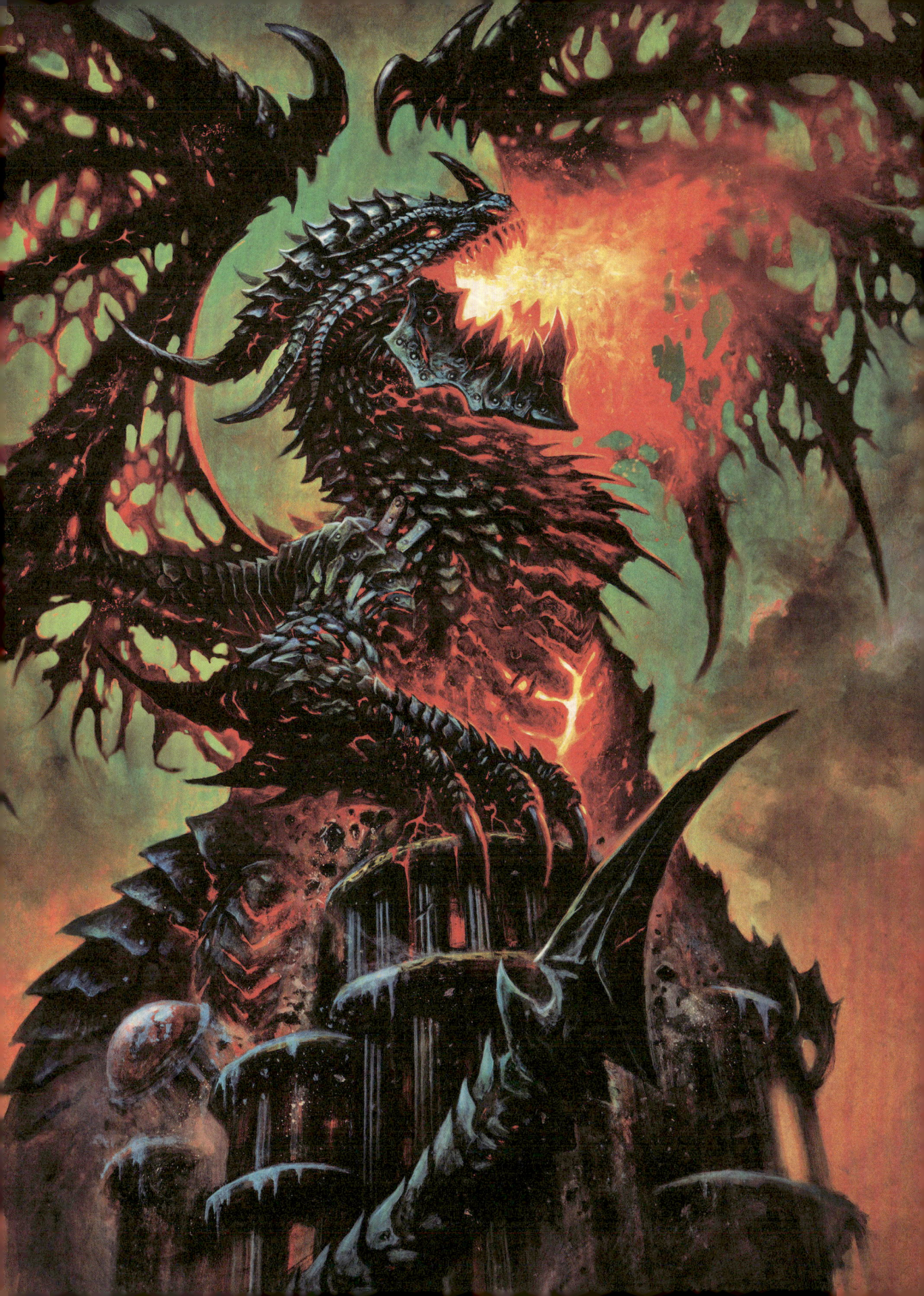

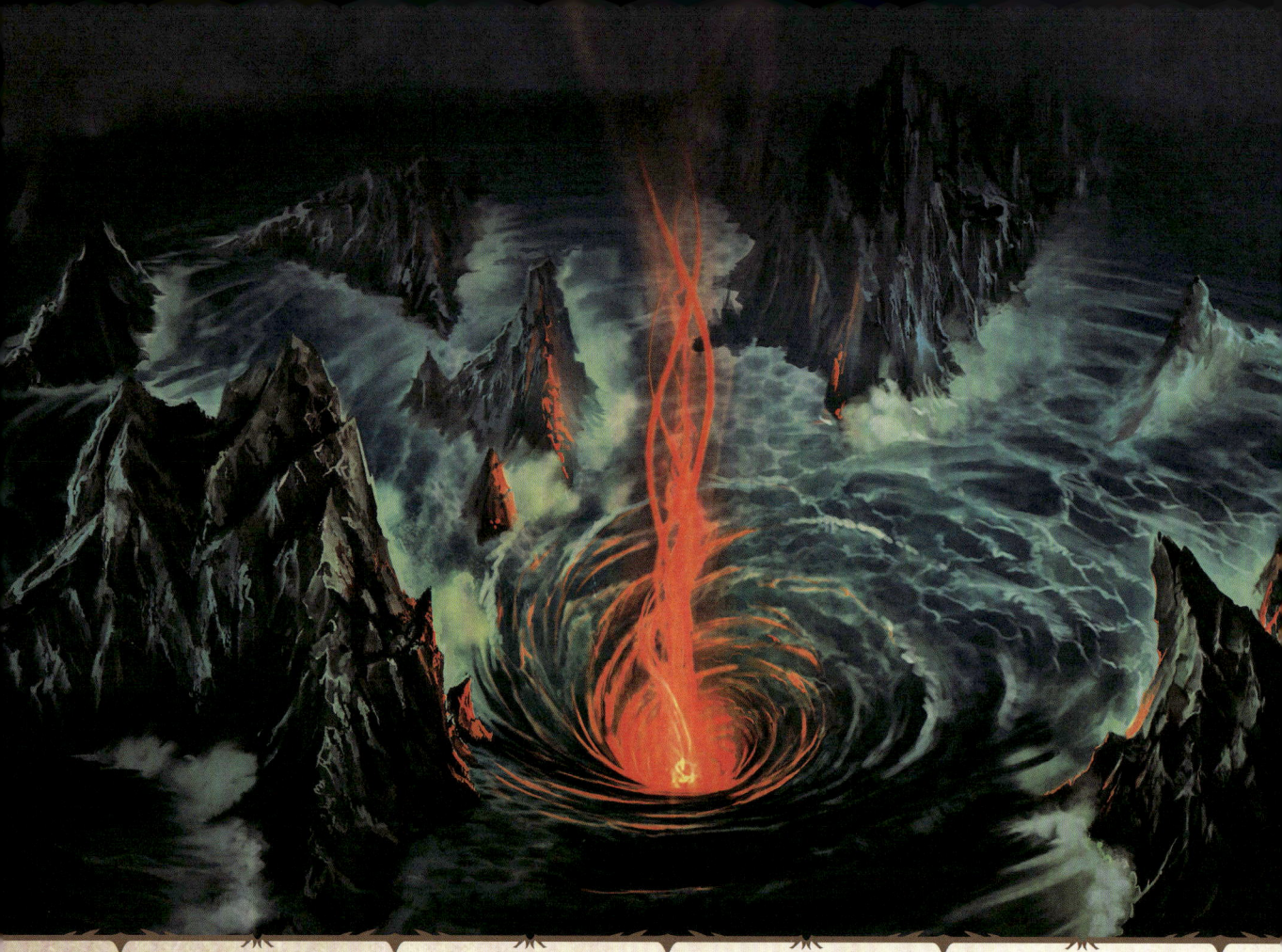

Banished from his ancient lair by Huln, who wielded the Hammer of Khaz'goroth, Neltharion escaped to the Elemental Plane of Deepholm, where he slumbered until the energy surge produced by the opening of the Dark Portal stirred his awakening. Though physically strengthened by his long rest, it is said that Deathwing's sanity had slipped further into a rage-filled loathing, especially for the red Aspect Alexstrasza. Still, he knew that the combined might of the Aspects would be his undoing, so Deathwing chose subtlety over direct conflict. In the visage of Lord Daval Prestor, he managed to sow seeds of chaos in Lordaeron while also guiding Zuluhed of the Dragonmaw clan to retrieve the Dragon Soul and use it to capture the Dragon Queen.

Beyond his machinations of chaos and revenge, the black Aspect also sought ways to restore his nearly extinct flight. After the destruction of Draenor and the seeming loss of his eggs, we know that Deathwing forged alliances with various factions of the Horde, including the Twilight's Hammer and the orcs of Blackrock Mountain. From within their various enclaves arose the twilight and chromatic dragonflights, created by his prime consort, Sinestra, and his son, Nefarian. At the same time, other preparations were underway to usher in the Hour of Twilight, an event heralding the end of all life on Azeroth. So even as Deathwing retreated from Grim Batol to the impenetrable depths of Deepholm to endure the agony of having new elementium plates attached to his unstable body, the black Aspect's efforts to restore the black dragonflight and serve the will of N'Zoth continued.

Then came the Cataclysm.

Erupting violently from the Elemental Plane to crack the World Pillar, Deathwing created a cascade of natural disasters that crumbled mountains and sent towering waves of death upon the land. Many thousands died in the initial onslaught, and the Aspect of Death continued his campaign of terror by indiscriminately burning towns and cities across Azeroth for months. It was in this time of prolonged fear and desperation that many turned to the prophecy and teachings of the Twilight's Hammer.

Yet in Azeroth's darkest moment, the heroes of the Horde and the Alliance joined forces with the Aspects and their dragonflights to honor the Wyrmrest Accord. Together they recovered the Dragon Soul from the pathways of time and infused it with both the power of the Aspects and the elemental forces wielded by the shaman Thrall. After they stood united against the combined might of Deathwing, the Twilight's Hammer, and the n'raqi of N'Zoth, the Dragon Soul was finally unleashed against the Destroyer.

Though he was imbued with an unimaginable surge of Void energy that further twisted his form into an unstable monstrosity, the legacy of the Earth-Warder was ended at the Maelstrom after Thrall channeled the last of the Aspects' power through the artifact.

SINESTRA

Prime Consort of Deathwing • Lady Sinestra • Sintharia • Mother of the Twilight Dragonflight

Due to his successful escape to Highmountain, and later to Deepholm, Deathwing largely avoided the consequences of his betrayal at the Well of Eternity. The same could not be said for the dragonflight he left behind: The dragons were viciously hunted to near extinction for the sins of their Aspect. It seemed for a time that the chosen dragonflight of Keeper Archaedas could well disappear from the skies of Azeroth forever. Yet in recognizing that the future of his brood depended on replenishing their lost numbers, Deathwing summoned his surviving consorts, whom he forced to endure the ever-burning flames of his corrupted body. Of all his mates, only Sinestra survived the brutality of their coupling, but she was left forever scarred. With no intention of dying like Deathwing's other mates, Sinestra set to work on creating a replacement brood: the twilight dragonflight.

After the death of her son, Nefarian, and his failure to stabilize the chromatic dragonflight, Sinestra traveled to Outland to investigate rumors of an ethereal species known as the nether dragons. Within the fel-tainted crags of Shadowmoon Valley, she forged an alliance with Overlord Mor'ghor of the Dragonmaw, who promised to secure nether eggs for her experiments on Azeroth. While there, Zendarin Windrunner handed over the nether dragon Zzeraku, who had been captured while roaming Azeroth.

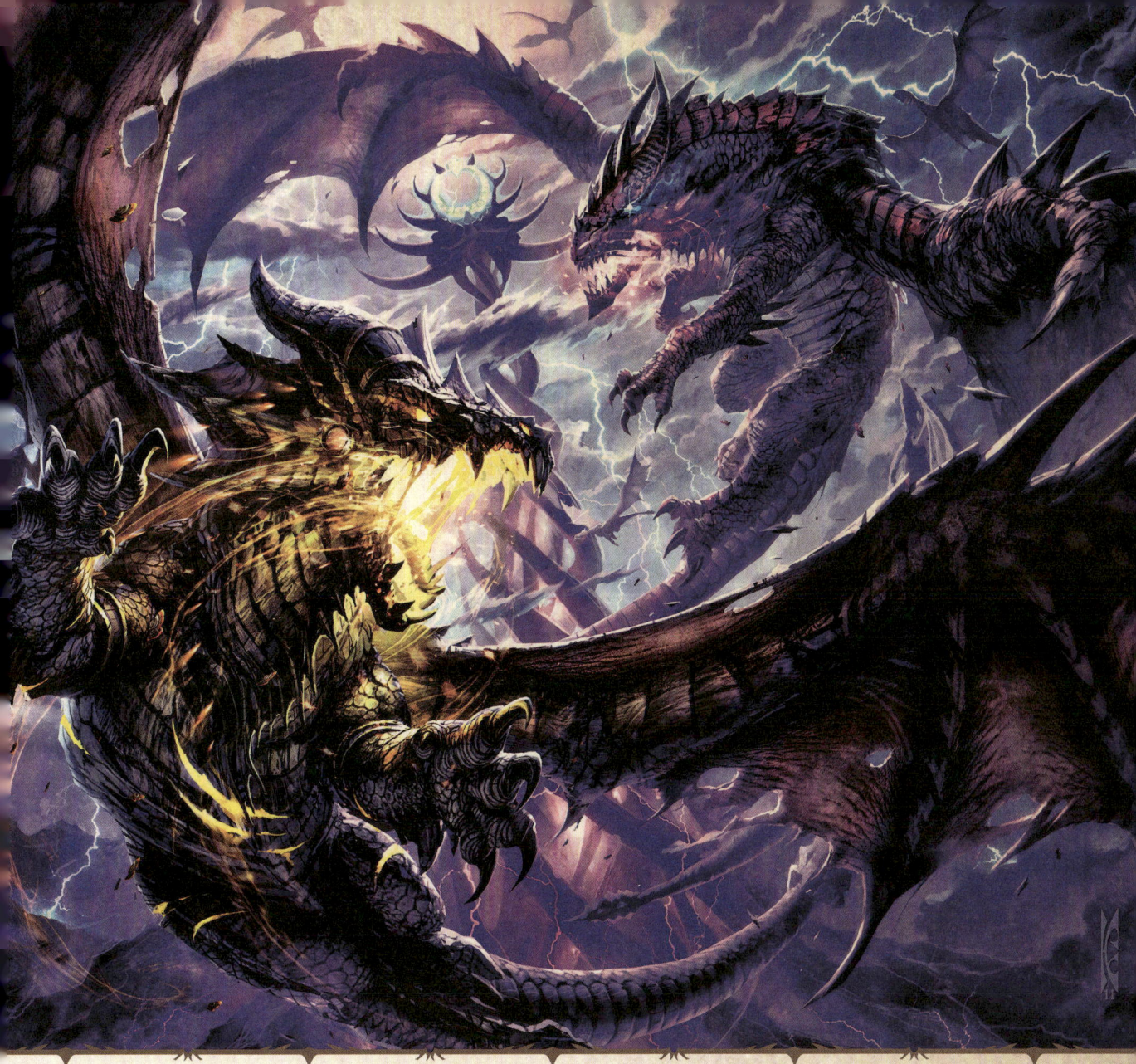

Using an artifact known as Balacgos's Bane, Sinestra managed to extract the essence of Zzeraku and used it to create a twilight dragon named Dargonax. Such success was short-lived, however; her efforts drew the attention of the red dragon Korialstrasz and the blue dragon Kalecgos. In their efforts to stop Sinestra and her twisted experiments, an explosion occurred that consumed both the black consort and Dargonax. Though it was believed that the entirety of her accursed brood was destroyed in the same blast that took Sinestra's life, Deathwing later discovered survivors within his consort's laboratory and continued to build upon her work.

Years later, the Twilight's Hammer raised Sinestra in undeath to see her work with the twilight dragonflight continued. Though Sinestra was reportedly destroyed by a brave group of fighters who breeched the Bastion of Twilight, her late offspring, Zeryxia, claimed that the consort continued to direct her until her own passing.

Bitter and hateful of Deathwing and the black dragonflight, Sinestra saught to build a successor dragonflight of her own.

NEFARIAN

Son of Deathwing • Lord Victor Nefarius • Lord of Blackrock • Father of the Chromatic Dragonflight

Much of what we know of Nefarian is suspect, since it largely comes from those who were taken in by his false identity as Lord Victor Nefarius of Blackrock. Working in concert with his father, Deathwing, and sister, Onyxia, Nefarian delighted in meddling in human affairs. His goal was to divide the Alliance of Lordaeron that formed after the opening of the Dark Portal.

After succeeding in that objective, Nefarian identified a new opportunity in the form of the Dark Horde, a group of orcs who claimed the upper reaches of Blackrock Mountain following the Second War. Stranded on Azeroth and desperate to forge a new life after the destruction of Draenor, the group led by Dal'rend Blackhand readily allied itself with Nefarian after having witnessed the unbridled power of the Dragonmaw's own red dragon captives.

In exchange for the black dragonflight's aid in battle, the orcs offered their protection and use of the mountain's upper spires for Nefarian's experiments. Yet to ensure the ongoing survival of both the orcs and his future brood of chromatic dragons, Nefarian would have to face the might of a Firelord.

In seeking to lay claim to the entire mountain, Nefarian declared war upon Ragnaros and the Dark Iron dwarves captured by the elemental lord since the War of the Three Hammers. It was an opportunity quickly seized upon by Moira Thaurissan, queen of the Dark Irons, who contrived to liberate her people by spreading rumors of great riches and powerful artifacts hidden within Ragnaros's stronghold of Molten Core. Her gambit to lure powerful fighters into the fray worked brilliantly and resulted in the denizen of flame's defeat and banishment back to the Elemental Plane of the Firelands. Believing that a similar ploy could work against her remaining foes, Moira next sent word to the orc Warchief Thrall. Infuriated by Dal'rend's pact with the black dragonflight, Thrall assembled the mightiest of his Horde warriors to claim the head of Deathwing's son.

Nefarian's story should have ended atop a bloody pike in Orgrimmar, yet his remains were later reanimated by the cultists of the Twilight's Hammer to continue his largely unsuccessful experiments with the chromatic dragonflight. The third and final attempt to raise Nefarian was thwarted by the black dragon Wrathion, who ensured the complete destruction of his kin's body before the battle of Ny'alotha.

Nefarian's greatest mistake was in underestimating the cunning and strength of mortals like Moira Thaurissan.

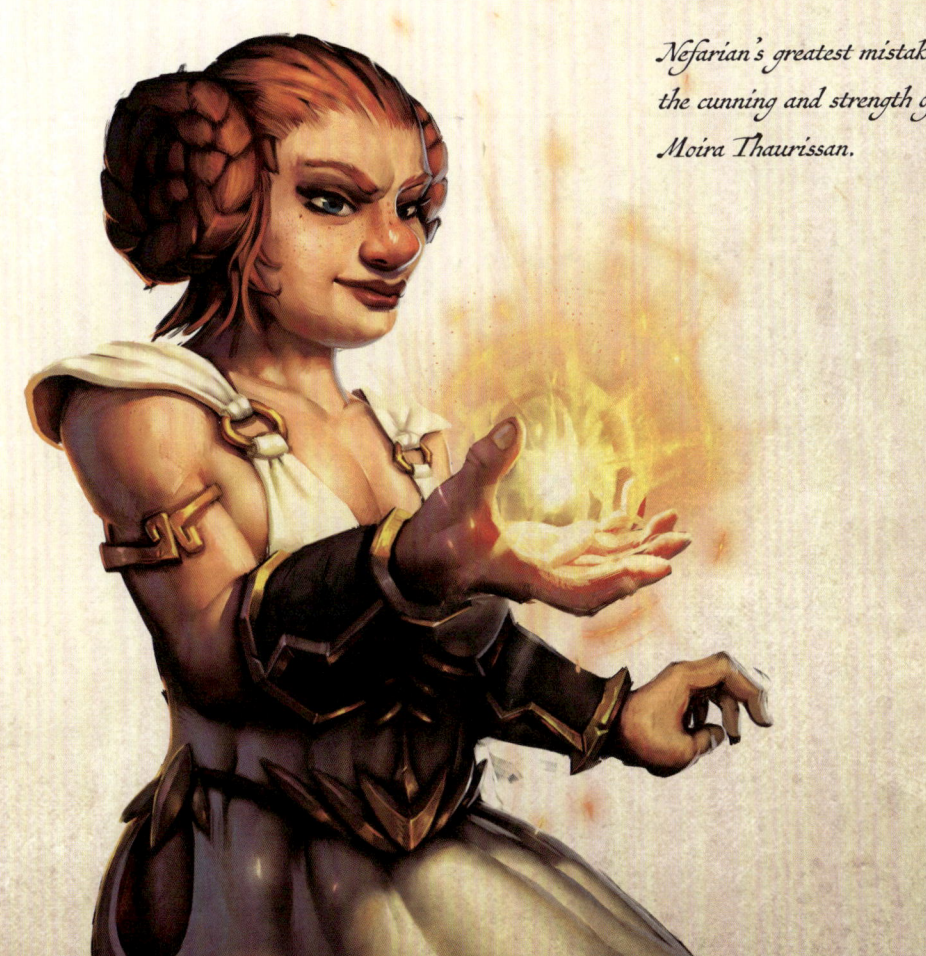

ONYXIA

Broodmother of the Black Dragonflight • Lady Katrana Prestor

While many of the black dragonflight's later plots occurred on a grand and catastrophic scale, Onyxia's more subtle contributions proved no less destructive. In her human visage as Lady Katrana Prestor, Onyxia furthered her family's scheme to spread rumor and unrest throughout the seven kingdoms that once made up the Alliance of Lordaeron. Between her dual efforts to stoke public anger over the exorbitant costs of the orc prison camps and also to misdirect the militia hunting remnants of the Horde following the Second War, she managed to fracture the unity of Kul Tiras, Gilneas, and Lordaeron. Then she moved south to infiltrate the recently liberated kingdom of Stormwind.

For one so cunning, it was not difficult to spot the prime opportunity to exploit tensions that surrounded the rebuilding of Stormwind City. With little effort, Onyxia fomented a riot between the Stonemasons' guild and the nobles of Stormwind, who were persuaded to withhold the artisans' wages over claims of faulty workmanship. Fierce fighting broke out in the streets and casualties quickly mounted. Among them was the queen of Stormwind, Tiffin Wrynn, who had sought to mediate tensions. Enraged by the death of his wife, Varian vowed death upon the Stonemasons, who had fled to nearby Westfall. In time, these outlaws became the Defias Brotherhood, a band of pirates, thieves, and assassins who wreaked havoc upon Stormwind's provinces for years. The Defias also later aided Onyxia in capturing Varian while the king was en route to Theramore.

The broodmother's plan was simple. By way of a dark ritual, she would sunder Varian's will, conscience, and sense of responsibility into a separate being—and kill it. The Varian who remained could be easily twisted to her will and act as her puppet. However, a band of naga unexpectedly disrupted her plans and allowed the sundered Varian to escape. While the meek Varian would be brought back to Stormwind to serve Onyxia's ends, the willful half would find himself lost without his memory in a foreign land. In time, the Varian known as Lo'Gosh recalled his identity and returned to Stormwind to challenge Onyxia, who he found ruling through his other half. Unwilling to surrender, Onyxia covered her escape by abducting Varian's son, Anduin, and fleeing across the sea to her lair in Dustwallow Marsh.

After mounting an expedition, the two halves of Varian faced the black dragon broodmother, whose errant miscast of magic made him whole again. Though the fearsome battle required the blades and magic of many brave fighters, the head of Onyxia was hung in triumph from the gates of Stormwind.

The true end of Onyxia mirrors that of her brother Nefarian. Both were reanimated for a brief time within the halls of Blackrock Mountain and defeated by champions of the Horde and the Alliance. To ensure that no further attempts were made to raise the siblings' rotting forms, Wrathion saw to the permanent destruction of their remains.

Many who accompanied the king of Stormwind in his hunt for Onyxia were slain not by the broodmother, but by the dozens of young whelplings defending her lair.

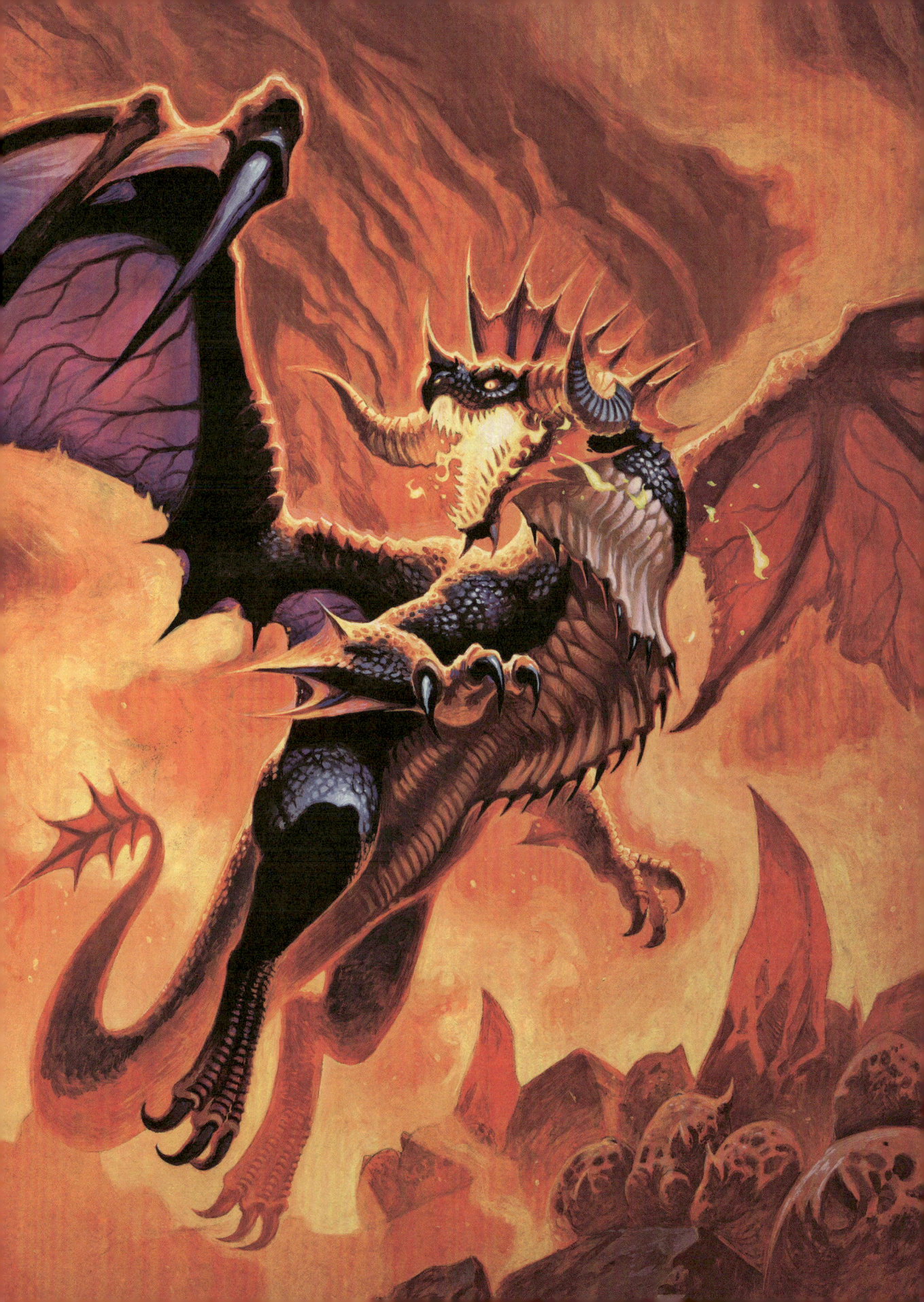

SABELLIAN

Baron Sablemane • Prime Lieutenant of Deathwing

Long considered a prime lieutenant of Deathwing, Sabellian is responsible for the continued black dragonflight presence found in Outland. After helping to forge an alliance with Ner'zhul and the remaining Horde left behind on Draenor, Sabellian oversaw his father's plan to hide black dragon eggs in what came to be known as the Blade's Edge Mountains. Believing that the clutch would be safe on the other side of the Dark Portal from the wrath of the dragonflights, neither Sabellian nor Deathwing expected to encounter a race of fearsome and territorial giants. Known as gronn, these towering warriors did not want any challengers in their domain.

As a result, many young drakes and dragons lost their lives fighting the gronn, who reveled in impaling the broken bodies of their draconic enemies upon mountainous spikes as a warning to other would-be invaders. Proving himself as an especially lethal foe until his own death, Gruul, leader of the gronn, eventually claimed the title of Dragonkiller, much to Sabellian's reported ire.

Despite the many deplorable methods used by Sinestra and Nefarian to rebuild their nearly extinct flight, Sabellian's steadfast stewardship of the eggs in his care ensured the continuation of the black dragon lineage and his flight's return to the Dragon Isles.

In his role as caretaker of the Outland brood, Sabellian ensured the survival of the black dragonflight.

WRATHION
The Black Prince

As the only black dragon known to fully resist his flight's corruption, Wrathion proved instrumental in defeating N'Zoth and currently seeks to rebuild the shattered black dragonflight after the fall of the Old Gods.

The Black Prince's remarkable journey begins in the arid wastes of the Badlands with the valiant efforts of the red dragon Rheastrasza. Believing that she had discovered a method to cleanse the black dragonflight of the Old Gods' tainted influence, Rheastrasza captured a black dragon named Nyxondra and forced her to produce an egg upon which to test her theory. Incredibly, Rheastrasza's experiment resulted in the purified egg that would hatch Wrathion, but the red's brazen act did not go unnoticed. Accepting that her discovery was too important to fall into Deathwing's claws, Rheastrasza sacrificed both her life and her own egg to misdirect the black Aspect.

According to the red dragonflight, Wrathion's egg was recovered and cared for within the Vermillion Redoubt by Corastrasza for much of its incubation; however, it was later stolen and brought to Ravenholdt Manor, where the Black Prince later hatched. Already possessed of a keen intellect and a wealth of worldly knowledge, Wrathion enlisted the aid of an unnamed rogue sent by the red dragonflight to help dispatch any black dragons found to be suffering the corruption of the Old Gods.

During his campaign to cleanse his tainted dragonflight, Wrathion claims to have experienced a dire vision of Azeroth's future that sent him to Pandaria; there, he enlisted champions who could avert the crisis. While exploring the many wonders of the formerly mist-shrouded nation, he also uncovered secrets to crafting powerful artifacts. Though many of his actions during this time seemed both cryptic and questionable, the results of Wrathion's efforts to aid in the defeat of both Lei Shen and Garrosh Hellscream dispel much of that earlier suspicion.

Still, it would not be long before the faith of the Horde and the Alliance (and yours truly!) was again tested after it was revealed that Wrathion had worked with the infinite dragonflight to allow for Garrosh Hellscream's escape into an alternate Draenor. Though he knew the optics of his actions risked turning the world against him, Wrathion believed his to be the only path that could prepare Azeroth to face the imminent threat of the Burning Legion. Whether he was right is a topic of endless debate, but some would say the fact that we are here to pose such questions does offer a mark in his favor.

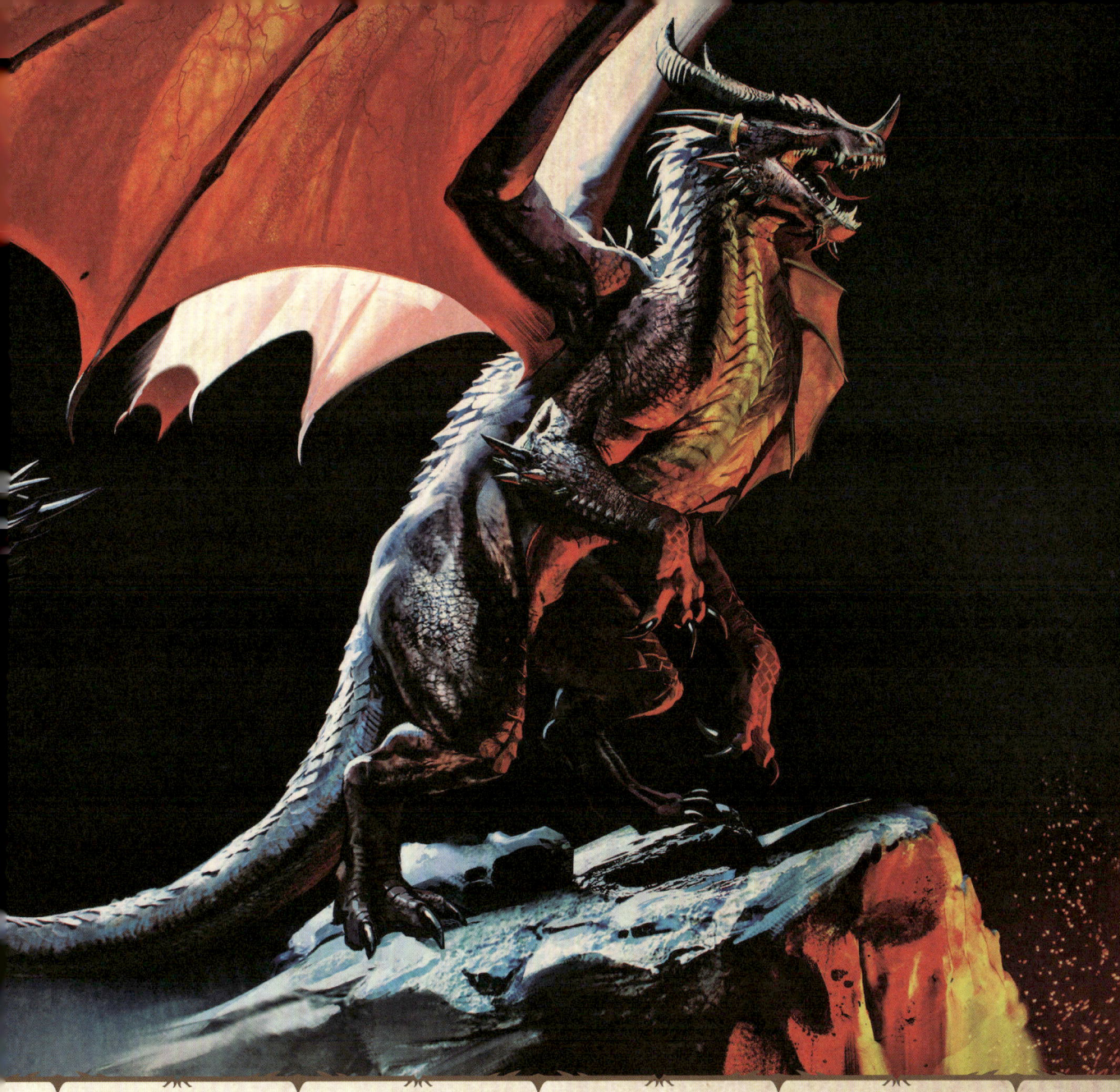

What seems beyond reproach is that the Black Prince's most recent contributions after Queen Azshara's defeat allowed for the escape of N'Zoth from his ancient prison. Had it not been for Wrathion's wise counsel on how to resist the visions of the Old God, breaching the Black Empire realm of Ny'alotha may have been impossible. By utilizing the corrupted black dragonscales left behind after the destruction of Onyxia and Nefarian's remains, Wrathion created a cloak that allowed his champion to face the might of N'Zoth without succumbing to the madness of the Void. It is also said that he risked himself to wield a powerful artifact known as the Blade of the Black Empire during the final battle, which weakened the Old God and opened a path to his core. Though suspicions still abound over the Black Prince's ultimate goals, it seems undeniable that Azeroth owes a considerable debt to Wrathion's many colorful solutions.

Despite Wrathion's many heroic accomplishments, some still have difficulty trusting one of Deathwing's brood so soon after the Cataclysm.

EBYSSIAN

Leader of the Black Dragonflight · Spiritwalker Ebonhorn

In a path similar to Wrathion's, Ebyssian is believed to have avoided falling to the corruption of his black dragon heritage, primarily due to the purification of his egg by the legendary tauren hero Huln Highmountain. Since that time, Ebyssian has chosen to show his eternal gratitude by watching over the descendants of Huln's Highmountain tribe under his visage of Spiritwalker Ebonhorn.

Though the ancient black dragon avoided the Old Gods' manipulation for millennia, the truth behind Ebyssian's unique resistance was uncovered after an attack on Thunder Bluff by the C'Thraxxi, Uul'gyneth, who exposed the Spiritwalker's surprising susceptibility. After nearly succumbing to the Void while away from his lair, Ebyssian realized that he, too, could fall to the Old God's influence without the protection of the Highmountain wards.

Despite his newly discovered weakness, Ebyssian later journeyed to the Chamber of Heart to channel his essence alongside Kalecgos, Alexstrasza, Merithra, and Chromie to empower the Heart of Azeroth, an artifact that allowed the champions who entered Ny'alotha to defeat the Old God N'Zoth.

Though the mantle of leadership could have reasonably fallen to Wrathion, Sabellian, or Ebyssian, it was decided after much discussion that Ebyssian's steadfast wisdom and impeccable nature best embodied the spirit of what they needed the Earth-Warder to be for the future of the black dragonflight.

Though Ebyssian and Wrathion couldn't be more different, they see each other as brothers.

SARTHARION

The Onyx Guardian

Charged by Deathwing to protect a clutch of twilight eggs, Sartharion, the Onyx Guardian, was forced to fight a mercenary group recruited to breach the Obsidian Sanctum and destroy the Void-twisted brood. While the reason behind Deathwing's decision to bring the eggs to Wyrmrest Temple and risk discovery remains unknown, it is said that Sartharion and his allies Vesperon, Shadron, and Tenebron upheld their charge until their dying breaths.

Though many originally saw the destruction of the Obsidian clutch as a setback to Deathwing's plans, others increasingly believe that it may have been a calculated loss to hide the existence of his remaining eggs.

Contrary to the advice given in Nostro's Compendium of Dragon Slaying, hiding behind a wall is not a safe bet when facing a dragon as powerful as Sartharion.

DUSTWALLOW MARSH

Few who enter this dense, humid thicket wish to be found, let alone trifled with. Through a perpetual fog, weathered hovels speak of the many scattered refugees of the Second War who are unable to find hearth or kin in a kinder climate. Here, an oppressive solitude pervades the land beneath a canopy so dense that it chokes off all sunlight. Though roadways connect dry stretches of land to coastal vistas, few beyond the occasional fisherman have risked such paths since the destruction of Theramore.

In earlier years, scattered reports of black whelps spotted in the southern region sent hunters rushing to claim Stormwind's bounty. Few ever succeeded in locating one of Onyxia's lost brood.

BLACKROCK MOUNTAIN

Fertile valleys once surrounded what is now Blackrock Mountain, a utopia of plenty that once nourished an exiled kingdom. Yet even as the riches of the dwarves grew both above and below the mountain, the halls they built became a paltry echo to the ancestral home they'd lost. Soon, war became the only balm to their wounded pride, a poison that would doom their clan. Acting from the grief of his inescapable loss, Thane Thaurissan summoned denizens of fire to destroy his former kin, only to watch in horror as the elementals buckled the earth and flooded the verdant lands with rivers of magma. As pristine pastures were turned to ash, their majestic home was transformed into a ruin of death and subjugation as desolate as the vengeance that had spawned it.

DEEPHOLM

Ageless stone encompasses a vast cavern, its ceiling lost in the endless, abyssal dark. No wind blows here and neither rain nor sun exists, yet somewhere there is light. It is a luminescence that catches the innumerable facets of mineral clusters so large and commonplace that they seem spun of sugar.

This is the realm of Therazane, the Stone Mother, lord of the Elemental Plane of earth. It is also where a suffering Aspect sought refuge after seeking deliverance within the whispers of madness.

Though the ancient voices of the Old Gods have since fallen silent, the scars of Neltharion's suffering remain forever etched upon this place.

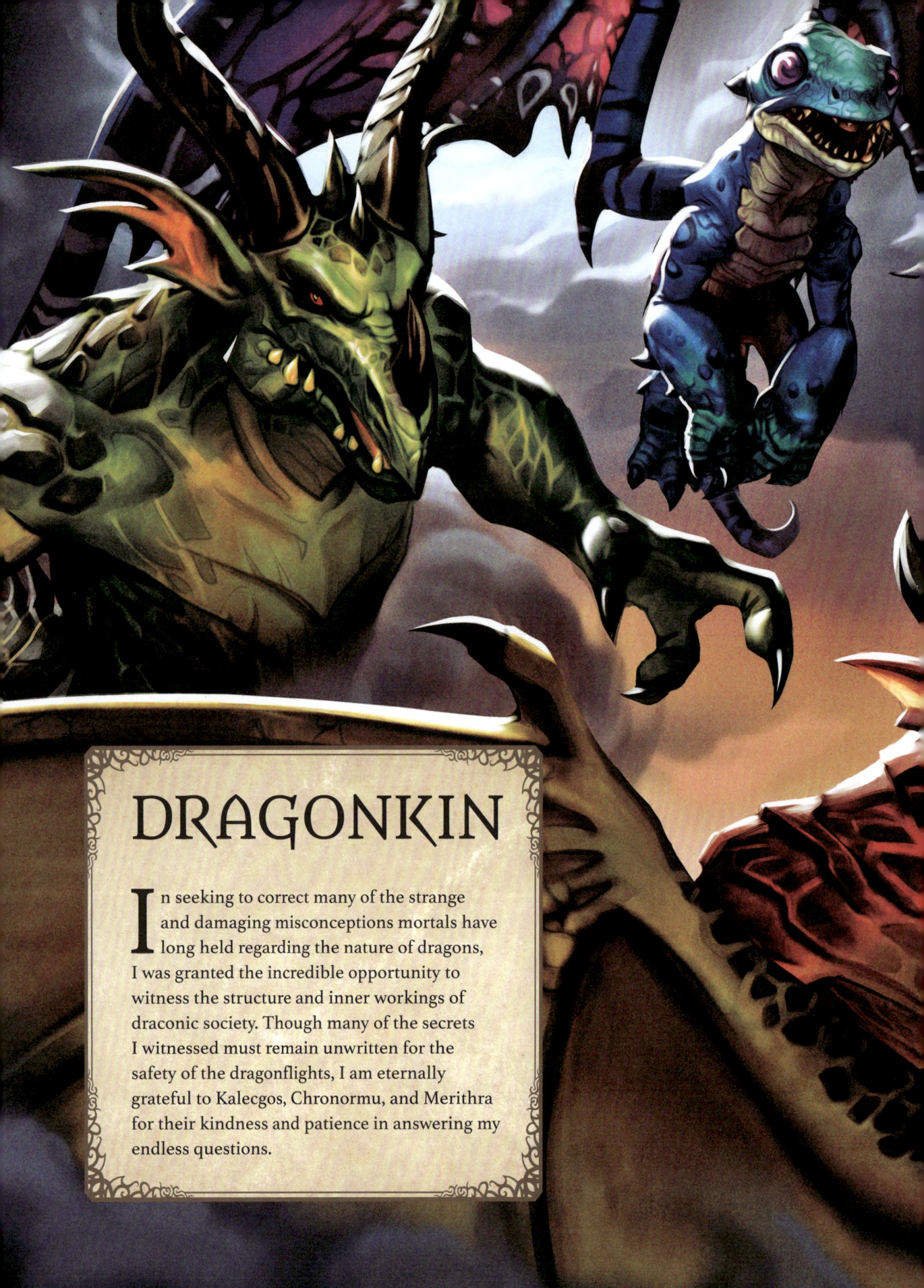

DRAGONKIN

In seeking to correct many of the strange and damaging misconceptions mortals have long held regarding the nature of dragons, I was granted the incredible opportunity to witness the structure and inner workings of draconic society. Though many of the secrets I witnessed must remain unwritten for the safety of the dragonflights, I am eternally grateful to Kalecgos, Chronormu, and Merithra for their kindness and patience in answering my endless questions.

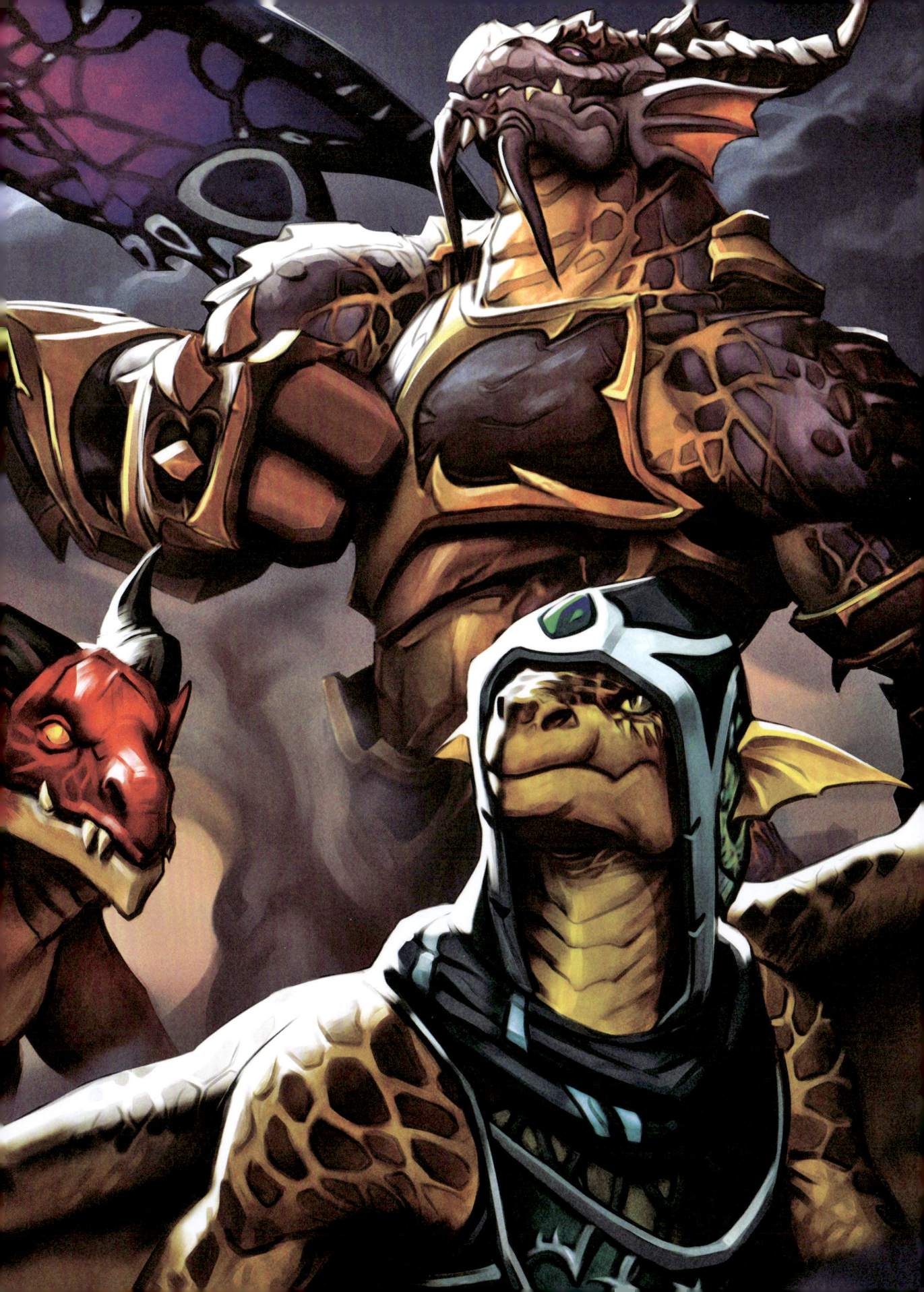

LIFE CYCLE OF DRAGONS

As with most reptilian life on Azeroth, dragons are oviparous and thus produce their young by way of eggs that hatch after a set period of maturation. While the incubation time from egg to whelp remains a secret of the dragonflights, one can identify an egg nearing its prime by its rough, stony texture and the appearance of protective spikes.

I'm told that the defense of such vulnerable young is the responsibility of the entire flight, who gather their eggs into large clutches where they are well guarded within their individual sanctums. It is also said that such close contact before hatching allows clutch-mates to form special bonds due to a keen awareness shared by all egg-bound dragons.

Upon emerging from the egg, a typical whelp measures approximately half the size of an average human and is quickly capable of both flight and limited breath attacks. Though impressive, the whelp stage of development is often the most dangerous for a dragon because they have yet to develop the armored scales of its older brethren.

After an egg hatches, it may take a decade or more for a whelp to reach maturity.

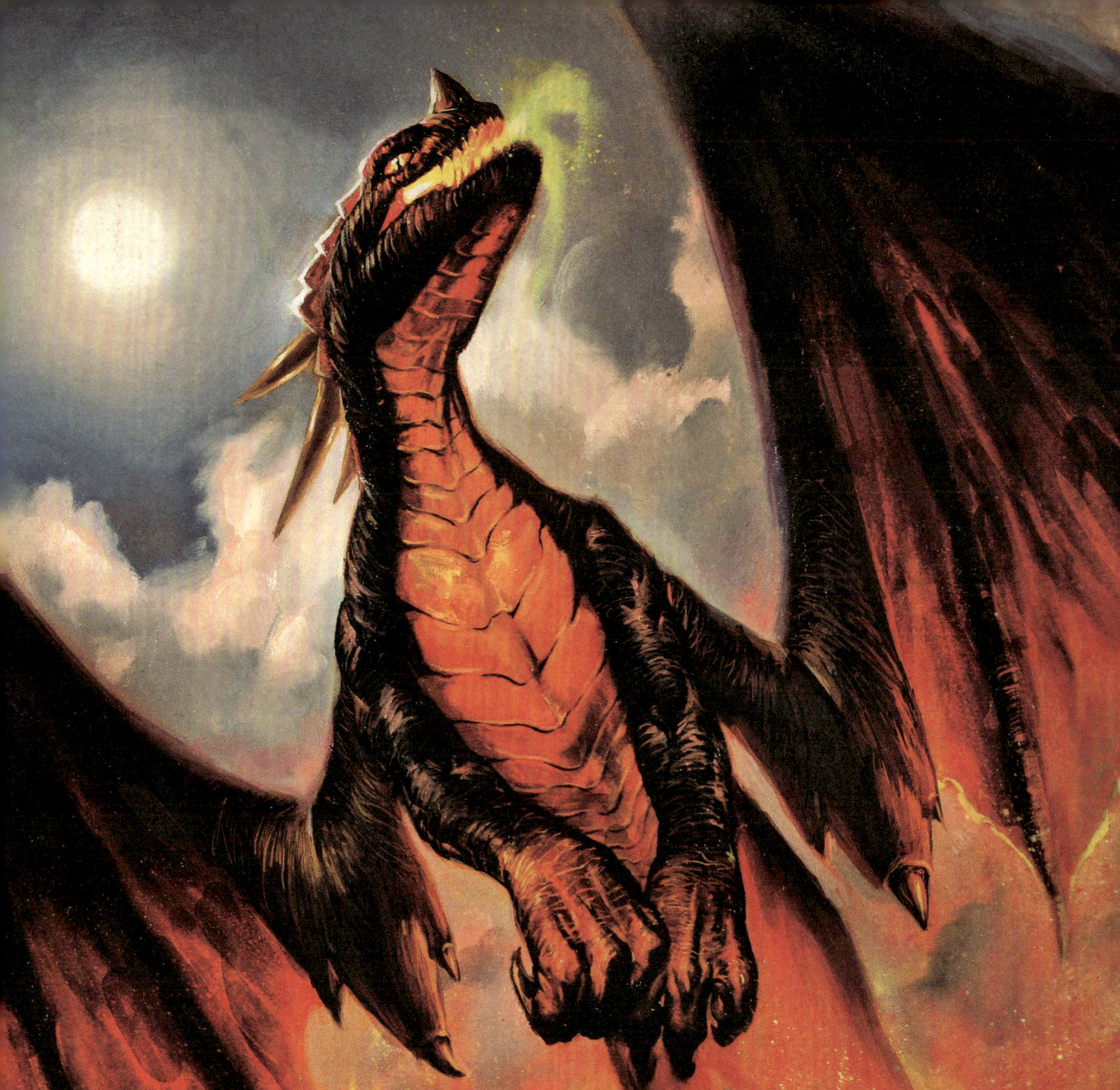

Matured whelps who have begun to take on the appearance of dragons are known as drakes. Though their average weight can easily exceed that of a paladin's charger, they have not yet developed the spikes and unique protrusions common to the mature dragons of their flight. Despite their continuing development, drakes can prove quite lethal to the unwary traveler or adventurer who accidentally trespasses into their domain.

While full dragons can vary greatly in size and power, most easily exceed the size of a small dwelling and are covered in brilliant, defensive scales that reflect the color of their namesake flight. Likewise, any horns, growths, fins, or crystals unique to their Aspect's titan calling have reached full maturity. Once fully grown, aging appears to slow drastically, allowing dragons to enjoy exceptionally long lifespans.

HUMANOID

All native life on Azeroth can trace its roots back to one of four ancient sources: the wild elementals, the seeping void of the Old Gods, the titan Eonar and the Emerald Dream, or the titan constructs who suffered the curse of flesh. In the beginning, only the elements of earth, fire, wind, and water held dominion over the land, with each waging an endless war upon the others. Though each was a strong and chaotic force of nature, the elemental lords' division made them weak and easily defeated upon the arrival of the Old Gods. Facing no further resistance after the subjugation of the elemental armies, the Black Empire rose to dominate Azeroth with its endless spread of insectoid aqir, faceless n'raqi, and C'Thraxxi Warbringers.

It took the might of the Pantheon to break the Old Gods' malignant hold and to banish the elemental lieutenants to their alternate realms. Yet despite the keepers' best efforts, minions of both armies managed to escape complete containment. The aqir of the Black Empire burrowed deep underground to await the eventual return of their masters, and many of the elementals evolved over time into the first primal dragons.

Determining a species' core origin is not always so easy, especially if one relies on sight alone. While admittedly a logical notion, many erroneously believe (as I once did) that the many physical similarities shared by dragonspawn, drakonids, dracthyr, and ordered dragons mean that they hold a shared lineage. However, the warriors and servants who aid the dragonflights bear no direct descendance from dragons themselves. Instead, they are humanoids who were altered to serve the needs of their respective flights. So while the same type of Order magic may have been the catalysts for their startling transformations, abilities, and longevity, these devoted guardians of the dragonflights are still of mortal birth.

Lastly, we come to the various dragonlike species drawn from the Emerald Dream and the vibrant titan enclaves that gave rise to the vast diversity of life on Azeroth. Though creatures such as faerie dragons and dragonhawks also bear many striking similarities to ordered dragons, neither is truly related to dragonkind. Still, it is not unusual to see these intelligent beings within the presence of dragons due to overlapping habitats and a shared affinity for both the arcane and the Emerald Dream.

While not for researchers with frail stomachs, Dr. Terrible's Building a Better Flesh Giant offers a fascinating, if not gory, theory on the curse of flesh and its effects on our ancestors, the vrykul.

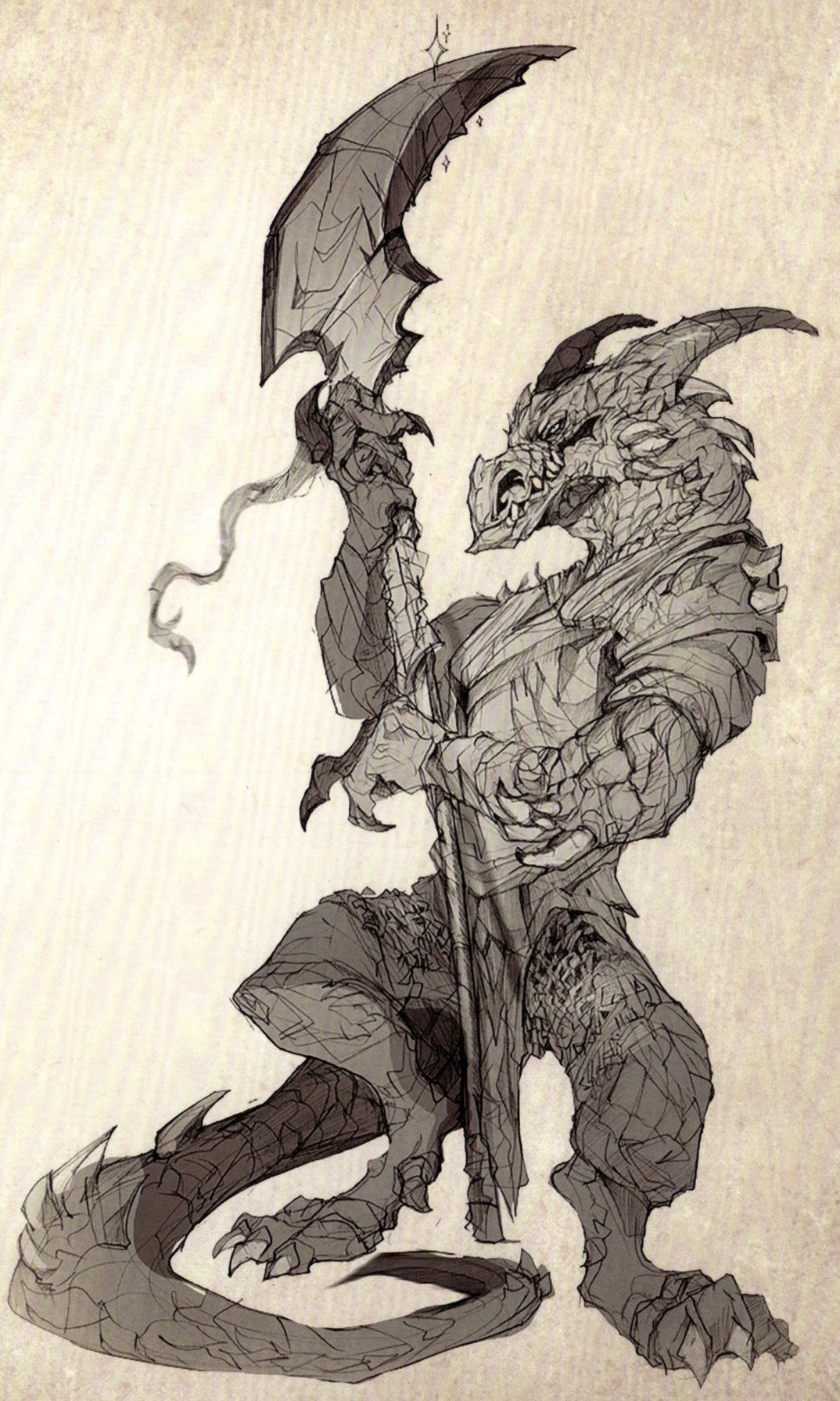

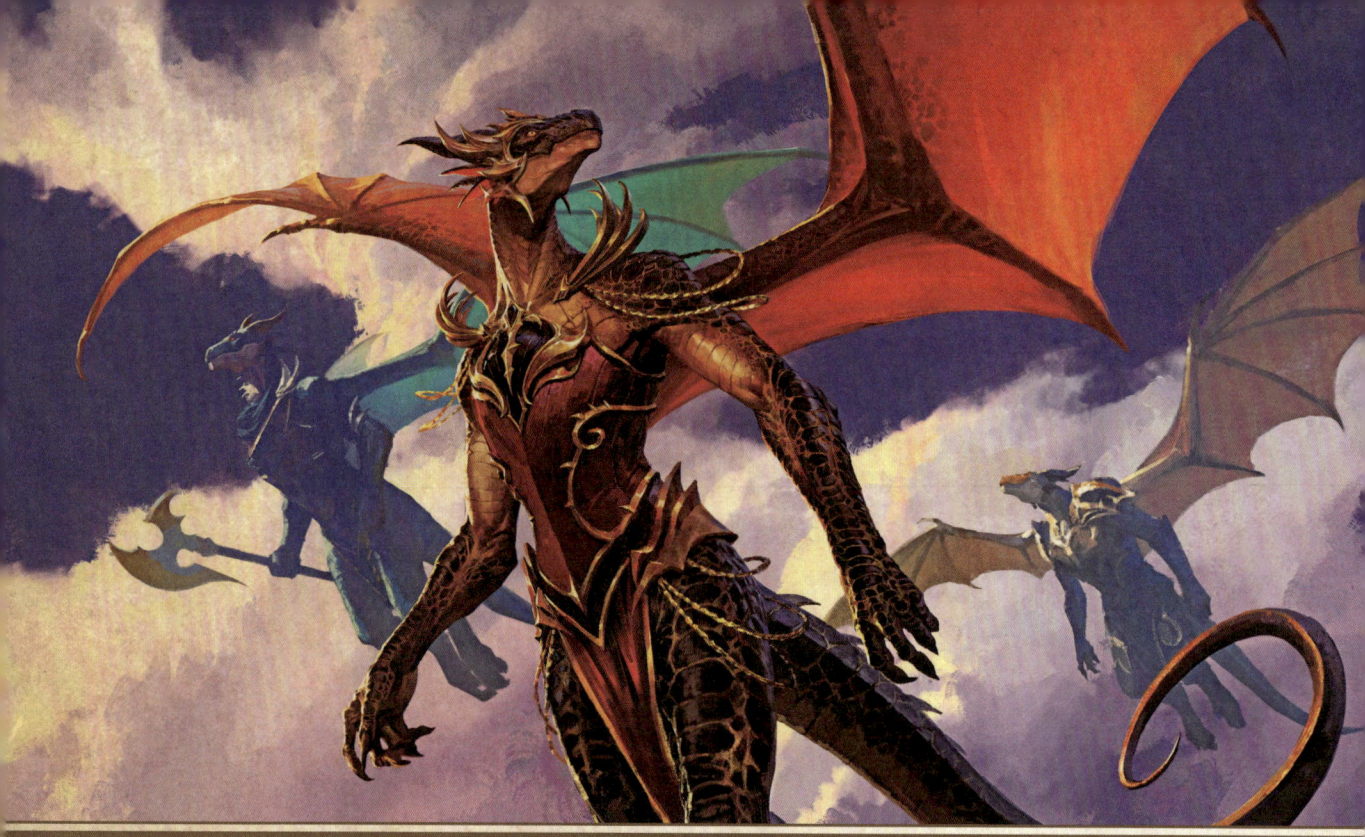

Dracthyr

While drakonid and dragonspawn are honored members of their various dragonflights, these indispensable warriors are not without their limitations. The powers they gain from their dragon allies tend to be in the form of increased strength, longevity, and immunity to their flight's particular elemental affinity. Those capable of wielding magic do so through a combination of mortal aptitude and rigorous training, yet they will never reach even a portion of their dragon masters' inherent potency.

As the threat of war rose between the Incarnates and the dragonflights, Neltharion sought new methods of enhancing their dragonkin allies as an effective counter to the Primalists' tarasek fighters. Though the red Aspect Alexstrasza and Vyranoth the Frozenheart both believed war could be averted between their two sides.

Fearing reprisal from the Dragon Queen, who did not believe that war was an inevitability for which to prepare, Neltharion continued his experiments in secret until he discovered a method to combine the powers of the five dragonflights with the cunning and ingenuity of the mortal races. These intelligent new dragonkin, which he called dracthyr, were capable of wielding elemental energies, tapping into the Emerald Dream, and even utilizing limited visages.

While the dracthyr were ultimately left behind in the statis field created by Malygos following the attack by Raszageth the Storm-Eater, it is speculated that Neltharion's later efforts to create the chromatic dragonflight may have originated from the dracthyr.

Created by Neltharion to combat the rising threat of the Primalists, the dracthyr are organized into fighter groups called weyrns under the command of a Scalecommander.

Drakonid

Serving a similar purpose as the dragonspawn, drakonid are unquestionably devoted allies of the dragonflights. While information is woefully sparse on the matter, a number of accounts make the same curious claim that drakonid are raised from the ranks of mortals who dared approach the majesty of the various dragonflights. Their name is said to mean many things, although "devoted one" seems to best reflect the dragons' deep appreciation for the elite defenders of their lairs, sanctums, and other realms of grave importance.

Though drakonid seem to be dragonkin of few words, they are known to be quite intelligent and capable of limited speech. In the presence of the dragons or Aspect of their flight, it is common for them to show their respect in the form of a bow or genuflect. Although more commonly associated with the five dragonflights of Azeroth, drakonid have been discovered in the service of chromatic dragons, nether dragons, and infinite dragons.

Most drakonid undergo their transformation willingly, but that is not true for all. Such examples include the mages forced into Malygos's service before the Nexus War, those altered by the Twilight's Hammer clan, and victims of Chromaggus's radiating affliction.

In correction of the many esteemed tomes that erroneously associate the drakonid solely with their more commonly seen roles as guardians and warriors, I have come to learn in my travels that there seem to exist a greater number who serve as architects, craftsmen, and caretakers of the dragons' sacred sites.

Drakonid thrive throughout the Dragon Isles and are responsible for creating many of its architectural wonders.

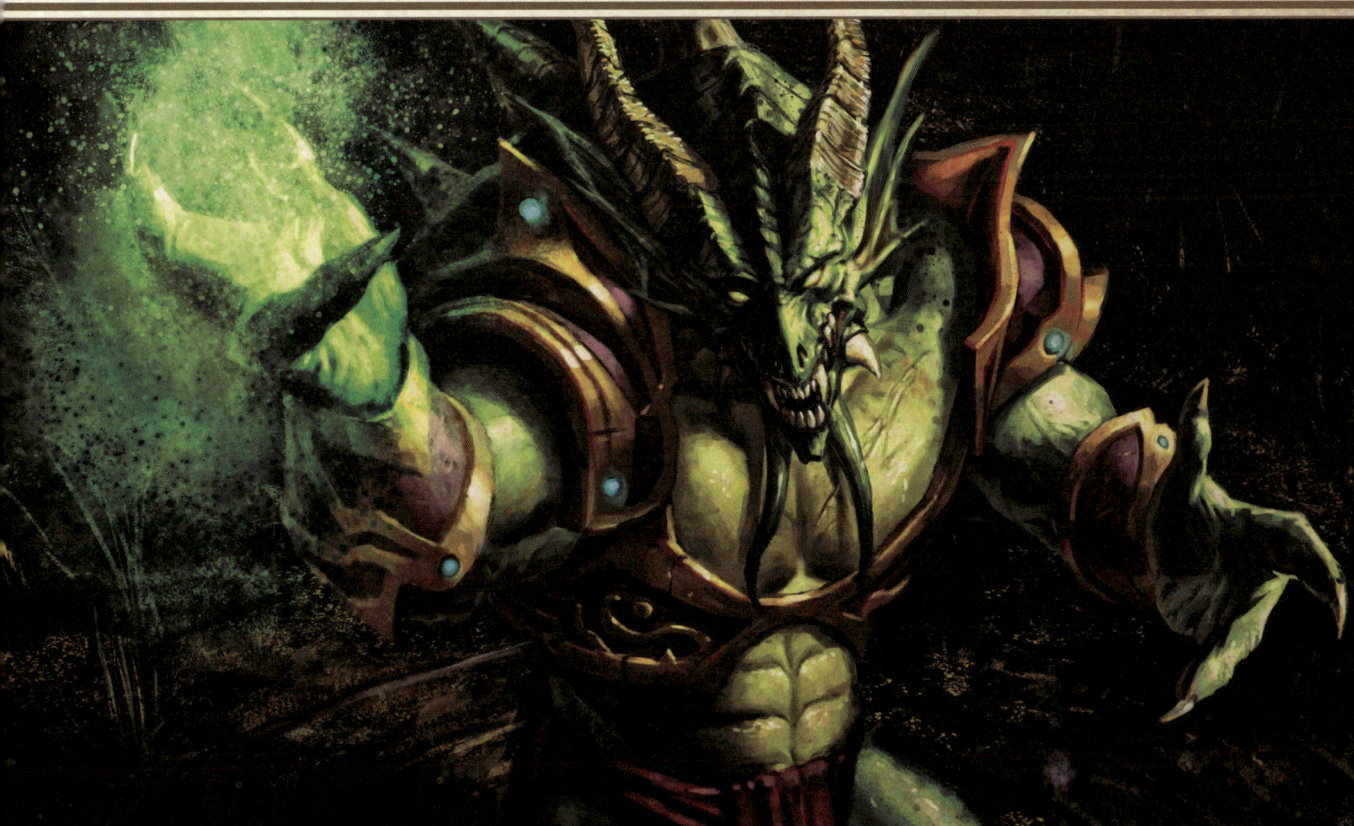

Ascendant

While the exact ritual used to create ascendants remains unknown, the process is believed to follow the arcane principle of transference, in which the essence of one unfortunate creature is siphoned and redirected into another. Since such dark magic exists primarily within the spell work of warlocks, it is likely that either Fel or Void energies are required in its casting.

Due to the ethical considerations of sacrificing one life to enhance another, this practice is forbidden within the dragonflights and throughout most learned societies of Azeroth. Still, this does not mean that ascendants haven't been made in times of war or by forces with little concern for the sanctity of life. This was most recently seen when the Twilight's Hammer siphoned the energy of elementals into its most powerful cultists.

Perhaps the most infamous ascendants ever created were those discovered in service to the Dragonmaw clan of Shadowmoon Valley. Produced by siphoning the essence of netherwing dragons into the bodies of fel-infused orcs, the resulting hulks served as the defenders and taskmasters of the clan's mining and dragon training operation near the Black Temple. Considering the Dragonmaw's long alliance with Sinestra and the inclusion of netherwing essence in her experiments, it is quite possible that the twilight dragonflight owes its existence to the dark ascendant rituals of the orcs.

The only tome known to outline the process in full is Forbidden Rites and Other Rituals Necromantic. It was destroyed by a band of heroes who infiltrated Scholomance. What? You didn't think I'd actually reveal the technique, did you?

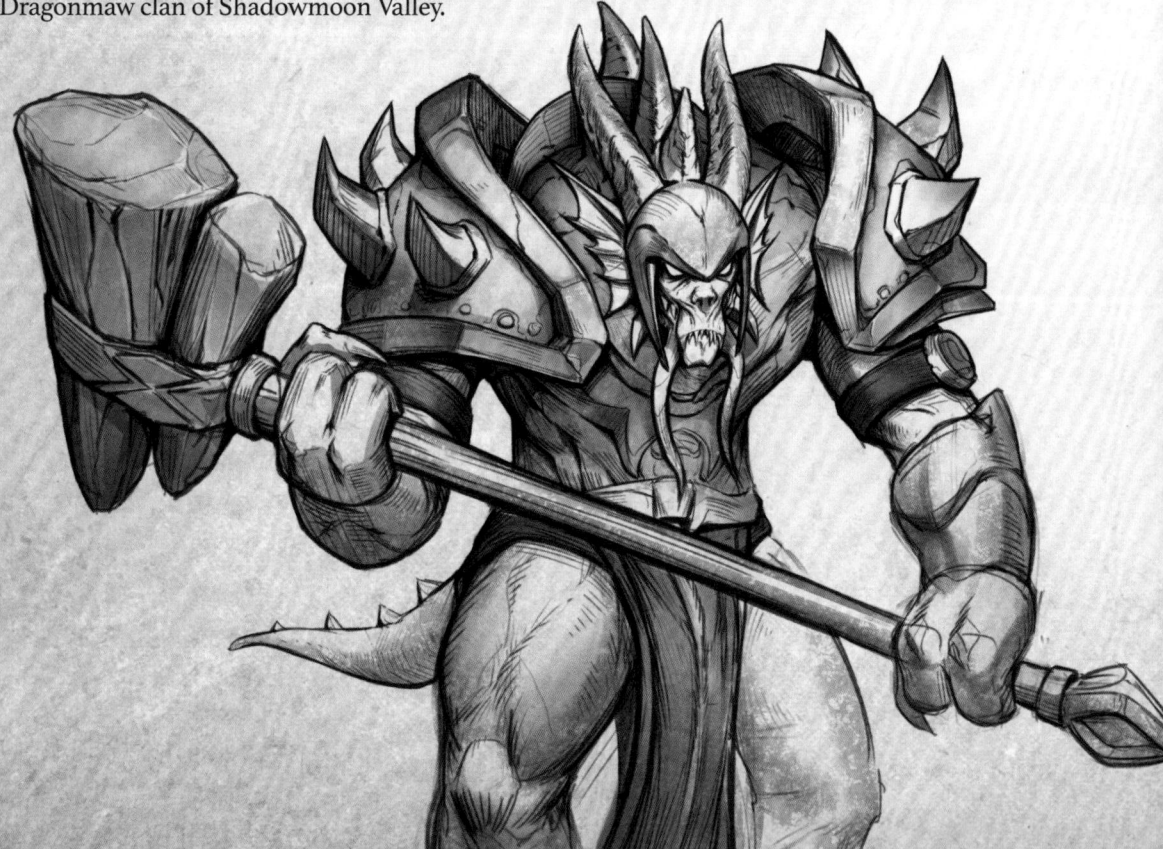

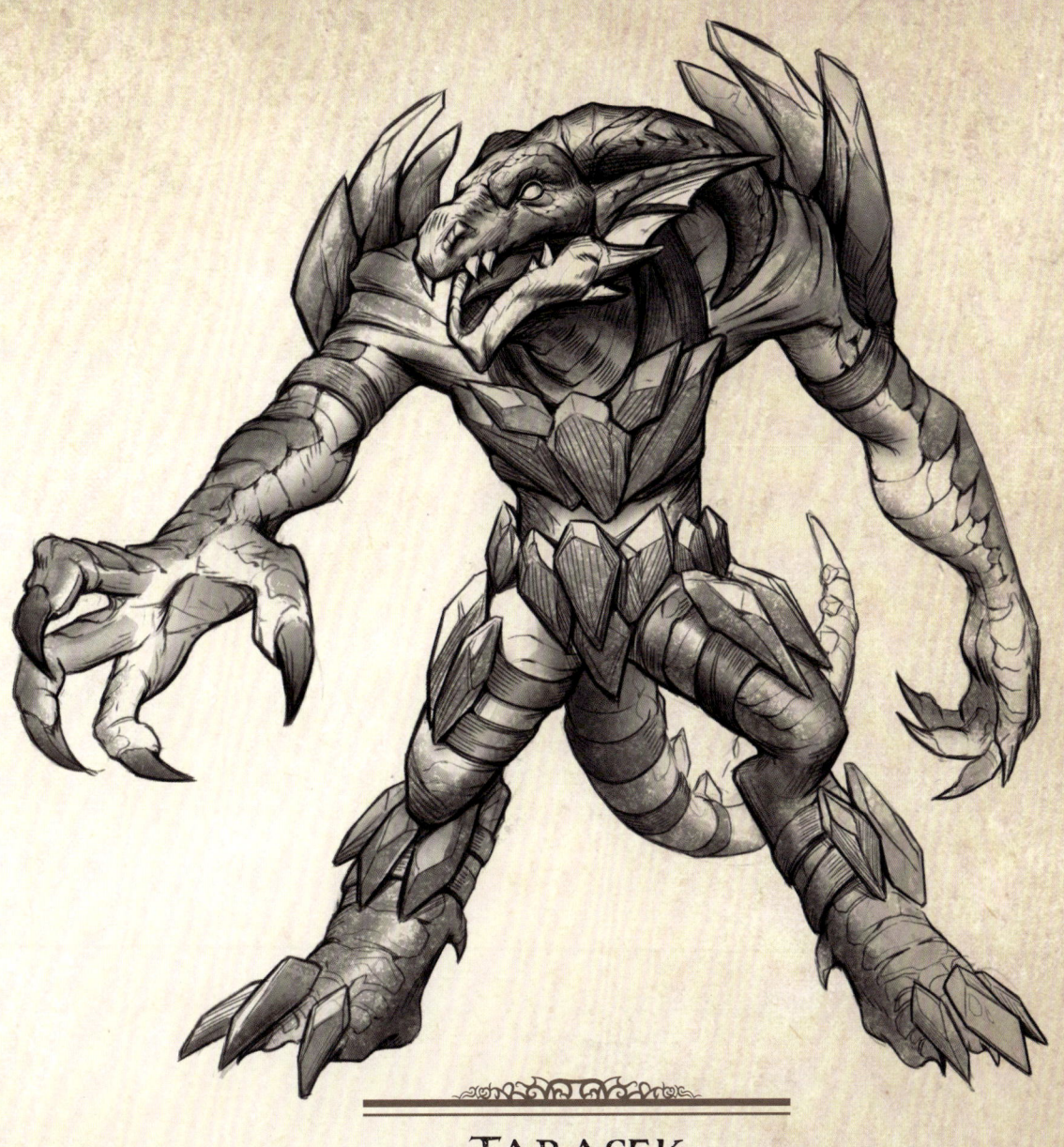

TARASEK

Like many creatures of the Dragon Isles, the tarasek bear limited draconic traits yet are believed to have evolved independently of the primal dragons. Before their inclusion within both the dragonflight and Primalist forces, the tarasek lived a rustic and wild existence that lacked the defined social structures of their respective dragon allies.

An important distinction I've come to learn is that not all tarasek who serve the draconic have been enhanced. To serve the dragonflights, tarasek must be altered by Order magic to accelerate their evolution into the various drakonid forces. Those pledged to the Primalists, however, were given the choice of whether to be infused with elemental power; this stemmed from the Incarnates' core belief that no one should be forced to change their physiology merely to serve their cause.

The physiology of a tarasek depends on what force, if any, they were infused with.

MORE DRAGONKIN

Wyrmkin

Misconceptions abound regarding the nature, purpose, and origins of the dragonspawn species. With their draconic features and uniquely quadrupedal forms, it is easy to conclude that they must be aberrations of the dragons themselves. Yet if the enhancements of Wyrmkin share any commonalities with the more humanoid servants of the dragonflights, then perhaps they, too, can be traced to mortal origins.

Tantalizing, however, are the many ancient tales told among the trolls, elves, tauren, and other cultures speaking of those who pledged themselves to the dragons and were rewarded with a draconic form. Still, stories are not fact, and since the dragons are not forthcoming on the topic, we must leave this as a theory, at best.

Encompassing the vast majority of a flight's dragonspawn force, Wyrmkin serve a similar purpose as the mortal rank of foot soldier. Though known to be fierce fighters and defenders, they require firm leadership to be fully utilized. Those exhibiting an affinity for the arcane or a mind for battle tactics are typically elevated to command positions as either Flametongues or Scalebanes. Though largely content to wield their blades in service to their given flight, Wyrmkin have been known to take on missions of great importance.

FLAMETONGUES

Highly honored and respected among the dragonspawn warrior class, I am told that the title of Flametongue is reserved for the few who show exceptional skill in combat, strategy, and battalion leadership. Their superior intellect often grants them the privilege of wielding unique and rare artifacts held by their particular dragonflight, along with the necessary tutelage to master techniques of spell casting, when applicable. Within the dragonspawn hierarchy, a Flametongue's main purpose is to act as the tacticians of a field command and to devise new solutions in the heat of combat. Typically seen with sword and shield in hand while on the battlefield, Flametongues can be difficult to distinguish from basic Wyrmkin, although the aftermath of their arcane mastery is quite unmistakable.

The old adage of fighting fire with fire has been the ruin of many young mages who crossed a Flametongue of the red dragonflight. The size of one's pyroblast means nothing when pitted against a Wyrmkin's innate elemental immunity.

SCALEBANES

Placed at the very apex of the Wyrmkin ranks are the heavily armored warriors and veteran commanders known as Scalebanes. Though little is known of their existence beyond the battlefield, these elite fighters are honored for their proven prowess in both physical combat and battlefield spell casting. Unlike Flametongues, who tend to have a slighter build due to their deeper focus on the intellectual pursuits of tactics and magic, Scalebanes are highly disciplined veterans who have mastered all levels of their offensive and defensive training. As the most devout followers of their dragonflight's purpose, Scalebanes are often recognized for their exceptional service with gifts of enchanted weaponry and the finest armor.

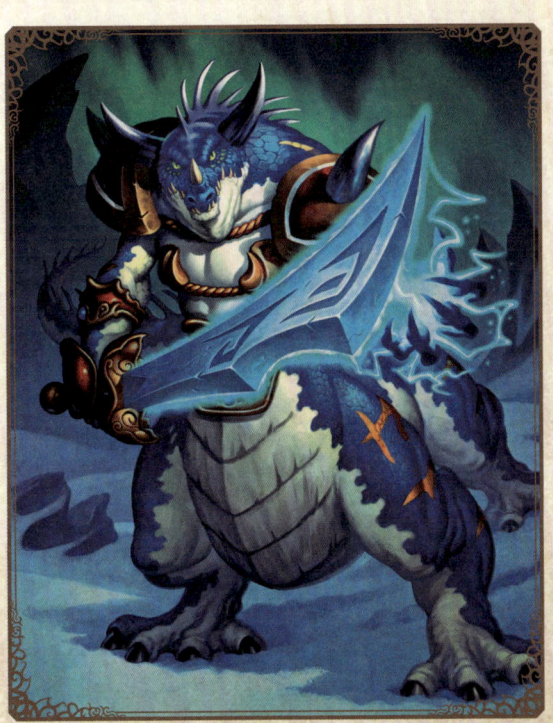

The arrival of a single Scalebane on the field can change the entire course of battle.

CREATURES

PRIMAL DRAGONS

A primal dragon's nature is most often described as willful and fierce, qualities that stand in clear reflection of the chaotic elementals from which they originated. As the progeny of Azeroth's first chaotic form of life, most primal dragons retained their connection to the elemental forces throughout their evolution from primal spirits into flesh and blood creatures. Endemic mainly to the Dragon Isles and the icy wastes of Northrend, the broods boast a variety of breath attacks—from electric discharges to blasts of flame, ice, sand, or noxious fumes. Yet despite their reputation as fearsome predators, a deep generational bond exists between primal dragons and the vrykul tribes of the Howling Fjord, who first trained them to augment the weaknesses suffered from the curse of flesh. As a result, members of the Dragonflayers are often encountered when hunting wild game in the evergreen forests of Northrend, with primal dragons serving as both mounts and hunting companions.

Though primal dragons were long believed to lack the ascended intelligence of the Aspects and their dragonflights, due to the more bestial broods encountered in Northrend, those found on the Dragon Isles, such as the Incarnate Raszageth, are capable of speech, complex reasoning, and enduring social structures.

Legend has it that although many ancient primal dragons were eager to accept the titan's gift and ascend into ordered dragons, many others bristled at the idea of abandoning their primordial roots in service to the Pantheon's vision. These divisive dragons came to be known as the Primalists. They increasingly saw their ascended brethren as aberrations unworthy of inhabiting the Dragon Isles. Though the ordered dragons and the Primalists once treated each other with the closeness of clutch-mates, the simmering hatreds that led them to war have only grown stronger during the dragonflights' long absence.

Until the rediscovery of the Dragon Isles, the most common habitat for primal dragons was the frozen continent of Northrend.

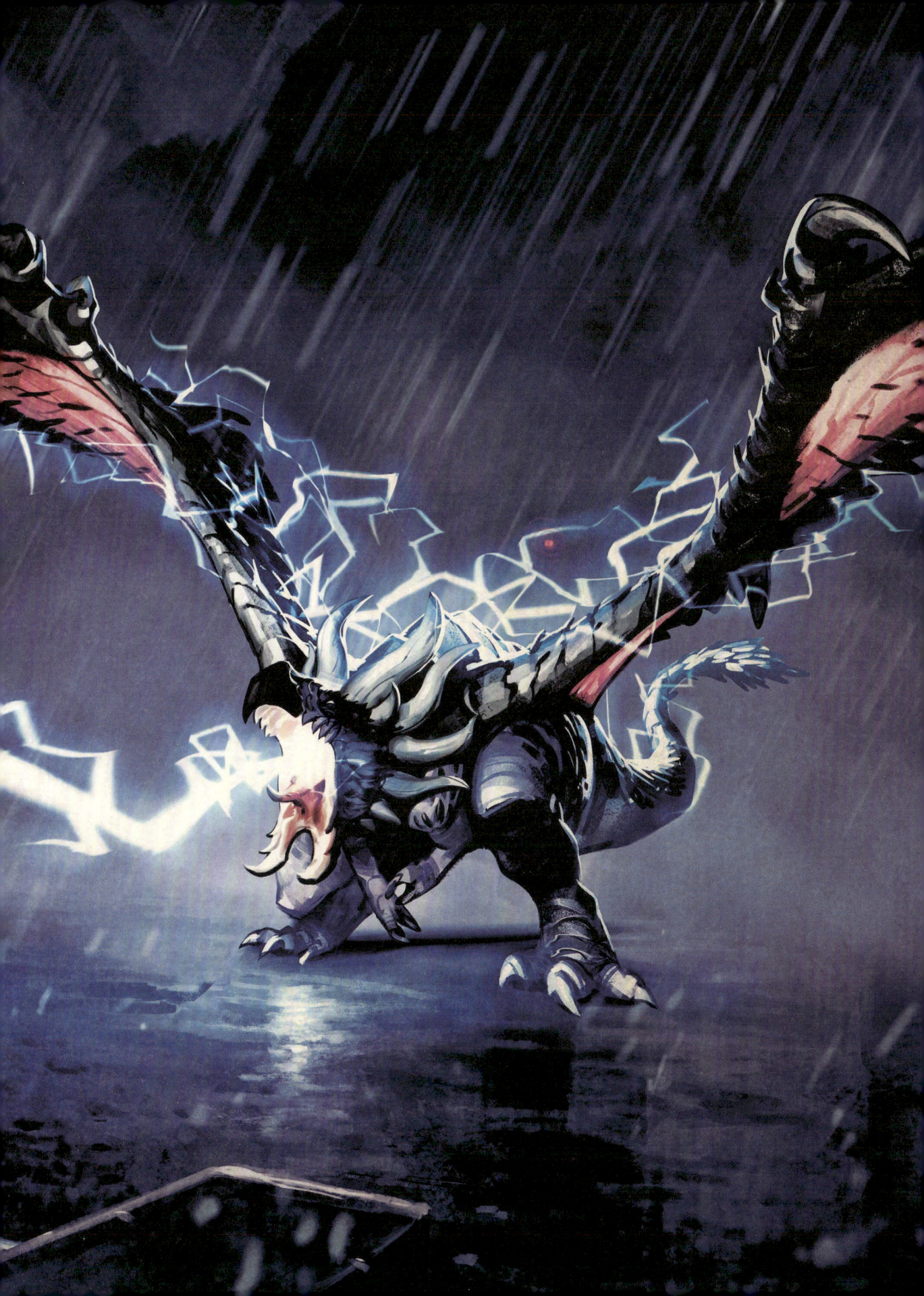

Cloud Serpents

The origin of Pandaria's cloud serpents remains as mysterious as the mist-shrouded continent they inhabit. While many scholars speculate that the creatures' command of elemental powers points to a similar evolutionary path as that of primal dragons, the ancient legend of Alani the Stormborn offers a tantalizing alternative.

First recounted by Loh-Ki the Storm Watcher, the story begins with a differing account of the emperor Lei Shen's final moments. An incredible storm of wild energy was being unleashed upon the Vale of Eternal Blossoms. At the apex of the tempest's fury, a bolt of lightning struck the center of Whitepetal Lake, setting its crystalline waters ablaze. The mystical fire burned unabated for many days before revealing the creation of a cloud serpent hatchling. Witnesses to this miraculous event claimed that the serpent's scales flashed with the ferocity of the storm that created her and thus named her Alani the Stormborn.

For many generations afterward, the inhabitants of Pandaria reportedly admired the cloud serpents from afar, never daring to approach the majestic and cunning beasts.

Then came another terrible storm that roared through the Jade Forest. Upon surveying the damage the following day, a pandaren named Jiang discovered an injured hatchling who had been thrown from his nest. Jiang decided to nurse him back to health. A lasting bond formed between the pair as a result of the pandaren's kindness. One day, when Lo was but half grown, he saved Jiang from the grips of the encroaching Zandalari, spiriting her to safety on his back. This gave Jiang an idea. Though the pandaren were skilled fighters, they had little defense against the trolls' deadly bat riders. On the backs of cloud serpents, however, they could take the fight to the air. Together, Lo and Jiang managed to break the troll ranks, proving the immense value of dragon riding and leading to the formation of the Order of the Cloud Serpents.

The bonds of loyalty between cloud serpent and rider are said to be so strong that, for decades after Jiang sacrificed her life to kill the troll leader Mengazi and stop the revival of Lei Shen, Lo continued to fly above the village searching for the beloved friend he'd lost.

Much of Pandaria's history is passed down through the tradition of oral storytelling, so the following should not be treated as a primary source.

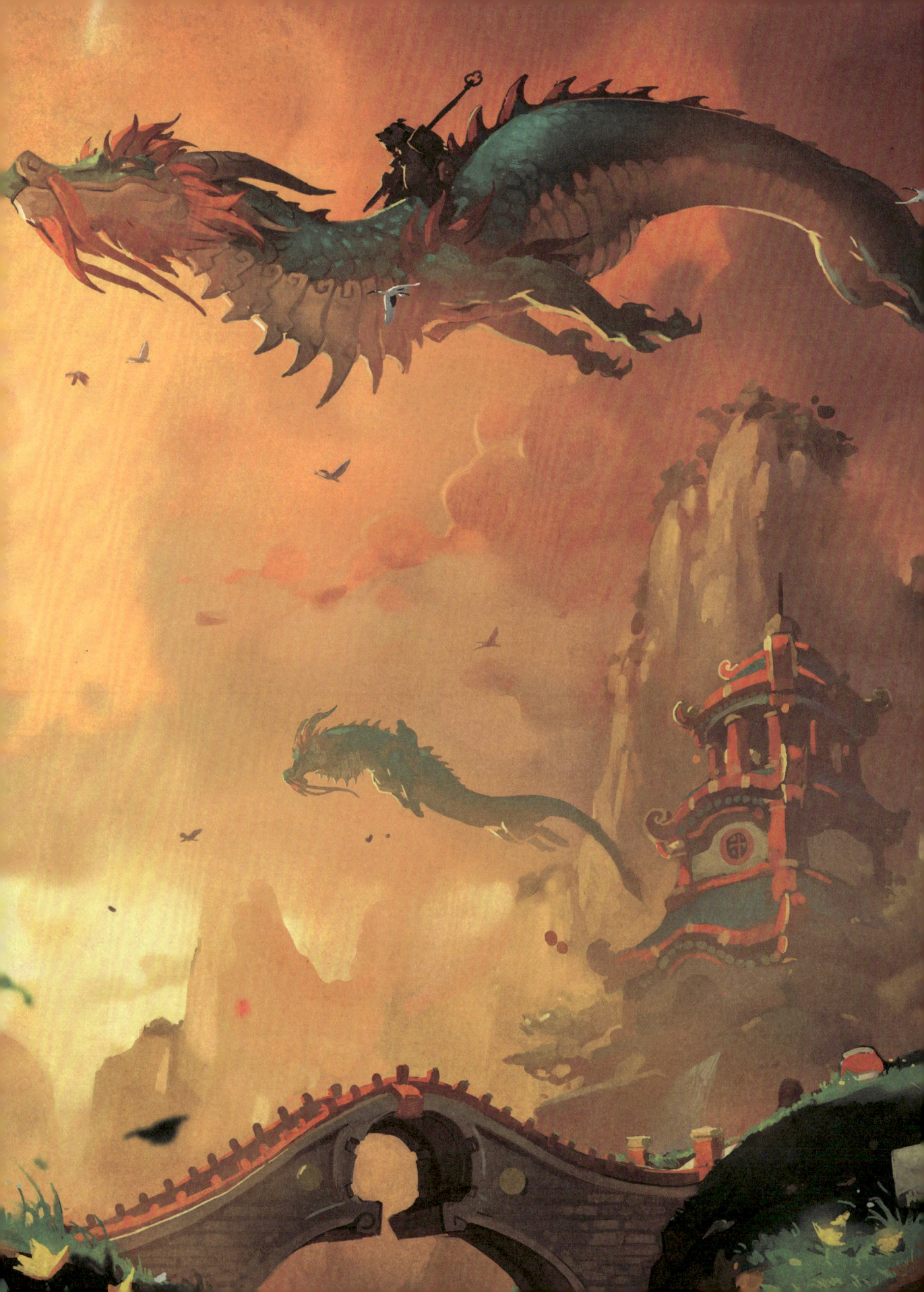

Elemental Dragons

Scholars agree that most dragons evolved from wild elementals that existed in the physical realm of Azeroth. However, growing evidence indicates that a reverse progression may have occurred, in which several primal dragons found their way into the various Elemental Planes. Though they retained much in the way of their original draconic form, it appears that the volatile forces of each environment altered their physiology, creating a new species known as elemental dragons. Whether this theory of their origins will hold true, only time will tell.

Although it's possible mortals may have encountered such dragons before, the discovery of elemental dragons was only formally acknowledged after the Cataclysm opened a pathway into the Elemental Plane of Deepholm, thus exposing the existence of its Stone dragons. Much remains unknown about this brood and its habits, due to the dragons' inability to use speech. However, they seem much like early primal dragons, in that they value raw strength and aggression over cunning or intelligence. As a result, their leader and broodmother, Aeosera, was known to show deference to Deathwing while he inhabited Deepholm.

Of a similar temperament are the Storm dragons of Skywall, who command the powers of wind and lightning in defense of the Elemental Plane of Air. Though many scholars seek to link the phoenixes of the Firelands to a similar path of development, an in-depth study of the fiery creatures has proven both highly dangerous and quite flammable.

While no known elemental dragon species exist within the plane of water, the Abyssal Maw is notoriously difficult to explore.

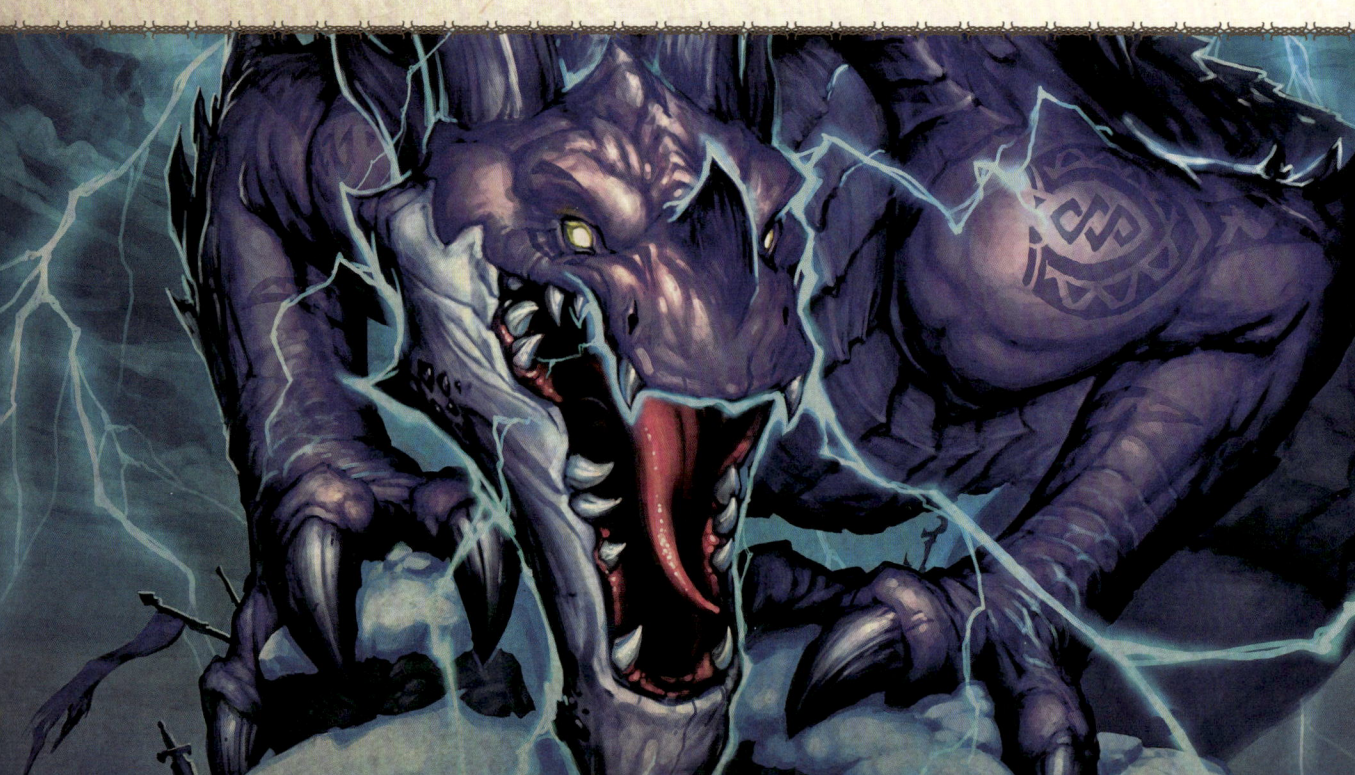

Thorignir

No one knows the true age of the Storm drakes of Stormheim, including the Thorignir themselves. However, a lack of inclusion within titan records leads most to believe that their brood evolved in isolation on the Broken Isles in the years following the Sundering. Led by Thrymjaris, who has chosen to ally her brood with Keeper Odyn and his Valajar army, the Thorignir are often called upon to aid in the infamous Trials of Valor, designed to test the might and worth of champions seeking glorious battle in Helheim.

As with other intelligent broods, allegiance to the titans is not universally accepted by all Thorignir; this has resulted in a splinter faction currently led by Nithogg. Those who have been honored in the Halls of Valor would do well to avoid the area surrounding the mountain of Nastrondir.

Veilwings

Believed to be the only dragon species native to the Shadowlands, the Veilwings of Ardenweald are considered some of the fiercest defenders of the Winter Queen's realm. As such, they are held in the highest esteem by the Night Fae. While it is unknown whether Veilwings are creations of the First Ones or evolved from spirits sent through the Arbiter's will, they stand unique among the draconic for their gradient transition of scales into a glorious mane of feathers. Veilwings wield a variety of breath attacks similar to dragons on Azeroth, although they have adapted to use a native source of energy known as anima rather than the elements.

The strength and beauty of the Veilwing is said to be so celebrated in Ardenweald that those who master the ability of soul shaping commonly choose to emulate their majestic forms.

During my brief visit to Ardenweald, I was unable to confirm whether Veilwings lack the capacity for speech or merely had little to say to an old mage.

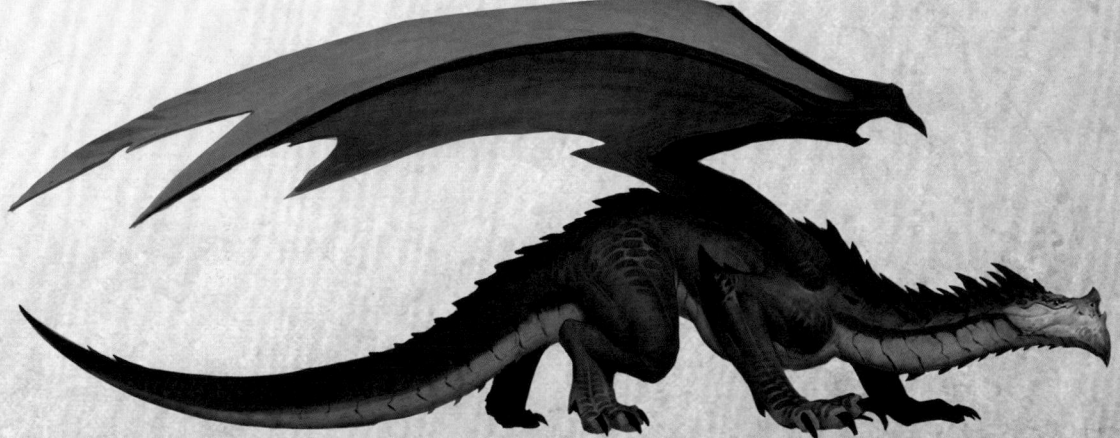

The recent discovery of a brood of Storm drakes in Thaldraszus may offer further insight into the when/where of this species' origin. As of yet however, no successful contact has been made.

Faerie Dragons

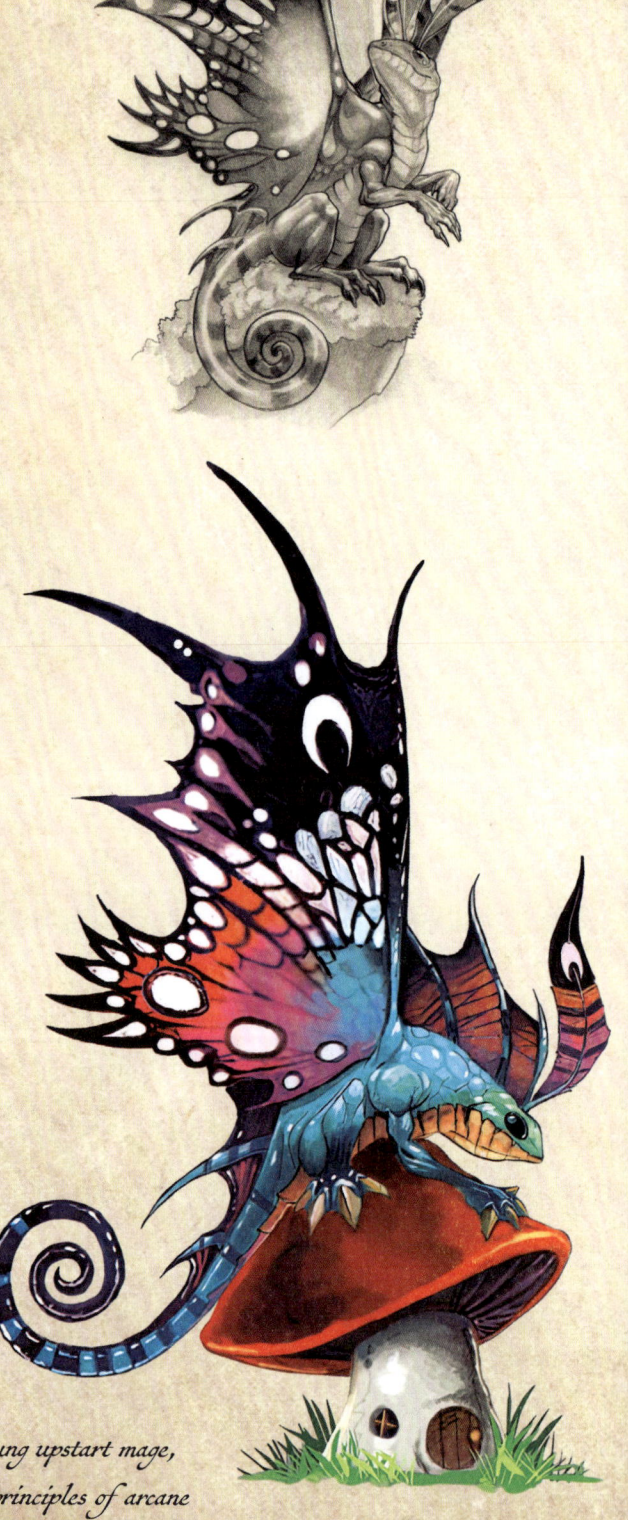

Often described as diminutive, intelligent, and mischievous, faerie dragons have a history that is nearly as intertwined into the story of Azeroth as that of the dragonflights. Though not true dragons, these winged creatures commonly inhabit the same realms due to their intrinsic connection to the Emerald Dream and their natural affinity for finding fonts of power. In fact, legend states that it was by following faerie dragons to the Well of Eternity that a band of curious dark trolls eventually became the first elves.

Known also by the name of sprite darter, blink dragon, and fey dragon, faerie dragons are largely capable of limited speech in a variety of local languages. Also unique is their elaborate command of the arcane for both offensive and defensive purposes. Such skills include the ability to disappear, blink from one location to another, and manipulate the magic of other casters by way of dampening, nullifying, or even causing a feedback effect of one's spell. For this reason, the priestesses of Elune have often called upon the faerie dragons to aid in the defense of Azeroth.

While there are many places in which to view these playful tricksters in the wild, the forests of Feralas and Ashenvale offer the best chance, due to their abundance of elven ruins and many abandoned moonwells. Though it is a rather rare occurrence, it is said that faerie dragons occasionally converge upon a mysterious mushroom ring in an area of Tirisfal Glade known as the Whispering Forest. Those fortunate to have witnessed such a gathering speak of an elaborate display of singing, illumination, and dancing that often ends as suddenly as it begins.

Should one ever be found teaching a young upstart mage, I recommend including a lesson on the principles of arcane feedback and counterspell within the forests of Ashenvale.

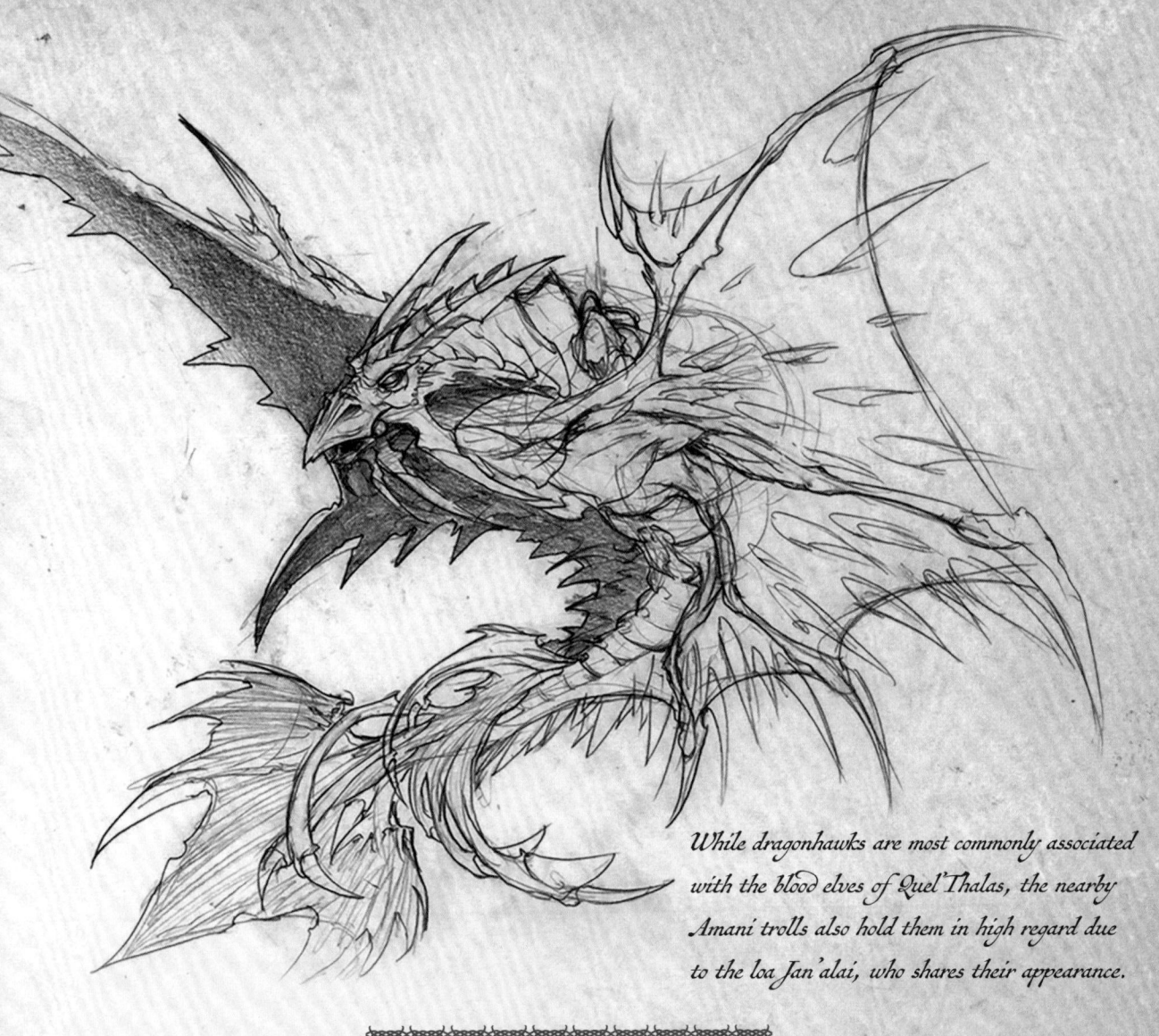

While dragonhawks are most commonly associated with the blood elves of Quel'Thalas, the nearby Amani trolls also hold them in high regard due to the loa Jan'alai, who shares their appearance.

DRAGONHAWKS

So named for their blended appearance, dragonhawks are commonly confused for dragonkin due to their many physical similarities and unique ability to breathe fire. While their riders and handlers report them to be highly intelligent creatures who exhibit an affinity for the arcane, they lack a faerie dragon's ability to effectively wield it. Native mainly to the forests of Quel'Thalas and Zul'Aman, dragonhawks have been known to accompany their blood elf allies into a variety of historic battles, including the assault on Icecrown Citadel.

As deft and adaptable predators, dragonhawks have been found thriving in various areas of Outland after the defeat of Prince Kael'thas Sunstrider's forces. Interestingly, while most reports claim that the eyes of dragonhawks in Quel'Thalas tend to have a blue glow, some have observed that those living in Outland often exhibit a green hue that seems a direct result of their intake of Fel energy.

Now that I think of it, perhaps I'll assign this as field research to the next mage who thinks it's funny to leave a portal to Stonard open in the Dalaran library.

PRIMALISTS

What follows is a humble attempt to provide a balanced account of the Primalists while also acknowledging the danger and shortcomings of presenting their cause through the view and historic record of their ancient adversaries.

Of all the varied reasons one could choose to raise blade or claw against an enemy, none is more noble than the protection of free will. The ability to choose the shape of one's own destiny is the greatest gift of life and should never be taken for granted. Yet as the titans set to ordering Azeroth in many vast and wonderous ways, their vision for how our world should exist was not shared by all.

After the empowerment of the Aspects, all dragons were offered the opportunity to be infused with Order magic, yet many were mistrustful or unwilling to abandon their pure and untamed existence in exchange for the titan's gift. These dragons came to be known as the Primalists. They eventually claimed that they alone represented the true evolutionary path of dragonkind and that the keepers had subverted their elemental birthright. When looking upon the ordered dragons, however, many still saw their original clutch-mates and believed that their concerns could be met—that was, until it was discovered that primal eggs had been taken and infused with Order magic against the will of their brood. Unwilling to negotiate with the Aspects and the dragonflights after such a terrible betrayal, the Primalists declared war.

Though it has been thousands of years since the four Incarnates were imprisoned and their forces scattered, most Primalists have never forgotten what they fought for or the age-old judgments that made peace an impossibility on the Dragon Isles.

After rejecting the gift of the titans, the Primalists turned to the elements to gain the power they needed to wage war on the Aspects.

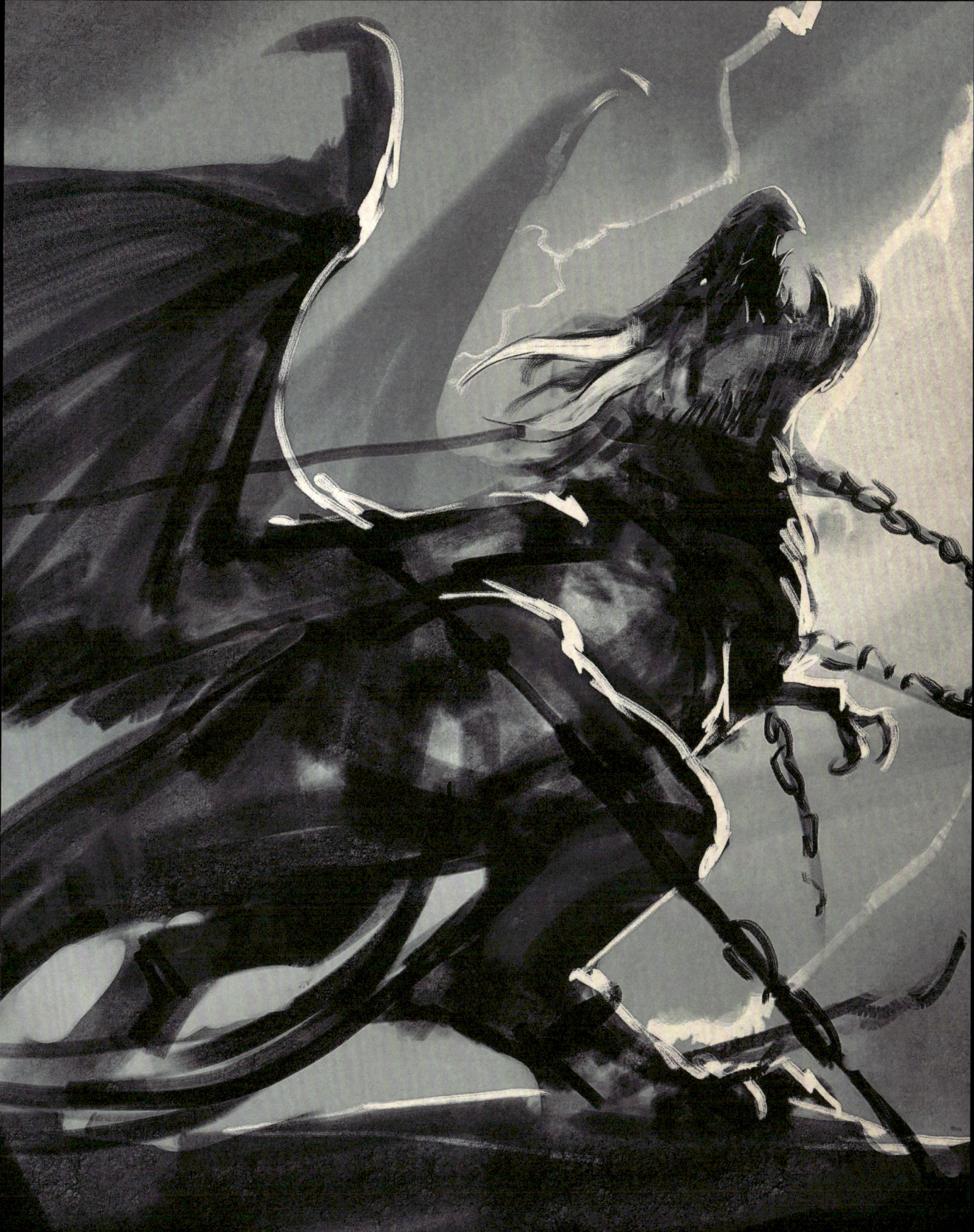

Iridikron the Stonescaled

Asserting himself as the leader of the Primalists due to his strategic guidance and incredible power, Iridikron was also the last Incarnate to be locked away within the titan-forged prison after the Battle of Harrowsdeep. Due to their shared connection to the earth, as well as their meticulous long-term planning, Iridikron was said to be the equal of his former friend and ally, the black Aspect Neltharion.

Iridikron once revered the Aspects for ending the threat of Galakrond, but he quickly grew discontented by the dragonflights' reverence to the titans and claimed them to be little more than the tamed pets of the keepers. Once it was discovered that Order magic had been used on primal eggs, it was easy to convince the others to adopt his views and wage war.

In seeking any possible advantage after the fall of the other Incarnates, Iridikron forged a desperate pact with an unlikely ally: the dragon-hunting djaradin. Though for centuries these fire giants were viewed as bitter adversaries by both broods, their mutual hatred for the Aspects made it possible to find common ground. The unexpected appearance of Igira the Cruel and her djaradin nearly broke the lines of the dragonflights' army, but the unity of the Aspects prevailed, leading to Iridikron's capture and Igira's forced retreat underground.

In a desperate bid to defeat the Aspects, Iridikron forged an alliance with an ancient enemy, the djaradin.

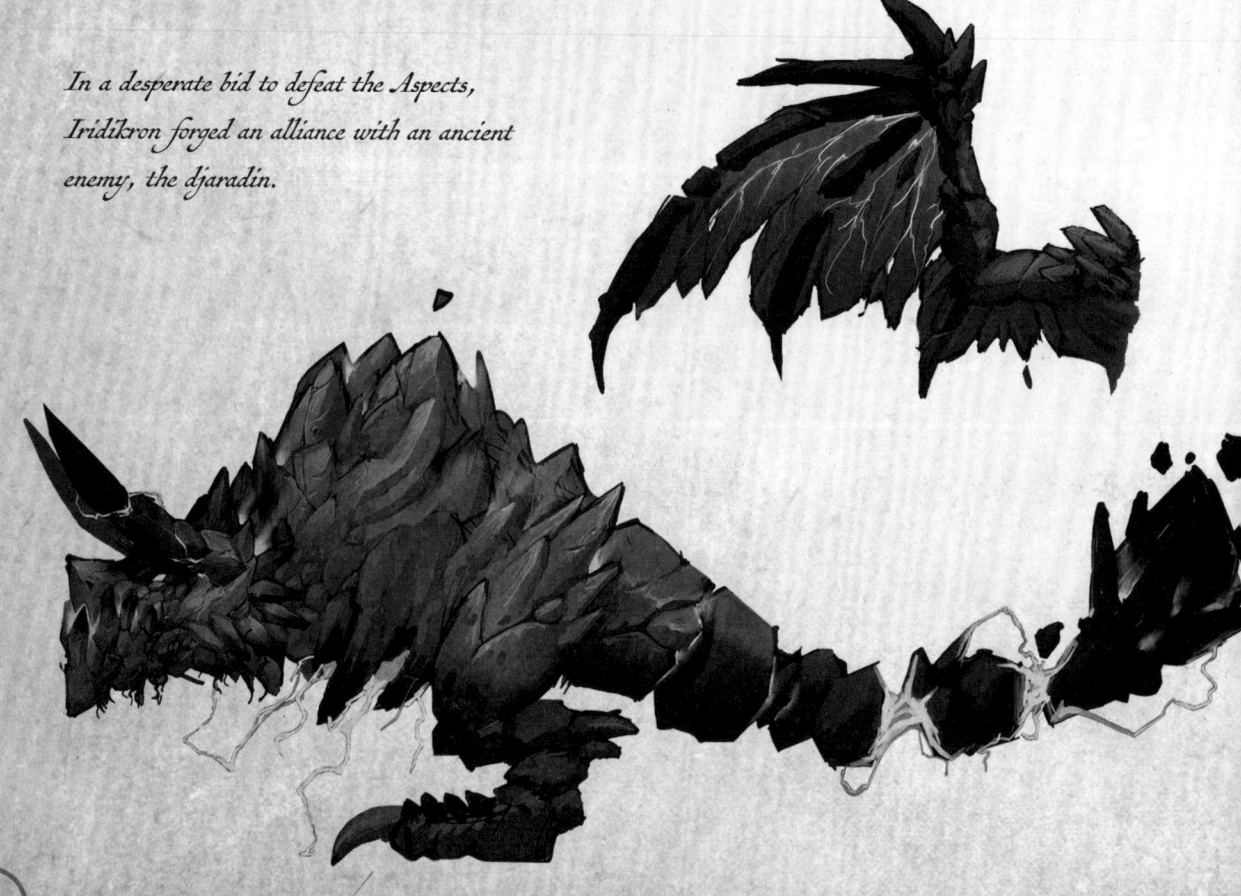

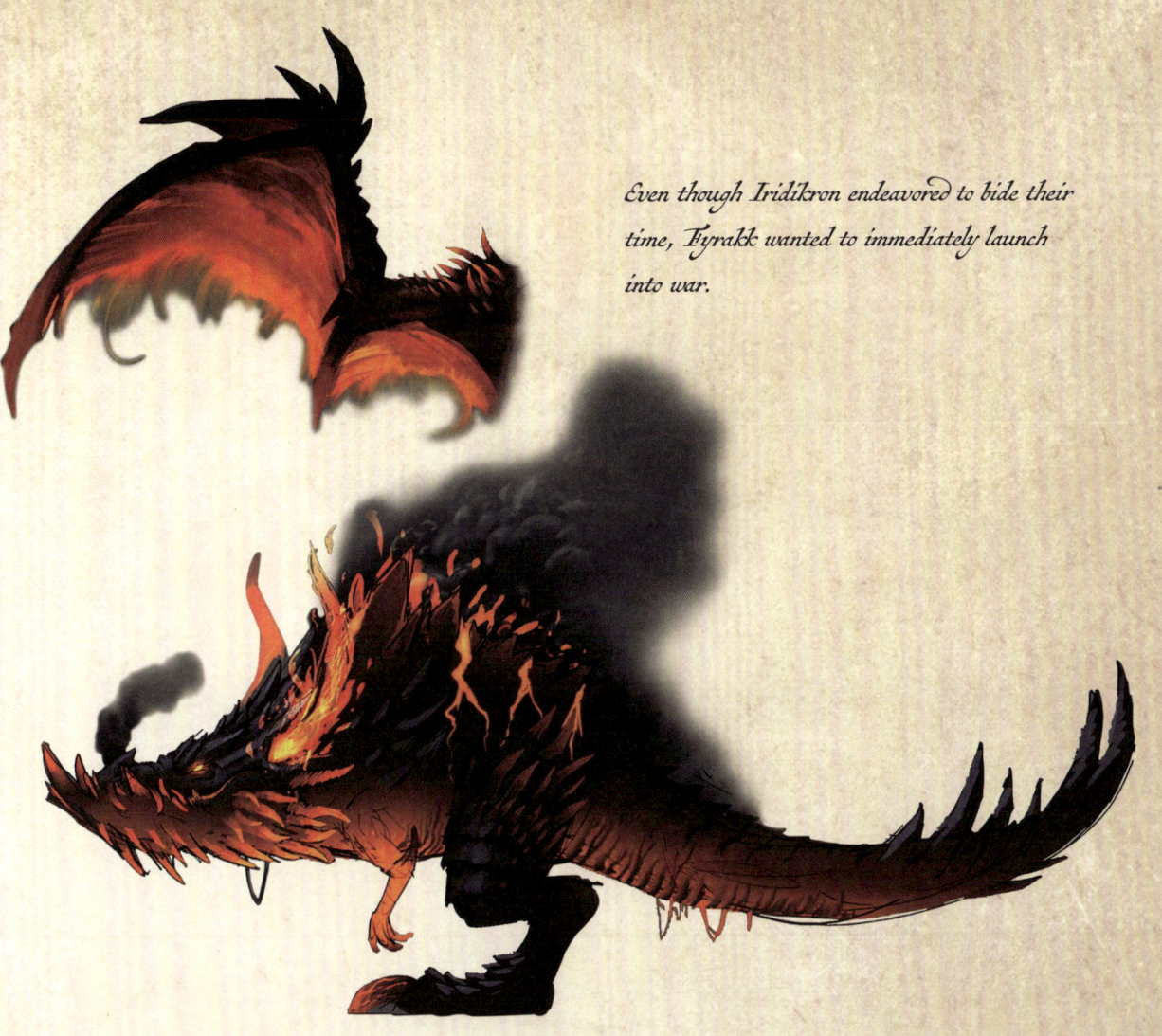

Even though Iridikron endeavored to bide their time, Fyrakk wanted to immediately launch into war.

FYRAKK THE BLAZING ONE

Though Fyrakk was a cousin of the Dragon Queen, his fiery temperament was said to be the utter antithesis of Alexstrasza. Like most primal dragons, he was known to be a fierce and capable hunter, yet honor in battle was not an ideal he sought. Instead, Fyrakk built a reputation as being especially cruel to his foes and was viciously driven to inflict pain and carnage upon his enemies.

Fyrakk's volatile temper and unwavering dissent also drew the unordered dragons together to form the Primalists. Having discovered the secrets to unlocking greater sources of elemental power, Fyrakk claimed that he and his fellow Incarnates were the true future of dragon evolution on Azeroth and that peace with the dragonflights was not only impossible, but intolerable. Although the Aspects were most concerned with Iridkron's scheming, Fyrakk's aggression made him the most widely feared, even among his own Primalist forces.

According to the archives, Fyrakk was the second Incarnate to be defeated and imprisoned, following the Battle of Flamesfall.

Those with a mind for battle tactics are most often the strongest voices for peace.

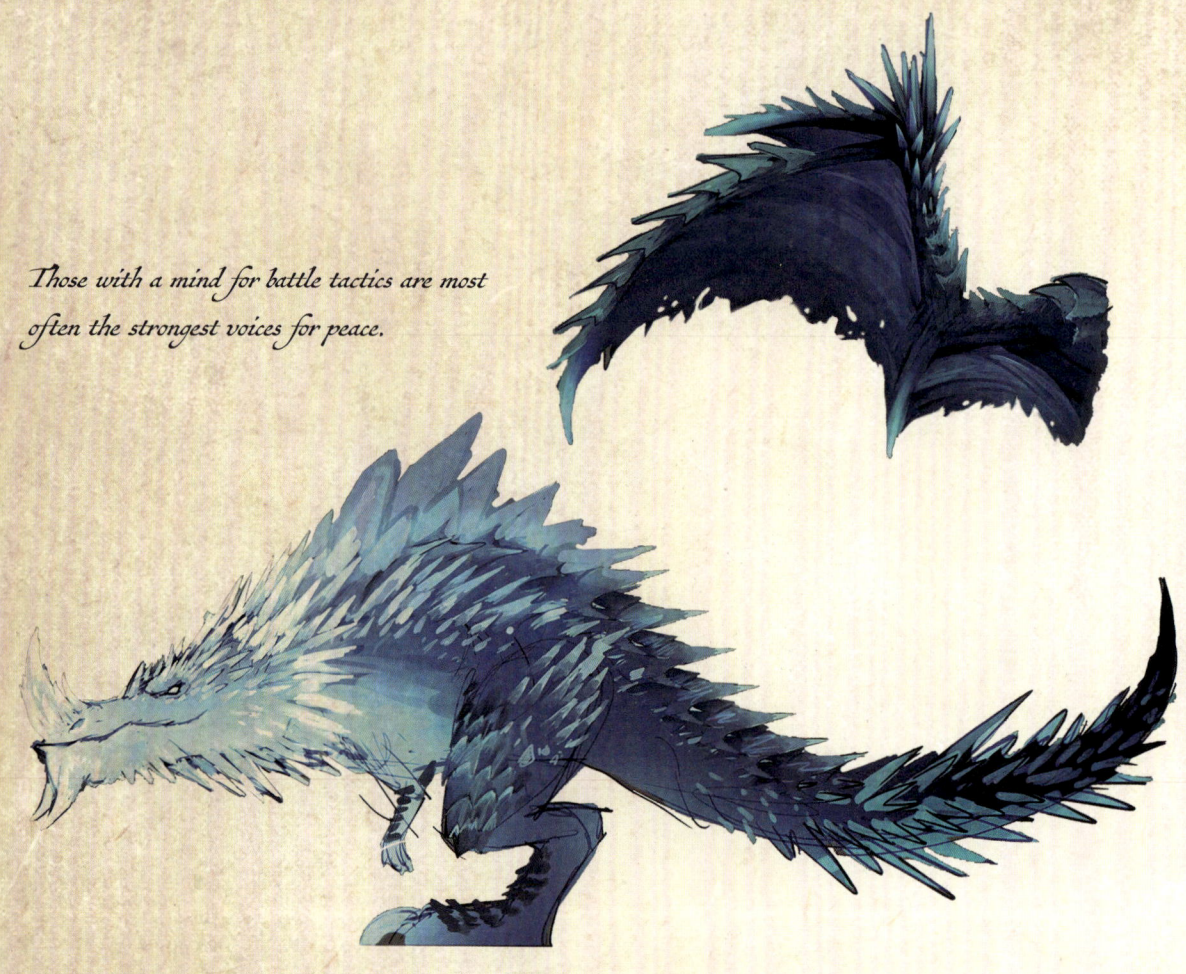

VYRANOTH THE FROZENHEART

Any hope for peace between the dragonflight and Primalist forces resided in the friendship between Alexstrasza and the primal dragon Vyranoth. Opposite of her close friend Raszageth, Vyranoth exhibited both a keen wisdom and a methodical intelligence that she applied to the deepening problems facing both broods. Though she initially rebuffed Fyrakk and Iridikron's invitation to join the Primalists, Vyranoth could no longer ignore the threat she saw from the titan's magic when she discovered that not only had Neltharion imprisoned Raszageth, but also that Alexstrasza had allowed a number of primal eggs to be infused with Order magic.

Accepting then the Primalist conviction that dragonkind was meant to draw its strength from the elements, Vyranoth allowed herself to be imbued with the elements to become the Incarnate of Ice. The addition of her measured and strategic thinking proved a vast boon to their cause over the many years of war until her final defeat and imprisonment following the Battle of the Icebound Eye.

Raszageth the Storm-Eater

As with most primal dragons who refused to be ordered, Raszageth argued that dragonkind was meant to be wild and untamed, much in reflection of the chaotic storms themselves. As such, she viewed the titans as intruders and subjugators whose "gift" of Order magic would instead chain her kind to their will.

It was not difficult to find others who felt as Raszageth did. Soon, she joined with Fyrakk and Iridikron to become the Incarnate of Storms. Together, they set out to recruit an army of tarasek with which to wage war upon the Aspects and their dragonflights.

Raszageth was the first Incarnate to be imprisoned after she led the Primalist forces against Neltharion and his dracthyr in a cunning sneak attack on what is now known as the Forbidden Reach. Though her gambit nearly overwhelmed the black Aspect and his forces, Neltharion called upon the powers of the Void to subdue and imprison Raszageth, thus breaking her offensive. Once word of the brazen assault reached the Dragon Queen, Alexstrasza made a final plea to the Incarnates for peace. Their response was an all-out attack upon Wyrmrest Temple led by Iridikron. Thus, the War of the Scaleborn began in earnest.

Had it not been for Neltharion's connection to the Void, Raszageth's gambit could very well have succeeded.

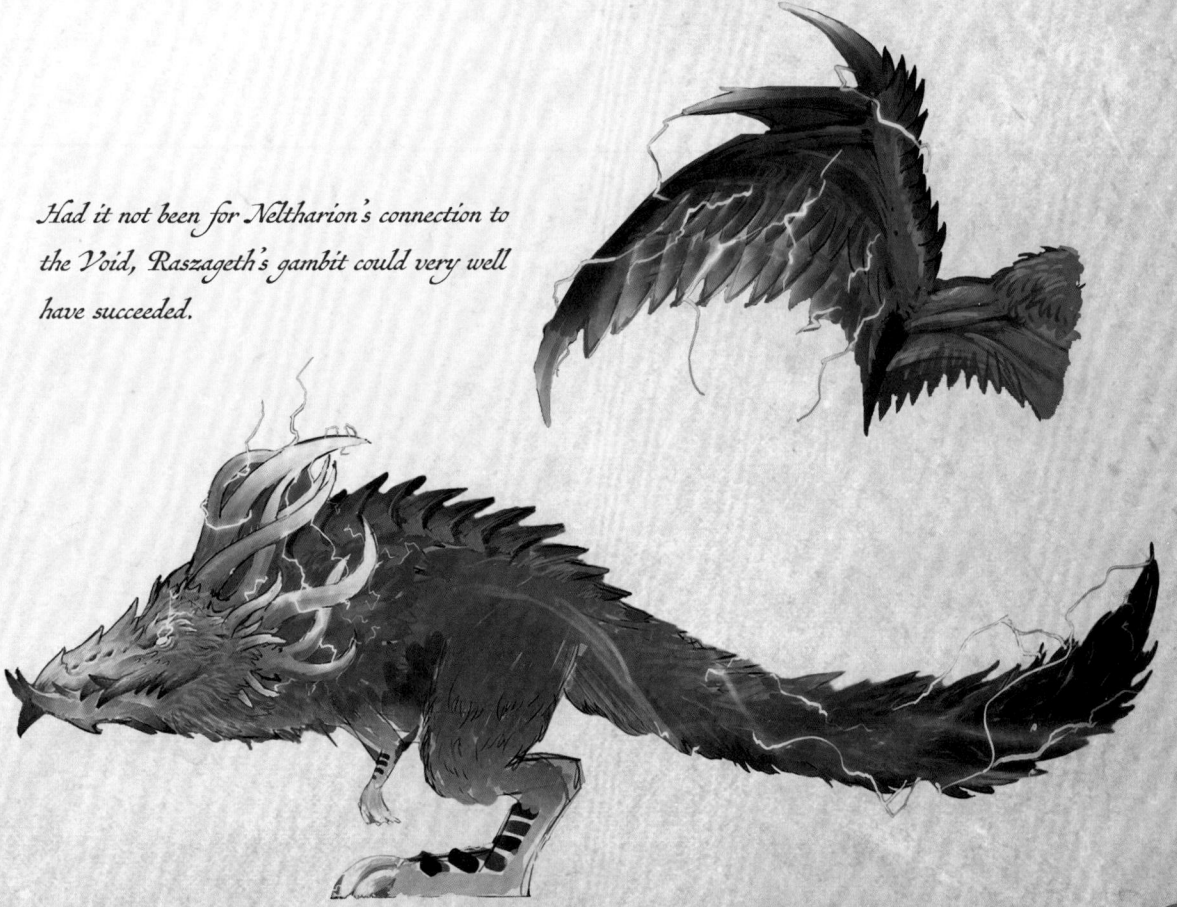

INFINITE DRAGONFLIGHT

Prophets warn that to know the moment of one's death is to invite madness and despair. Given the choice, few would willingly accept such a glimpse into their future, yet such is said to be the reality for every member of the bronze dragonflight. As keepers of time who navigate the pathways of the past, present, and future, such knowledge is both an unavoidable reality and an inevitable fate due to the sacred titan pledge that prohibits their interference.

Yet what if the future held something truly catastrophic, a vision of death and carnage so consuming that it threatened the entirety of existence? When weighed against preserving the sanctity of all life in the universe, of what possible value is a titan directive? Given the chance to alter such a grim future, who wouldn't be tempted to stray from the primary timeline? The correct decision seems to lie somewhere between the opposing directives of the bronze and infinite dragonflights.

With the powers of the Aspects lost and the Hour of Twilight averted, all we can do is hope that our defiance of the infinite dragonflight's vision proves to be the right choice.

While they await their corrupted Aspect, the infinite dragonflight has no leader.

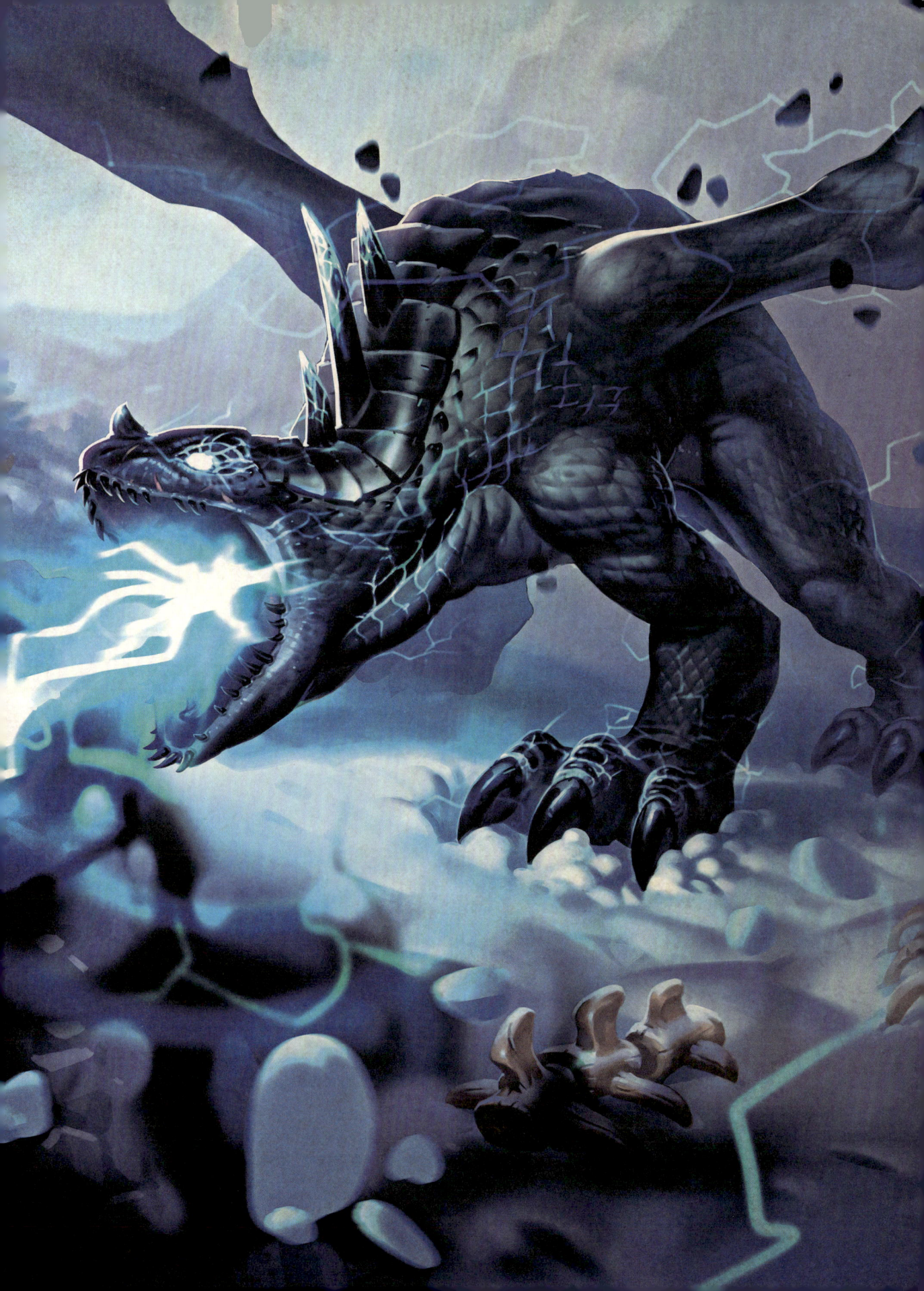

MUROZOND

The Lord of the Infinite • Corrupted Aspect of Time • Leader of the Infinite Dragonflight

No one knows whether Nozdormu's corruption is the result of upholding his oath to the one true timeline or of betraying it.

It is said that, from the moment of Nozdormu's ascension to Aspect, he already knew the way his life would end. If this is true, then it may also mean that the Timeless One has carried the burden of his inevitable corruption over the many long millennia of his existence.

Such intricacies of time are often difficult for mortals to grasp, for the infinite branching possibilities of the pathways are simply too vast to comprehend. In the simplest terms, for every change made, a ripple of consequence is created that often proves far worse than the original tragedy it sought to avert. It is for this reason that the bronze dragonflight's prime duty lies in safeguarding the sanctity of the one true timeline.

Despite the importance of his charge, it is known that the Aspect of Time will eventually turn away from the directive of Highkeeper Ra and seek to bring about the end of all life on Azeroth. For Nozdormu, his transformation into the corrupted Murozond has always been not a matter of if, but when. Yet with the Hour of Twilight averted, the question arises whether Nozdormu's grim future has been changed or whether the victory over Deathwing was merely an expected step along the path to the true End Time. That the infinite dragonflight continues to meddle with the flow of time and seek the Aspect's corruption seems to warn the latter.

Reports of an infinite dragon acquiring a First One artifact is of equally dire concern. Luckily, it was retrieved after a Broker from Tazavresh stole it.

OCCULUS

The Pure • The Corrupted

Occulus was once a devoted member of the bronze dragonflight and a guardian of the Caverns of Time, so his sudden corruption was as chilling as it was mysterious. The young drake was soon discovered roaming the searing Tanaris desert while prophesying about the rise of the infinite and the end of the Keepers of Time.

Unsettling as his madness was, it was the drake's altered appearance that most disturbed the bronze dragons who dared to approach. In place of his brilliant, golden scales was a hide blackened to deepest night, interlaced with cracks of raw, colorless energy.

As Occulus foretold, he was not the last time-shattered dragon the bronzes would encounter.

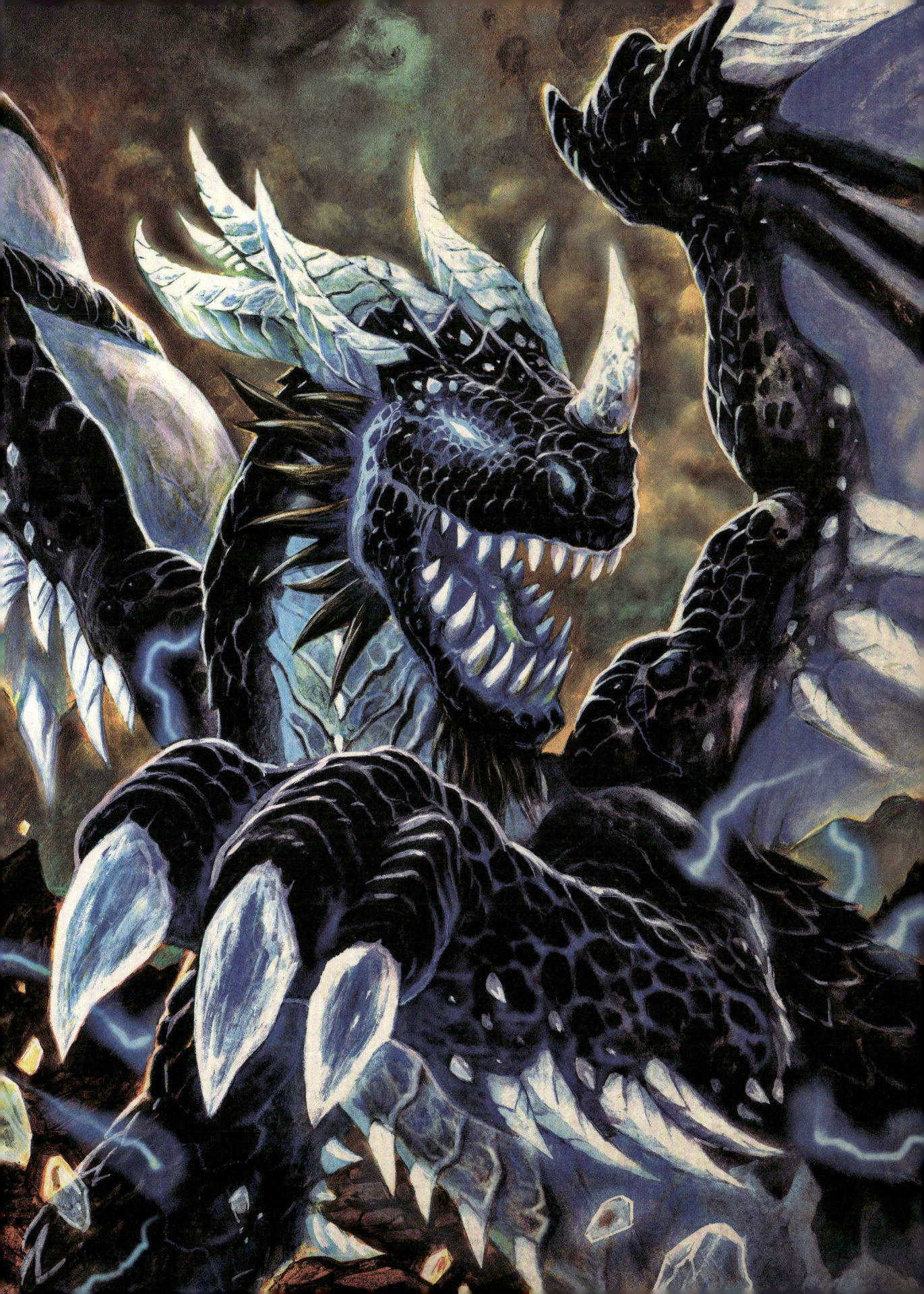

EPOCH HUNTER

Agent of the Infinite Dragonflight

Seeming to lie at the heart of the infinite dragonflight's early mission was the Legion's second invasion of Azeroth. For reasons that remain unknown, the infinites sought to change the history of the Legion's defeat by going back in time to remove any hero capable of preventing Azeroth's destruction.

To these ends, the infinite sent the drake Epoch Hunter to interfere with Thrall's historic escape from Durnholde Keep. Raised by the human Aedelas Blackmoore and trained as both a gladiator and a strategist, it was from this fated moment that the Horde gained its most essential and respected Warchief and the Earthen Ring gained its most powerful shaman. Most historians believe that, without Thrall to lead the Horde and broker peace with the other factions of Kalimdor, the Legion would have claimed our world.

Thanks to the efforts of several mortals and the guidance of the bronze dragons Andormu and Erozion, Epoch Hunter was defeated, and the sanctity of the timeline was restored.

Remove the keystone, and even the mightiest structure will come crashing down.

AEONUS, DEJA & TEMPORUS
Chrono-Lords of the Infinite Dragonflight

Deep within the Black Morass, a group of mortal champions bore witness to the historic moment as the last guardian of Azeroth summoned a gateway between worlds. This figure was Medivh, the most powerful human mage to ever exist, and the moment was the opening of the Dark Portal that ushered in the orc invasion of Azeroth. Yet rather than alter such a tragic event to prevent the resultant war it created (as many might expect), the group was sent by Andormu to safeguard it from a concerted attack led by Temporus of the infinite dragonflight.

After their earlier failure to kill Thrall, the infinite chose a moment further back in time in which they could prevent the arrival of the orc clans altogether. To overwhelm the mortal defenders protecting Medivh, several portals were opened to admit waves of corrupted dragonkin in advance of Temporus and Chrono-Lord Deja's arrival in the battle. Though the infinite forces threatened to overwhelm the fighters at many points, they ultimately triumphed over the time-stop spell work of Aeonus and ensured the completion of Medivh's crucial task.

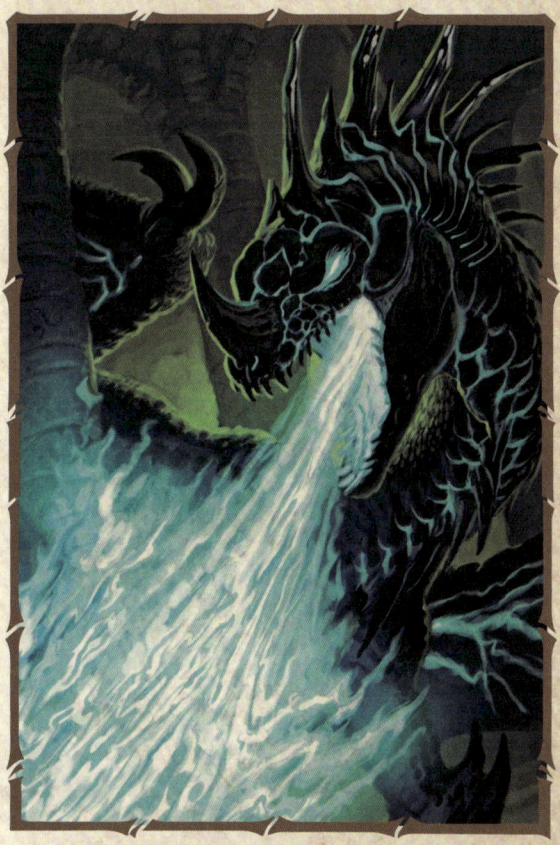

Had the infinite succeeded, the horrors of the First War would never have happened.

Though the defenders are largely seen as heroes for preserving the timeline, many wonder if it wouldn't have been better to allow the infinite dragonflight to stop Medivh. As witness to so many of the resulting tragedies of my former master's actions, I, too, am guilty of spending countless hours in such endless and tiring debate. Yet for all the horrific loss of life incurred during the First and Second wars, historians largely agree that, without the combined might of the Horde and the Alliance, the Legion's second (and, most likely, third) invasion of Azeroth would have succeeded.

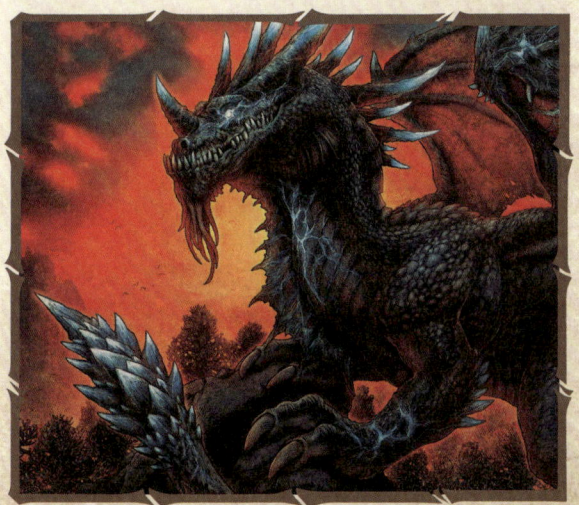

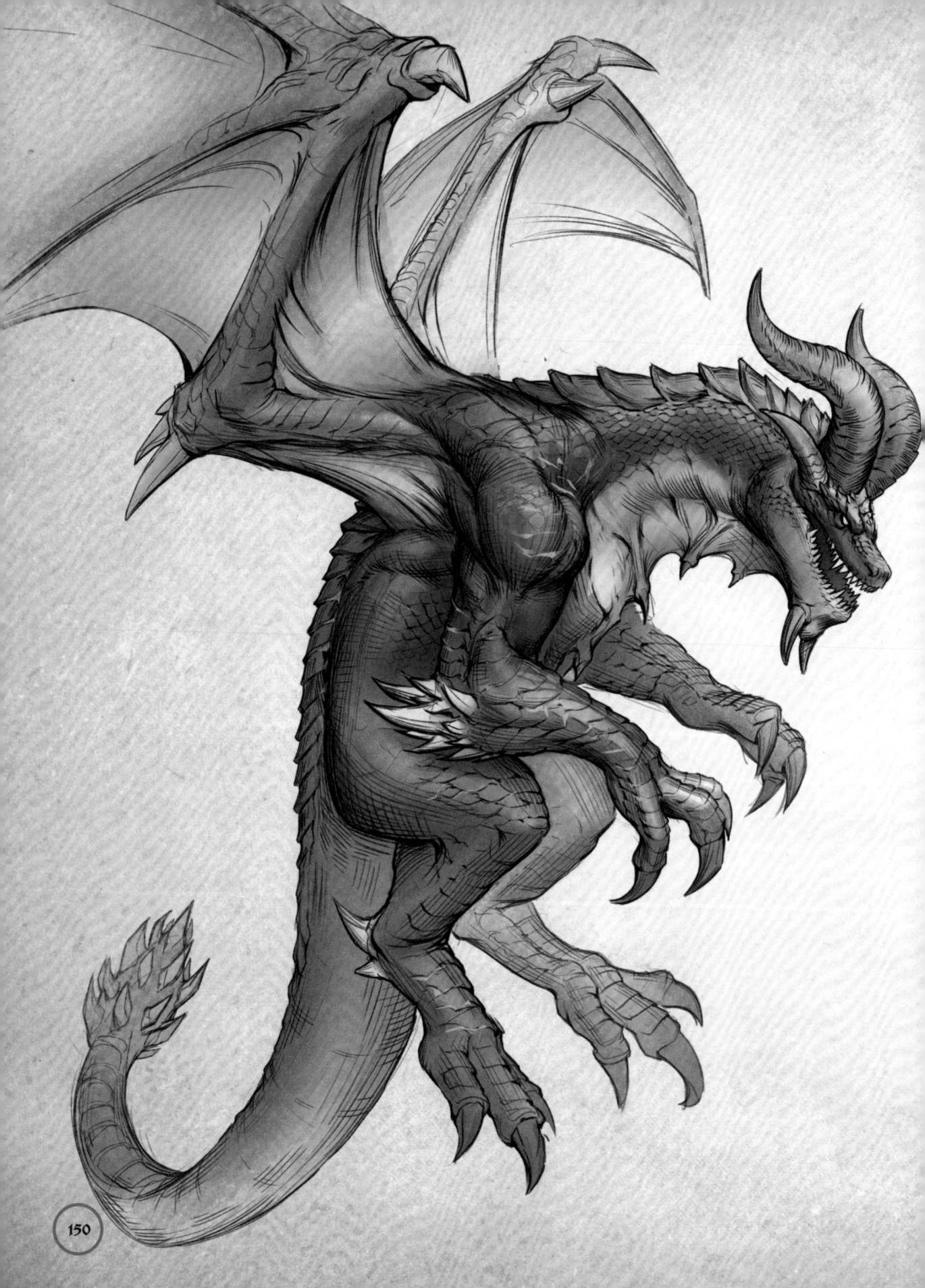

ETERNUS

Exhibiting a deadly combination of keen intelligence and ruthless determination, Eternus has emerged as one of the most concerning members of the infinite dragonflight. As with most of her brood, it is said that she sees their infinite condition not as corruption, but as the inevitable evolution of dragonkind. Likewise, she claims that the conversion of Nozdormu into the infinite Aspect will herald the next major advancement for her dragonflight and their control of the time pathways.

Though she doesn't seem to share the same aggressive tendencies as others of the infinite brood, Eternus is said to view the bronze's titan directive as heavily flawed and a subversion of dragonkind's true destiny.

Aside from Nozdormu, the infinite dragonflight has not typically attempted to recruit the bronze; instead, the dragons await their kin's eventual awakening.

CHRONO-LORD DEIOS

As with most infinite plots, it is unknown whether Chrono-Lord Deios acted upon his own plans or served as part of a more concerted campaign. What seems certain, however, is that his primary goal was to prevent the Aspects from regaining their lost power.

After a group of champions was sent to explore the possible existence of an important artifact in the keeper vault of Uldaman, Chrono-Lord Deios interfered with their attempt, to ensure none could challenge the infinite's control of the timeways. Chrono-Lord Deios's efforts to prevent our success in Uldaman gives some small hope that perhaps a path does exist to averting the Aspects' fall.

The titan-forged vault of Uldaman had long been explored and mapped, its treasures thought discovered. Little did we know that more still awaited discovery.

END TIME

A desolation like none ever known by the living pervades this sacred plain of ash and dust. Within the once vibrant dragon shrines, crimson petals and emerald tears lie drained to blackened husks. Impaled atop the delicate titan architecture of Wyrmrest Temple hangs the shattered remains of the Destroyer, his blood still smoldering ages later with the horded rage of the long-dead elements. The sun has set on the age of mortals, leaving behind only twilight.

Yet in the distance, the flapping of wings suddenly draws the eye: It is a dragon of immense size with blackened scales that crackle with the volatility of lightning. Behind him stands a familiar device of glass, bronze, and sand—an artifact out of time and of time itself. In this reality, the infinite Aspect shares the same wind-scoured fate as almost every other soul on Azeroth. What you see before you is merely a dragon counting the moments until his own inevitable demise.

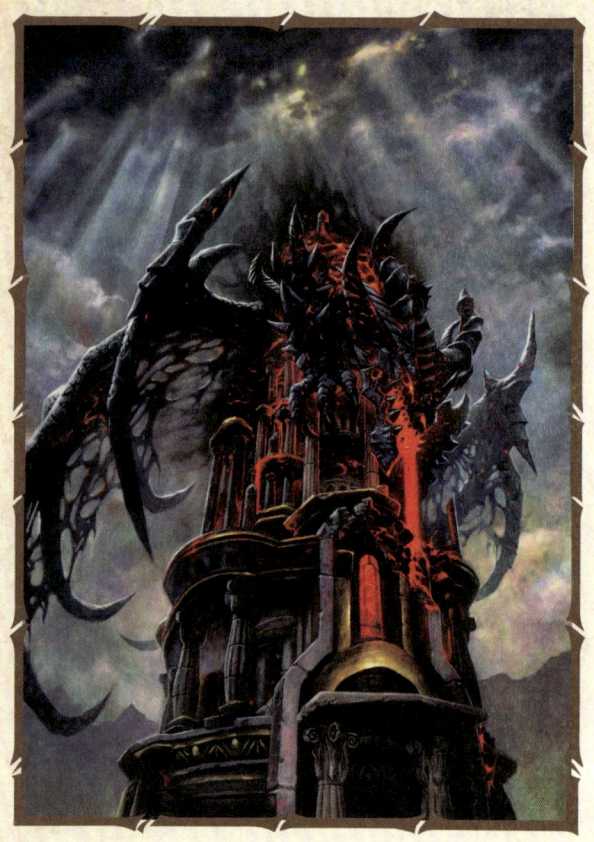

TARREN MILL

Bountiful farmlands give way to forested hills teeming with all manner of wild game. Here, the scars of war lie hidden amid the tall grass in the form of rusted blades and orcish war hammers. Within the neat rows of apple trees, one can recall the glory of Lordaeron and perhaps momentarily forget the ravenous undead wandering the neighboring Silverpine Forest. For the sons and daughters of Arathor who dreamed of peace, only ruin awaited them at the intersection of two worlds.

Yet from the ashes of such differences, a friendship formed. Among the simple homes and shops of this tiny hamlet is a human girl who showed love and compassion for a hated enemy, thus forever forging the fires of peace in the heart of a warchief.

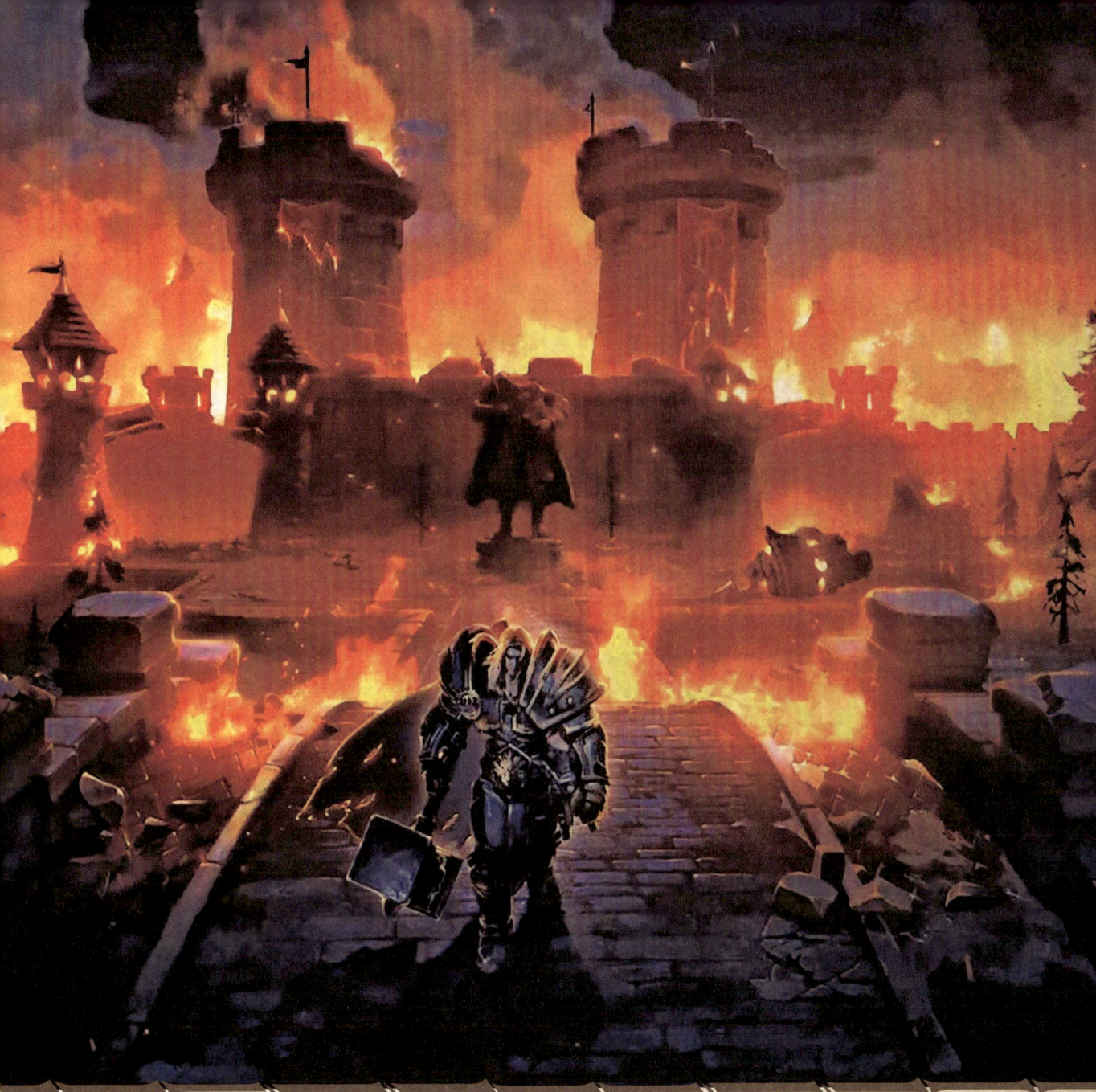

STRATHOLME

Plague fires burn through this once glorious city of stone and light as shambling forms flit from one shadow to the next. Sacks of freshly reaped grain lay abandoned before storefronts, and an odor of rot seeps from between the weaves of burlap. In the distance, the chilling screams of innocents are silenced by the blows of a paladin's once righteous hammer.

Waiting amid such chaos and despair is the nightmare's architect, a dreadlord born of the Prideful to serve the will of a Dark Titan. In the Legion's name, he has controlled entire worlds—yet tonight, he seeks only to drown a single soul in darkness.

TWILIGHT DRAGONFLIGHT

Most incorrectly assume that the twilight dragonflight was so named due to its affiliation with the Twilight's Hammer clan and the doomsday prophecy called the Hour of Twilight. Thanks to the detailed account of Archmage Rhonin, we know that the true origin lies with the draenei priestess Iridi, who first described the nether-infused dragons encountered within Grim Batol as bearing a striking resemblance to the twilight sky of Azeroth. Existing as an ascendant merge of netherwing essence and native dragon physiology, the twilight brood is as beautiful as it is deadly. Though the dragons were created only after the opening of the Dark Portal, the story of the twilight dragonflight begins much earlier, with Deathwing's ancient betrayal at the Well of Eternity.

Desperate to halt the volatile energies tearing his body apart after wielding the Dragon Soul, Neltharion retreated to his lair in Highmountain and all but abandoned his flight to the vengeance of the other Aspects. While most of Deathwing's consorts survived until his eventual return, nearly all perished during their Aspect's attempt to repopulate their devastated flight. Foreseeing her own inevitable demise and the certain end of the black dragonflight, Sinestra turned her attention toward creating a new type of dragon that would rule all others.

Claiming the Dragonmaw's former stronghold of Grim Batol after the Dragon Queen's escape, Sinestra succeeded in channeling the siphoned energy of the nether dragon Zzeraku into the various eggs she had stolen from the other flights. Though Sinestra's results were unstable and ultimately led to the prime consort's death when Dargonax exploded, Deathwing continued her work to rebuild their flight before the Hour of Twilight.

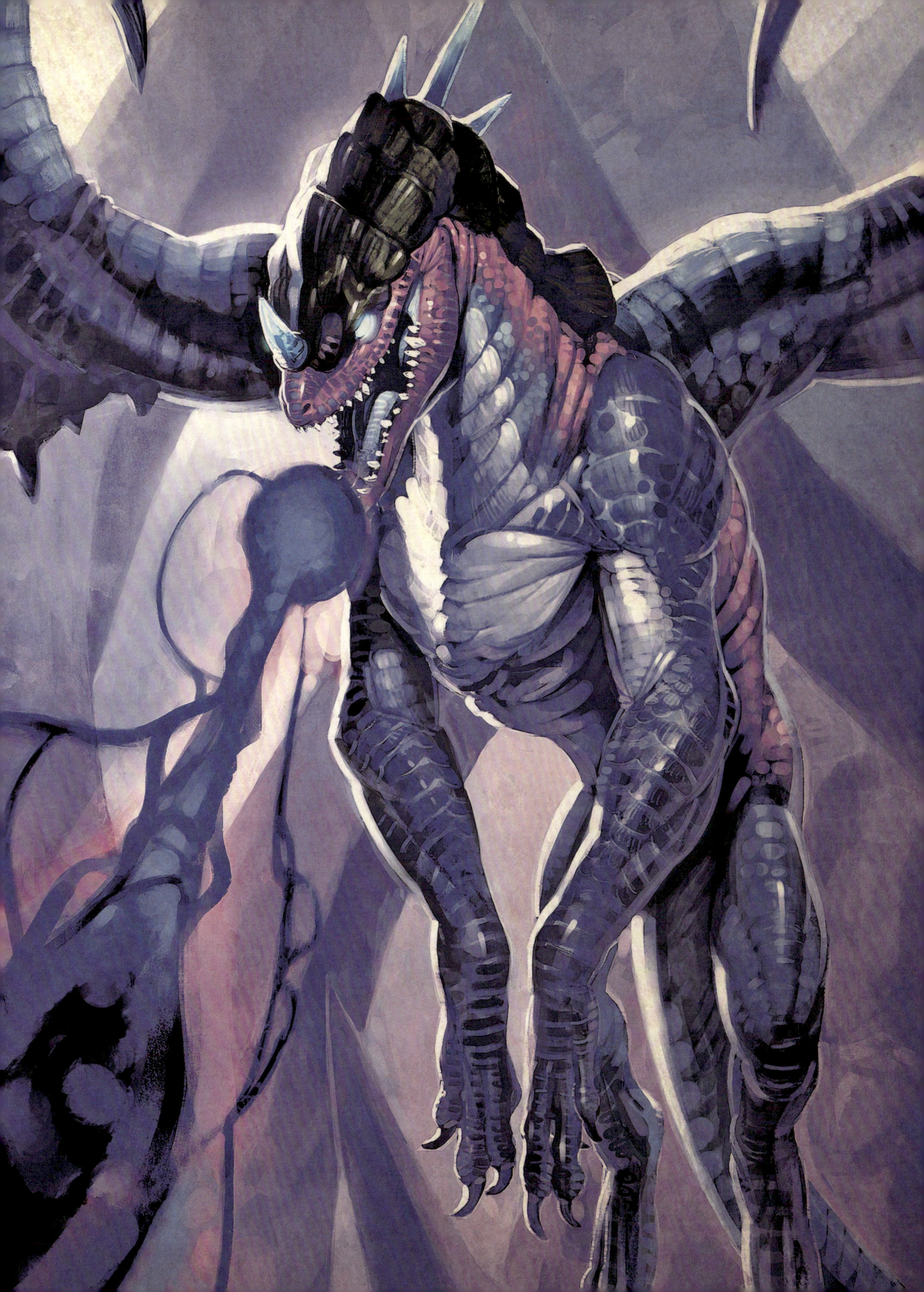

HALION
The Twilight Destroyer

With the focus of the Wyrmrest Accord turned toward the offensive against the Lich King, a warband of black and twilight dragons took advantage of their distraction to storm the Ruby Sanctum beneath Wyrmrest Temple. Their primary intent was to steal the red dragonflight's clutch to create more corrupted dragons, but many also considered the brutal attack an act of retribution for the death of the Onyx Guardian Sartharion and the twilight dragon eggs he guarded. Together with the black dragon lieutenants Saviana Ragefire, Baltharus the Warborn, and General Zarithrian, Halion led a merciless raid on the Dragon Queen's sanctum.

With its guardians slaughtered, the difficult task of reclaiming the fallen Ruby Sanctum fell to the same mortal champions who had led the assault on the Obsidian Sanctum. Yet rather than face towering waves of lava and the blaze of fire elementals, the heroes encountered the full fury of a twilight dragon capable of inhabiting multiple planes of reality.

Thanks to the mortal commander's brilliant tactics, the heroes divided their numbers between both the physical and the twilight realms to bring Halion to a swift end.

Relieved to find its eggs safe, the red dragonflight never suspected that Halion's attack was a mere precursor to the enemy's true efforts. With the defenses of the sanctums weakened by the death of its defenders, it proved an easy task for the Twilight's Hammer to infiltrate and corrupt the eggs of each dragonflight. By the time Korialstrasz discovered their malicious deed, it was already too late to purify the clutches. To save his beloved Alexstrasza and the other Aspects the pain of destroying their own eggs, the red consort sacrificed himself to raze the sanctums and eradicate the dragonflights' tainted offspring.

The ability to shift between realms was once the sole dominion of the green dragonflight.

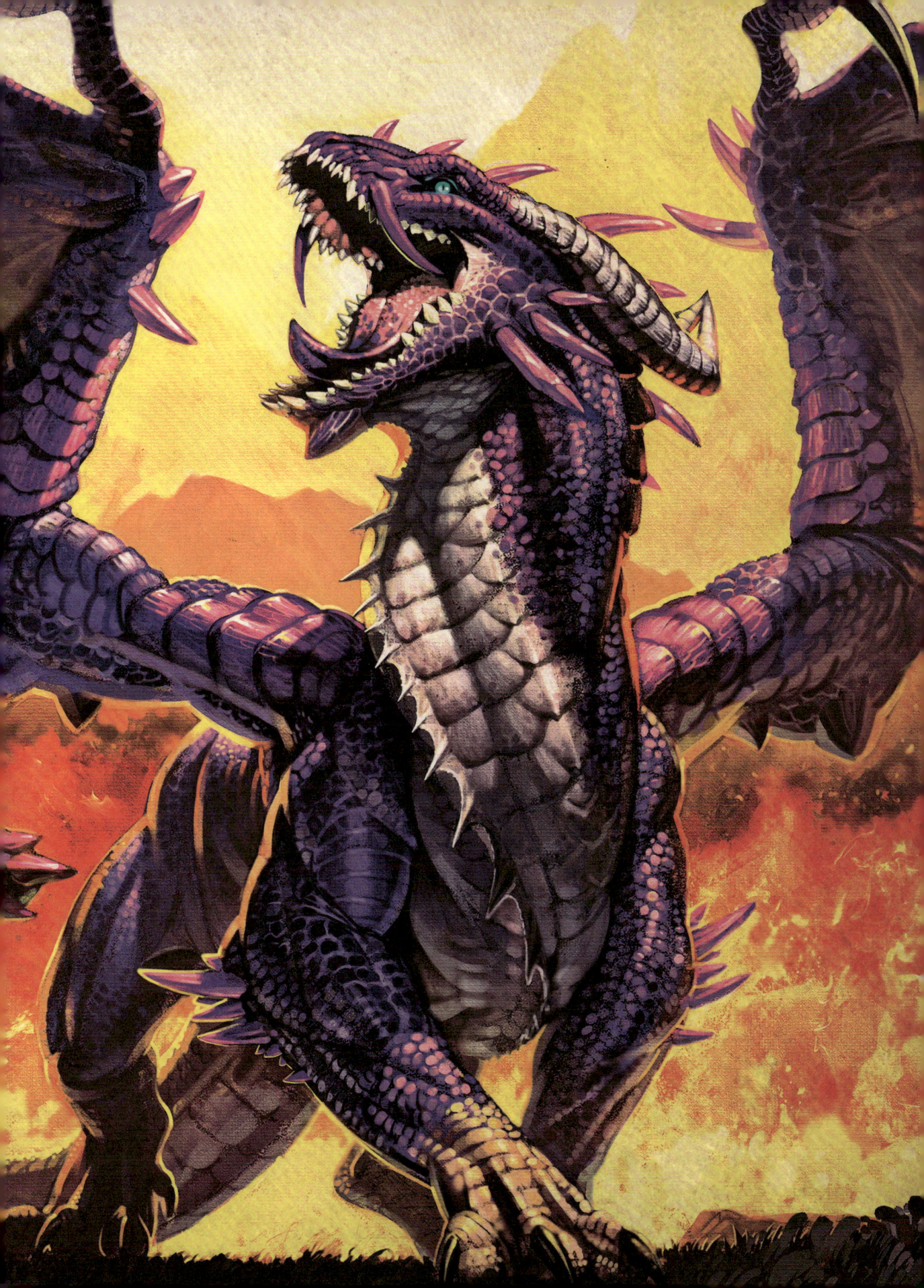

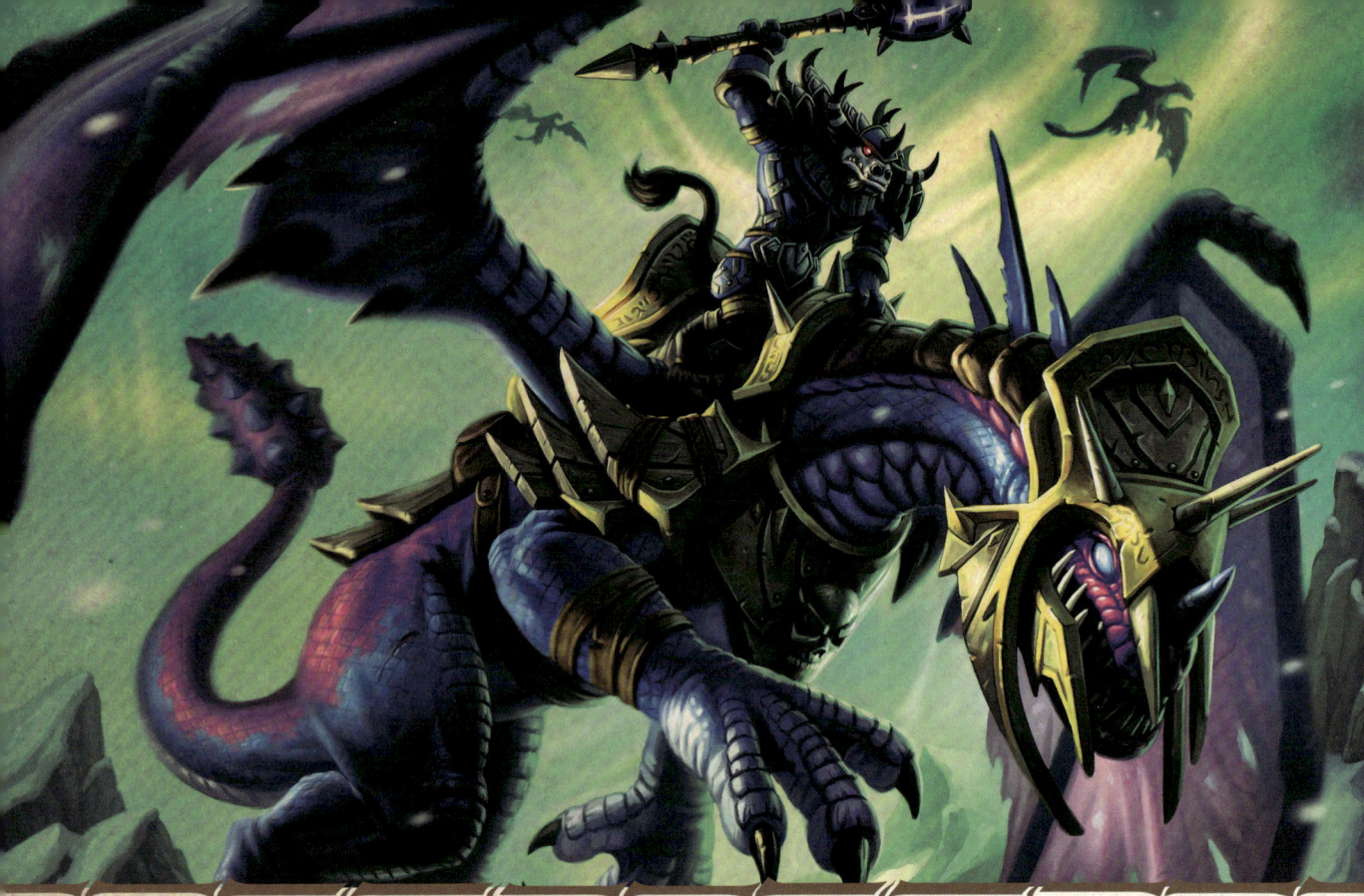

GORIONA
Battle Mount of Warmaster Blackhorn

Witnesses from the upper balcony of the Wyrmrest Temple speak of the incredible blast of draconic and elemental energy that surged forth from the Dragon Soul, dealing a catastrophic blow to the Aspect of Death. Where only moments earlier Deathwing gloated of his certain victory, he now recognized that another hit from the accursed weapon would mean his certain downfall. Seeing no other choice but to flee toward the Maelstrom and the safety of Deepholm once more, the black Aspect did not anticipate his enemy's dogged pursuit.

As Deathwing fled to the south, warriors of the Horde and the Alliance quickly assembled aboard the *Skyfire*, one of the few airships capable of matching speeds with the wounded black Aspect. Yet as Sky Captain Swayze leveled his ship above Deathwing in preparation of attack, the pursuers came under an impressive volley by the twilight drake Goriona. She continued to assail the ship after delivering Warmaster Blackhorn to its decks, but she later abandoned her tauren master once it was clear that he had failed in his efforts to take the vessel.

Though there have been no recent sightings, most believe that Goriona survived the siege of Wyrmrest and remains one of the few twilight dragons still in existence.

Only by working together could the Horde and Alliance manage to prevent Deathwing's escape back into Deepholm.

ABYSSION
Guardian of the World Pillar Fragment

After Deathwing shattered the World Pillar to usher in the Cataclysm, the mortal races struggled merely to survive the earthquakes, tidal waves, and devastating flames that consumed many of their cities and homelands. Under such dire conditions, they knew nothing of the many active plots initiated by the Twilight's Hammer to bring about the Hour of Twilight. They also were unaware that the cultists had already infiltrated the Stonemother's elemental realm of Deepholm.

Their presence was uncovered only thanks to the shamans of the Earthen Ring, who sought to restore the World Pillar and prevent the Elemental Plane from crumbling into Azeroth. Yet as they attempted to piece the titan artifact back together, the shamans discovered that an essential fragment was being guarded by a twilight dragon named Abyssion. Believing that all mortals were weak, Abyssion recklessly attacked the group, only to be captured by their superior elemental power and easily defeated. Upon inspecting the twilight dragon's lair, the Earthen Ring found a large cache of twilight eggs and exposed the fact that Deathwing had been using Deepholm as a replacement for the Obsidian Sanctum.

One dragon versus the Earthen Ring? I almost feel bad for Abyssion. Almost.

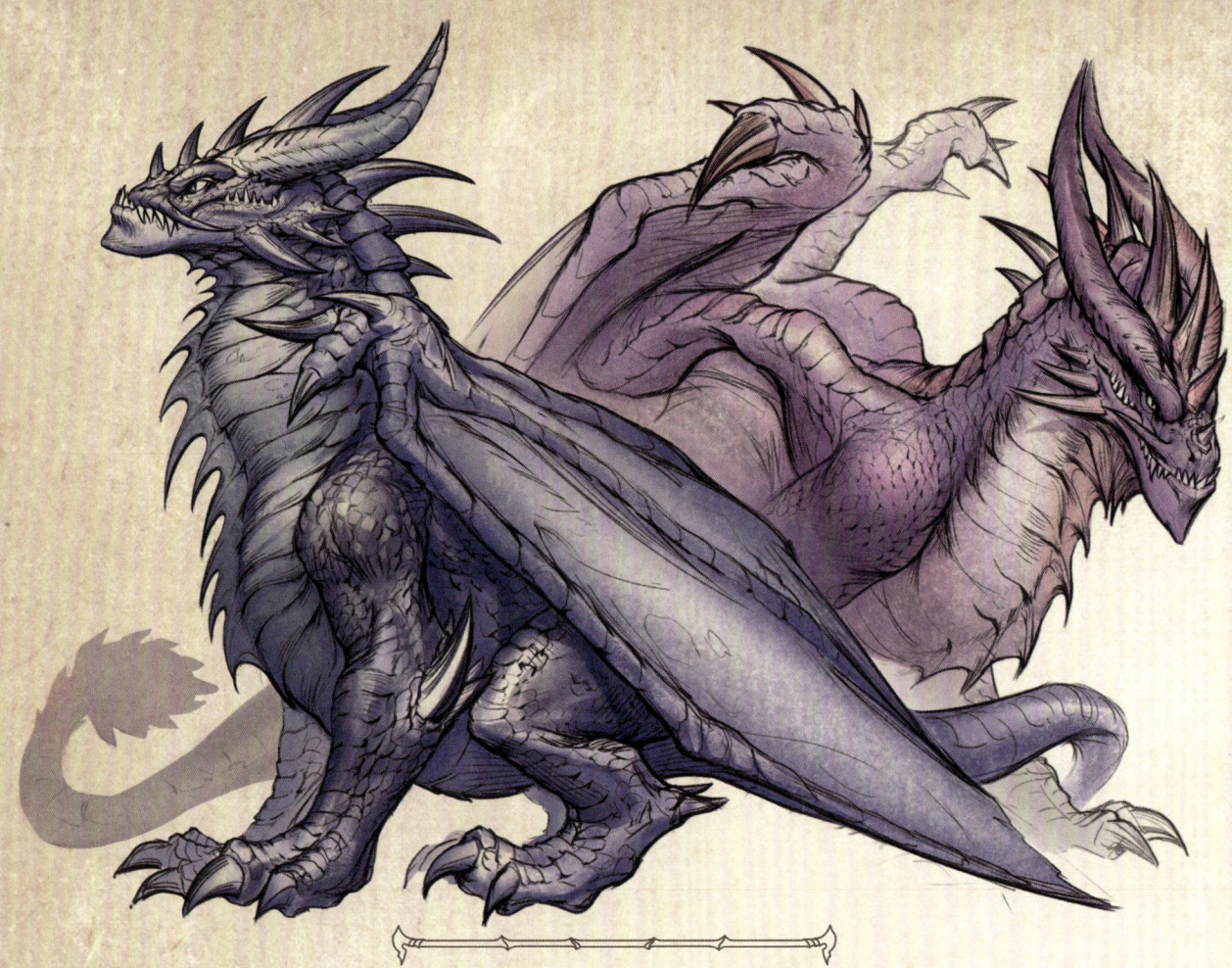

THERALION & VALIONA

Paragons of the Twilight Dragonflight

Even from within their eggs, whelps have the uncanny ability to sense the world around them and the essence of other living creatures. As a result, dragons often speak of forming deep bonds with their clutch-brothers and -sisters, even across various dragonflights. Whether a result of the Old God's corruption or their accelerated maturity, the twilight dragons Theralion and Valiona proved quite the exception.

Raised within the Bastion of Twilight to represent the apex of the flight's capability and cunning, the siblings seemed to present almost as much danger to each other as they did to the mortal fighters who bravely sieged the Void-cursed tower. Much like the twilight dragon Halion, who assailed the Ruby Sanctum, Theralion and Valiona exhibited an affinity for shifting effortlessly between both the physical and twilight realms, yet they also wielded a terrifying array of shadow-casting abilities.

One of the humbler members of the raiding party involved in the defeat of Theralion and Valiona admitted that, had the pair of dragons coordinated their attacks, history would have recorded a different victor in the battle.

The bond between clutch-mates is said to be deep, loving, and everlasting, although some statistical anomalies do occur.

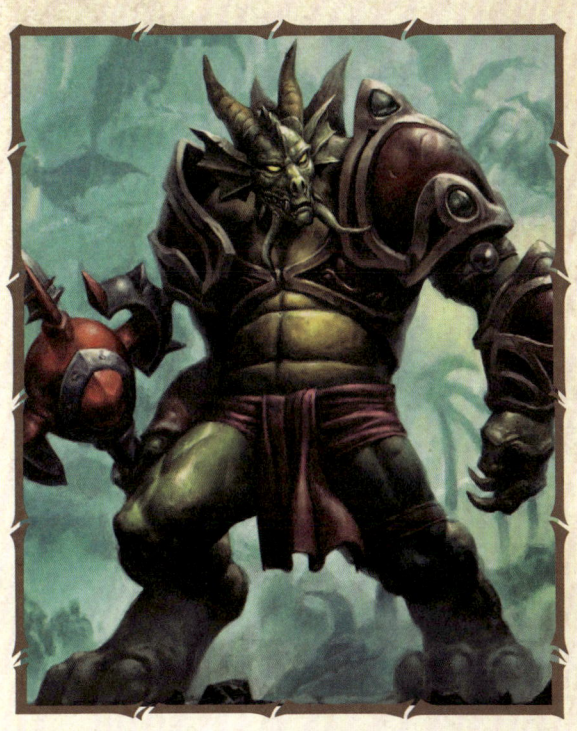

RUBY SANCTUM

Entrance into the sacred shrine occurs through an elaborate, shifting portal within the lowest level of Wyrmrest Temple. In the span of a breath, icy tundra transitions to autumn hills as a rush of delicate perfume greets visitors from the vibrant flora that grows throughout the glade. Towering trees of crimson offer gentle shade for clusters of spiny eggs, each harboring an emerging life that, even now, seems keenly aware of your presence.

A brilliant flash of sunlight draws sharp attention to a huge axe wielded by the sanctum's guardian, an immense dragonkin who regards all newcomers with the same deadly scrutiny. Only then do you spot the eyes of a dozen more and realize that you've perhaps made a terrible mistake in coming here.

BASTION OF TWILIGHT

A piece of windswept terrain sits between a line of towering peaks and an endless, roiling sea. It is a land of refuge and resilience, upheaval and coexistence among the creators, invaders, and former captives of Grim Batol. Here upon the ancient site of Northeron, the dwarves and orcs draw a tenuous peace, united in their mistrust for the mysterious Bastion of Twilight rising in the west.

Even to look upon the twisting, ebony tower is to sense the very madness and despair of the Void. Its seeping energy fouls the water and taints the air, turning the wildlife into twisted manifestations of its hateful corruption. For all who revel in the malevolent whisperings of the Old Gods, it stands as a monument to the very end they seek and the annihilation of all that ever existed.

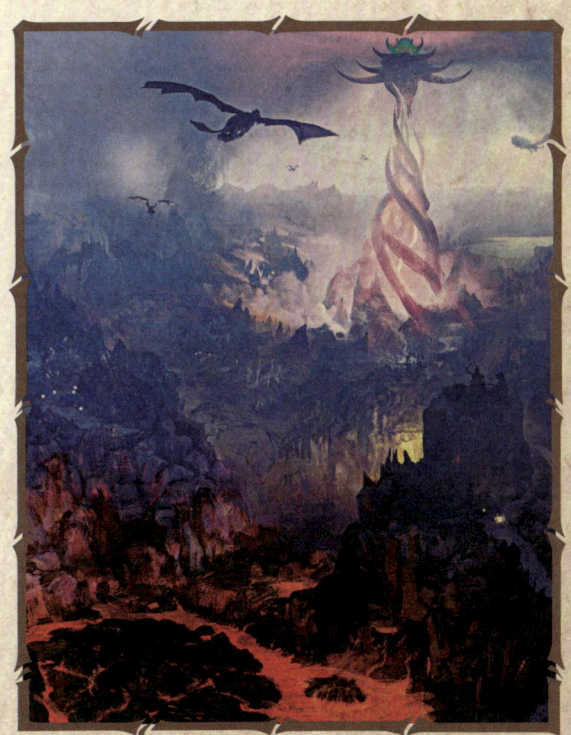

NIGHTMARE DRAGONFLIGHT

A wise lion once told me that from the depths of grief can arise either the mightiest of heroes or the most depraved of villains. To lose that which matters most can strip away all the layers of duty, purpose, and desire that form the very basis of who we are, leaving behind only a choice between hope or despair. For Fandral Staghelm, who was forced to watch as his son Valstann was torn in two by the qiraji General Rajaxx, such devastating pain led down a path of darkness that ultimately destroyed him and nearly ended the Emerald Dream.

Yet to understand the seeds of this tragedy, we must begin much earlier, with the growing appearance of saronite, a mineral said to form from the blood of the Old God Yogg-Saron. Knowing that the druids dare not leave such corruption unchecked, Fandral decided that the best way to eradicate the threat was to steal clippings of the World Tree Nordrassil and plant them at the various sites of infection. While his reckless efforts to cleanse the rot were initially scorned, his plan appeared successful until the wildlife surrounding the new World Tree Andrassil grew wrathful and chaotic. In investigating the disturbance, the druids made a horrifying discovery: It appeared that the roots of the World Tree had burrowed so deep into the soil that they had pierced Yogg-Saron's prison, allowing the corruption of the Old God to seep into the tree. Though the druids quickly destroyed Andrassil and halted the corruption of the forest, they were unaware the corruption had already spread into the Dream.

Fandral's fall to the spreading Nightmare was all but assured after the Nightmare Lord Xavius sent the archdruid dreams detailing a way to restore his fallen son to life. Desperate to believe the satyr's lies, Fandral silenced and misdirected many of the druids who might otherwise have noticed the growing presence of the Nightmare within the Dream. Lost in the depths of madness and hope, the archdruid planted a new World Tree grafted with a branch from Xavius's tree, all but ensuring the full infection of the Emerald Dream.

By the time the first physical manifestations of the Nightmare were uncovered within the Wailing Caverns, Dire Maul, and the sunken temple of Atal'Hakkar, the infection had grown well beyond the ability of the druids or the green dragonflight to stop it on their own.

The pain of Fandral's loss never eased, making his desperation the perfect tool with which to destroy the Emerald Dream.

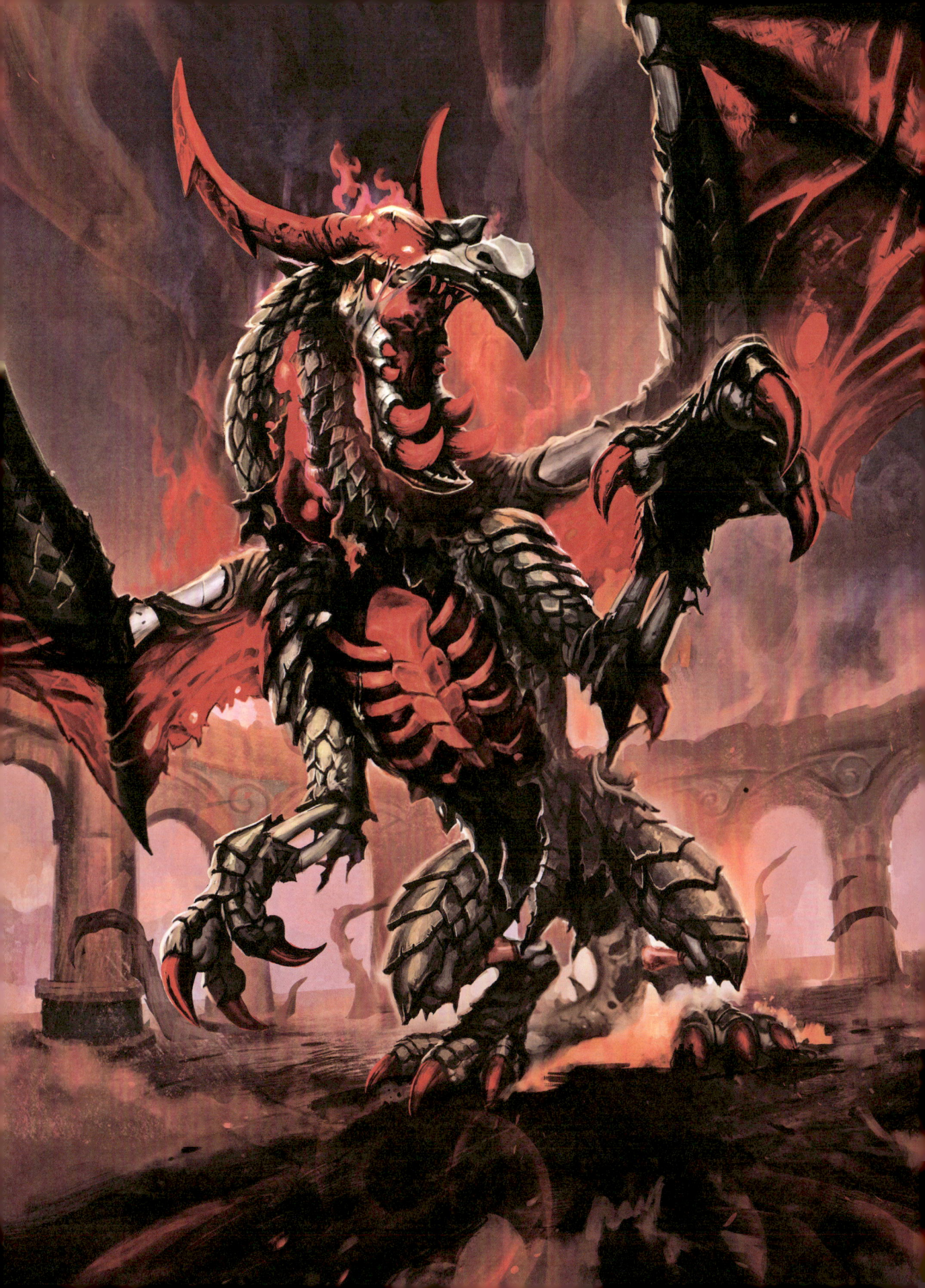

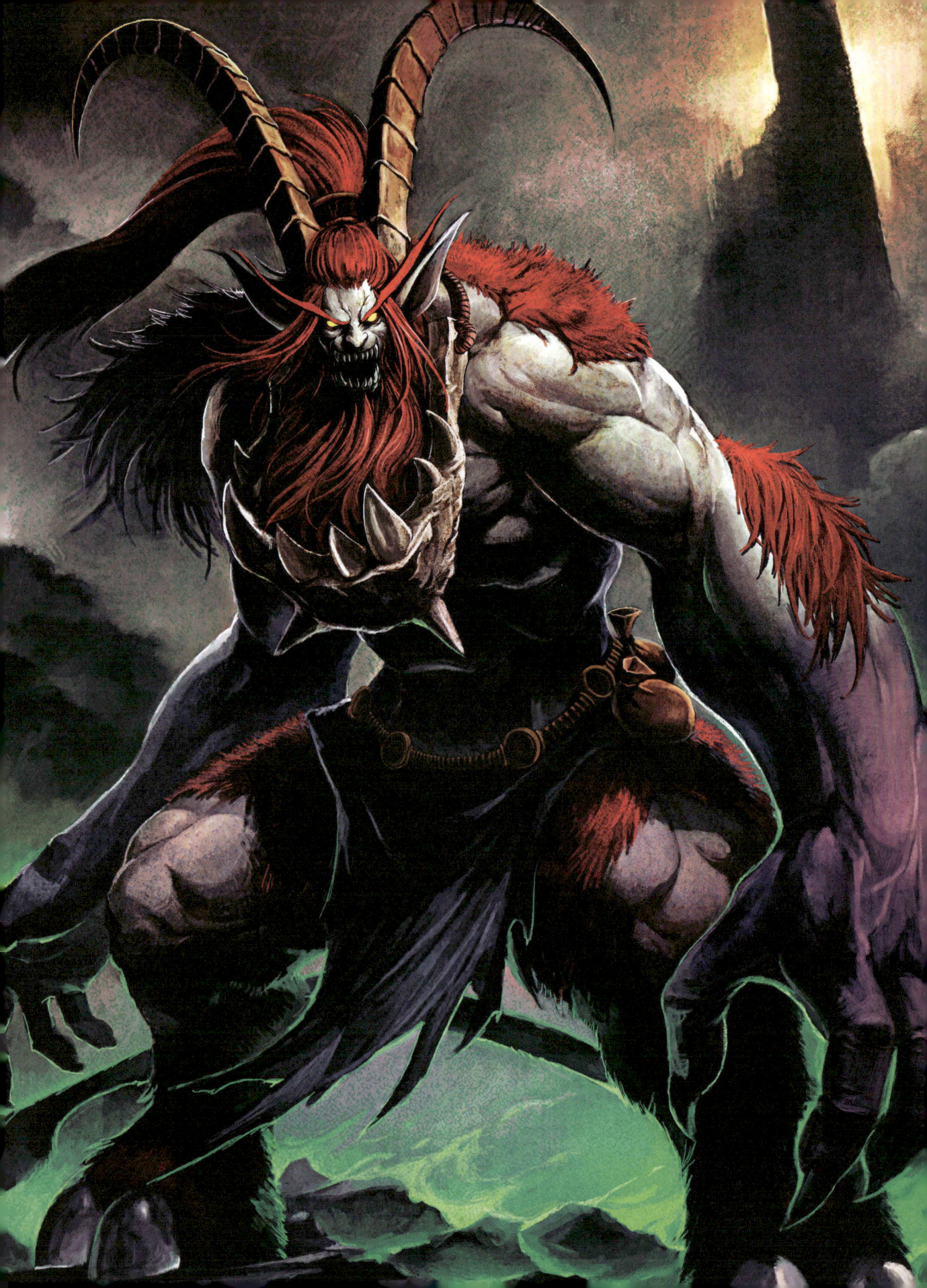

DRAGONS OF NIGHTMARE
Servants of the Nightmare Lord Xavius

Survivors who were purified of the Nightmare often share similar accounts of how the infection's slow, insidious progress made the drift of their sanity nearly imperceptible. Whether dragon, druid, or denizen of the Dream, each describes the same creeping madness that was at first isolating and then consuming. None spoke at the time of their tormented dreams or their simmering rage, for such things occurred over the course of weeks, months, and even years. Worse still was the stigma among the druids that such chaos of the mind was the antithesis of their long training and a weakness to be overcome through increased meditation. Even the dragons who should have recognized the mark of the Old Gods failed to see the spreading rot due to their relative solitude, both within the Dream and as sentinels of the physical world. It is for these reasons that the Nightmare was recognized only upon the emergence of the Dragons of Nightmare from the dream portals of Azeroth.

What befell Ysondre, Lethon, Emeriss, and Taerar was neither a failure of strength nor a lack of dedication to their flight. Each was an ancient dragon and long-trusted lieutenant of the Aspect Ysera. It is believed that what triggered their early downfall was likely their long slumber within the Emerald Dream, a condition that prevented them from sensing the writhing tendrils of corruption that had threaded itself amid the realm's abundant life energy. Regardless of the cause, the result was a force of dragons with a singular goal: the extinction of all life on Azeroth.

Emerging from the dream portals in the Hinterlands, Duskwood, Feralas, and Ashenvale, the Dragons of Nightmare sought to spread madness and terror throughout the mortal realm. Their raging challenges echoed amid the very boughs of the World Trees that Fandral Staghelm had himself so unwisely planted, daring anyone brave enough to test the might of a dragon. Although defeated, and with the groves cleansed of their foul essence, they would later return again when Xavius launched an attack on Val'sharah.

Though the dragons' suffering continued for many years, each was eventually redeemed and their souls returned to the purified Emerald Dream.

Though N'Zoth transformed Lord Xavius into the Nightmare Lord, the Highborne's ancient transformation into the first satyr was the result of Sargeras's displeasure.

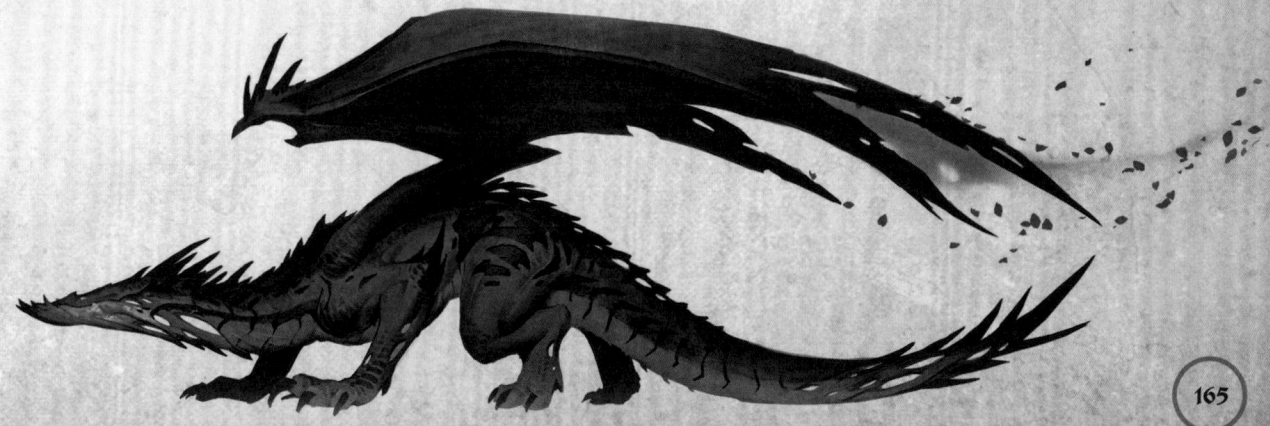

NYTHENDRA

Guardian of the World Tree Shaladrassil · Guardian of the Dream · Gatekeeper of Corruption

Mighty Shaladrassil, thought to have been grown from the great Mother Tree G'Hanir in the time before the Sundering, stood at the center of both Val'sharah and druidic culture since the kaldorei first dared reach toward the Dream. Here it served as a bastion of learning for the Dreamweavers, a group of elves so ancient that they watched their World Tree take root and bind itself to the Emerald Dream. For eons, Shaladrassil towered peacefully over the verdant elven lands until, one day, its brilliant crown inexplicably began to blacken and emit a sinister crimson aura.

With the threat of Xavius and the Nightmare thought sealed away, the sudden surge of corruption in Val'sharah caught not only the local defenders by surprise, but also Malfurion Stormrage. Here the rot chose to slip deep into Shaladrassil's roots before driving the ancient defender Cenarius, along with Oakheart and Nythendra, to madness. With its greatest threats culled, the infection quickly spread to the town of

Shala'nir and much of the elven forests beyond. As once emerald foliage became gnarled and blackened, the druids and dragons sleeping within Shaladrassil were transformed into foul servants of the Nightmare Lord Xavius.

Under such control, Nythendra of the green dragonflight was mutated into a plagued skeletal monstrosity. Once she and Oakheart had defended the World Tree in the name of the Emerald Dream, but they now turned upon the mortal champions who attempted to breech the sanctum and fight back its corruption. Unable to resist the Nightmare Lord's commands, the former green dragon unleashed her pestilence upon the fighters, killing many with her virulent rot. Yet despite her incredible ferocity, Nythendra's eternal guardianship was ended and her spirit was finally freed of the Nightmare.

Though the Nightmare itself was defeated in time, the many crimson scars of its infection remain upon Shaladrassil and the land of Val'sharah.

Even in the depths of madness, the noble guardians of Shaladrassil upheld their charge.

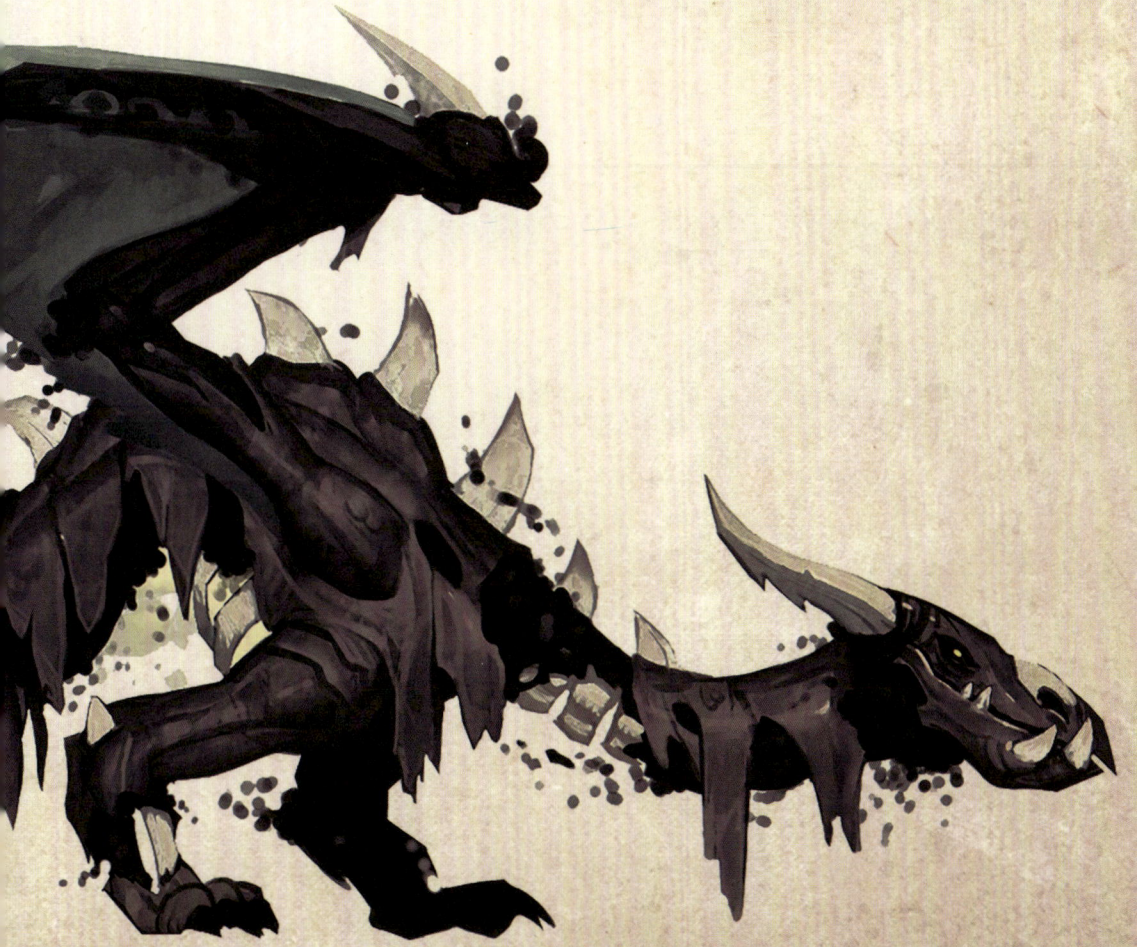

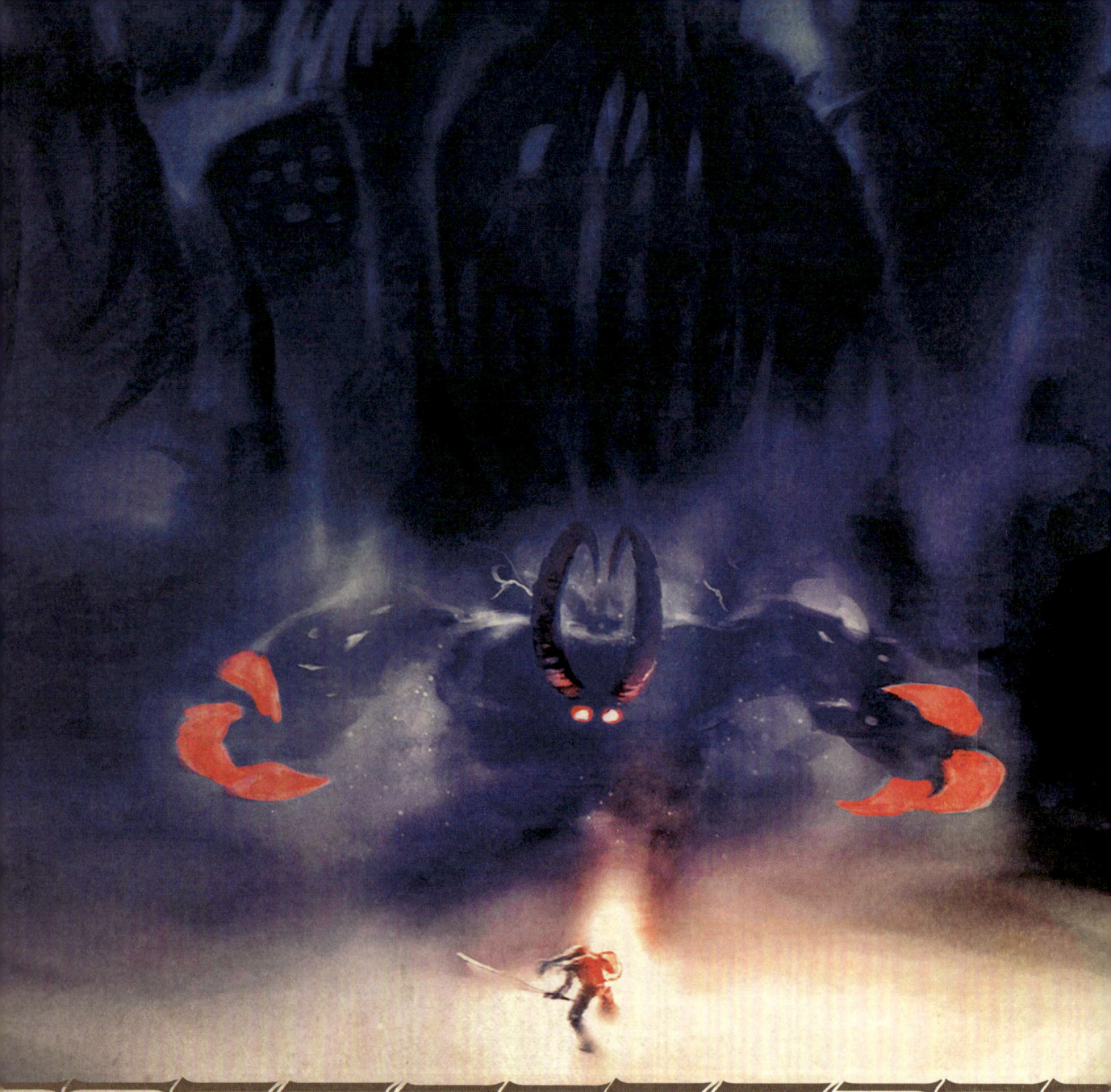

TWILIGHT GROVE OF DUSKWOOD

An elven grove stands amid an accursed land, a curiosity of ancient creation erected far from the loving gaze of Elune. Low hills ring a towering World Tree whose lofty branches filter the sunlight into dim flickers, casting the land below into a perpetual twilight. Beside a dormant gateway woven of vines, the waters of a shallow well shimmer like pearlescent moonlight.

As with all such hallowed battlefields, the echoes of the fallen reach through time, hoping to be immortalized in the tales we tell of fateful younger days.

The Nightmare corruption seen throughout the Dream and Azeroth stemmed from Xavius.

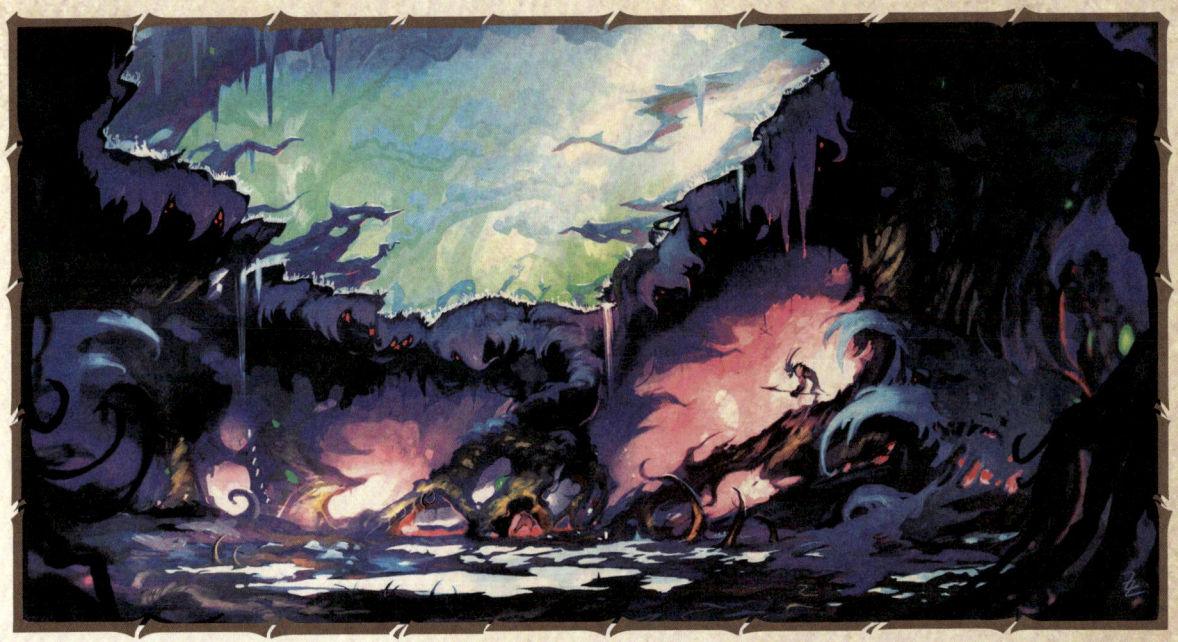

VAL'SHARAH/SHALA'NIR

Even from a distance, a crimson aura of dread warns any unwise enough to enter the once pristine forests of Shala'nir. Master-worked buildings stand twisted and broken as thorny iron roots seek to draw everything of beauty down into the vile earth. Vile aberrations and creatures of shadow follow the trespass of the living, hungrily waiting for their moment to attack. Even heroes of old have become enemies here, with their victories buried under the weight of madness and disease.

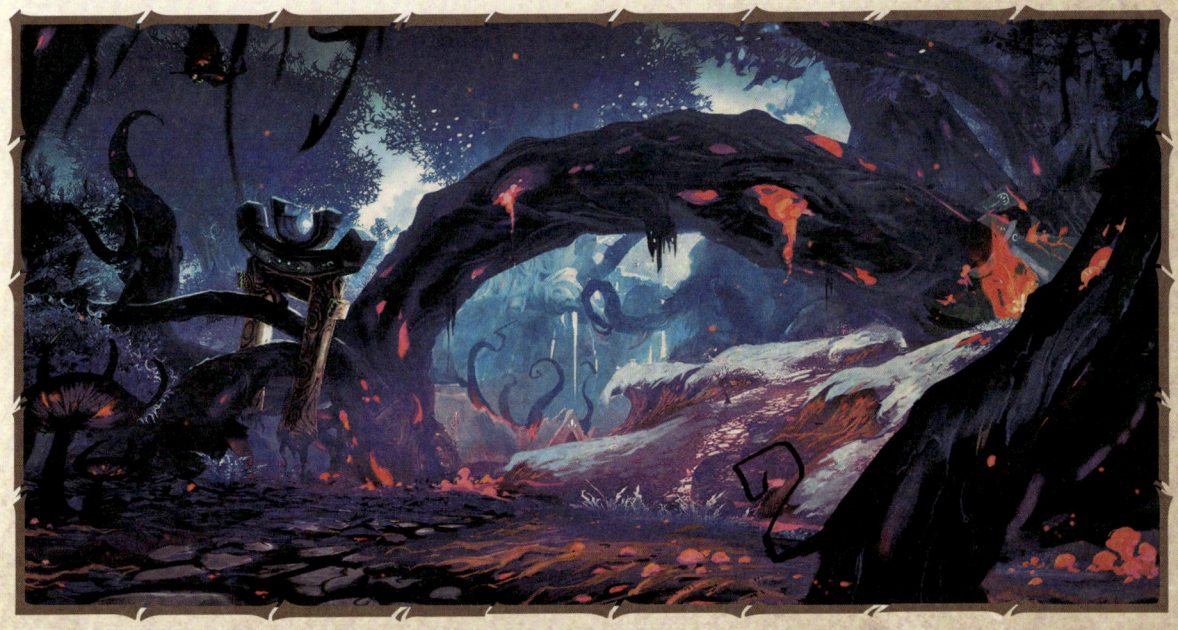

What possible future awaits such a corrupted place where even the might of an Aspect could not tread?

FROSTBROOD

And the bells rang for his return...

Those present on that fateful day speak of its festival atmosphere, a celebration that drew hopeful citizens to the capital of Lordaeron from the farthest reaches of the kingdom. So many desperate months had passed since their beloved prince had set off for Northrend in search of the plague's cause, leading many to believe that his return heralded an end to their suffering. Little could they know that an even worse fate awaited them.

With rose petals raining down upon Arthas Menethil's every step, none seemed to notice the prince's many changes. In place of his golden paladin's armor, he now wore a vicious set of spiked saronite. Missing, too, was his hammer, replaced with a sword seemingly formed from the very hoarfrost of Northrend itself. Those most astute later recalled a strange glow to the prince's eyes, an effect most had only ever seen among the neighboring high elves of Quel'Thalas. Yet before such details had a chance to illicit concern, the prince moved along to be welcomed home by his father.

Though it seems unlikely after so many years, the stain of King Terenas's bloody crown remains visible upon the majestic inlays of Lordaeron's throne room. Whether as a display of loyalty to the Lich King or merely a depraved desire to cut all ties to his mortal life, Arthas Menethil killed his father moments before unleashing an army of unthinking, unliving creatures upon his own people.

Among the most deadly and destructive of his vast undead forces were the Frostbrood, a flight of terrifying skeletal dragons raised from the remains found beyond the sacred boundaries of the Dragonblight.

Even all these many years later, the scars of Arthas's march from Lordaeron to the Isle of Quel'Danas can still be seen. Though much of the dead and blackened earth has been scattered by the winds, the deep strafing lines of the Frostbrood's icy breath will remain forever etched upon the land.

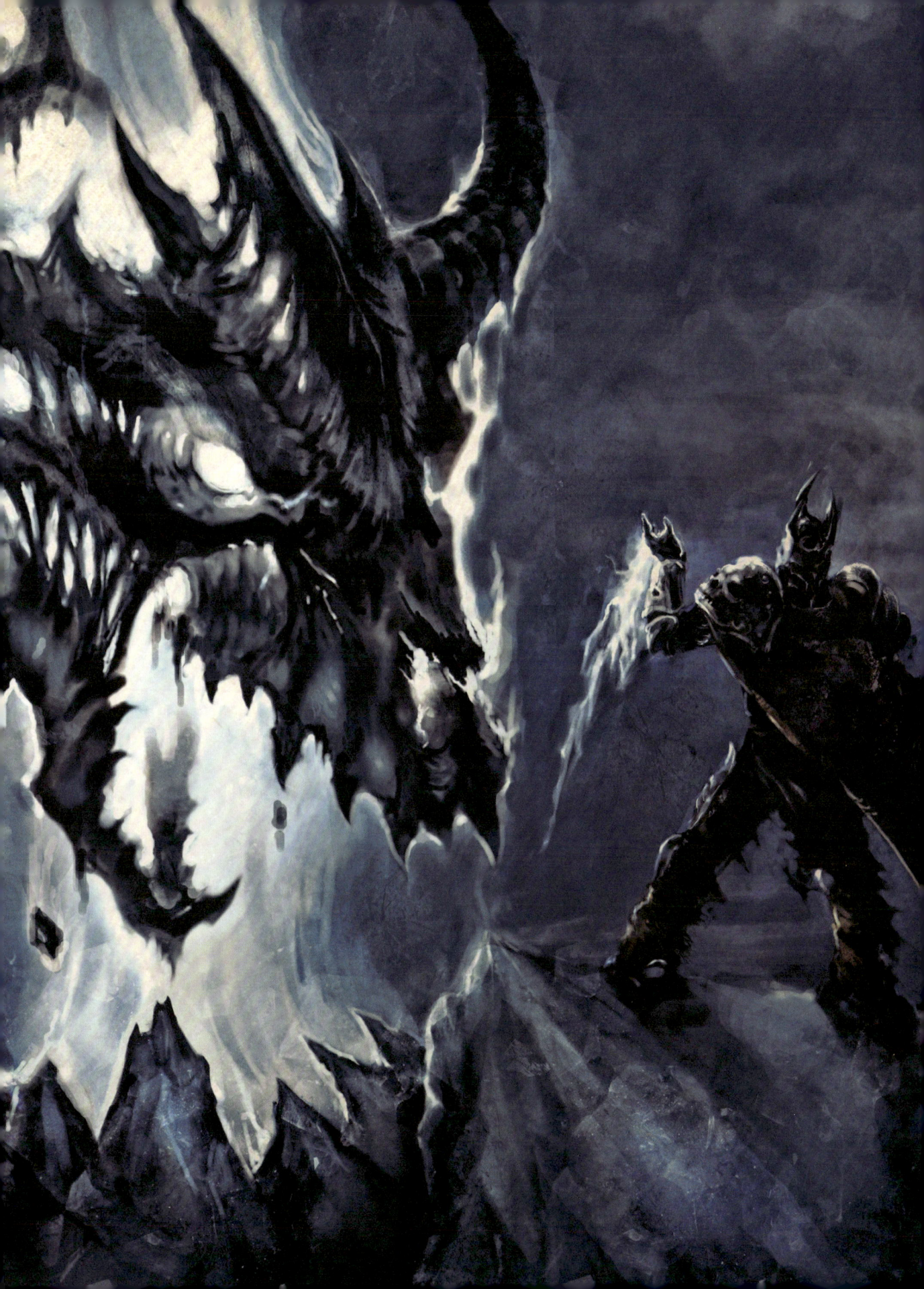

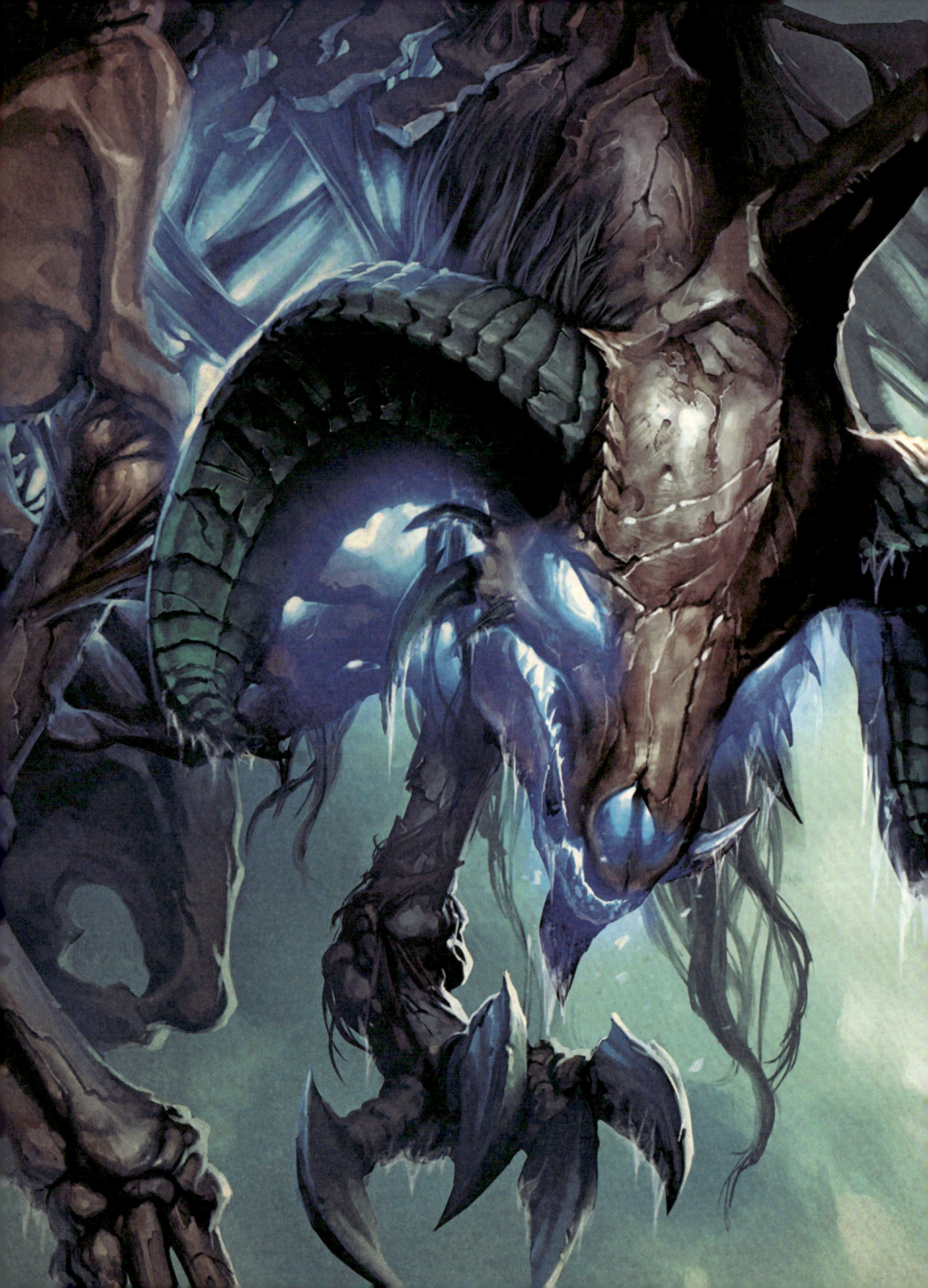

SAPPHIRON

Key Guardian to the Focusing Iris · Guardian of Naxxramas

As is the common charge of many blue dragons, Sapphiron was a devoted caretaker of arcane artifacts and a trusted guardian of his flight's most powerful device: the Focusing Iris. For reasons unknown, Sapphiron chose to carry out his sacred duty outside the Nexus in a lair located near the entrance to the nerubian city of Azjol'Nerub. It was this decision that led to his unfortunate fate as an undead guardian for the necromancer Kel'Thuzad.

As Arthas Menethil's ship landed on the coast of Northrend to defend the Frozen Throne from Illidan, he came under fierce attack by a contingent of blood elves led by Prince Kael'thas Sunstrider, seeking vengeance for the fall of Quel'Thalas. Most historians agree that Arthas would likely have met his end upon that craggy shore had it not been for the intervention of Anub'arak, a cryptlord originally of an aqir race known as the nerubians who had been raised into undeath to serve the Lich King. While Arthas was successful in driving the elves into retreat, he feared that the battle had cost him precious time and that he would not be able to reach Icecrown before Illidan, who sought to destroy the Lich King. Not only did Anub'arak offer to guide Arthas through the underground city of Azjol'Nerub, but he also gave him the chance to acquire powerful artifacts by raiding Sapphiron's lair.

Though the blue dragon was initially amused by Arthas's stated intent to kill him, Sapphiron realized the error of his arrogance when he was quickly overwhelmed by the Scourge forces under the death knight's command. Not only did Arthas succeed in stealing the blue dragon's artifacts, but he also raised Sapphiron into a powerful frost wyrm with the last of his waning necromantic power.

After being forced to help Arthas in his quest to defend the Frozen Throne, Sapphiron was stationed in Naxxramas. It was from here that Kel'Thuzad carried out the work of the Lich King, with Sapphiron serving as guardian to the necromancer's inner sanctum.

As with all other souls taken by the mourneblade Frostmourne, Sapphiron's essence was released into the Shadowlands after the defeat of Arthas and the shattering of his accursed sword.

SINDRAGOSA

The Frost Queen · Queen of the Frostbrood

The rise of the Frost Queen began with her initial downfall at the claws of Deathwing. Caught in the catastrophic blast of the Dragon Soul that similarly doomed much of her flight, Sindragosa was flung into the far reaches of Northrend by the enormous blast. Sensing that she was near to death, the blue consort attempted to fly to the Dragonblight; however, she proved too weak to make such a distance and crashed into a mountainside within Icecrown. With the last of her energy, she cried out to her beloved mate, Malygos, but heard only the uncaring winds in response. And so, for more than ten thousand years, Sindragosa's broken body lay forgotten in the ancient glacier of the frozen north.

But then she felt something, a pull of dark energy that called to her and commanded her to rise in undeath and serve the will of another. Fury tore through her mind, for the mate who had ignored her call and the asinine mortals who had brought the Legion down upon Azeroth in their folly to wield the arcane. Though the once proud blue would have bristled to be brought under another's control in life, within the Lich King's unyielding command lay the fulfillment of her dying wish for vengeance. With a resounding crack of ice that resonated throughout the snow-bound wastes of Icecrown, the skeletal form of Sindragosa rose from her icy tomb to deliver death upon the living.

Years after her defeat at Icecrown, Sindragosa's spirit was finally set to rest alongside Malygos's by Kalecgos on the Dragon Isles.

Sindragosa was not the only dragon found in Icecrown Citadel. While theories abound, the Lich King's plan for Valithria of the green dragonflight remains unknown.

SARATHSTRA

Scourge of the North

Seeking to disrupt the Alliance and Horde forces amassing to breech Angrathar the Wrath Gate, the Lich King ordered several of his Frostbrood to claim the skies above the Dragonblight and terrorize his enemies. Rokhan of the Darkspears and his shadowhunters managed to bring down most of the skeletal dragons with relative ease, but one proved far more cunning than the rest: Sarathstra.

After recruiting several skilled veterans of the Horde to retrieve the dragon's frozen heart, Rokhan lured the frost wyrm into a clever trap and then led the attack against the monstrous dragon. Over the course of the battle, Sarathstra unleashed an unusual mix of frost and shadow attacks but was ultimately slain through the combined might of the assembled fighters. Though the heart was given over to Captain Gort at the Horde outpost of Agmar's Hammer, there is no official record of what became of it.

Field records state that Rokhan lost a number of his dragon hunters to extreme fall damage.

ICECROWN CITADEL

Forged from saronite, the blood of an Old God, the towering fortress known as Icecrown Citadel is a conduit between realms, a prison of souls forged to end a flawed cycle of judgment. Within these halls, a thousand voices cry out for release; others scream for vengeance. Amid so much suffering, it is hard to focus on a single tragedy, yet the sight of a father outliving his son weighs on even the most hardened heart.

Now all stands silent—a throne shattered and a legacy soon forgotten.

NETHERWING FLIGHT

Most scholars believe that the black dragonflight was unaware of its Aspect's pending betrayal at the Well of Eternity. However, their unwavering loyalty to Deathwing in the aftermath made them prime targets for the fury of the other Aspects and their broods. To those present that day, it seemed impossible that any dragon could condone such a despicable act—until the black brood's tragic vulnerability to the Old God's corruption was discovered. Though many saw the flight's malady as an incurable trait that needed to be eradicated, others devoted themselves to finding a cure that could someday redeem their ordered brethren. What nobody yet knew, however, was that far beyond the influence of Azeroth's eldritch beings, the remnants of Deathwing's lost Outland brood would one day exist untouched by the Void's dark calling.

In seeking a sanctum for his final clutch that could evade the notice of the other Aspects, Deathwing took his eggs through the Dark Portal and hid them deep within a mountainous region of Gorgrond. Here he believed he could protect his vulnerable whelps and replenish the numbers of his dying dragonflight. Despite the black Aspect's efforts to be circumspect, an Alliance expedition had followed him and managed to turn the local population of ogres and gronn against him. Unwilling to be driven out, Deathwing ordered his brood to wage war upon the defenders. It was a stubborn choice that not only led to the unnecessary death of many black dragons, but also caused the Aspect to suffer a terrible wound that required his retreat from Outland.

Shortly after Deathwing's escape came the shattering of Draenor, a catastrophic event that caused the lands of Frostfire Ridge to crash into Gorgrond, creating what is now the Blade's Edge Mountains. Despite such incredible upheaval, the black dragon eggs survived; however, they were twisted by the wild cascade of energies released upon the planet's destruction. The result was a new type of ethereal dragon composed of energy drawn from the Twisting Nether.

Though many inherited their temperament from their forefathers, the nether dragons exhibited no signs of the corruption that had long plagued their black dragon kin, even while on Azeroth.

Contrary to the oft-incorrect Draconic Compendium, Volume IV, *netherwing dragons can and do shift into visage forms.*

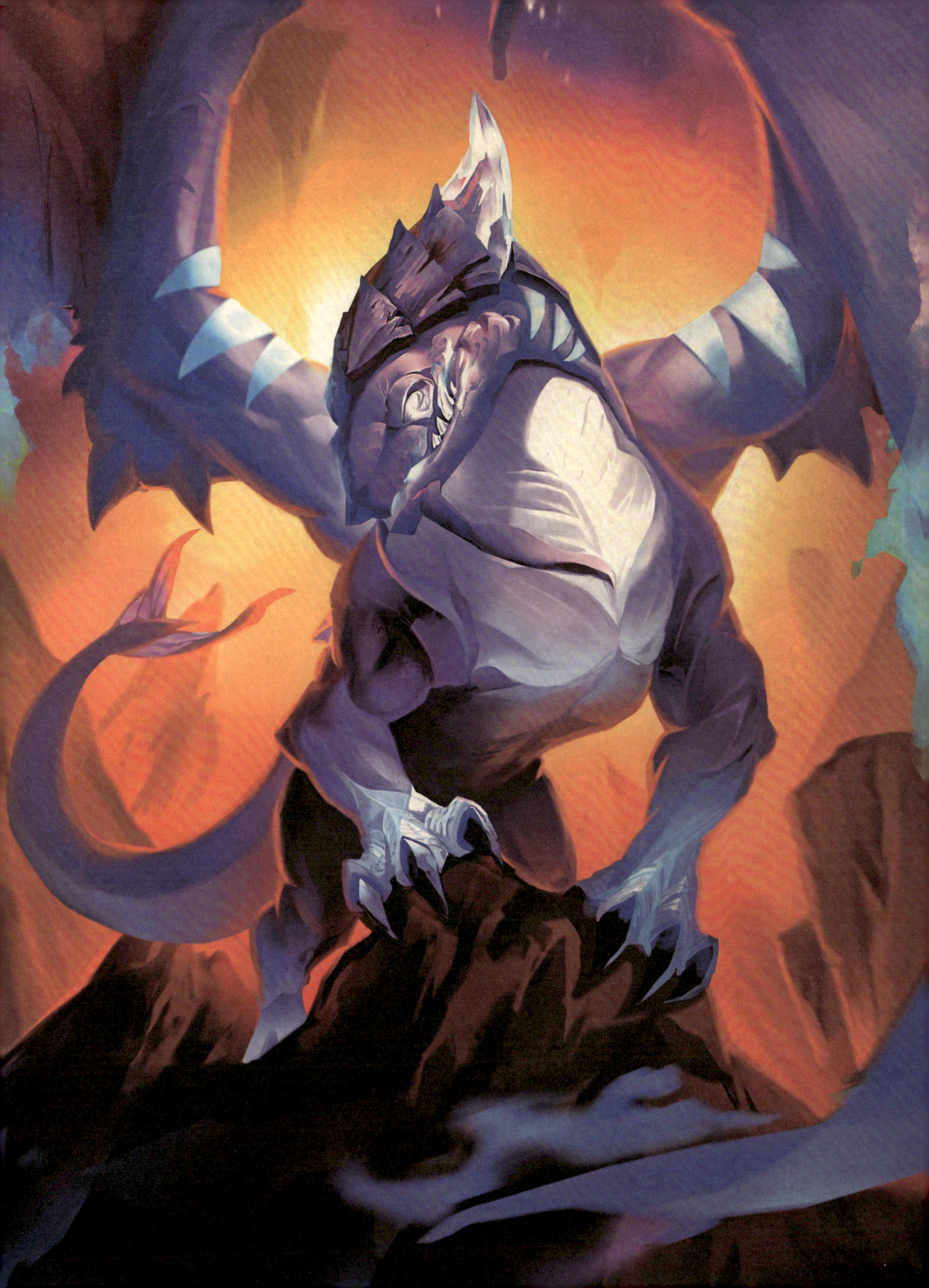

NELTHARAKU & KARYNAKU

Patriarch and Broodmother of the Netherwing

In the wake of Draenor's destruction, several factions rose to fight for domination over the shattered remnants of Outland. Seeking to consolidate their power in an alliance with Illidan Stormrage, Warchief Zuluhed the Whacked of the Dragonmaw clan captured the newly discovered netherwing dragons to ensure a continuous supply of mounts for his dragonriders. The orc failed to anticipate, however, that a death knight named Ragnok Bloodreaver had forged his own alliance with a force of fel orcs and ethereal mercenaries to steal most of the netherwings under the clan's control.

Left behind during Ragnok's raid, Karynaku remained a prisoner of the Dragonmaw until her mate, Neltharaku, located fighters willing to besiege the orc camp and mount a rescue. In the wake of their successful mission, the mortal champions brokered an alliance with the leaders of the netherwing flight, whose aid later proved instrumental in weakening Illidan's forces within Shadowmoon Valley.

The dragon depicted here is one of Neltharaku and Karynaku's brood.

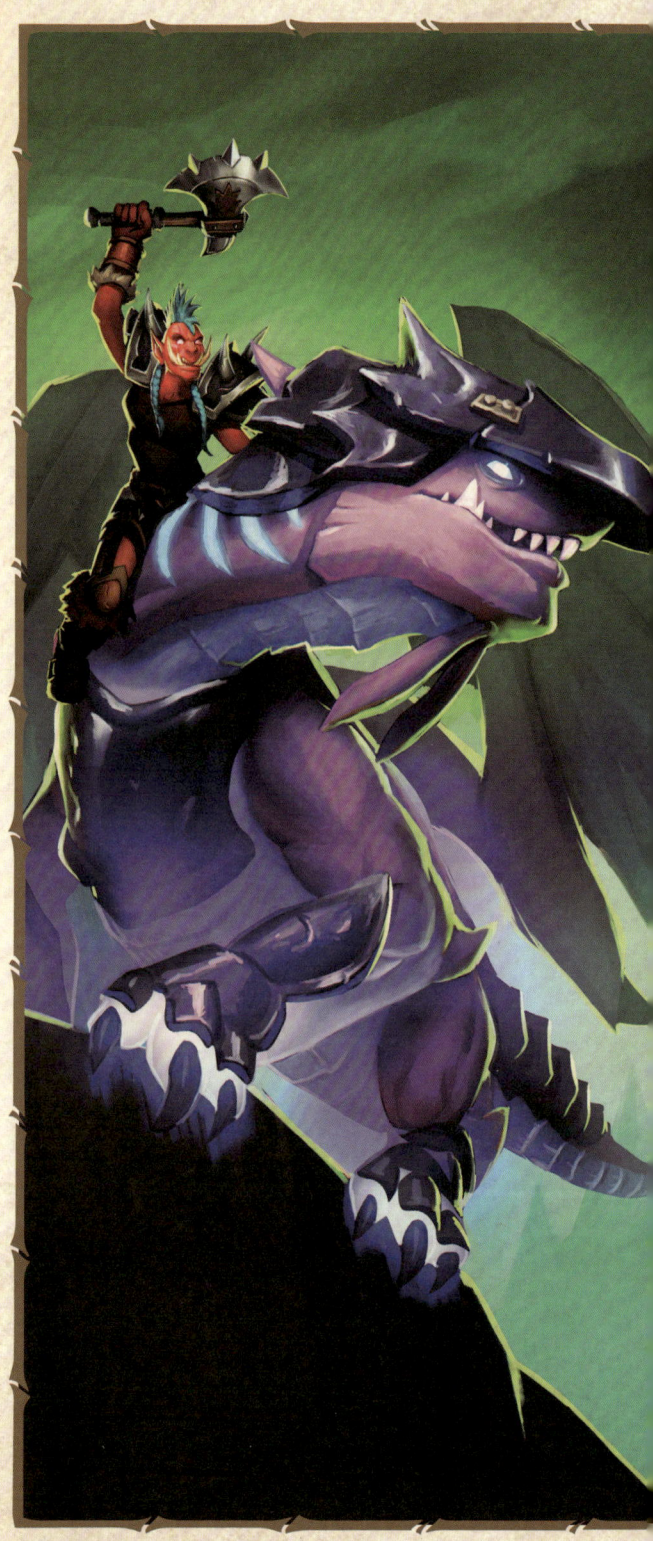

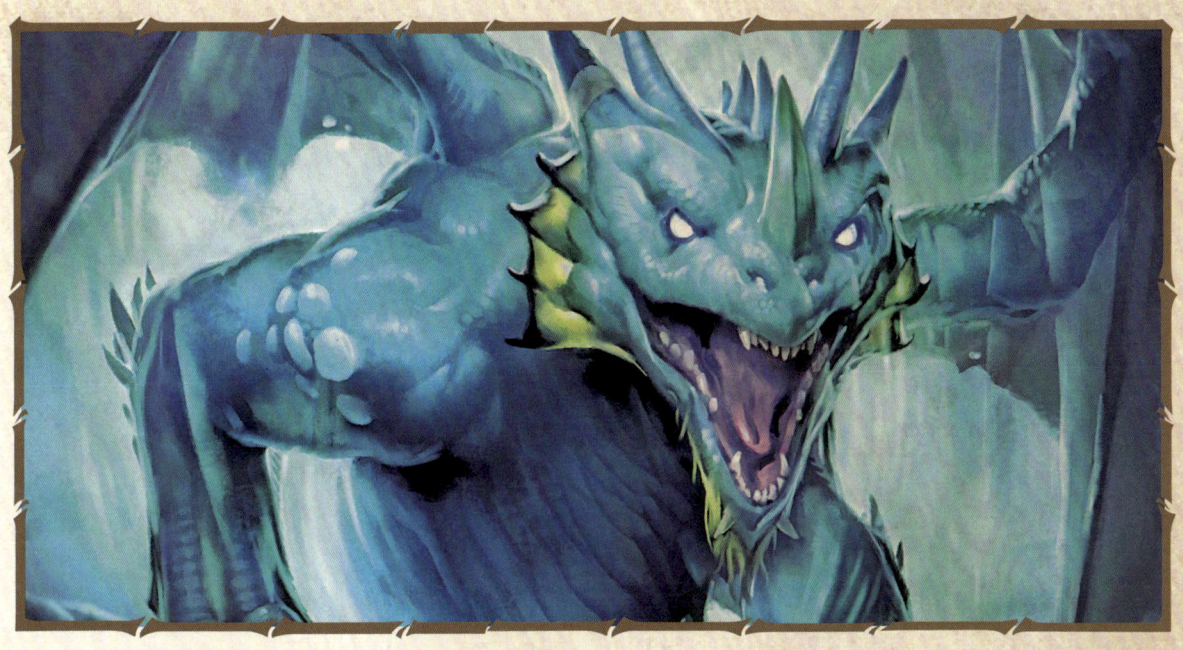

ZZERAKU

Of the Netherwing

While investigating the source of a strange yet familiar energy emanating from Outland, Tyrygosa was attacked by the death knight Ragnok Bloodreaver, who sought to capture dragons for his army. Though initially suspicious of the blue dragon, Zzeraku of the netherwing was eventually drawn to Tyrygosa's story of the black dragonflight and her belief that the nether dragons could trace their origins back to Deathwing's lost eggs. Though their trust of each other remained tenuous, Tyrygosa and Zzeraku worked together to free his enthralled broodmates during an attack on the Dark Portal.

The nether flight's victory was short lived after Tyrygosa realized that freedom from Ragnok's control device would result in the brood's deaths unless the dragons were given an incredible source of power to feed upon. Believing that the Nexus could offer the energy they required, Tyrygosa brought the injured nether dragons to the blues' lair. However, the nether dragons suddenly turned on her kindness and attempted to claim the power for themselves. The sudden chaos of their battle awakened Malygos, who saw Zzeraku's brood as invaders and, without mercy, consumed nearly all of them.

Though it is unknown how Zzeraku escaped the Nexus, his survival turned out to be quite brief. After wandering Azeroth for a time, Zzeraku was captured by Zendarin Windrunner, who was allied with Deathwing's consort, Sinestra. And so it came to be that, within the gloom of Grim Batol, Zzeraku's essence was drained to create Dargonax and the first generation of the twilight dragonflight.

Zzeraku's heroic attempt to save the draenei priestess Iridi proved essential to Dargonax's defeat.

NETHERSTORM

The once verdant fields of Farahlon were torn apart during the destruction of Draenor, leaving behind a shattered landscape of floating rocks and crackling energy where the Twisting Nether and physical realm bleed together. It was on the crumbling outskirts of this land that the blue dragon Tyrygosa sought to watch over a colony of nether dragons.

SHADOWMOON VALLEY

A pristine glade of gentle night and twilight hues lies as but an echo to a tortured landscape boiling with the fury of fel elementals. It was once the sacred home of orc and draenei who sought spiritual guidance beneath the loving embrace of the Pale Lady. Now only the Twisting Nether fills the sky while its burning minions sow their hatred upon the land.

While it is here that the nether dragons faced their darkest hour at the hands of mortals, it is also here that they made their greatest mortal allies.

PLAGUED DRAGONFLIGHT

While most of the dragonflights owe their creation to either the titans or the dragons themselves, the plagued brood holds the unique distinction of being the only flight engineered by mortal design. Though the necromancer Kel'Thuzad later spread a virulent and long incubating version of the Lich King's plague of undeath throughout Lordaeron, we know that his earliest efforts began near the ruins of Caer Darrow, south of Andorhal. There, by the invitation and largess of the local Barov family, Kel'Thuzad established a school, laboratory, and training ground named Scholomance for his loyal followers, known as the Cult of the Damned.

Within the sheltered walls of the keep, all manner of unfortunate creature was experimented upon, in the hopes of creating a more deadly and contagious variant of the plague that the paladins of the Argent Dawn could not so easily neutralize. To achieve this goal, members of the cult contracted with various outside agents to secure a steady supply of varied test subjects. One such mercenary, a goblin named Tinkee Steamboil, managed to convince a group of adventurers to raid a clutch of black dragon eggs in the Burning Steppes for her master, Vectus.

The cultists saw the incredible potential in the dragons' ability to both spread and withstand the effects of the plague, and the black dragon eggs were injected and then hatched. Survival rates were relatively high, but the contagion had the unforeseeable effect of stunting both the whelps' growth and their intelligence, ultimately leading the project to be declared a failure and ended.

Interestingly, reports from soldiers of the Northrend campaign claim to have encountered both eggs as well as full-grown primal dragons under the control of the vrykul, who seemed to be imbued with plague. While their existence was corroborated by both the Horde and the Alliance, and there's still the occasional rumored sighting, little else is known about the methods of their creation or their rates of survival.

Likewise, no one knows the current state or whereabouts of the plague brood. The Argent Crusade has seen ongoing cultist activity on the island of Caer Darrow over the years, but the Cult of the Damned seems to have lost interest in draconic experimentation.

Had the Cult of the Damned succeeded, the plague of undeath could have spread throughout Azeroth on the breath of dragons.

SCHOLOMANCE

Sheltered on an island in the middle of Darrowmere Lake sit the ruins of Caer Darrow, a once bright institution now dedicated to the darkest, most vile arts—where human monsters seek to push the bounds of power and life itself.

CHROMATIC DRAGONFLIGHT

Deep within the earthen corridors of Blackrock Spire, Nefarian toiled to achieve what his father had long been unable to do—the creation of a new type of dragon that would seamlessly combine the essence of all five flights. To do so, Nefarian turned to the darkly brilliant design of the Dragon Soul and sought to combine the powers of the five flights within a single dragon. Yet to achieve his ambitious creation, the son of Deathwing needed to understand the power of each flight from the source. Thus, he sent his agents to capture both eggs and dragons for his twisted experiments.

Witnesses who saw the inside of Nefarian's laboratories during the siege of Blackrock speak of the unfathomable atrocities committed upon his subjects, especially those of the red dragonflight. Though he was increasingly close to stabilizing his creations, only a few chromatic dragons ever reached near maturity, such as Dal'rend Blackhand's war mount, Gyth.

Most believe that, had it not been for Queen Moira Thaurissan's clever scheme to draw the Horde into Blackrock in pursuit of the Dark Horde, Nefarian would have eventually succeeded in making a chromatic dragonflight as powerful and prolific as his mother's twilight brood. If only his first death had marked the true end of his tale, perhaps none of his creations would have survived to threaten the world. Instead, Cho'gall and the Twilight's Hammer resurrected Nefarian to continue his work with the chromatic dragonflight.

Nefarian turned the unity of the dragonflights' power into an abomination.

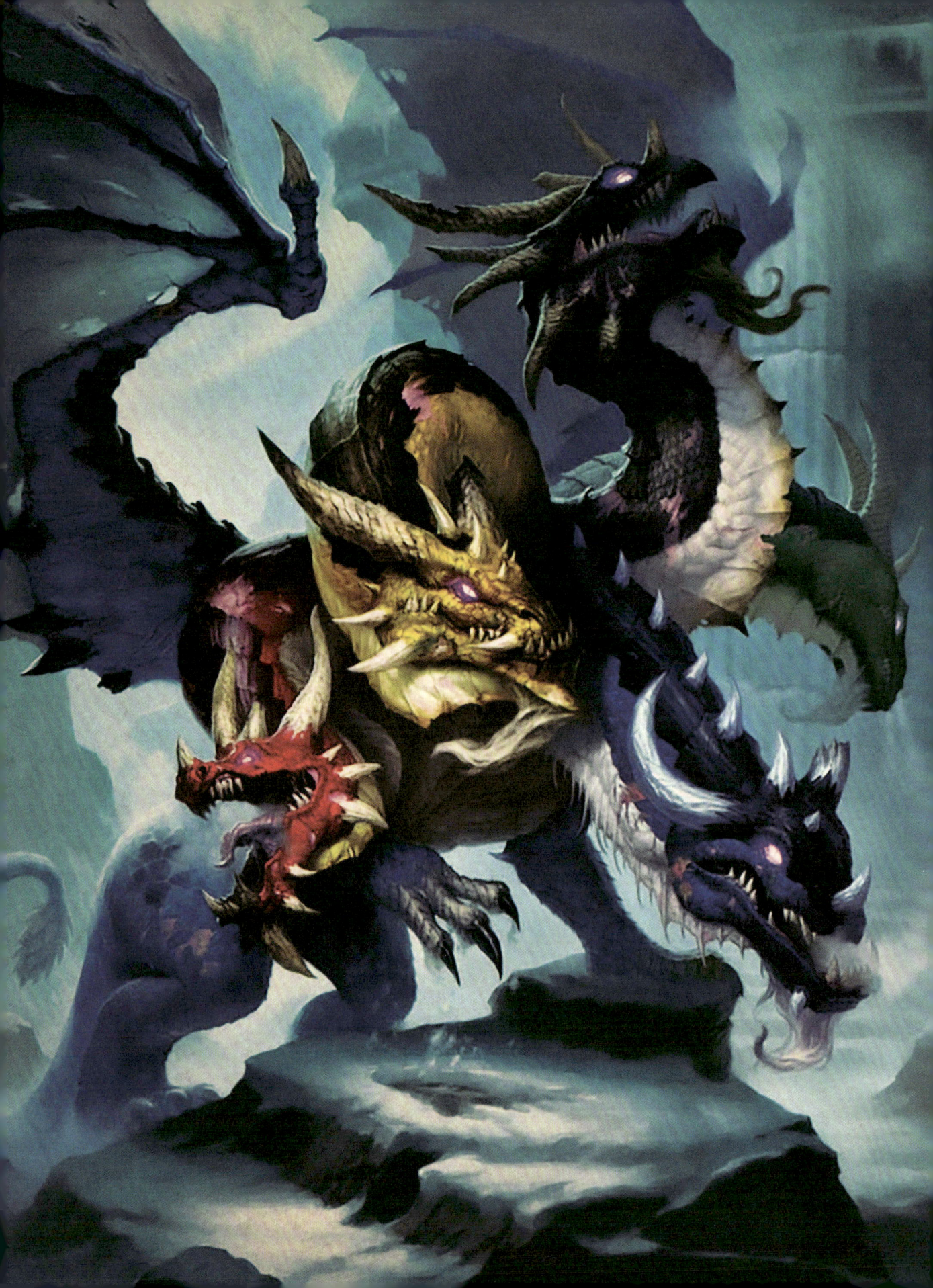

CHROMATUS
Last of the Chromatic Dragonflight

Following Nefarian's initial defeat, the body of Chromatus sat inert within Blackrock Spire in a state that could be classified as neither alive nor dead. He was the greatest achievement of the chromatic experiment, yet for all his potential, the dragon lacked the vital spark of life. Ultimately, it was Archbishop Benedictus, known later as the Twilight Father, who managed to unlock the secrets to animating the five-headed dragon.

Though the death of Cho'gall struck a definitive blow to the efforts of the Twilight's Hammer, the clan's new leader proved no less cunning and ruthless. Known formerly as Archbishop Benedictus, the Twilight Father seized control of the clan and, with it, the research gained after Nefarian was raised in undeath to continue his chromatic experiments. Seeing potential in the vanquished black dragon's work, the Twilight Father devised a plan in which twilight dragons would wage a diversionary attack upon Wyrmrest Temple while his cultists infiltrated the dragon sanctums to transform the dragonflights' clutches into chromatic abominations.

Tragically, the Twilight Father's efforts were successful, leaving the red consort Korialstrasz no choice but to sacrifice himself to end the threat of a chromatic brood. Yet even with its plans seemingly thwarted, the cult showed no intention of retreating from Wyrmrest Temple. Instead, Benedictus ordered his followers to deliver the five-headed behemoth known as Chromatus.

After sacrificing his former ally, the blue dragon Arygos, Benedictus managed to do what Nefarian's years of experimentation had failed to accomplish: He imbued the spark of life into the chromatic monstrosity. What the other dragonflights beheld as they arrived to reclaim their home was nothing short of terrifying: a dragon capable of wielding their own unique powers against them.

Though their initial efforts to battle Chromatus seemed dire, a vision reportedly received by Ysera showed each Aspect fighting a head wielding a different affinity from its own. Yet after their initial rally, Chromatus managed to overwhelm Ysera, forcing the Aspects into retreat. It was then that the orc shaman Thrall suggested a plan to bind the Aspect's power with his own elemental affinity in what served as a precursor to the attack that later defeated Deathwing. As Chromatus reared all five heads for a finishing strike, a beam of pure white light slammed into the monstrosity's chest, causing him to fall to the ground, lifeless.

In the aftermath of the battle, the Aspects sought to destroy the corpse of Chromatus but found that some form of dark magic had been woven throughout his body to prevent its complete annihilation. With no clear way to eliminate his remains, the Aspects committed Chromatus's body to the security of an arcane prison.

Despite Nefarian's tireless efforts, it was Archbishop Benedictus, known later as the Twilight Father, who succeeded in bringing the monstrosity known as Chromatus to life.

FUTURE OF DRAGONS

After the defeat of Deathwing and the loss of the Aspects' power, we seem to find ourselves in uncharted territory. Against all odds, the many disparate races of Azeroth came together to defeat not only the Aspect of Death, but also the very Old Gods themselves. Though many enemies remain scattered throughout both space and time, we stand united for the first time on the precipice of choice. The question is, what kind of world will we build?

For too long, we suffered a cycle of hatred and madness. While most had no choice but to fight in the various wars mentioned within these pages, we can now choose to shape a better future. Together we saved Azeroth, and together we can rebuild our shattered world.

And so, I choose to end this account with a message of hope: For the refugees who found shelter in the scattered corners of Azeroth. For the veterans of countless campaigns. For those who lost so much to the madness of a once noble Aspect and a beloved prince consumed by darkness. To a world that dared to defy the will of a Dark Titan and the domination of the Maw. To a new future for all citizens of Azeroth, both mortal and dragon alike.

—*Khadgar*
Archmage of the Kirin Tor

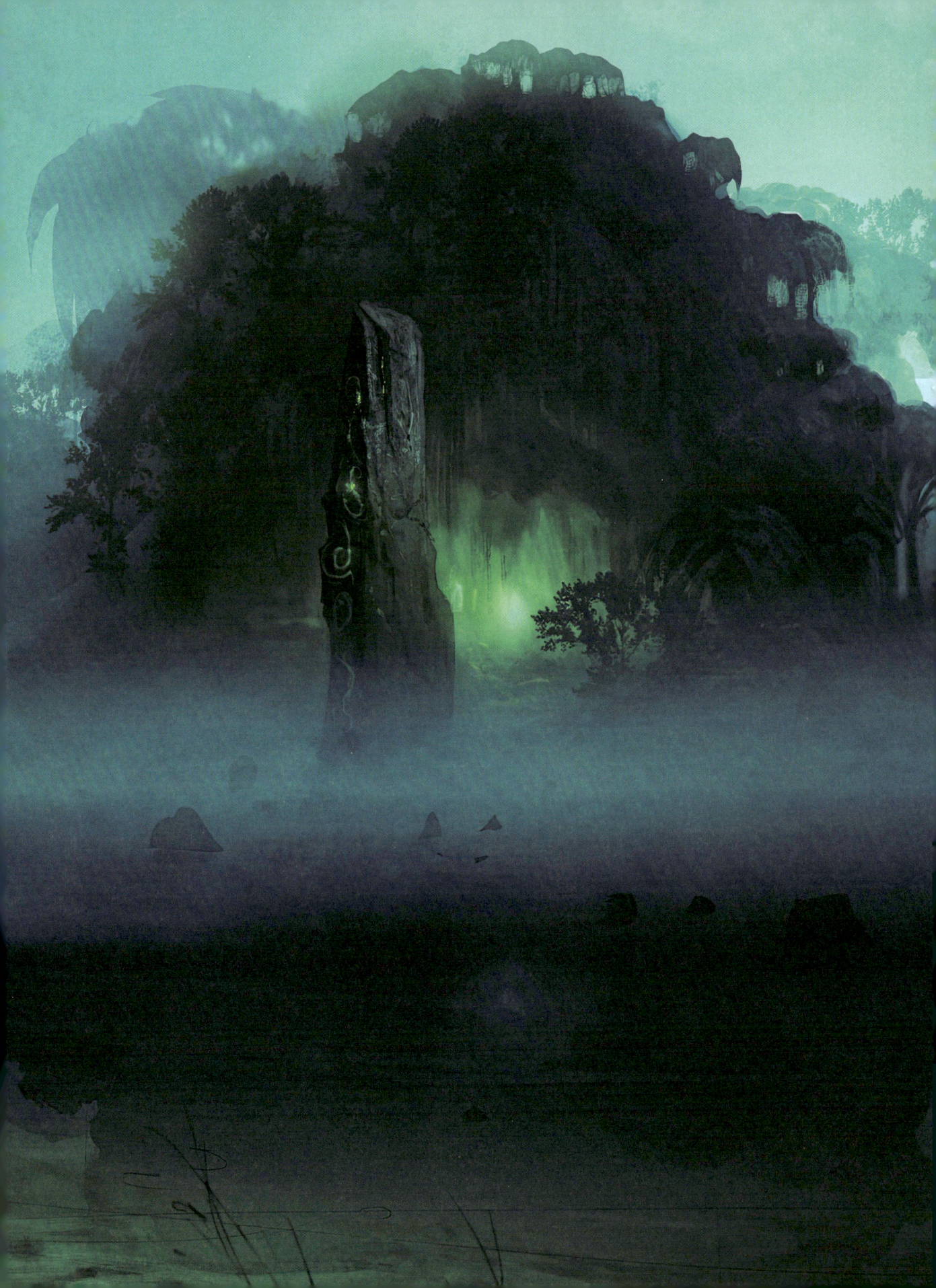

ARTIST CREDITS

Blizzard Artist: 82, 96, 116, 123, 129, 174
Laurel D. Austin: 38, 61, 133
Daren Bader: 149
Adam Baines: 2, 113
Kerem Beyit: 149
Eric Braddock: 90
Zoltan Boros: 74, 88, 161
Arthur Bozonnet: 120
Milivoj Ćeran: 29
Sukjoo Choi: 140–143
Peet Cooper: 134
Hannah JS Davis: 136
Eric Deschamps: 125
Samwise Didier: 1, 136
Cole Eastburn: 97, 190
Jesper Ejsing: 51
Gabriel Gonzalez: 163
Lucas Graciano: 121
Johan Grenier: 66
Alex Horley: 64, 101, 103, 147, 152, 174
Andrew Hou: 144
Tyler Hunter: 171
Ruan Jia: 106
Brian Kang: 170
Jason Kang: 184
Trent Kaniuga: 36
Joe Keller: 166, 167
Roman Kenney: 61, 128, 137
Kim: 155, 157, 185
Michael Komarck: 72
Justinn Kunz: 34, 35
Peter C. Lee: 26, 52, 82, 110, 180, 181
Jimmy Lo: 6, 7, 53, 83, 97, 117, 168
Slawomir Maniak: 37, 179
Ryan Metcalf: 135, 165
Raven Mimura: 159
Caio Monteiro: 163
MoonColony: 12, 13, 14, 16, 17, 18, 20, 21, 22, 23, 24, 25, 40, 41, 56, 59, 70, 71, 86, 87, 131
Craig Mullins: 161
Will Murai: 61

Tyson Murphy: 107
Jim Nelson: 129
Sam Nielson: 154
Dusty Nolting: 132
Jake Panian: 61
Bill Petras: 182
Laurent Pierlot: 19
Dmitry Prozorov: 175
Alexandra Quinby: 32
Glenn Rane: 15, 80, 100
Chris Robinson: 90
James Ryman: 57, 93, 106, 186
Mike Sass: 158
Gustav E. Schmidt: 44, 45, 52, 53, 102, 115, 175
Ittoku Seta: 108
Mongsub song: 188, 189
Peter Stapleton: 178
BOSi Studio: 177
N-iX Game & VR Studio:
 Lead Artist - Valentyn Khruslov
 Artists - Oleksandr Utkin: Cover Art, 10, 11, 42, 43
 Vadym Kutsenko: 77, 91, 94, 111, 114, 126, 127, 150, 160
 Andrii Shvyrov: 54, 55, 68, 69, 84, 85, 98, 99, 118, 119
Lemon Sky Studios: 153
Alex Stone: 109
Raymond Swanland: 33, 39, 47, 62, 75, 104, 105
Gabor Szikszai: 88
Lianna Tai: 162
Hideaki Takamura: 164
Josh Tallman: 8, 61, 67, 172
Steve Tappin: 148
Wei Wang: 89
Richard Wright: 96
Bayard Wu: 30, 31, 46, 73, 112, 124, 139
Anton Zemskov: 145, 183
Benjamin Zhang: 78
Phillip Zhang: 169
Mark Zug: 48
Fabio Zungrone: 19, 116

Published by Titan Books, London, in 2023.

TITAN BOOKS

A division of Titan Publishing Group Ltd
144 Southwark Street
London SE1 0UP
www.titanbooks.com

Find us on Facebook: www.facebook.com/TitanBooks
Follow us on Twitter: @titanbooks

© 2023 Blizzard Entertainment, Inc. Blizzard and the Blizzard Entertainment logo are trademarks or registered trademarks of Blizzard Entertainment, Inc. in the U.S. or other countries.

Published by arrangement with Insight Editions, San Rafael, California.
www.insighteditions.com

No part of this publication may be reproduced, stored in a retrieval system, or transmitted, in any form or by any means without the prior written permission of the publisher, nor be otherwise circulated in any form of binding or cover other than that in which it is published and without a similar condition being imposed on the subsequent purchaser.

A CIP catalogue record for this title is available from the British Library.

ISBN: 9781803368092

Publisher: Raoul Goff
VP, Co-Publisher: Vanessa Lopez
VP, Creative: Chrissy Kwasnik
VP, Manufacturing: Alix Nicholaeff
VP, Group Managing Editor: Vicki Jaeger
Publishing Director: Mike Degler
Art Director: Catherine San Juan
Senior Editor: Justin Eisinger
Editorial Assistant: Sami Alvarado
Managing Editor: Maria Spano
Senior Production Editor: Katie Rokakis
Senior Production Manager: Greg Steffen
Senior Production Manager, Subsidiary Rights: Lina Palma-Tenema

BLIZZARD ENTERTAINMENT

Associate Manager, Consumer Products: Peter Molinari
Director, Manufacturing: Anna Wan
Direct Manufacturing Project Manager: Chanee' Goude
Senior Director, Story and Franchise Development: Venecia Duran
Senior Producer, Books: Brianne Messina
Associate Producer, Books: Amber Proue-Thibodeau
Senior Manager, Editorial: Chloe Fraboni
Senior Editor: Eric Geron
Book Art & Design Manager: Corey Peterschmidt
Senior Manager, Lore: Sean Copeland
Senior Producer, Lore: Jamie Ortiz
Associate Producer, Lore: Ed Fox
Associate Historian: Madi Buckingham, Courtney Chavez, Damien Jahrsdoerfer, Ian Landa-Beavers
Creative Consultation: Ely Cannon, Steve Danuser, Stacey Lee Phillips, Korey Regan, Bayard Wu

Special Thanks: Madison Clark, Adamari Rodriguez, Derek Rosenberg

Insight Editions, in association with Roots of Peace, will plant two trees for each tree used in the manufacturing of this book. Roots of Peace is an internationally renowned humanitarian organization dedicated to eradicating land mines worldwide and converting war-torn lands into productive farms and wildlife habitats. Roots of Peace will plant two million fruit and nut trees in Afghanistan and provide farmers there with the skills and support necessary for sustainable land use.

Manufactured in China by Insight Editions

10 9 8 7 6 5 4 3 2 1